HUMANITIES THROUGH THE BLACK EXPERIENCE

Edited by

PHYLLIS RAUCH KLOTMAN

DAVID N. BAKER
Indiana University—Bloomington
MARIAN SIMMONS BROWN
Florida Junior College—Jacksonville
PHYLLIS RAUCH KLOTMAN
Indiana University—Bloomington
ROBERT H. KLOTMAN
Indiana University—Bloomington
ROSLYN ADELE WALKER
Illinois State University—Normal
JIMMY L. WILLIAMS
North Carolina A & T State University—Greensboro

An audio cassette tape and slides which
may be used as supplementary material
to accompany this text are available
through the publisher.

KENDALL/HUNT PUBLISHING COMPANY
2460 Kerper Boulevard, Dubuque, Iowa 52001

Cover design photograph: "Boy's World" by Charles McGee
1965. From the collection of Robert and Phyllis Klotman.
Photo: Lawrence F. Sykes.

Copyright © 1977 by Kendall/Hunt Publishing Company

Library of Congress Catalog Card Number: 76-44126

ISBN 0—8403—1631—3

Printed in the United States of America

CONTENTS

We wish to acknowledge support from the Office of Research and
Graduate Development at Indiana University and to dedicate
Humanities Through the Black Experience to the Afro-American
Studies Department, which was under the direction of Herman Hudson when the idea for the book was first conceived and which is
presently chaired by Joseph J. Russel.

Bloomington, Indiana

INTRODUCTION

<div style="text-align:center">

black/white students *can* you . . .

read the lines?

read between the lines?

draw a line between reading between the lines
at a point/
which will permit you to still read the lines?

learn to be/ respect your/ other black/ white, white/ black
selves without effacing selves?

see that the image/images you have of your/other selves
are not independent *but* indeed dependent?

Jimmy Lee Williams

</div>

A humanities course concerns itself *with* humanity. Lack of knowledge and understanding among and about other ethnic groups has produced our present state of polarity and divisiveness. The study of structured "subjects" tends also to produce a sometimes arbitrary separateness. The study of literature usually goes on in an "English" class in which we read and discuss English, American, even Afro-American literature. Except in rare instances, art is confined to art class, music to music class, drama to drama class. We have gathered them all together in this text to emphasize their inter-relatedness.

Traditionally, the arts in Africa were not separated from life, were not "studied," but lived and ex-perienced. Music served a function as did art objects (such as masks and statues) and oral tales; cer-tain dances were part of a religious ceremony or secular ritual, initiation or fertility rites, marriage, birth or death ceremonies. Drums communicated important messages, horns called villagers together for conferences on domestic or foreign affairs—peace or war. We have attempted here not to restore an anachronistic pattern, but to deal in larger and more meaningful constructs in order to illuminate the Humanities through the Black Experience.

Although the tools of the poet, the composer and the artist are different, each may address himself or herself to the same idea in a poem, a composition or a painting. In general, it is the idea and the function around which the following chapters are organized. Even so, the divisions are not mutually exclusive. For instance, there are references to and examples of spirituals in chapter 1, *Ceremony and Ritual,* and further references in chapter 3, *The Spiritual in Song and Story.* (Whenever relevant, parallels to works by artists in the mainstream of American culture are suggested, for Afro-American artists do not function or create in a vacuum.) If some of the poetry in chapter 1—particularly the poems in tribute to Malcolm X—appears that it could fit as well in chapter 6, *Rebellion in the Arts,* it undoubtedly could; however, the focus in chapter 1 is on ceremony and ritual and the sequence of poems written to Malcolm X are deific as well as revolutionary.

The authors encourage creative use of the materials in the text by teachers and students. The plays can be read aloud as well as discussed. The paintings may suggest other artistic responses as the music undoubtedly will. Sermons could be preached and the blues sung, hummed or strummed. Chapter 2 is as good a beginning point as chapter 1; indeed the philosophy behind the organization of the book is that the teacher can easily adapt and select materials to the individual classroom situation.

Humanities Through the Black Experience is an invitation to enter into one of the most vital and richest cultural traditions in America.

Footnote references to musical and spoken examples are found on the supplementary tape which is available, along with slides of the art works (listed in each chapter) as an accompaniment for classroom use with this text. Each chapter contains, in addition, a discography of musical references as well as some additional bibliographical recommendations for listening and reading. Above all—for enjoyment and learning.

CEREMONY AND RITUAL

The Afro-American has made an overwhelming contribution to the development of a purely American music. The true source of early minstrel songs, spirituals, blues, gospel, jazz, rock and roll and soul lies in the black oral tradition—music, poetry and the narrative tale. While these elements reached fruition in America, their roots lie in the African past. In African societies music and the other arts were a functioning, integral part of society, not a cultural appendage. Music accompanied every aspect of the life experience, not only those consummated in ritual, such as birth, circumcision, marriage and death, but everyday life experiences as well: lovemaking, farming, rowing, harvesting, hunting. In other words, music, as well as all art, was synonymous with living.

Although time has blotted out the relationship between customs and their original African function, these elements are so ingrained in black culture that we do not question their source. Take, for example, the participative element that is so much a characteristic of black church ritual. Here success is dependent upon interaction of preacher, choir and audience. The entire church is involved with the preacher who is the protagonist (from Greek, meaning the "first actor"; therefore, the character around whom the action revolves in a novel, play, etc.) of the drama.

Drama in fact marks the ceremony and ritual of the Black Church as it did religious ritual in Africa. From the outset of the service to its final benediction, one stands in awe of the artistic acumen demonstrated by the preacher. Years of experience have taught him the art of proper timing. He knows when to use a particular stock phrase and the "right" song to emphasize a given point, thus guaranteeing the appropriate response from the congregation.

The black fundamentalist preacher does not attempt to elevate his text to an abstract philosophical plane. Though often not seminary trained, he is able to present his sermon successfully because he has at his disposal a storehouse of stock phrases and ideas inherited from the past. Very often the sermon will begin in a narrative fashion. Here the preacher prepares the audience for what is going to take place. In

other words, "he sets them up." In this section he will very often describe himself and the task before him in religious terms: "As a duty-bound servant of God, I am going to try to bring you a message tonight of thus saith the Lord." Within the main body of the sermon, he begins to employ numerous stock phrases and ideas. Very popular are those which attempt to describe God: "A captain who has never lost a battle," "the bright and morning star." There are also attempts to describe the sinner: "a stone in the shoe," "a thorn in the flesh."

Midway in the message the preacher begins to chant his words rhythmically. It is within this section that he uses an expulsion of breath and/or a lyrical field holler to punctuate his couplets. By this time, interaction of preacher, congregation, choir and organ has quickened the tempo of the service. However, clarity is facilitated through chanting the sermon rhythmically and on pitch. At this point it is not unusual to witness a song being born as these elements are fused. One such example is "The Remnant."[1]

THE REMNANT

Brothers and sisters, being a duty-bound servant of God, I stand before you to-night. I am a little hoarse from a cold. But if you will bear with me a little while we will try to bring you a message of "Thus sayeth the Lord." If God is willing we will preach. The hell-hounds are so swift on our trail that we have to go sometime whether we feel like it or not. So we are here to-night to hear what the spirit has to say.

It always make my heart glad when I run back in my mind and see what a powerful God this is we serve. And every child . . . Pray with me a little while children—that has been borned of the spirit, I mean born until he can feel it, ought to feel proud that he is serving a captain who has never lost a battle, a God that can

"The Remnant," from *The Book of Negro Folklore,* ed. by Langston Hughes and Arna Bontemps, New York: Dodd, Mead & Company, 1958.

1. Example 1. Excerpt read by William H. Wiggins, Assistant Professor of Folklore and Afro-American Studies, Indiana University. (On accompanying cassette.)

speak and man live, but utter his voice and man lay down and die. A God that controls play across the heaven. Oh, ain't He a powerful God? He stepped out on the scope of time one morning and declared "I am God and there's none like me. I'm God and there is none before me. In my own appointed time I will visit the iniquities of the earth. I will cut down on the right and on the left. But a remnant I will save." Ain't you glad, then, children that he always spares a remnant? Brothers (pray with me a little while), we must gird up our loins. We who are born of the spirit should cling close to the Master, for he has promised to be a shelter in the time of storm; a rock in a weary land. Listen at Him when He says "behold I lay in Zion, a stone, a tried stone.". . . What need have we to worry about earthly things. They are temporal and will fade away. But we, the born of God have laid hold on everlasting life. Every child that has had his soul delivered from death and hell (Pray with me brothers) stayed at hell's dark door until he got his orders is a traveler. His home is not in this world. He is but a sojourner in a weary land. Brothers! this being true we ought to love one another; we ought to be careful how we entertain strangers. If your neighbor mistreat you, do good for evil, for a-way by and by our God that sees all we do and hears all we say will come and woe be unto him that has offended one of these His "Little Ones." I know the way gets awful dark sometimes; and it looks like everything is against us, but listen what Job said, "All the days of my appointed time I will wait on the Lord till my change comes! Sometimes we wake up in the dark hours of midnight, briny tears flowing down our cheeks (Ah, pray with me a little longer, Brothers). We cry and don't know what we are crying about. Brother, If you have been truly snatched from the greedy jaws of Hell, your feet taken out of the miry clay and placed on the rock, the sure foundation, you will shed tears sometime. You just feel like you wan to run away somewhere. But listen at the Master when he says: "Be still and know that I am God. I have heard your groans but I will not put on you a burden you cannot bear." We ought to rejoice and be glad for while some day they think, we know we have been born of God because we have felt His power, tasted His love, waited at Hell's dark door for orders, got a through ticket straight through from hell to heaven; we have seen the travel of our soul; He dressed us up, told us we were His children, sent us back into this low land of sorrows to tarry until one sweet day when He shall send the angels of death to bear our soul from this old earthly tabernacle and bear it back home to glory, I say back home because we been there once and every since that day we have been making our way back. Brothers! A-ha! Glory to God! The Captain is on board now, Brothers. Sit still and hear the word of God, a-ha; away back, away back brothers, a-ha! Before the wind ever blowed, a-ha! Before the flying clouds, a-ha! Or before ever the earth was made, a-ha! Our God had us in mind. Ha! oh, brothers, oh brothers! Ha! ain't you glad then, a-ha! that our God, Ha! looked down through time one morning, a-ha! saw me and you, a-ha! ordained from

the very beginning that we should be his children, a-ha! the work of His Almighty hand, a-ha! Old John the Revelator, a-ha! a-looking over yonder, a-ha! in bright glory, a-ha! Oh, what do you see John! Ha! I see a number, a-ha! Who are these, A-ha! I heard the angel Gabriel when he answered, a-ha! "These are they that come up through hard trials and great tribulations, a-ha! who washed their robes, a-ha! and made them white in the blood of the lamb, a-ha! They are now shouting around the throne of God," a-ha! Well, oh brothers! Oh, brothers! Ain't you glad that you have already been in the dressing room, had your everlasting garments fitted on and sandals on your feet. We born of God, a-ha! are shod for traveling, a-ha! Oh, Glory to God! It won't be long before some of us here, a-ha! will bid farewell, a-ha! take the wings of the morning, a-ha! where there'll be no more sin and sorrow, a-ha! no more weeping and mourning, a-ha! We can just walk around, brother, a-ha! Go over and shake hands with old Moses, a-ha! See Father Abraham, a-ha! Talk with Peter, Matthew, Luke and John, a-ha! And, Oh yes, Glory to God! we will want to see our Saviour, the Lamb that was slain, Ha! They tell me that His face outshines the sun, a-ha! but we can look on him, a-ha! because we will be like Him; and then oh brother, Oh brother, we will just fly from Cherubim to Cherubim, There with the angels we will eat off the welcome table, a-ha! Soon! Soon! we will all be gathered together over yonder Brothers, ain't you glad you done died the sinner death and don't have to die no more? When we rise to fly that morning, we can fly with healing in our wings Now, if you don't hear my voice no more, a-ha! remember, I am a Hebrew child, a-ha! Just meet me over yonder, a-ha! on the other side of the River of Jordon, away back in the third heaven.

The following characteristics are identifiable within the sermon:

1. sermon begins as a narrative.
2. stock phrases which attempt to describe God.
3. the preacher asks for congregational response.
4. punctuation of couplets with similar phrases: "Brothers, pray with me a little while; Pray with me brothers; Ah, pray with me a little longer, Brothers."
5. the preacher identifies the beginning of the chant sermon with the phrase: "the Captain is on board now, Brothers."
6. punctuation of couplets within the chant sermon with expulsion of breath.
7. rhythmic chanting of sermon on pitch.
8. distinctive melody arising from rhythmic chanting and pitched delivery.

The fundamentalist black preacher is a master craftsman at weaving the threads of emotional fer-

vor. The church literally rocks but not by chance. Rather, it is the result of skillful manipulation of diverse elements: biblical text, secular ideas, congregational response, praying and singing. Sermon texts are often chosen for their adaptability to the congregation. For example, at a church service in Jacksonville, Florida, the minister developed his sermon from John 3:16, a favored text. In his sermon he likened the spiritual state of a world in need of redemption to the physical state of a person in need of a blood transfusion. With this approach he emphasized the necessity for a life-giving, life-sustaining substance. For him, the world needed some new blood—a transfusion, possible only through the blood of Jesus Christ. He presented an interpretation of the selected scriptural text in plain, commonplace language. Everyone there could relate to this, if not directly, vicariously. Though the accuracy of the text became cloudy at times, the essence of the age-old story shone forth as the preacher proclaimed:

> The Great God Almighty said, "Somebody has got to go down and giv' some blood," and Jesus stepped forth saying, "If you prepare me a body, I'll go down." For God so loved the world, that he gave his only begotten Son, That whosoever believeth in him should not perish, but have everlasting life. John 3:16.

Although the preacher is at the helm, steering the energies of the congregation, he is never alone in his efforts. The congregation realizes they are essential in helping to maintain the emotional fervor and spiritual tension of the worship service. From beginning to end, the participative element is very much apparent—from verbally responding to his call to percussively accompanying his chant, the congregation and choir are a significant, functioning part of the service.

Additional characteristics present within the example:[2]

1. Rhythmic chanting of the sermon.
2. Pitched responses of congregation.
3. Percussive, rhythmic accompaniment to rhythmic chanting of preacher.
4. Punctuation of couplets by expulsion of breath (a-ha and field holler type).

The oratory of Rev. Martin Luther King is characterized by the way he blends the voice quality, dynamics, and phrasings epitomized by the fundamentalist preacher with his own particular flair for prose and figures of speech. In Reverend King's "I Have a Dream" speech,[3] we hear punctuation of a couplet with a single line of prose (I Have a Dream) and the collective response by the audience; in this instance, marchers gathered in Washington, D.C. Although this particular gathering was secular in nature, the collective response by the listeners mirrors the same attitude as that of Sunday worshippers responding to the preacher's call. It measures the extent to which the audience sanctions the speaker's message and how emotionally involved they are.

No matter where one travels, the fundamentalist Black Church is universal in its manner of praising God—"With a loud voice." An important part of church worship is the testimony service which precedes the regular morning worship and sets the spiritual tone for the regular service. Each testimony is often preceded by a vocal selection which reflects the spiritual state of a particular individual.

Although the emotional fervor during these services can become overwhelming, this is not to suggest that the service lacks organization. An elder always presides. The elements governing these services are not written down, which attests to the fact that much of grass roots black culture is maintained orally. The audience appears to have an almost intuitive comprehension of what is going to occur. For example, whereas group interaction is desirable in the regular service, the individual response is the key in the testimony service. No one attempts to overshadow his brother. When an individual takes to the floor, from this moment on, it is his personal time to give open thanks to God. In the majority of instances, group response occurs only when called for. When individuals testifying are seized with the spirit of God they rejoice by shouting and giving thanks to God. One often used exclamation at this moment is "Praise Him, Praise Him, Praise Him!" At this point the entire congregation responds by applauding and stamping on the floor of the church in acknowledging the presence of God's grace flowing through the body of their sanctified brother. When there is organ accompaniment, the tempo of its melodic and rhythmic responses quickens as it accompanies the fast foot movements of the individual who is shouting.[4]

Even the little children in the congregation respond knowingly to the events in the worship service. Very often they sit in a designated section of the church sharing in the percussive accompaniment by shaking tambourines, playing bongos, clapping and scraping washboards. It is this environment and these acts

2. Example 2. St. James Holiness Church, Durham, North Carolina. (On accompanying cassette.)

3. "I Have a Dream," Rev. Dr. Martin Luther King, Jr. *In Search of Freedom.* Mercury SR 61170 Side 2, Band 4.

4. Example 3. Church of God in Christ, Jacksonville, Florida. (On accompanying cassette.)

which have unintentionally provided the seed bed for the musical growth of many black commercial recording artists today.

During the testimony service, gospels are also sung. For more than fifty years gospel music has provided an avenue of creative expression for black Americans. As a post-emancipation form it illustrates the culmination of musical elements of ante-bellum spirituals, post-bellum hymns and blues. Of no less importance is the sociological base from which this form emerged. The new found mobility afforded through emancipation, and the frustration at being unprepared to cope with the problems it presented, thrust the black man firmly towards the one culturally binding and spiritually guiding force he knew best—the church. Thus, it was in a religious environment that he sang *about* and *to* an experience, modifying those musical elements inherited from the past, thereby creating a variant musical genre.

Gospels further evolved out of the northward migration, particularly during the 1920s and 1930s, of southern Blacks who were in search of a "greater" freedom, both economic and social. They brought with them their religious fervor which was embodied in their music. Gospel, which emerged out of these migrant Blacks' singing of their religious conviction, their innermost feelings of God, found its free expression in the storefront fundamentalist churches which were not organized with the formality of the traditional churches.

Spiritual and gospel music are often confused even by knowledgeable people. Pearl Williams-Jones, in "Afro-American Gospel Music,"[5] makes six specific distinctions between spirituals and gospels: (1) While the gospel songs are "contemporary black urban religious songs, some of which are composed . . . ," spirituals are religious songs which emanated from slavery. They were preserved and perpetuated through the oral tradition. Gospel songs, on the other hand, were written as well as orally preserved. Gospel even refers to a particular style of singing and performing black religious music. (2) Spirituals are basically "sorrow songs," whereas gospel songs can be characterized as " joyful." (3) Gospels are generally accompanied by an instrument or an ensemble. In the early days, the Hammond organ was the most popular accompanying medium. More recently, "rock" instrumentation (guitars and percussion) has become the chief accompaniment. Spirituals, on the other hand, are traditionally performed without accompaniment. (4) Gospel songs are contemporary expressions utilizing contemporary harmonies and syncopated polyrhythms. Spirituals tend to reflect a certain

simplicity in their harmonies with simple syncopation in the melody. They tend to retain the uncomplicated flavor of their original forms. (5) Although both spirituals and gospels utilize the African "call and response, gospels tend to take advantage of a variety of forms: verse-chorus, ballads, theme and variations, three-line blues structures, call-and-response chants, strophic (all the stanzas of the text are sung to the same music), modified strophic, and through-composed structures (different music for each stanza). These forms are used instrumentally as well as vocally since both are conceived as one."[6] (6) Spirituals have their texts rooted in Biblical stories and often contain double meanings, while gospel songs deal with the contemporary black experience. Although gospels concern themselves with the trials and tribulations of contemporary life—the more recent songs being protest in nature—they tend to be optimistic in mood and exuberant in performance.

Specifically the gospel idiom is characterized by particular usage of call and response, a variety of vocal devices, improvisation, breaks or rests within phrases, dissolution of melody into motifs, and percussive instrumental (piano and/or organ) accompaniment. All of these are present in the musical example "I've Decided to Make Jesus My Choice."[7]

Example 4

Some folks would rather have houses and land
Some folks choose silver and gold.
These things they cherish and forget about their souls.
I've decided to make Jesus My Choice.

Chorus:
The rode is rough, the going gets tough.
The hills are hard to climb.
I started out a long time ago.
There is no doubt in my heart.
I've decided to make Jesus my choice.

Today gospel continues to express philosophical and spiritual beliefs. Symbolically it is a medium for expressing the awareness of a people to the sociological implications of their existence and their reaction to their immediate environment.

5. A chapter in Vada Butcher's *Development of Materials for a One Year Course in African Music for the General Undergraduate Student* (Office of Education, United States Department of Health, Education and Welfare, 1970), p. 204. Spirituals are discussed and illustrated in detail in Chapter 3.
6. Pearl Williams-Jones, Butcher book, Chapter III, p. 203.
7. Example 4. "I've Decided to Make Jesus My Choice." Church of God in Christ, Apostolic Faith, Copley Road, Baltimore, Maryland. (On accompanying cassette.)

"Do You Know the Man from Galilee?"	Bell Jubilee	Jewel Label
"This Is a Mean Old World to Live in by Yourself"	Sam Cooke	Speciality SPS2146
"Lord, Do It for Me Right Now"	Brother James Cleveland and the Voice of the Tabernacle Choir	Savoy Label
"All Things Work Together for Those That Love the Lord"	Institutional Church of God and Christ	Cotillion SDO D55
"Amazing Grace"	Aretha Franklin	Atlantic SD2-906
"May the Work I've Done Speak for Me"	Gospel Consolers	Peacock Label
"Precious Lord, Take My Hand"	Aretha Franklin	Atlantic SD2-906

For additional materials see discography, pp. 8-9.

While many gospel selections are based on biblical events and biblical characters and their lives, many grow out of individual experiences of the people who perform them. They retain their religious aura, but express belief and confirmation of faith in contemporary black idiom. This is what makes the Black Church as a spiritual body so alive and emotionally responsive. "Too Late," (see listening Selections/Analyses, page 6) by the Southern Jacksonaires, although cast in a religious framework, was born out of incidents in the life of an individual whom these singers knew well. The stanzas of the song actually narrate a span of time in that individual's life. "Jesus is Alright with Me," by Brother James Cleveland (Savoy 14063) is a personal testimony. When this recording was made, Brother Cleveland had met with overwhelming success in his ministry. Here he is proclaiming the "might and power" of Jesus through his own personal experience.

Gospel is a style—a manner of performance. This is clearly illustrated in "Peace Be Still" (see Listening Selections/Analyses, page 8) by Brother James Cleveland and The Angelic Choir (Savoy MG14076). This piece also features the use of dynamics for effect. It shows how a simple hymn tune can be adapted and modified by submitting it to specific stylistic elements and thus transforming it completely.

Gospel music of today reflects yet another influence—that of commercial music. Not only are performers incorporating the vocal and instrumental experiments of commercial artists, but many of them are also fluctuating quite easily between sacred and secular idioms. This is facilitated by performance practices to which both groups adhere. Only the textual changes identify the genre. Characteristics, such as those described above, remain the same. It therefore becomes easy for Aretha to sing "My Man" instead of "My Lord," and The Staple Singers to sing "I'll Take You There" instead of "Will the Circle Be Unbroken." Their overall style is in no way altered.

On the other hand the gospel tradition has provided the training ground for many artists who later distinguished themselves in jazz, rock, and soul. Ray Charles, Dionne Warwicke, Sam Cooke, The Staple Singers, Roberta Flack, Lou Rawls, Aretha Franklin, and Martha of Martha and the Vandellas are only a few of the commercial artists whose styles reflect the influence of the Church and specifically the gospel tradition.

Gospel Listening Selections/Analyses

I. Sam Cooke with the Soul Stirrers, "This is a mean old World" from *That's heaven to me* (SPS 2146).

This text focuses on the concept of loneliness and how one needs a friend, especially in the time of trouble and trials.

Characteristics

1. melismatic phrasing employed by the leader
2. use of falsetto and improvisatory techniques
3. Section I does not use call and response in the traditional manner; the leader sings text while the remainder of the group supplies harmonic background on neutral syllables (oooh, hmmm).
4. Section features the group singing the text while the leader improvises.
5. text not based on specific scriptural text
6. The leader employs the same melismatic technique here at the ends of

phrases as he does in his secular recordings.

II. The Staple Singers, "Pray On" from *Pray On* (XEM I 15703).

This text emphasizes the need for prayer, a favorite concept:

> You can talk about me but that's alright.
> I have Jesus!

Specifically the songster sings:

> You can talk about me as much as you
> please, but the more you talk,
> I'm gonna bend my knees.

Section I

1. call and response; fragments of phrases are divided between leader and group in this fashion:

leader	*group*
Pray on my child	pray on my child
gotta home on high	yes, I gotta home on high
well I been talked about	sure as you born
I need Jesus	to carry me on, etc.

2. Leader uses distinctive vocal timbre: throaty, husky.
3. Guitar accompaniment provides an additional interacting voice part; it does not follow the melodic rhythm of either the response or the call of the leader continuously.

Section II

4. Leader improvises extensively. The melodic rhythm of the improvisation is very much akin to that of the rhythmic chanting employed by many preachers.

III. "Father I stretch my hands to thee" from *The Best of the Five Blind Boys* (PLP 139).

This is a familiar text during revivals. It reflects the act of the mourner as he humbles himself before god, asking for mercy and forgiveness of his sins:

> Father, I stretch my hands to thee,
> no other help I know.

1. The beginning of this selection parallels one aspect of the black fundamentalist church service: interaction between preacher and congregation. Listen to the group as it responds to the leader's delivery with exclamations of "Yes, oh, Yes."
2. The leader employs a highly improvisatory technique in the way he sets forth his text after his initial statement of the text proper.
3. The improvisation of the leader includes punctuation of phrases with a lyrical field holler which is still used today by many southern black fundamentalist preachers.

IV. "God put a rainbow in the sky" from *Miss Sallie Martin and the Evangelical Choral Chapter* (Savoy 14242).

Miss Sallie Martin was a pioneer along with Prof. Thomas A. Dorsey in the field of gospel music. This text is based on scriptural text of events surrounding Noah and the Ark:

1. traditional use of call and response: choir answering the leader with "God put a rainbow in the sky" as a response
2. featuring high pitched soprano obligato
3. using modified field holler by leader
4. change of pronunciation, Noah to "Norah"
5. organ and piano accompaniment

V. "It don't cost very much" from *Miss Sallie Martin and the Evangelical Choral Chapter* (Savoy MG 14242).

This text is based on a concept often used as sermon texts by the fundamentalist preacher: "Getting along with your fellow man."

1. traditional use of call and response; choir response based on fragments of phrases sung by leader
2. featuring high pitched soprano obligato
3. organ and piano accompaniment

VI. Jackson Southernaires, "Too Late" from *Too Late* (SB 212).

Although these lyrics are presented within a religious framework; they are not based on biblical imagery or scriptural text. Events of the text are taken from the life of an individual these singers knew. Thus the text becomes an admonition for its listeners—"Don't let it be too late."

1. introduction by leader presenting the ideas upon which the song text is based
2. Within the main body of the song, the leader uses the rhythmic chanting technique which is also used by the black preacher at a slower pace.
3. using modified field holler
4. group response employing falsetto
5. leader employing expulsion of breath at one point for phrase punctuation.

VII. "How Jesus Died" from *Lou Rawls and the Pilgrim Travelers* (SPS 2147).

This text is based on biblical imagery—The Passion.

1. The initial accompanied phrase: If I die and my soul be lost It's nobody's fault but mine presents ideas upon which the song is based which is redemption through the death of Jesus Christ.
2. There is no traditional use of call and response; background harmony is provided by group on neutral syllables while leader chants text.
3. piano accompaniment (ostinato figure)

VIII. "I love the Lord," from The Pilgrim Travelers by Dr. Watts, *Shake my Mothers Hand* (SPS 2147).

This illustrates how any given song becomes uniquely black through the manner in which it is sung.

1. Organ pedal-point provides harmonic background for introduction in free rhythm.
2. Note use of exclamations similar to those in actual church service: Lord, Lord, Lord, Lord!
3. The melodic rhythm here is similar to that often used in lining out tunes, psalms, and selected biblical scriptures in many southern fundamentalist churches.

IX. James Cleveland with the Voices of Tabernacle, "I'm a Soldier in the Army of the Lord" from *The Gospel in Song* (HBX 2110).

These lyrics are a favorite at revivals and testimony services. This surface material is an emphatic affirmation of faith by the Christian. There were many antebellum spirituals which focused on the concept of the soldier in battle as the slave pictured himself fighting a war against the evils of slavery.

1. In the introduction, the leader gives an intimate view of a setting from which this song emerged: I went to a meeting the other night and all the saints of God were getting together to have a testimony meeting. Over in the Amen corner my old grey-haired grandmother stood up; she wanted to give her testimony.
2. traditional use of call and response: In the army of the Lord, in the army.
3. ostinato in organ and piano
4. instruments: organ, tambourine, drum
5. use of gospel clap

X. The Four Interns, "You Better Min' " from *Count Your Many Blessings* (KS G3 1128).

This selection is an arrangement of an antebellum spiritual. While this is presented within a religious context, it symbolizes the category of songs which sounded alarms and warnings during the period marked by slave revolts and insurrections.

> You gotta giv' in account at the judgement
> You better min'.

For the antebellum slaves, judgement was symbolic of the wrath that would surely fall upon them at the hand of the slave masters if they were caught participating in African cult meetings.

The admonition continues:

> You better min how you talk
> You better min what you talkin' about.
> You gotta give in account at the judgement,
> You better min'.
>
> You better min how you walk
> You better min where you walkin' to.
> You gotta giv in account at the judgement,
> You better min'.

XI. The Four Interns, "I'm Troubled" from *Count Your Many Blessings* (KS G3 1128).

This is an arrangement of an antebellum spiritual which says:

> I'm troubled, I'm troubled, I'm troubled in mind.
> If Jesus don't help me, I surely will die.

7

1. The song is an excellent example of the use of call and response. Singers emulate the style of the pop singer of the 50s and late 60s. This shows the influence of secular commercial elements on gospel. The response is given on neutral syllables.
2. accompaniment: piano (boogie-woogie ostinato), drum.

XII. James Cleveland with the Angelic Choir, "Peace be Still" (Savoy MG 14076).

This is a gospel arrangement of a hymn tune.

Section I

1. solo presenting hymn tune employing turns, sliding tones, blue notes, distinctive vocal timbre, melismatic phrasing and falsetto.
2. employing the technique of heightened pitch for dramatic effect.

Section II

1. The choir provides harmonic background. It employs increasing use of dynamics for dramatic effect: FF followed abruptly by piano.
2. Note spontaneous response by audience.
3. traditional usage of call and response by choir: repetition of a single motif which is Peace.
4. improvisatory call by leader.
5. accompaniment: piano, organ and percussion.

XIII. Bill Moss and the Celestials, "Hard Times" from *I Have Already Been to the Water* (WE 176).

The ideas which give birth to the text are set forth as a solo introduction:

I was very young when I left home
Thought that I was grown and wanted to go out on my own.
Then my mother came to me, she was hurt I could plainly see
Then she warned me as she said these words to me,
It's not gonna be easy, you're gonna have a hard time, etc.

The text emphasizes the need for prayer because there will be trouble, strife, and misery.

1. Sustained chords by the organ provide harmonic base for solo introduction.
2. use of turns at ends of phrases, sliding tones, blue notes
3. phrases punctuated by "growl" and field holler type yell
4. use of distinctive vocal timbre
5. responses interjected by female vocalist: "Sing, Bill, Sing"
6. This particular interpretation has many stylistic characteristics of a rock piece: the "licks" of the organ and drum.
7. instruments: electric guitar, drum, piano, organ.

XIV. Bill Moss and the Celestials, "I've Already Been to the Water" from *I Have Already Been to the Water* (WE 176).

This text is based on biblical imagery of transformation through baptism.

Section I

1. hard, driving rhythm, similar to rock beat
2. Compare the tightly knit harmony of this selection to the soul recording, "Don't Take my Kindness for Weakness" (Soul Children, STAX 0132).

Section II

3. leader rhythmically chanting his lines while back-up group giving responses on selected fragments of the text: "my feet," "my waist"
4. repetition of single rhythmic and melodic motif as accompaniment during this section.

Discography

Gospel

James Cleveland: God's Promises. Savoy—MG-14220
———: Peace Be Still. Savoy—MG-14076
Reverend Gary Davis. Bluesville—L049
Dixie Hummingbirds: Best, Peacock—8055-138M
Beverly Glenn Chorale: Coming Again So Soon. Cross Records—LPS 333
Bessie Griffin: Gospel Heart. Sunset—5195
Edwin Hawkins Singers: More Happy Days. Buddah—M85064

Mahalia Jackson: Best. Kenwood—500
———: Right out of the Church. Columbia—CS-9813
Negro Church Music. Atlantic—1351
Art Reynolds Singers: Tellin' It Like It Is. Capitol—T2534
Don Shirley: Gospel According to Don Shirley. Columbia—CS-9723
Ward Singers: The Famous. Savoy—4046

Mahalia Jackson

On January 27, 1972, Mahalia Jackson, the great gospel singer, died in Chicago, but *two* cities paid tribute to her: New Orleans, where she was born, and Chicago, where she lived for many years. One of her aunts remembers that "one Friday night, 48 years ago, 12-year-old Mahalia 'came off the mourner's bench during a revival, and with tears in her eyes she confessed Christ.' She was baptized in the Mississippi by Mt. Moriah's pastor, the Rev. E. D. Lawrence, then went back to 'receive the right hand of fellowship.' Later, Mahalia would often say, 'Ever since that day I promised the Lord that I'd dedicate my life to Him in song.' "[8]

The following is a poem by Quandra Prettyman which recognized, long before Mahalia's death, that the singer and the song were one.

WHEN MAHALIA SINGS*

Quandra Prettyman

We used to gather at the high window
of the holiness church and, on tip-toe,
look in and laugh at the dresses, too small
on the ladies, and how wretched they all
looked—an old garage for a church, for pews,
old wooden chairs. It seemed a lame excuse
for a church. Not solemn or grand,
with no real robed choir, but a loose jazz band,
or so it sounded to our mocking ears.
So we responded to their hymns with jeers.

Sometimes those holiness people would dance,
and this we knew sprang from deep ignorance
of how to rightly worship God, who after
all was pleased not by such foolish laughter
but by the stiffly still hands in our church
where we saw no one jump or shout or lurch
or weep. We laughed to hear those holiness
rhythms making a church a song fest:
we heard this music as the road to sin,
down which they traveled toward that end.

I, since then, have heard the gospel singing
of one who says I worship with clapping
hands and my whole body, God, whom we must
thank for all this richness raised from dust.
Seeing her high-thrown head reminded

me of those holiness high-spirited,
who like angels, like saints, worshiped as whole
men with rhythm, with dance, with singing soul.
Since then, I've learned of my familiar God—
He finds no worship alien or odd.

Ralph Ellison had this to say about Mahalia Jackson in 1958 in the *Saturday Review of Literature*. The following excerpt is taken from his book *Shadow and Act*.

AS THE SPIRIT MOVES MAHALIA**

There are certain women singers who possess, beyond all the boundaries of our admiration for their art, an uncanny power to evoke our love. We warm with pleasure at mere mention of their names; their simplest songs sing in our hearts like the remembered voices of old dear friends, and when we are lost within the listening anonymity of darkened concert halls, they seem to seek us out unerringly. Standing regal within the bright isolation of the stage, their subtlest effects seem meant for us and us alone; privately, as across the intimate space of our own living rooms. And when we encounter the simple dignity of their immediate presence, we suddenly ponder the mystery of human greatness.

Perhaps the power springs from their dedication, their having subjected themselves successfully to the demanding discipline necessary to the mastery of their chosen art. Or, perhaps, it is a quality with which they are born as some are born with bright orange hair. Perhaps, though we think not, it is acquired, a technique of "presence." But whatever its source, it touches us as a rich abundance of human warmth and sympathy. Indeed, we feel that if the idea of aristocracy is more than mere conceit, then these surely are our natural queens. For they enchant the eye as they caress the ear, and in their presence we sense the full, moony glory of womanhood in all its mystery—maid, matron and matriarch. They are the sincere ones whose humanity dominates the artifices of the art with which they stir us, and when they sing we have some notion of our better selves.

Lotte Lehmann is one of these, and Marian Anderson. Both Madame Ernestine Schumann-Heink and Kathleen Ferrier possessed it. Nor is it limited to these mistresses of high art. Pastoria Pavon, "La Nina de Los Peins," the great flamenco singer, is another and so is Mahalia Jackson, the subject of this piece who reminds

*Quandra Prettyman, "When Mahalia Sings," reprinted by permission of the author.

**From *Shadow and Act* by Ralph Ellison. Copyright (©) 1964 by Ralph Ellison. Reprinted by permission of Random House, Inc.

8. *Ebony Magazine,* April, 1972, p. 66.

us that while not all great singers possess this quality, those who do, no matter how obscure their origin, are soon claimed by the world as its own.

Mahalia Jackson, a large, handsome brown-skinned woman in her middle forties, who began singing in her father's church at the age of five, is a Negro of the *American* Negroes, and is, as the Spanish say, a woman of much quality. Her early experience was typical of Negro women of a certain class in the South. Born in New Orleans, she left school in the eighth grade and went to work as a nursemaid. Later she worked in the cotton fields of Louisiana and as a domestic. Her main social life was centered in the Baptist Church. She grew up with the sound of jazz in her ears, and, being an admirer of Bessie Smith, was aware of the prizes and acclaim awaiting any mistress of the blues, but in her religious views the blues and jazz are profane forms and a temptation to be resisted. She also knew something of the painful experiences which go into the forging of a true singer of the blues.

In 1927, following the classical pattern of Negro migration, Mahalia went to Chicago, where she worked as a laundress and studied beauty culture. Here, too, her social and artistic life was in the Negro community, centered in the Greater Salem Baptist Church. Here she became a member of the choir and a soloist with a quintet which toured the churches affiliated with the National Baptist Convention. Up until the forties she operated within a world of music which was confined, for the most part, to Negro communities, and it was by her ability to move such audiences as are found here that her reputation grew. It was also such audiences which, by purchasing over two million copies of her famous "Move On Up a Little Higher," brought her to national attention.

When listening to such recordings as *Sweet Little Jesus Boy, Bless This House, Mahalia Jackson,* or *In the Upper Room,* it is impossible to escape the fact that Mahalia Jackson is possessed of a profound religious conviction. Nor can we escape the awareness that no singer living has a greater ability to move us—regardless of our own religious attitudes—with the projected emotion of a song. Perhaps with the interpretive artist the distinction so often made between popular and serious art is not so great as it seems. Perhaps what counts is the personal quality of the individual artist, the depth of his experience and his sense of life. Certainly Miss Jackson possesses a quality of dignity and the ability to project a sincerity of purpose which is characteristic of only the greatest of interpretive artists.

Nor should it be assumed that her singing is simply the expression of the Negro's "natural" ability as is held by the stereotype (would that it were only true!). For although its techniques are not taught formally, Miss Jackson is the master of an art of singing which is as complex and of an even older origin than that of jazz.

It is an art which was acquired during those years when she sang in the comparative obscurity of the Negro community, and which, with the inevitable dilutions, comes into our national song style usually through the singers of jazz and the blues. It is an art which depends upon the employment of the full expressive resources of the human voice—from the rough growls employed by blues singers, the intermediate sounds, half-cry, half-recitative, which are common to Eastern music; the shouts and hollers of American Negro folk cries; the rough-edged tones and broad vibratos, the high, shrill and grating tones which rasp one's ears like the agonized flourishes of flamenco, to the gut tones, which remind us of where the jazz trombone found its human source. It is an art which employs a broad rhythmic freedom and accents the lyric line to reinforce the emotional impact. It utilizes hard-tones, glissandi, blue notes, humming and moaning. Or again, it calls upon the most lyrical, floating tones of which the voice is capable. Its diction ranges from the most precise to the near liquidation of word-meaning in the sound; a pronunciation which is almost of the academy one instant and of the broadest cotton-field dialect the next. And it is most eclectic in its use of other musical idiom; indeed, it borrows any effect which will aid in the arousing and control of emotion. Especially is it free in its use of the effect of jazz; its tempos (with the characteristic economy of Negro expression it shares a common rhythmic and harmonic base with jazz) are taken along with its intonations, and, in ensemble singing, its orchestral voicing. In Mahalia's own "Move On Up a Little Higher" there is a riff straight out of early Ellington. Most of all it is an art which swings, and in the South there are many crudely trained groups who use it naturally for the expression of religious feeling who could teach the jazz modernists quite a bit about polyrhythmics and polytonality.

Since the forties this type of vocal music, known loosely as "gospel singing," has become a big business, both within the Negro community and without. Negro producers have found it highly profitable to hold contests in which groups of gospel singers are pitted against one another, and the radio stations which cater to the Negro market give many hours of their air time to this music. Today there are groups who follow regular circuits just as the old Negro jazzmen, blues singers and vaudeville acts followed the old T.O.B.A. circuit through the Negro communities of the nation. Some form the troups of traveling evangelists and move about the country with their organs, tambourines, bones and drums. Some are led by ex-jazzmen who have put on the cloth, either sincerely or in response to the steady employment and growing market. So popular has the music become that there is a growing tendency to exploit its generic relationship to jazz and so-called rock-and-roll.

Indeed, many who came upon it outside the context of the Negro community tend to think of it as just another form of jazz, and the same confusion is carried over to the art of Mahalia Jackson. There is a widely held belief that she is really a blues singer who refuses, out of religious superstitions perhaps, to sing the blues; a jazz singer who coyly rejects her rightful place before a

swinging band. And it *is* ironically true that just as a visitor who comes to Harlem seeking out many of the theatres and movie houses of the twenties will find them converted into churches, those who seek today for a living idea of the rich and moving art of Bessie Smith must go not to the night clubs and variety houses where those who call themselves blues singers find their existence, but must seek out Mahalia Jackson in a Negro church. And I insist upon the church and not the concert hall, because for all her concert appearances about the world she is not primarily a concert singer but a high priestess in the religious ceremony of her church. As such she is as far from the secular existentialism of the blues as Sartre is from St. John of the Cross. And it is in the setting of the church that full timbre of her sincerity sounds most distinctly.

Certainly there was good evidence of this last July at the Newport Jazz Festival, where one of the most widely anticipated events was Miss Jackson's appearance with the Ellington Orchestra. Ellington had supplied the "Come Sunday" movement of his *Black, Brown and Beige Suite* (which with its organ-like close had contained one of Johnny Hodges's most serenely moving solos, a superb evocation of Sunday peace) with lyrics for Mahalia to sing. To make way for her, three of the original movements were abandoned along with the Hodges solo, but in their place she was given words of such banality that for all the fervor of her singing and the band's excellent performance, that Sunday sun simply would not rise. Nor does the recorded version change our opinion that this was a most unfortunate marriage and an error of taste, and the rather unformed setting of the Twenty-third Psalm which completes the side does nothing to improve things. In fact, only the sound and certain of the transitions between movements are an improvement over the old version of the suite. Originally "Come Sunday" was Ellington's moving *impression* of Sunday peace and religious quiet, but he got little of this into the words. So little, in fact, that it was impossible for Mahalia to release that vast fund of emotion with which Southern Negroes have charged the scenes and symbols of the Gospels.

Only the fortunate few who braved the Sunday morning rain to attend the Afro-American Episcopal Church services heard Mahalia at her best at Newport. Many had doubtless been absent from church or synagogue for years, but here they saw her in her proper setting and the venture into the strangeness of the Negro church was worth the visit. Here they could see, to the extent we can visualize such a thing, the world which Mahalia summons up with her voice; the spiritual reality which infuses her song. Here it could be seen that the true function of her singing is not simply to entertain, but to prepare the congregation for the minister's message, to make it receptive to the spirit and, with effects of voice and rhythm, to evoke a shared community of experience.

As she herself put it while complaining of the length of the time allowed her during a recording session, "I'm used to singing in church, where they don't stop me until the Lord comes." By which she meant, not until she had created the spiritual and emotional climate in which the Word is made manifest; not until, and as the spirit moves her, the song of Mahalia the high priestess sings within the heart of the congregation as its own voice of faith.

When in possession of the words which embody her religious convictions Mahalia can dominate even the strongest jazz beat and instill it with her own fervor. *Bless This House* contains songs set to rumba, waltz and two-step but what she does to them provides a triumphal blending of the popular dance movements with religious passion. In *Sweet Little Jesus Boy,* the song "The Holy Babe" is a Negro version of an old English countryrhyme, and while enumerating the gifts of the Christian God to man, Mahalia and Mildred Falls, her pianist, create a rhythmical drive such as is expected of the entire Basie band. It is all joy and exultation and swing, but it is nonetheless religious music. Many who are moved by Mahalia and her spirit have been so impressed by the emotional release of her music that they fail to see the frame within which she moves. But even *In the Upper Room* and *Mahalia Jackson*—in which she reminds us most poignantly of Bessie Smith, and in which the common singing techniques of the spirituals and the blues are most clearly to be heard—are directed toward the after life and thus are intensely religious. For those who cannot—or will not—visit Mahalia in her proper setting, these records are the next best thing.

Samuel Allen utilizes the oral tradition of the Black preacher and the musical tradition of the Gospel to give poetic expression to "Big Bethel," the following poem never before published:

BIG BETHEL

(Call and Response)

| Dearly beloved | Alright |
| Brethren in spirit | Alright now |

Children in sorrow	O Yes
Pilgrims . . along the way.	Alright, alright
When we have come	Weellll
to the last hour of the journey	Unnhn
When we've won through	Weellll
to the close of the day	Unnhn unnn
Dearly beloved, we shall walk	Weeelll
from the shadows	Weeelll
From the bend	Yesss
in the river	Yesss
Down the broad bank	Alright
of the river	Yesss
Moving into the deep, the sullen sweep, steady	
in His keep	Look out
til the end of the way.	Preach
	Tell it, Reverend
	Alright
	let's get away.
So let us move on together	Alright
On the road to the kingdom	Road to the kingdom
The heart of the kingdom	Heart of the kingdom
The sweet scent of Canaan	Preach now
O the gates to the City	Yesssss
I'm talking this morning	Talk
Say talking this morning	Talk
I'm here to tell you bout the evil	Evil
—O there is evil to be joined	Yesss
on the road to the kingdom—	Yesss
there is evil	
in the souls of men.	O yes there is Yes there is
You know that once there was a mighty king	Mighty king
an evil king	Evil king
old wicked Nebuchadnezzar	Alright
	Go head
	You're preaching now
O yes, we have em here today	Alright
Proud men	Yesss

Powerful and proud	O yesss
Men who are corrupted and vain	Corrupted and vain
Holding dominion they hold a rough dominion	O yes they do
from their high and mighty place	Talk about em, Reverend
I saw one the other day	Talk Talk
O yes, I'll talk about him	Alright
I'll get to him this morning	
Bring him to his soul's salvation.	Get him
	Yesss
	Alright, now
You know I know a smokescreen when I see one	Weelll
Everywhere you go	Weelll-
these people talking bout application	Application
If you want consideration	
You must submit your application	O yes
They say fifteen pages explanation	Yes
In fifty leven duplication	Tell it Reverend
You know one day they'll be plying for mercy	Yesss
O yes they will	O yes
They'll be making application	Yesss
solicitation	Solicitation
explanation	Explanation
supplication	Supplication
asking toleration	Preach
mercification	Look out now
relentation	Relentation
They'll be plying for mercy *mercy*	O yesss
. . . and you know	And you know
Doncha know . . .	Doncha know
. . . there ain't gon' *be* none!	Preach
	Tell it Reverend
	Talk about em
	Lighten up now
Well, maybe a little bit	Go head Reverend
Maybe . . .	
Not too soon	Naw
	Not at all
	None

When Right is no more on the scaffold O My Lord

And Wrong is driven from the throne You preaching

 this morning

 Talk

Yes, I'll tell it, talking bout

 You people can't go in there

 Only us allowed in here

 O I'll make em see Jesus this morning Preach you preaching

You know last Monday Monday

Went down to the building Building

Went down to see the man Alright

Leastwise he calls himself a man Look out now

Man say Go head now

So called man say Talk about him

We don't know about the mortgage O my gracious

Seems you people started coming over here O doncha know

You hear what he say O yesss

We cannot tell about the mortgage Unnhn unnn

Your people . . are coming . . over here Unnhn unnn

You'll just have to make your application Unnhn unnn

For our due consideration Unnhn

Said he can't extend the mortgage Naw unnn

If you people— You people

Talking bout *you* people You people

Superior! Yesss

Arrogant! Yesss

Blind! Yesss

Can*not* see! Naw

Don't *want* to see! Naw

Never *will* see! Naw

But the day is gonna come Lord Lord Lord

O it's coming Yesss

There is a day coming O it's coming

When every mother's son will see Preach

When every child of God will see O you preaching

 Tell em

 Go head now

O yes Yesss

Or as sure as I'm standing here Yesss

The fi *yah* will burn one day Yesss Yesss

And mountain tides of water Yesss

 will roll down O yes

 upon a proud and heedless people Yesss

Armies of righteousness Yesss

 will sweep over Yesss Yesss Yesss

 a vain and stiff necked people Yes they will Yes they will

And He will raise up a nation Preach and a half

 that will obey Him. O yes O yes O yes

So brethren

Faint not and don't you grow weary Alright

Walk and never tire Alright

O I know the footsores of the pilgrim

The bleeding footsores blessed footsores

 of the pilgrim O yes

But I have seen the glory of the kingdom Yessss

The heights of the City Alright

So let us all move on together Alright

Up the bank of the river Yesss

Beyond the approaches Yesss

The outskirts of the City Yesss

Past the bastion of Pisgah Ha!

Past the bastion of Pisgah O Yesss

Past Past

Past the bast- *Bast*ion of Pisgah

Walk on up into glory So sweet the sound

Behold His effulgence Yesss

Bathe in His radiance Yesss

Kneel down before Him Kneel

Rise and step forward Lovely Lovely

And sit at the Right Hand Weeelll

In that incorruptible dispensation Weeelll unnn

Dwelling forever Unnhn

In His love and His beauty Unnhn unnn

In peace and His power Unnhn unnn

Warrant of glory Unnhn unnn

the everlasting plenty

of the radiant

—He is able—

The most high King

Let us pray.

It's alright

It's alright, now

It's alright

Note: The above lines may be considered a framework for improvisation by the speakers. Gospel music is suggested as an appropriate background.

Laura, in *Tambourines to Glory,* is a gospel singer; in fact the play could be described as a gospel play for Langston Hughes insists that much of its meaning lies in its songs. Hughes and Jobe Huntley wrote many original numbers for the play, but they also used some traditional songs and hymns, such as, "Who'll Be a Witness," "Hand Me Down My Walking Cane," "Leaning on the Everlasting Arms," and others. In his notes the author suggests that:

At certain points in the show audience participation might be encouraged—singing, foot-patting, hand clapping, and in the program the lyrics of some of the songs might be printed with an invitation to sing the refrains along with the chorus of Tambourine Temple.

The play then reflects one of the major qualities of black music, the element of participation.

In climactic Scene 7 of Act 1, several people in the Tambourine Temple make their "determination" and here it is possible to see how Langston Hughes makes creative use of the actual "testimony" service of the church and of the Gospel Music form. This selection begins with "As I Go" and ends with "I'm Gonna Testify!"

TAMBOURINES TO GLORY

Langston Hughes

Scene Seven

The glowing rostrum of Tambourine Temple in a newly converted theatre. It is a bright and joyous church. Besides an electric organ, there is a trio of piano, guitar, and drums—*Birdie Lee* is the drummer—with a colorfully robed *Choir* on tiers in the background, some *Singers* holding tambourines. *Deaconess Hobbs* stands before the rostrum, an imposing woman with a big voice. On either side of her sway two tall *Deacons,* and also *Deacon Crow* and *Bud.* The four men hum "As I Go" softly to end of refrain. As the curtain rises, the *Deaconess* sings.

Deaconess.
 I cannot find my way alone.
 The sins that I bear I must atone

And so I pray thy light be shone
To guide me as I go through this world.

Deacons.
 As I go, as I go,
 Oh, Jesus walk by my side as I go.
 As I go, as I go,
 Be my guide as I go through this world.
 (Refrain repeats softly under talk)

Deaconess. Now, dear friends, as the preliminaries of this meeting draws to a close, we proceed to the main body of our ceremonies. I thank God for these long tall deacons, these basses of Jehovah—the Matthew, Mark, Luke, and John of this church—and your humble deaconess and servant, myself, Lucy Mae Hobbs, who prays—

 As I go, as I go
 Oh, Jesus, walk by my side as I go!
 As I go, as I go,
 Be my guide as I go through this world.

Birdie. Sing the song, Sister, sing the song!
 (*Deaconess Hobbs'* voice soars in song as the *Four Deacons* support her. On the final verse *Essie* enters singing)

Essie.
 I need some rock on which to stand,
 Some ground that is not shifting sand,
 And so I seek my Savior's hand
 To guide me as I go through this world.

Birdie. Keep your hand on the plow, Sister Essie. Hold your holt on God!

(The refrain continues as the *Deaconess* and the *Deacons* retire to the choir stalls and *Essie* takes over at the rostrum)

Essie. Brothers and sisters, I am humble, humble tonight, humble in His presence. Pray for me, all of you, as I go! He has been so good to me! I thank God for His name this evening, for Sister Laura, for our fine Minister of Music there at the piano, for all of

you congregation, for Deacon Crow, Sister Birdie Lee, young C. J., and for my daughter, Marietta, God has sent to me. Marietta, daughter, rise and state your determination.

(*Marietta* speaks as the *Choir* continues to hum "As I Go" to end of chorus)

Marietta. Dear friends, Jesus brought me out of the deep dark Southland up here to the light of New York City, up here to my mother, Essie. Jesus brought me to her, and to you, and to this church. I want to be worthy of your love, and of all my mother has done and is doing for me. And most of all, dear friends, I want to be worthy of the love of God. Friends—

> I want to be a flower in God's garden,
> To know each day the beauty of his love,
> Take from the sun its warmth and splendor,
> From gentle dews the kiss of heaven above.
> I want to share each beam of holy sunshine,
> Help make the world a radiant happy place,
> A place of joy and love and laughter,
> A howdy-do on everybody's face.
> If God will give me understanding,
> Lead me down the path his feet have trod,
> If God will help me grow in wisdom,
> Let my life be rooted in his sod.
> Oh, just to be a flower in God's garden!
> Oh, just to be a flower in his sight—
> A tiny little flower in God's garden,
> A flower in his garden of delight.

(The song becomes a prayer as the chorus joins *Marietta*)

> Dear God, just give me understanding.
> Lead me down the path your feet have trod.
> Dear God, just help me grow in wisdom,
> Yes, let my life be rooted in your sod.
> I want to be a flower in your garden.
> I want to be a flower in your sight.
> A tiny little flower in God's garden,
> A flower in your garden of delight.

(The song ends softly to subdued amens. There is a roll of drums. The spotlight falls on *Laura,* regal at one side of the stage. Tambourines shimmer as she marches toward the rostrum to the melody of "Home to God")

Laura. Oh, saints of this church, blooming tonight in God's garden! My heart is full of joy! See what Tambourine Temple has done—united mother and daughter, brought this young lamb to the fold, filled Essie's heart with joy for her child! Blessed me, blessed you! What other hearts here are filled with joy tonight? Who else wants to speak for Jesus as Marietta has done? Who else?

(A tall, scrawny old man, *Chicken-Crow-For-Day,* emerges from the *Choir*)

Crow. Great God, I do! I has a determination to make.

Laura. Make it, brother, make it! Deacon Crow-For-Day! Our friend converted to Jesus! Testify, brother!

Essie. Testify! Testify!

(*Crow-For-Day* takes the center)

Crow. Oh, I am here to tell you tonight, since I started to live right, it is my determination to keep on—on the path to glory. In my sinful days, before I found this church, I were a dyed-in-the-wool sinner, yes, dyed-in-the-wool, sniffing after women, tailing after sin, gambling on green tables. Saratoga, Trenton, New Orleans—let 'em roll! Santa Anita, Tanforan, Belmont, Miami, I never read nothing but the racing forms. In New York, the numbers columns in the *Daily News,* and crime in the comic books. Now I've seen the light! Sister Essie and Sister Laura brought me to the faith. They done snatched me off the ship of iniquity on which I rid down the river of sin through the awfullest of storms, through gales of evil, hurricanes of passion purple as devil's ink, green as gall.

Birdie. Green, green, green as gall!

Crow. I shot dices. Now I've stopped. I lived off women. Uh-huh! No more! I make my own living now. I carried a pistol, called it *Dog*—because when it shot, it barked just like a dog. Don't carry no pistol no more. Carried a knife. Knives got me in trouble. Don't carry a knife no more. I drank likker.

Birdie. Me, too! Me, too!

Crow. It made me fool-headed. Thank God, I stopped.

Birdie. Stopped, stopped, stopped!

Crow. I witnessed the chain gang, the jail, the bread line, the charity house—but look at me now!

Birdie. Look, look, look!

Crow. I lived to see the chicken crow for day, the sun of grace to rise, the rivers of life to flow, thanks be to God! Lemme tell you, I've come to the fold! I've come—

(He sings and the whole church bears him up)

> Back to the fold—
> How safe, how warm I feel
> Yes, back to the fold!
> His love alone is real . . .

Birdie. In the fold! The fold! Yes, in the fold!

Crow.
> Back to the fold
> How precious are my God's ways!

Birdie. Where the streets are streets of gold!

Crow.
> Back to the fold!
> So bright are all my days.

(*Birdie Lee* begins to bang her drums then leaps and dances in ecstasy as the *Chorus* hums)

Birdie. Hold your holt, Crow! Hold you holt on God! Hold your holt!

Laura. Birdie Lee, why don't you set down?

Birdie. Set down? I can't set down—too happy to set down—got to stand—got to talk for Jesus—testify

this evening in His name. I got to tell you where I come from—*underneath* the gutter. On the street, I heard Sister Laura preaching, Sister Essie praying, I said I got to take up the Cross and come back to the fold. Yes, they preached and prayed and sung me into the hands of God! I said goodbye to sin—and I wove my hand. (She waves her hand) Yes, I wove my hand to the devil—and said goodbye. That's why tonight, brothers and sisters, *I'm* gonna testify!

(Gradually her speaking rhythm merges into song as she returns to her drums and begins to play and sing)

Crow. Testify, Sister, testify!

Essie. Tell the world about it, Miss Lee, tell the world!

Birdie.
I'm gonna testify!
I'm gonna testify!
I'm gonna testify!
Till the day I die.
I'm gonna tell the truth
For the truth don't lie.
Yes, I'm gonna testify!

Sin has walked this world with me.
Thank God a-mighty, from sin I'm free!
Evil laid across my way.
Thank God a-mighty, it's a brand new day!

I'm gonna testify!
I'm gonna testify!
I'm gonna testify!
Till the day I die.
I'm gonna tell the truth
For the truth don't lie.
Yes, I'm gonna testify!

I didn't know the strength I'd find
Thank God a-mighty, I'm a gospel lion.
Things I've seen I cannot keep.
Thank God a-mighty, God does not sleep!

I'm gonna testify!
I'm gonna testify!
I'm gonna testify!
Till the day I die.
I'm gonna tell the truth.
For the truth don't lie.
Yes, I'm gonna testify!

In the following sermon from *Jonah's Gourd Vine* by Zora Neale Hurston, notice the poetic devices used by the preacher along with those musically aspirated ha's: personification, metaphor, simile, hyperbole. The minister, John Pearson, is in trouble with his congregation chiefly because his wife has just divorced him and held him up to public ignominy. Elder Pearson does not defend himself in court, however. Knowing that many of her accusa-tions are true—folks don't mind a man being a man among men, but they don't want him to be a man among women—he doesn't retaliate. But the main reason he doesn't speak out against her in court is that the white folks are there and he won't give them the satisfaction. What will be John Pearson's last sermon turns out to be a brilliant one on the betrayal of Jesus, not by his enemies, but by his friends. "It is not your enemies that harm you all the time. Watch that close friend," the preacher says in a prefatory note.

The black preacher is a leader, orator, counselor, but he is also human. In reading, watch for the kinds of poetic devices mentioned above. For example, "Faith" is personified in the sermon—she has no eyes but she does have long legs and human beings can take up her spy-glass to look into the dwelling place of God. The slow but inexorable movement of time is described as two thousand years going by on "their rusty ankles." The preacher uses the richness of black idiom to draw his parable and the result is a wholly believable, human Jesus performing super-human acts for the benefit of mankind. Within the context of the poem, the hyperbole is completely natural. Jesus puts His foot on the "neck of the storm," speaks to the "howlin' winds," lifts the billows in his lap and rocks the wind to sleep on his arm.

Ah!
Faith hasn't got no eyes, but she' long-legged
But take de spy-glass of Faith
And look into dat upper room
When you are alone to yourself
When yo' heart is burnt with fire, ha!
When de blood is lopin' thru yo' veins
Like de iron monasters [monsters] on de rail
Look into dat upper chamber, ha!
We notice at de supper table
As He gazed upon His friends, ha!
His eyes flowin' wid tears, ha! He said
"My soul is exceedingly sorrowful unto death, ha!
For this night, ha!
One of you shall betray me, ha!
It were not a Roman officer, ha!
It were not a centurion
But one of you
Who I have chosen my bosom friend
That sops in the dish with me shall betray me."
I want to draw a parable.
I see Jesus
Leaving heben will all of His grandeur

Dis-robin' Hisself of His matchless honor
Yielding up de scepter of revolvin' worlds
Clothing Hisself in de garment of humanity
Coming into de world to rescue His friends.
Two thousand years have went by on their rusty ankles
But with the eye of faith, I can see Him
Look down from His high towers of elevation
I can hear Him when He walks about the golden streets
I can hear 'em ring under His footsteps
Sol me-e-e, Sol do
Sol me-e-e, Sol do
I can see Him step out upon the rim bones of nothing
Crying I am de way
De truth and de light
Ah!
God A'mighty!
I see Him grab de throttle
Of de well ordered train of mercy
I see kingdoms crush and crumble
Whilst de archangels held de winds in de corner
 chambers
I see Him arrive on dis earth
And walk de streets thirty and three years
Oh-h-hhh!
I see Him walking beside de sea of Galilee wid His
 disciples
This declaration gendered on His lips
"Let us go on to the other side"
God A'mighty!
Dey entered de boat
Wid their oarus [oars] stuck in de back
Sails unfurled to de evenin' breeze
And de ship was now sailin'
As she reached de center of de lake
Jesus was sleep on a pillow in de rear of de boat
And de dynamic powers of nature became disturbed
And de mad winds broke de heads of de Western drums
And fell down on de lake of Galilee
And buried themselves behind de gallopin' waves
And de white-caps marbilized themselves like an army
And walked out like soldiers goin' to battle
And de zig-zag lightening
Licked out her fiery tongue
And de flying clouds
Threw their wings in the channels of the deep
And bedded de waters like a road-plow
And faced de current of de chargin' billows
And de terrific bolts of thunder—they bust in de clouds
And de ship begin to reel and rock
God A'mighty!
And one of de disciples called Jesus
"Master!! Carest Thou not that we perish?"
And He arose
And de storm was in its pitch
And de lightnin' played on His raiments as He stood on
 the prow of the boat
And placed His foot upon the neck of the storm
And spoke to the howlin' winds
And de sea fell at His feet like a marble floor

And de thunders went back in their vault
Then He set down on de rim of de ship
And took de hooks of His power
And rocked de winds to sleep on His arm
And said, "Peace, be still."
And de Bible says there was a calm.
I can see Him wid de dye of faith.
When He went from Pilate's house
Wid the crown of seventy-two wounds upon His head
I can see Him as He mounted Calvary and hung upon de
 cross for our sins.
I can see-eee-ee
De mountains fall to their rocky knees when He cried
"My God, my God! Why hast Thou forsaken me?"
The mountains fell to their rocky knees and trembled
 like a beast
From the stroke of the master's axe
One angel took the flinches of God's eternal power
And bled the veins of the earth
One angel that stood at the gate with a flaming sword
Was so well pleased with his power
Until he pierced the moon with his sword
And she ran down in blood
And de sun
Batted her fiery eyes and put on her judgment robe
And laid down in de cradle of eternity
And rocked herself into sleep and slumber
He died until the great belt in the wheel of time
And de geological strata fell aloose
And a thousand angels rushed to de canopy of heben
With flamin' swords in their hands
And placed their feet upon blue ether's bosom, and
 looked back at de dazzlin' throne
And de arc angels had veiled their faces
And de throne was draped in mournin'
And de orchestra had struck silence for the space of half
 an hour
Angels had lifted their harps to de weepin' willows
And God had looked off to-wards immensity
And blazin' worlds fell of His teeth
And about that time Jesus groaned on de cross, and
Dropped His head in the locks of His shoulder and said,
 "It is finished, it is finished."
And then de chambers of hell exploded
And de damnable spirits
Come up from de Sodomistic world and rushed into de
 smoky camps of eternal night,
And cried, "Woe! Woe! Woe!"
And then de Centurion cried out,
"Surely this is the Son of God."
And about dat time
De angel of Justice unsheathed his flamin' sword and
 ripped de veil of de temple
And de High Priest vacated his office
And then de sacrificial energy penetrated de mighty
 strata
And quickened de bones of de prophets
And they arose from their graves and walked about in
 de streets of Jerusalem

I heard de whistle of de damnation train
Dat pulled out from Garden of Eden loaded wid cargo
 goin' to hell
Ran at break-neck speed all de way thru de law
All de way thru de prophetic age
All de way thru de reign of kings and judges—
Plowed her way thru de Jurdan
And on her way to Calvary, when she blew for de switch
Jesus stood out on her track like a rough-backed moun-
 tain
And she threw her cow-catcher in His side and His blood
 ditched de train
He died for our sins.
Wounded in the house of His friends.
That's where I got off de damnation train
And dat's where you must get off, ha!
For in dat mor-orin', ha!
When we shall all be delegates, ha!
To dat Judgment Convention
When de two trains of Time shall meet on de trestle
And wreck de burning axles of de unformed ether
And de mountains shall skip like lambs
When Jesus shall place one foot on de neck of de sea,
 ha!
One foot on dry land, ah
When His chariot wheels shall be running hub-deep in
 fire
He shall take His friends thru the open bosom of an
 unclouded sky
And place in their hands de "hosanna" fan
And they shall stand 'round and 'round his beatific
 throne
And praise His name forever,

Amen.

In the Black Church baptism is a ritual replete with music and words of worship. The believer is dressed according to the dictates of the occasion and participates in a drama which is staged and directed by the preacher. Not all baptisms, however, achieve the height of pomp and circumstance desired by the participants. Sometimes nature conspires against the worshippers. Young Anne Moody's baptismal experience in the following selection is graphically described in her autobiography *Coming of Age in Mississippi*.

Baptism at Mount Pleasant was the biggest event of the year. Some people saved all year to buy a new outfit. Mama got busy planning what we both would wear. She went to the one store in Centerville that gave credit to Negroes and got a gray fall suit and a pair of shoes for herself. The candidates for baptism had to wear all white so Mama had a white dress made for me and bought me a blue one for after baptism. When she said that the white dress symbolized that I was entering the church pure and the blue one meant that I would always be true and faithful to the church, I felt more than ever like running away.

Saturday, the day before the baptism it rained. I had hoped it would flood so that baptism would be called off, but it didn't rain that hard. On Sunday morning, baptism day, I got up and the rain had stopped. I was the last one up. Everybody else had eaten breakfast, dressed and everything. When I saw that Mama had laid my baptism clothes out at the foot of my bed, I sat there thinking of jumping out of the window and disappearing forever. Instead, I looked at that *white* dress, those *white* socks, that *white* slip, and those *white* drawers, and thought, "This shit means I've been washed clean of all my sins!"

"My sins!" I said, kicking everything off onto the floor like a wild woman.

Just then Mama came in.

"Gal! Looka here what you done! Gettin' this white dress all dirty! Get outta that bed!" she screamed angrily, picking up the dress like I had wounded it. "How you 'spect to be baptized layin' up in the bed pokin' your mouth out, kickin' these clothes on the floor. God'll *slap* the *breath* outta you, playin' with him like this! Get up! Take a bath and get these clothes on. It's nine-thirty and I gotta get you out there 'fore eleven o'clock," she continued, hollering all the way to the kitchen. "Can't do nothing with these hardhead chaps."

Getting out of bed, I looked at those white things again and thought, "Washed clean!" I threw off my pajamas and pulled on the drawers. "Washed clean!" I said, putting on the slip. "Washed clean!" I said louder, pulling on the socks. "Wa-a-a-shed cle-e-e-an!" I yelled, pulling the dress over my head.

"Get outta them clothes and take a bath!" Mama yelled and pushed me onto the bed, just as I was putting my arms through the sleeves of the dress, which was still over my head. As I hit the bed I heard a loud rip.

"Looka there! Looka there! Done *tore* that damned dress! Gal, I could *kill* your ass! Get on in there and *take* a bath while I sew this dress up! God*damn* you!" she yelled, pushing me out of the room.

Finally I put that white dress on and we were on our way out to Mount Pleasant. Everyone had left the church for the pond except the dozen or so candidates who were waiting for me. I was almost an hour late. A couple of deacons used their cars to drive us to the pond. As we drove past the pond where they usually had baptism and turned into the old gravel road I had walked so many times on my way to school, I asked Deacon Brown which pond we were going to.

"They just build a new pond out there right in front of Miss Rose them. That's a better setup 'cause it'll be easier for y'all to change clothes at Miss Rose's house."

Deacon Brown parked the car in front of Miss Rose's, saying "Oh, they're all out there, huh? Pretty big day today."

Getting out of the car, I looked down the hill and saw hundreds of people standing around near the levee of a

big new pond. Opposite the levee, on the far side of the pond, stood a whole group of cows. They looked like they were part of the service.

We walked through the gate and headed toward the pond. I felt the dampness of the ground from yesterday's rain. It was a gloomy and chilly September morning and it looked as if it was going to rain again. As I got closer to the crowd, they looked to me like they were huddling together to keep each other warm. Looking at them made me even colder. The girls were shivering in their gaily colored nylon dresses. The young boys stood motionless in their thin suits, with their hands in their pockets. Even the old ladies were too cold to talk. I spotted Mama in the crowd in her new fall suit and thought, "At least she knew how to dress."

When we got to the edge of the pond where Reverend Tyson was standing with two deacons, we were told to line up. I looked over at the crowd and saw that they had spread out so everyone could see better. There were a lot more people than I had thought. Seeing all those brightly colored dresses and hats, the long earrings, beads, and fancy hairdos, the blood-red lipstick laid on so thick that on some lips it looked purple made me even more aware that we were all dressed in white, even the boys. I felt like a stuffed white rabbit in an Easter parade.

Now that we were all lined up, we were asked to slip our shoes off. Then Reverend Tyson was led out into the water by two deacons. Just as they stepped into the water, I heard Sister Jones's voice sing out, loud and-clear, "Take me to the wa-a-ters . . ."

She was immediately joined by everyone else standing around the pond.

> Take me to the wa-a-ters . . .
> Take me to the wa-a-ters . . .
> To be-ee bap-tized . . .

As the people caught their breaths for the next verse, several moos could be heard. The mooing got so loud that the singing stopped for a moment. Reverend Tyson, in water up to his knees, turned toward the cows and raised his hand as if to quiet them. When they stopped mooing, everybody laughed. Then the singing began again.

When Reverend Tyson and the two deacons were standing in water up to their chests, the first candidate was led out. Everyone continued to sing "Take Me to the Waters" but much lower. Most of the candidates looked scared, especially the girl in front of me. I couldn't tell whether she was shaking because she was scared or cold, or both. I heard Jack, one of the wildest, crap-shootingest boys around, whisper from behind me, "Lookit all that *cow* shit in that water!" I looked down at the water and saw big piles of cow manure floating around. The thought of being ducked under that water made me want to vomit. The water was so muddy, the whole pond looked like a giant mud pie. Then I looked at the girl standing between Reverend Tyson and one of the deacons.

"I baptize you in the name of the Father, in the name of the Son, and in the name of the Holy Ghost, A*men*,"

Reverend Tyson said, drawing out the last syllable as he ducked her quickly under the water. She came up coughing and sputtering, her white dress was now dark brown. Her hair was dripping with mud. All the other candidates stared at her as the deacons helped her back to the edge of the pond. She was shaking and she looked like she wanted to cry so bad. All the candidates were aware of the saying that if you coughed when you were being baptized, it meant the Devil was coming out of you. I knew she was embarrassed because she had coughed.

"All dressed in white! Washed clean! Look at that!" I thought, looking at her.

As the girl ahead of me was being led out, Jack leaned close and whispered, " 'Member, Moody, betta not cough out there. Sister Jones gonna say you were a *sinner*. Hee-hee-hee."

"You got a lot more to cough about than me," I said. I saw two deacons coming for me. As I waded into the water, I could feel the mud sticking to my legs. I was mad as hell, and I heard Sister Jones's voice singing "Nothing but the righteous . . ." along with the rest, I thought, "Nothing but the *righteous*. Some shit!"

I was so mad I barely heard Reverend Tyson shouting, "I baptize you in the name of the Father, in the name of the Son, and in the name of the Holy Ghost, A-*men*!" Suddenly a wet hand was slapped over my face and I felt the mud folding over me, sucking me down. Just as I began to feel the heaviness of the mud, I was lifted out of the water. I tried to open my eyes but mud stuck to my lashes, so I just left them closed. I felt shitty all over. As they were leading me out of the water, I could hear the cows mooing, Jack laughing, and everyone singing, "Take Me to the Waters." Everything sounded far away. It took me a minute to realize that my ears were stuffed full of mud.

After the last candidate was baptized, we were all rushed up to Miss Rose's where we washed off and changed. Even then, I still smelled like wet mud, and the smell lingered for weeks.

The revival meeting moved northward with the Great Migration of Blacks from the South to Chicago, Detroit and especially New York. The following is from Rudolph Fisher's "Harlem Sketches," *Vestiges,* which first appeared in *The New Negro: An Interpretation,* edited by Alain Locke (1925).

REVIVAL

Rare sight in a close-built, top-heavy city—space. A wide open lot, extending along One Hundred and Thirty-eighth Street almost from Lenox to Seventh Avenue; baring the mangy backs of a long row of One

Rudolph Fisher, "Harlem Sketches—Revival." First published in *The New Negro: An Interpretation,* ed. Alain Locke, (1925) Atheneum Publishers.

Hundred and Thirty-ninth Street houses; disclosing their gaping, gasping windows, their shameless strings of half-laundered rags, which gulp up what little air the windows seek to inhale. Occupying the Lenox Avenue end of the lot, the so-called Garvey tabernacle, wide, low, squat, with its stingy little entrance; occupying the other, the church tent where summer camp meetings are held.

Pete and his buddy, Lucky, left their head-to-head game of coon-can as darkness came on. Time to go out—had to save gas. Pete went to the window and looked down at the tent across the street.

"Looks like the side show of a circus. Ever been in?"

"Not me. I'm a preacher's son—got enough o' that stuff when I was a kid and couldn't protect myself."

"Ought to be a pretty good show when some o' them old-time sisters get happy. Too early for the cabarets; let's go in a while, just for the hell of it."

"You sure are hard up for somethin' to do."

"Aw come on. Somethin' funny's bound to happen. You might even get religion, you dam' bootlegger."

Lucky grinned. "Might meet some o' my customers, you mean."

Through the thick, musty heat imprisoned by the canvas shelter a man's voice rose, leading a spiritual. Other voices chimed eagerly in, some high, clear, sweet; some low, mellow, full,—all swelling, rounding out the refrain till it filled the place, so that it seemed the flimsy walls and roof must soon be torn from their moorings and swept aloft with the song:

Where you running, sinner?
Where you running, I say?
Running from the fire—
You can't cross here!

The preacher stood waiting for the song to melt away. There was a moment of abysmal silence, into which the thousand blasphemies filtering in from outside dropped unheeded.

The preacher was talking in deep, impressive tones. One old patriarch was already supplementing each statement with a matter-of-fact "amen!" of approval.

The preacher was describing hell. He was enumerating without exception the horrors that befall the damned: maddening thirst for the drunkard; for the gambler, insatiable flame, his own greed devouring his soul. The preacher's voice no longer talked—it sang; mournfully at first, monotonously up and down, up and down—a chant in minor mode; then more intensely, more excitedly; now fairly strident.

The amens of approval were no longer matter-of-fact, perfunctory. They were quick, spontaneous, escaping the lips of their own accord; they were frequent and loud and began to come from the edges of the assembly instead of just the front rows. The old men cried, "Help him, Lord!" "Preach the word!" "Glory!" taking no apparent heed of the awfulness of the description, and the old women continuously moaned aloud, nodding their bonneted heads, or swaying rhythmically forward and back in their seats.

Suddenly the preacher stopped, leaving the old men and old women still noisy with spiritual momentum. He stood motionless till the last echo of approbation subsided, then repeated the text from which his discourse had taken origin; repeated it in a whisper, lugubrious, hoarse, almost inaudible: " 'In—hell—' " paused, then without warning, wildly shrieked, " 'In hell—' " stopped—returned to his hoarse whisper— " 'he lifted up his eyes. . . .' "

"What the hell you want to leave for?" Pete complained when he and Lucky reached the sidewalk. "That old bird would 'a' coughed up his gizzard in two more minutes. What's the idea?"

"Aw hell—I don't know.—You think that stuff's funny. You laugh at it. I don't, that's all." Lucky hesitated. The urge to speak outweighed the fear of being ridiculed. "Dam' 'f I know what it is—maybe because it makes me think of the old folks or somethin'—but—hell—it just sorter—gets me—"

Lucky turned abruptly away and started off. Pete watched him for a moment with a look that should have been astonished, outraged, incredulous—but wasn't. He overtook him, put an arm about his shoulders, and because he had to say something as they walked on, muttered reassuringly:

"Well—if you ain't the damndest fool—"

In his autobiography *The Big Sea,* published in 1940, Langston Hughes tells of his experience at a revival meeting when he was still very young.

SALVATION

I was saved from sin when I was going on thirteen. But not really saved. It happened like this. There was a big revival at my Auntie Reed's church. Every night for weeks there had been much preaching, singing, praying, and shouting, and some very hardened sinners had been brought to Christ, and the membership of the church had grown by leaps and bounds. Then just before the revival ended, they held a special meeting for children, "to bring the young lambs to the fold." My aunt spoke of it for days ahead. That night I was escorted to the front row and placed on the mourners' bench with all the other young sinners, who had not yet been brought to Jesus.

My aunt told me that when you were saved you saw a light, and something happened to you inside! And Jesus came into your life! And God was with you from then on! She said you could see and hear and feel Jesus in your soul. I believed her. I had heard a great many old people say the same thing and it seemed to me they ought to know. So I sat there calmly in the hot, crowded church, waiting for Jesus to come to me.

The preacher preached a wonderful rhythmical sermon, all moans and shouts and lonely cries and dire pictures of hell, and then he sang a song about the ninety and nine safe in the fold; but one little lamb was left out in the cold. Then he said: "Won't you come? Won't you come to Jesus? Young lambs, won't you come?" And he held out his arms to all us young sinners there on the mourners' bench. And the little girls cried. And some of them jumped up and went to Jesus right away. But most of us just sat there.

A great many old people came and knelt around us and prayed, old women with jet-black faces and braided hair, old men with work-gnarled hands. And the church sang a song about the lower lights are burning, some poor sinners to be saved. And the whole building rocked with prayer and song.

Still I kept waiting to *see* Jesus.

Finally all the young people had gone to the altar and were saved, but one boy and me. He was a rounder's son named Westley. Westley and I were surrounded by sisters and deacons praying. It was very hot in the church, and getting late now. Finally Westley said to me in a whisper: "God damn! I'm tired o' sitting here. Let's get up and be saved." So he got up and was saved.

Then I was left all alone on the mourner's bench. My aunt came and knelt at my knees and cried, while prayers and songs swirled all around me in the little church. The whole congregation prayed for me alone, in a mighty wail of moans and voices. And I kept waiting serenely for Jesus, waiting, waiting—but he didn't come. I wanted to see him, but nothing happened to me. Nothing! I wanted something to happen to me, but nothing happened.

I heard the songs and the minister saying: "Why don't you come? My dear child, why don't you come to Jesus? Jesus is waiting for you. He wants you. Why don't you come? Sister Reed, what is this child's name?"

"Langston," my aunt sobbed.

"Langston, why don't you come? Why don't you come and be saved? Oh, Lamb of God! Why don't you come?"

Now it was really getting late. I began to be ashamed of myself, holding everything up so long. I began to wonder what God thought about Westley, who certainly hadn't seen Jesus either, but who was now sitting proudly on the platform, swinging his knickerbockered legs and grinning down at me, surrounded by deacons and old women on their knees praying. God had not struck Westley dead for taking his name in vain or for lying in the temple. So I decided that maybe to save further trouble, I'd better lie, too, and say that Jesus had come, and get up and be saved.

So I got up.

Suddenly the whole room broke into a sea of shouting as they saw me rise. Waves of rejoicing swept the place. Women leaped in the air. My aunt threw her arms around me. The minister took me by the hand and led me to the platform.

When things quieted down, in a hushed silence, punctuated by a few ecstatic "Amens," all the new young

lambs were blessed in the name of God. Then joyous singing filled the room.

That night, for the last time in my life but one—for I was a big boy twelve years old—I cried. I cried, in bed alone, and couldn't stop. I buried my head under the quilts, but my aunt heard me. She woke up and told my uncle I was crying because the Holy Ghost had come into my life, and because I had seen Jesus. But I was really crying because I couldn't bear to tell her that I had lied, that I had deceived everybody in the church, that I hadn't seen Jesus, and that now I didn't believe there was a Jesus any more, since he didn't come to help me.

In *The Book of Negro Humor* Langston Hughes has collected a number of selections which reflect the lighter side of religious belief and practice.

FAITH AND EXPERIENCE

When it is dark enough, you can see the stars. I shall never forget the first time I took a night flight in one of our powerful jets. As that mighty plane lifted up into the heavens, I looked out of my window and saw great spurts of flame pouring out from the side of the plane. I became a little concerned. The stewardess, noticing this, came over to explain to me that those very flames emanated from jet planes at all times when they took off in flight. She told me that they were there when the planes took off in the daytime. The point was, you couldn't see them unless it was dark enough. Now I want you to know that the fears which had come to me at the sight of those flames didn't indicate that I have no faith in God in the air. It's just that I have more experience with Him on the ground.

From a sermon at Ebenezer Baptist Church, Atlanta,
"You Can See the Stars,"
Martin Luther King, Jr. (1915-1968)

NOTHING BUT THE GOSPEL

A Negro minister was visiting on the farm of one of his church members. The land was in excellent condition and prospects were bright for a good harvest. Upon numerous occasions the pastor would compliment his charge, saying, "You and the Lord have certainly done a fine job out here." As the pastor was leaving, he remarked once again upon the success "you and the Lord" are having.

The Negro farmer, somewhat amused, could not help remarking, "Yes, Parson. What you say is true. But I just wish you could have seen this here farm about five years ago, when the Lord had it all by Himself!"

Four Sketches from *The Book of Negro Humor,* edited by Langston Hughes, New York: Dodd, Mead & Company, 1966.

GRACE BEFORE MEAL

The late Dr. W. E. B. DuBois, when once asked to say grace at the table of a fashionable hostess, bowed his head. No sound came from his lips. When he raised his head, his hostess said, "But, Dr. DuBois, I could not hear you."

Dr. DuBois replied, "Madam, I was not talking to you. I was talking to God."

FAREWELL

The pastorate of a large Baptist church had been vacant for sometime because of evil dissention in the congregation. But at long last a minister from another city was invited to fill the pulpit. Soon, however, the congregation turned against the new pastor, too, and requested, just as they had of the previous minister, his resignation. Without a word the good man complied. In fact, he complied so meekly that those in the church who enjoyed a ruckus were disappointed. On the day of his final sermon the edifice was filled. He preached without rancor. But as the recessional was played and he prepared to walk down the center aisle of the church and out the door for good, he said, "Brothers and sisters, as I go down the aisle I beg of you take note of the little sprig of mistletoe pinned to my coattail."

A MOTHER'S PRAYER*

Lucy and John went out on the porch and sat slyly side by side. Emmeline burst out of the parlor.

"Lucy! What you doing setting on top of that boy?"

"I ain't setting on top of him. A milk cow could get between us."

"Don't talk back to me. When I speak, you move. You hear me?"

"Yes 'um."

"How come you ain't moving? My orders is five feet apart. Heifer! Move that chair away from that boy! Mind what I say! I'm gonna tell God about you, madam."

Emmeline pulled back the curtain in the parlor so that she could see every move on the porch, and prayed.

"O Lord and our God, you know I tries to raise my children right and lead them in the way that they should go, and Lord, you know it ain't right for boys and girls to be setting on top of one another; and Lord, you know you said you'd strike disobedient children dead in their tracks, and Lord, make mine humble and obedient, and to serve Thee and walk in Thy ways and please make them to set five feet apart. And when I done sung my last song, done prayed my last prayer, please, sir, Jesus, make up my dying bed and keep my children's feet pointed to Thy starry pole in glory and make them set five feet apart. These and all other blessings I ask in Jesus name, amen, and thank God."

From *Jonah's Gourd Vine*,
Zora Neale Hurston

Backsliders are an inevitability even among the devout. In the following one-act play Thomas Pawley takes a humorous look at a young man who is not quite prepared for Judgment Day.

JEDGEMENT DAY**

A Play by Thomas D. Pawley

The Cast

Zeke	Gabriel	Hannabelle Lee
Minerva	Mephistopheles	Solomon Jones
Rev'm Brown	Pluto	Cato

Scene. The plainly furnished home of Zeke and Minerva Porter. Its appointments include an old dresser, a water basin and white pitcher, a double bed, chairs and a table. In the left wall there is a window through which can be seen a street sign marked "Plum Street" and a few feet beyond a grayish frame church. In the center, a door which opens on a porch. On the other side of the room, two doors, one of which leads into the kitchen, the other to a clothes closet. (These doors in the scene of the "jedgement" represent Paradise and Club Hades.)

Time. One Sunday Morning. As the scene opens, Zeke is lying asleep on the bed with his feet extended toward the audience. He is dressed only in his shirt and long drawers and is snoring contentedly. Through the kitchen door, which stands partly open, Minerva is heard singing in a rich alto voice:

> "I looked over Jordan
> An' what did I see,
> Comin' fo' to carry me—"

Suddenly the singing stops and Minerva begins calling Zeke.

Minerva. Zeke! You up yit? Zeke!

Zeke. (sleepily) Huh?

Minerva. I say, it's time to git up!

Zeke. Un-huh.

(Zeke turns over as Minerva enters the room completely dressed for church. She is halfway across before she realizes that Zeke is still in bed.)

Minerva. Well, if'n you ain't de laziest man what ever lived! Here I'se all ready to go an' you ain't started to git dressed! Zeke! Git up from dere! Don't you know it's mos' time fo' church, huh?

(Zeke merely stirs and grunts sleepily.)

Well! If talkin' ain't enough to git you up, I know what will!

(She turns abruptly and seizes the water pitcher. Returning to the bed she empties its contents on the sleeping black man. Zeke sits up immediately, fighting off an imaginary foe.)

Zeke. Cut it out! You don' push me right into de river!

Minerva. Ain't nobody don' push you into no river. You's only dreamin'.

Zeke. Den if I'se only dreamin' what's de whole ocean doin' on me!

Minerva. Dat ain't no ocean—dat water come from de water company!

Zeke. Den somebody musta poured it on me.

Minerva. They sho' did. (grasping the pitcher) An' if you don' git out'n dat bed somebody's gon' pour some mo' on you.

Zeke. Hey, waita minute . . . I'se up! What's de matter wif' you, anyhow? When I don' come home an' go to bed you raise hell; an' when I do, damn if you don't try to run me out agin'. Now I asks you, what's a man gon' do wif a woman like you?

Minerva. Don' you know it's mos' 'leven? Church's gon' be startin' in a few minutes. Look yonder—some of de sisters is already goin' in. Laws' a mussy—Hannabelle Lee's got on a new bonnet, too!

Zeke. You know dis ain't my mornin' to go to church.

Minerva. How come it ain't? Zeke Porter, you better watch out befo' de Lawd strike you stone dead.

Zeke. He ain't got no time to be bothered with me. Not today, He ain't!

Minerva. (shocked) You's blasphemin'!

Zeke. Naw I ain't, I'se tellin' de truth. Don't de Lawd listen to everybody's prayers? Sho' he do. An' ain't dere 'bout a million people a-prayin' to Him dis Sunday morning all over de worl'? Sho' dey is. Den how you figure He's gon' take time out to see what I'm doin'?

Minerva. You's crazy, dat's what you is—But what you mean by sayin' dis ain't yo' mornin'?

Zeke. Well, it ain't. Dis ain't communion day, is it?

Minerva. What difference dat make?

Zeke. Well, it ain't no us'n my goin' to church when it's right across de street. 'Sides, I c'n lie here in bed an' shout 'n sing jus' as loud as I could over dere any day. Den I c'n do it lyin' down an' dat's easier on my feet.

Minerva. What's de communion got to do with it?

Zeke. Well, dey gives away free wine on dat day. So when I gits thirsty from shoutin', all I'se gotta do is step up to de rail an' ask fo' communion.

Minerva. You's a sinner! Oh, Lawd have mercy on him! He don' know what he's a-sayin'!

Zeke. Minerva, ain't no us'n you botherin' Him—I tell you He's too dawgone busy.

Minerva. Oh, what's I'm gonna do 'bout you. De devil'll git you sho' if I don' do sump'n!

Zeke. Listen, honey. If dat devil come at me wif his pitchfork, I'm goin' right back at him wif my razor.

(*Minerva* begins to wail in despair.)

Minerva. Oh Lawd! What's I'm gonna do?

(At this moment a kindly looking old colored gentleman enters. His hair is grey and he wears a long frock tail coat. Among other things he wears a pair of grey spats on spotless brown shoes.)

Brown. What's the matter, sister?

(*Minerva* looks up, sees the minister, and runs toward him.)

Minerva. Oh, I'se sho' glad you come in, Rev'm Brown!

Zeke. (standing up) Mornin' Rev'm.

Brown. Mornin' Zeke. I was jus' passin' on my way to church when I heard Minerva shoutin'. So I come to see what's the matter. Is there anything I can do?

Minerva. There sho' is, Rev'm.

Brown. Zeke, you ain't been beatin' Minerva, has you?

Zeke. Naw, Rev'm. Do it look like I been beatin' anybody?

Brown. No, it don't. What's the matter with you anyhow? You look like you'd gone swimmin' with all your clothes on.

Zeke. Ask her. She done it.

Brown. Minerva?

Minerva. Rev'm, I hadda do sump'm. Him sleepin' when its mos' time fo' church.

Brown. Oh!

Minerva. Den after I gits him up he come tellin' me dat he ain't goin' 'cause it ain't communion day.

(*Zeke* turns sheepishly.)

Brown. What's all this, Zeke?

Zeke. Well, Rev'm, I jus' can't see why I'se got to go to church when she's jus' across de street.

Brown. That's jus' why you should go. Look at me—I come all the way 'cross town jus' to give you people the gospel—simply 'cause I know it's my duty.

Minerva. Amen!

Zeke. I ain't got nothin' 'gainst goin'. But it ain't no use if I c'n hear everything here jus' as plain as day.

Brown. (pleased) Can you?

Zeke. Sho' I can! When dem brothers 'n sisters gits to shoutin' it's a wonder de whole town don' hear 'em!

Brown. (catching himself) Even so, it's—it's the spirit of goin' that counts.

Zeke. Maybe—but I ain't got the spirit today. 'Cose I'll be over on communion day like I said.

Brown. It might be too late then. Besides, you should come every Sunday. Remember, He said, "Six days shalt thou labor and on the seventh" . . .

Zeke. (sitting on the bed) ''Rest.'' An' dat's jus' what I'm gonna do!

Brown. (confused) But—but that ain't what He meant—

Zeke. Well, dat's sho enough what He said, ain't it?

Brown. (grudgingly) Ye-yes.

Zeke. Well, now, ain't no us'n you tryin' to git me to go 'gainst de Bible. 'Cause when de Bible tell me to res', I'm sho' gonna do it!

Brown. (approaching) Zeke Porter, I command you in the name a' Gawd to get off of that bed and go into church and ask fo'giveness for your sins!

Zeke. Now, Rev'm, you's gettin' just like Minerva.

Brown. If you don't, I'll call down the wrath-a Gawd on you. Your soul will burn forever. You'll never see the gates-a paradise.

Zeke. What's all dat you talkin' 'bout?

Brown. On the day of jedgement when Gabriel gits to blowin' his trumpet an' the dry bones rise outa the valley, yours'll sink deep into the depths of Hell!

Minerva. Oh, Lawd, Lawd. Save him befo' it's too late! (She falls to her knees.)

Zeke. (frightened) Cut out all dat moanin', Minerva! Now Rev'm you know nothin' like dat ain't a gonna happen!

Brown. I leave the matter in the hands-a Gawd—I wash my hands of it. I can't 'low the sacred garment of the min'stry to be soiled by a disciple of the devil!

Minerva. Save him—save him!

Brown. Come sister, there ain't nothin' more we can do. It's up to him now. If you want to be saved an' enter them green fields when you come befo' Him for jedgement, get down on your knees an' ask Him for fo'giveness. Then come into His church an' be baptised of your sins.

Minerva. Come on, Zeke, befo' it's too late!

Zeke. I ain't a comin' nowhere. Y'all jus' tryin' to scaire me, dat's all—an' it ain't gonna work. Now git!

(*Minerva* and *Brown* move towards the door. As they reach the threshold *Brown* turns, shakes his head sadly, then points at *Zeke*.)

Brown. Your soul belongs to the devil!

(They go out. *Zeke* watches them for a moment and then falls back on the bed and starts mumbling to himself.)

Zeke. Dey's both crazy—don't know what dey's talkin' about—tryin' to scaire me—Gawd, I'se some sleepy!

(He lies still for a moment and the service across the street is heard to begin with a jubilant spiritual:

 ''I got shoes,
 You got shoes,
 All God's chillun' got shoes,
 When I gits to Hev'n

 Gon' put on my shoes
 An' gon' shout all over God's Hev'n.''

Zeke begins to mutter sleepily as the spiritual dies.)

Zeke. Dey's tryin' to scaire me. Ain't nothin' goin to happen . . . jedgement.

(His voice trails off as the lights fade on the bed and come up slowly on the far side of the room. Immediately two brown angels appear through the doors.)

Gabriel. Well, this is the day.

Mephistopheles. It sho' is.

Gabriel. I suppose we might as well get started. The chiefs'll be out in a minute.

Mephistopheles. Yeah, might as well.

(At this point they take out signs from under their garments. Gabriel takes out one marked ''Paradise,'' dusts it off, and nails it over the kitchen door. Mephistopheles takes out another marked ''Club Hades'' and nails it over the closet. As they finish both stand back to admire their work.)

Gabriel. Pretty smooth, huh?

Mephistopheles. Nothing like it—nowhere! Say ain't you Gabriel?

Gabriel. That's right, an' you?

Mephistopheles. Well, they call me Mephistopheles.

Gabriel. Mephistopheles! Well! Ain't seen you since the boss kicked you an' Pluto into Hades.

Mephistopheles. (as they shake hands) Yeah, it's been a hell of a long time, ain't it? Reckon you'll be sort of glad to blow your trumpet, too.

Gabriel. Yeah, I've been practicin' a pretty long time now. Well, what do we need?

Mephistopheles. A table for one thing.

Gabriel. What's the matter with this one? (He indicates a table which stands between the two doors.) Just pull her out a bit.

Mephistopheles. There, that don't look so bad, do it Gabe?

Gabriel. No, it don't, but let's hurry on an' get the chairs. (Looking at his wrist watch.) It's almost time for me to sound the call.

Mephistopheles. Okay.

(Each picks up a chair and places it behind the table.)

Gabriel. I 'spose the chief'll lay me out for not havin' his throne ready on time. But I been so devilish busy that judgment was here before I knew it. (Looking around.) I guess that's all. You think of anything else?

Mephistopheles. No, I don't. An' now I got to beat it an' get things ready on the inside.

Gabriel. Me, too! So long, Mephistopheles.

Mephistopheles. I'll be seein' you, Gabriel.

(They both go out through their respective entrances. For a moment *Zeke* is heard snoring gently, then *Gabriel* returns with a silver trumpet. He pauses, looks at his trumpet, takes a deep breath and blows a terrific blast. Startled, he examines the instrument; then decides that it must be all right.)

Gabriel. Hear ye, hear ye, ye descendents of Cain! Draw nigh on this day of judgment so that the Lords of Heaven an' Hell may pass judgment upon ye.

(With this he blows the trumpet once more. Again there is a discordant blast and he walks off, giving up the whole thing as a bad job. Almost immediately *Pluto* appears out of Hades wearing a top hat and evening clothes. From Paradise Minister *Brown* appears attired as before. He carries a huge black book which he places before him. He and *Pluto* do not greet each other, but merely bow. Minister *Brown* motions with his hands and a church choir begins humming softly. Simultaneously the devil motions and a familiar swing band begins jamming the same air. After a moment the music fades and they sit. Then the Minister, after much ado, pronounces the first name.)

Brown. Hannabelle Lee!

(The front door opens and the over-dressed Miss *Lee* primps up before them.)

Hannabelle. Howdy, Rev'm. (The minister draws himself up haughtily.) Hi ya, Pluto.

Pluto. Hi, ya, babe!

Hannabelle. How's things doin'? (*Pluto* starts to get up.) Never mind, I'll be over soon enough to find out.

Brown. Well, since this woman had already made up her mind, I see no need for proceeding further in *this* case.

Pluto. Okay by me! Over here, Hannabelle!

Hannabelle. Better come on down tonight, Rev'm. (To *Pluto*) Well, where do I go from here?

Pluto. Mephistopheles is waitin' on the inside. He'll take care of you. See you later!

Hannabelle. Okay. So long boys! (She goes out.)

Brown. Solomon Jones!

(The front door opens again and an old man enters. He walks reverently up before the judgment.)

Pluto. You're Solomon Jones?

Jones. Yessuh!

Pluto. Want to join up with me? We're goin' to have a big time on the inside.

Jones. (shaking his head) No, I'se had my fling. All I wants to do now is res'.

Pluto. Okay, gran'pop. (To *Brown*) Your man.

Brown. Over here, Solomon. Nos jus' go straight ahead an' don't be afraid. Nothin' ain't goin' to harm you now.

Jones. Yessuh! (He goes out.)

Brown. Cato!

(The door opens again and a flashily dressed Harlem pimp comes in.)

Brown. What's your last name—we don't have no record of it.

Cato. Cato!

Brown. What's your first name?

Cato. Julius Caesar—

Brown. (writing) Julius Caesar Cato! Well, Cato, you're charged with cheating at cards, shootin' dice, cuttin', an' livin' unmarried with women. What you got to say for yourself?

Cato. Nothin'.

Brown. Don't you know you'll burn forever if you don't ask for fo'giveness?

Cato. Sho'.

Brown. Don't you want to be fo'given?

Cato. Don't make a damn bit of difference to me.

Brown. You'd better take him.

Pluto. Okay. (He motions to Cato who comes over to him.) Listen, there's a dame inside named Hannabelle Lee. Go on in an' tell her I sent you.

Cato. Hannabelle Lee! Say, this ain't gonna be half bad! (He enters "Club Hades.")

Pluto. Who's next?

Brown. Minerva Porter! (*Minerva* enters. She has been weeping.)

Brown. What's the matter, Minerva?

Minerva. Nothin'.

Brown. What're you cryin' for then?

Minerva. Well, I'm worried 'bout Zeke. Please let him come with me. I don' want him to go one way an' me another.

Pluto. Well, from what I hear about this guy if you'll come on in with me, you'll be sho' to be with him!

Minerva. No—I'se a good Christian, I is. An' I want Zeke to be with me.

Pluto. Ain't much chance of that, sister.

Brown. Yes, he's got a mighty bad record.

Minerva. But ain't there nothin' you can do?

Brown. I don't know. If he wa'nt such a good fo' nothin', maybe I could set him off on a star for a couple of thousand years—an' than after that maybe I could let him come to see you once in a while. But as it is—(He shakes his head.)

Minerva. Den if he can't come I guess I'se got to go on by myself.

Brown. You go on in—I'll do what I can. But I think his case is pretty hopeless. (*Minerva* enters "Paradise.")

Brown. Zeke Porter!

(The door doesn't open. *Pluto* and *Brown* look at each other.)

Pluto. Louder, maybe he didn't hear you.

Brown. Zeke Porter! (*Zeke* begins to stir.)

Zeke. Who dat call me?

Brown. Zeke Porter, come to judgment!

Zeke. Jedgement! How come it come so soon? I ain't ready to go yit.

Pluto. Maybe I'd better send Mephistopheles after him.

Zeke. Dat's all right. Dat's all right. I'se comin'. (He approaches the table.) So dis is jedgement? It sho looks familiar!

Brown. Zeke Porter, of all the souls that have come before us, yours is the worse. Of all those we shall yet judge, not one approaches such a record as yours.

Zeke. Is I—all dat bad?

Brown. You mean, were you all dat bad. 'Cause you no longer exist as you were. Do you realize that you can't enter Paradise, and Hades don't want you?

Zeke. But I gotta go somewhere. I can't jus' wander 'bout 'mong de stars.

Brown. That's jus' the trouble.

Pluto. Well, what're we going to do with him?

Brown. I don't know. He's so lazy that he didn't even get to judgment on time!

Pluto. (after a pause) I got it. We'll draw cards. The one that pulls the ace of spades don't have to take him.

Brown. Good enough! Hand me the cards. I'll shuffle them.

Pluto. Say—don't you trust me none?

Brown. Sho' I trust you, but not on this deal. (He shuffles them.) Now cut!

(*Pluto* reaches for the deck which *Brown* hands him. He looks at it for a moment, then draws a card which he looks at but keeps covered. *Brown* then places the deck in front of him, spreads the cards out, and picks one.)

Brown. All right. Show your card.

(*Pluto* does so. It is the ace of spades. *Brown* looks at it for a moment then turns up his card, also the ace of spades.)

Pluto. I oughta known it'd turn out this way. You musta stacked the deck.

Brown. I didn't do nothin' of the kind.

Pluto. Well, them two aces didn't jus' walk into that deck.

Brown. How you know they didn't?

Pluto. Huh?

Brown. I say, mine did.

Pluto. You mean—

Brown. Has you forgotten who I am? All I'se got to do is wish for something to be, an' by the time I finish it shall have been!

Pluto. Well, this don't get us nowhere.

Brown. No, it don't.

Pluto. Then there ain't but one thing to do.

Brown. What's that?

Pluto. Divide him up between us.

Zeke. No-no—don't do that! Please Mr. Devil!

Brown. That's the only way—cut him up between us—half an' half.

Pluto. Mephistopheles! Bring me the butcher knife!

Mephistopheles. Yes, sire!

Zeke. Fo' Gawd's sake, don' cut me up!

Brown. What you mean by calling on God? Maybe we oughta cut him up in quarters!

Zeke. I'll do anything, anything you say! But don' cut me up!

Brown. You oughta thought about that when you were alive on earth.

Mephistopheles. (entering) The butcher knife, sire. (He presents the knife to *Pluto* and then goes out.)

Zeke. Keep dat butcher knife away from me! Stay back I tell you!

Pluto. (hypnotically) Come here, Zeke.

Zeke. Wha-what?

Pluto. Come here, Zeke!

Zeke. Yessuh, yessuh, I'se comin'.

(*Pluto* advances with the butcher knife while Zeke crawls tremblingly forward. They stand facing one another.)

Pluto. Take off your shirt and prepare to die.

Zeke. Yessuh, Mr. Devil! (He does so.)

Pluto. Hurry.

Zeke. I'se hurrin' as fas' as I can.

Pluto. Now say your prayers.

Zeke. Oh, Lawd have mercy on me! Have mercy! Fo'give me, Lawd. Fo'give me.

(The lights begin to fade; then they come up again on *Zeke* tossing on the bed.)

Zeke. (sitting up). Dey's gone! An' I'se saved! I'se saved!

(At this moment the choir across the street begins to sing.)

Zeke. An' dey's still over dere singin'! Maybe I'd better git over dere befo' it's too late.

(He begins pulling on his shoes hastily. His movements become slower and slower until finally he emits a huge yawn.)

Golly, I'se *so* sleepy. I reckon I'll jus' take a little nap befo' I go—

"Creation" is the most famous of James Weldon Johnson's "Sermons" from *God's Trombones* and it is a celebration of life, the life of the first man. Death, however, inspires rituals among all peoples and one of the most moving of the poetic sermons in that book is "Go Down Death." There is in the language of this sermon, as in the others, a naturalness of poetic expression that allows the reader to identify with the bereaved yet feel no depression. It is not merely the attitude of acceptance of death as a natural phenomenon, nor the release from an overburdened life brought on perhaps by reaction against the harshness of the slave condition, but it is also a lack of fear in the face of the inevitable that one finds perhaps only in Whitman's "Come lovely and soothing death," from "When Lilacs Last in the Dooryard Bloom'd." We are in a sense with Sister Caroline, home and happy in the arms of a loving God. "Go Down Death" is the fourth poetic sermon in *God's Trombones* which is available in several editions. (The Viking Compass paperback is now in its sixth printing.)

The ritualistic glorification of death as a release from the ills of this world is rapidly declining among Blacks. The reasons actuating this decline are, no doubt, highly complex. Two entities of the phenomenon are worth exploring here: the black man's loss of Christian religious fervor and his changing concept of the relationship between death and freedom.

To verify that some Blacks have always distrusted Christianity because of its perversion by many professed Christians (to the end of keeping Blacks in a state of submission), we need only examine an excerpt from Henry Bibb's narrative of his life as a slave. In attempting to account for the licentious behavior—drinking, gambling, fighting, and dancing ("pat [ting] juber")—of fellow slaves on the Sabbath, Bibb avers

... This is all principally for want of moral instruction.
.... [There is] no one to preach the gospel who is competent to expound the Scriptures, except slaveholders. And the slaves, with but few exceptions, have no confidence at all in their preaching, because they preach a pro-slavery doctrine. They say, "Servants be obedient to your masters;—and he that knoweth his master's will and doeth it not, shall be beaten with many stripes;"—means that God will send them to hell, if they disobey their masters. This kind of preaching has driven thousands into infidelity. They view themselves as suffering unjustly under the lash, without friends, without protection of laws or gospel, and the green eyed monster tyranny staring them in the face. They know that they are destined to die in that wretched condition, unless they are delivered by the arm of Omnipotence. And they cannot believe or trust in such a religion, as above named.[9]

Considering the influence that the church reputedly has had upon the lives of black people, one might conclude either that Bibb's estimate that there were only few believers in his day is a gross exaggeration or that the church in reality merely served as a meeting place for Blacks for events which were more of a social rather than a religious nature—a notion which is probably not without some validity in that there were hardly any other places Blacks were allowed to congregate in large numbers immediately following slavery. On the other hand, there may have been a substantially large number of Blacks who were able to distinguish between the principles of Christianity and the perversion of those principles, thereby keeping the Black Church alive. Nevertheless, for whatever reasons, it is an indisputable fact that the decline in the youth membership in the traditional black churches and the concurrent steady increase in the youth membership of the Muslim faith—which is not a white man's religion—indicate that the black man has lost much of his Christian religious fervor.

Many are no doubt familiar with the words "Before I'll be a slave, I'll be buried in my grave and go home to my master and be free." The concept of the relationship between death and freedom in black consciousness has changed radically in the recent past as is evidenced in the following poem by Nikki Giovanni:

THE FUNERAL OF MARTIN LUTHER KING, JR.

His headstone said
Free at Last, Free at Last
But death is a slave's freedom
We seek the freedom of free men
And the construction of a world
Where Martin Luther King could have lived and preached non-violence

Atlanta
4-9-'68

"It is impossible to know what King—and another assassinated black leader, Malcolm X, the apostle of

9. *Narrative of the Life and Adventures of Henry Bibb* in *Puttin' On Ole Massa*, ed. by Gilbert Osofsky, pp. 68-79.

the unchurched—might have done to change the struggle, had they lived. According to King's assistant, Wyatt Tee Walker: 'Their deaths set back our struggle by 25 years.' "[10]

In addition to the numerous films and books on Martin Luther King which are available for classroom use, a recent play entitled "I Have a Dream" starred Billy Dee Williams in the role of Dr. King. The world premiere was presented at historic Ford's Theatre in Washington, D.C., on April 5, 1976. The play is dedicated to: James Earl Chaney, Addie May Collins, Medgar Wiley Evers, Andrew Goodman, Jimmy Lee Jackson, Denise McNair, The Rev. James J. Reeb, Carole Robertson, Michael Henry Schwerner and Cynthia Wesley, all victims of bigotry, irrationality, violence.

History demands that a twentieth century "prince of peace" be recognized for his contributions to the world, as Virginia Williams suggests with such phrases as "Black Moses," "Black peace preacher," "Brave black man from Atlanta."

BLACK MAN FROM ATLANTA

Virginia Williams

Black man from Atlanta
 Minister
 Family man
 Peace Prize Winner of the world
 Dressed in jeans
 Steps aboard his plane
 Clutching his Bible

 Mission?
To serve an unjust sentence
In a Brimingham jail
 Crime?
Marching for freedom
Justice
Equality
Dignity
Brotherhood of man
 Impossible!
Brave black man from Atlanta
Ill . . . unshaven
Sentence served

Steps aboard his plane
Destination?
Home

Black peace preacher
From the clay hills
Of Georgia . . .

 Work unfinished
 Set out for Memphis
 Mission?
 Another march for
 Freedom
 Justice
 Equality
 Dignity
 Brotherhood of man
 Possible!
 Marching!
 Marching!
 Marching!
 Black Moses of his time
 Worn and weary
 Battle scarred warrior—
 Scar on his heart
 Scar on his head
 Scar on his throat
 Mission ended . . .
 Steps aboard his plane
 —For the last time—
 . . . Heads toward heaven

The decline in Christian fervor among Blacks perhaps has resulted in a simultaneous rise in the quest for manhood. This is not to say that Christianity itself negates manhood; the *perversion* of the principles of Christianity does. From the moment that the first black man set foot on American soil to this very moment, white America has systematically contrived to emasculate—both figuratively and literally (literally via hanging and castration)—the black male. It has done so with the knowledge that no race of people can be strong if its men are weak; hence the rationale for keeping black men black boys. Malcolm X, whom Ossie Davis (noted playwright, actor and director) termed "Black Manhood" and "The Black Shining Prince," represents the epitome of manhood for many Blacks. In 1969 Broadside Press published an anthology of poems entitled *For Malcolm X* which was edited by Dudley Randall and Margaret Burroughs. Among those were the following two poems. In reading them, one should be especially concerned with the images of manhood and with the notion that the achievement of manhood is necessary for the spiritual rejuvenation of Blacks.

From *A Galaxy of Black Writing,* ed. by Baird Shuman. Reprinted by permission of Moore Publishing Company, Durham, North Carolina.

10. *Time* Magazine Essay, April 4, 1969, p. 29.

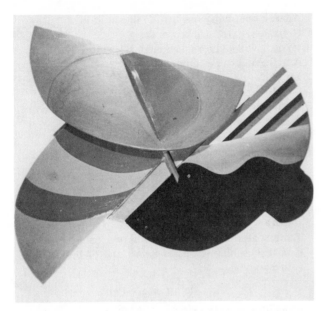

Figure 1.1. "Boston Red" was another name by which Malcolm X was known. It is the title of this work by Mahler Ryder. Courtesy of the artist.

MALCOLM X*

For Dudley Randall

Gwendolyn Brooks

Original.
Hence ragged-round
Hence rich-robust.

He had the hawk-man's eyes.
We gasped. We saw the maleness.
The maleness raking out and making guttural the air
And pushing us to walls.

And in a soft and fundamental hour
A sorcery devout and vertical
Beguiled the world.

He opened us—
Who was a key.

Who was a man.

James Worley does not see Malcolm's death resulting in a spiritual wasteland, but rather views him as a symbol of hope (though the hope is tinged with elements of despair). Observe how the poet fabricates his work out of language traditionally used in the scientific disciplines (mathematics, chemistry, and archaeology). There is a dualism in the entity "X." As a mathematical term it represents the

unknown; as Malcolm's last name it indicates his denial of his Cristian surname (which, ironically, was "Little"). These two factors give an added dimension to the ambivalent tone of the poem.

LET "X" BE HOPE**

James Worley

In a geometry of pain
What theorem holds, what answer heals?
Only carbon and its compounds,
Black stain running through the stone,
Endure. Words disintegrate,
And yearnings are forever swerved
By torpid hearts and careless skies.

Impaled upon satiety,
The favored alm the begging man;
While under fists of hydrogen,
Lovers and losers—scholars—fend,
Footnoting each his page of pangs:
Need is camouflaged by plight;
Who seek the wheat must brook the chaff.

This life, nothing but becoming,
Withering when it's defined,
Makes fossils of all faithlessness.
Can they that in desire would question
To the very pit of time,
From a chemistry of grief
Distill a measure of belief?

The black man's quest for manhood is undoubtedly the animating force behind Margaret Walker's *Prophets for a New Day*.† It is important to observe that she diversifies manhood. The references to the Biblical prophets obviously suggest contemporary leaders. Her descriptions should give you all the clues you need.

1.

As the Word came to prophets of old,
As the burning bush spoke to Moses,
And the fiery coals cleansed the lips of Isaiah;
As the wheeling cloud in the sky

Clothed the message of Ezekiel;
So the Word of fire burns today
On the lips of our prophets in an evil age—
Our sooth-sayers and doom-tellers and doers of the
 Word.
So the Word of the Lord stirs again
These passionate people toward deliverance.
As Amos, Shepherd of Tekoa, spoke
To the captive children of Judah,
Preaching to the dispossessed and the poor,
So today in the pulpits and the jails,
On the highways and in the byways,
A fearless shepherd speaks at last
To his suffering weary sheep.

2.

So, kneeling by the river bank
Comes the vision to a valley of believers
So in flaming flags of stars in the sky
And in the breaking dawn of a blinding sun
The lamp of truth is lighted in the Temple
And the oil of devotion is burning at midnight
So the glittering censer in the Temple
Trembles in the presence of the priests
And the pillars of the door-posts move
And the incense rises in smoke
And the dark faces of the sufferers
Gleam in the new morning
The complaining faces glow
And the winds of freedom begin to blow
While the Word descends on the waiting World below.

3.

A beast is among us.
His mark is on the land.
His horns and his hands and his lips are gory with out
 blood.
He is War and Famine and Pestilence
He is Death and Destruction and Trouble
And he walks in our houses at noonday
And devours our defenders at midnight.
He is the demon who drives us with whips of fear
And in his cowardice
He cries out against liberty
He cries out against humanity
Against all dignity of green valleys and high hills
Against clean winds blowing through our living;
Against the broken bodies of our brothers.
He has crushed them with a stone.
He drinks our tears for water
And he drinks our blood for wine;
And he drives us out of the city
To be stabbed on a lonely hill.

Amos—1963

Amos is a Shepherd of suffering sheep;
A pastor preaching in the depths of Alabama
Preaching social justice to the Southland
Preaching to the poor a new gospel of love
With the words of a god and the dreams of a man

Amos is our loving Shepherd of the sheep
Crying out to the stricken land
"You have sold the righteous for silver
And the poor for a pair of shoes
My God is a mighty avenger
And He shall come with His rod in His hand . . . "
Preaching to the persecuted and the disinherited
 millions
Preaching love and justice to the solid southern land
Amos is a Prophet with a vision of brotherly love
With a vision and a dream of the red hills of Georgia
"When Justice shall roll down like water
And Righteousness like a mighty stream."
Amos is our Shepherd standing in the Shadow of our
 God
Tending his flocks all over the hills of Albany
And the seething streets of Selma and of bitter Birm-
 ingham.

Amos (Postscript—1968)

From Montgomery to Memphis he marches
He stands on the threshold of tomorrow
He breaks the bars of iron and they remove the signs
He opens the gates of our prisons.
He speaks to the captive hearts of America
He bares raw their conscience
He is a man of peace for the people
Amos is a Prophet of the Lord
Amos speaks through Eternity
The glorious Word of the Lord!

Micah
(In Memory of Medgar Evers of Mississippi)

Micah was a young man of the people
Who came up from the streets of Mississippi
And cried out his Vision to his people;
Who stood fearless before the waiting throng
Like an astronaut shooting into space.
Micah was a man who spoke against Oppression
Crying: Woe to you Workers of iniquity!
Crying: Woe to you doers of violence!
Crying: Woe to you breakers of the peace!
Crying: Woe to you, my enemy!
For when I fall I shall rise in deathless dedication.
When I stagger under the wound of your paid assassins
I shall be whole again in deathless triumph!
For your rich men are full of violence
And your mayors of your cities speak lies.
They are full of deceit.
We do not fear them.
They shall not enter the City of good-will.
We shall dwell under our own vine and fig tree in peace.
And they shall not be remembered in the Book of Life.
Micah was a Man.

Religious Art

Much of traditional African art stems from
religious belief. Black Africans, the ancestors of

black Americans, believed in a Supreme Being, the Ultimate Source of Life, even before the arrival of Europeans and their God, or monotheistic belief. But, this Supreme Being was not approached directly; prayers and offerings or sacrifices were directed to the ancestors who would in turn give the blessings and/or intercede with the Supreme Being. It is the ancestors—mythical and real—who are commemorated in wooden masks and statues, bronze heads for altars, and whose representations or symbols embellish everyday household articles and implements.

Who are these ancestors? As indicated above, they were real as well as mythical persons. For example, among the Yoruba in southwestern Nigeria, there is Sango (pronounced Shango), the god of thunder. Sango is thought to have been a real, living ruler in the early history of the Yoruba people, who was deified after his death. Lightning is his magic being performed (for he was a magician) and thunder is the expression of his anger. Among the Bambara, in Mali (fig. 1.2) there is Tyi wara (pronounced Chi wara), the mythical half-beast/half-man who introduced agriculture. Ogun, another Yoruba deity, is the god of iron and war to whom one makes an offering before engaging in the use of metal objects and arms, or today, if one is a believer, before he turns on the ignition of his automobile. The living elder held a special position of influence and respect due to his wisdom and as the link between the living and the deities in the spirit world. Thus, upon his "death" he continued to influence the living and was accorded respect through commemorative rituals. In this sense, there is a continuity of life beginning and ending in the ancestors.

Once in the new world, the captive African could continue to honor his traditional beliefs under the guise of Christian Catholicism (in South America and the Caribbean) but those captives who came under the influence of Protestantism were denied this right. As evidenced by the Haitian Revolution in 1791, black gods were powerful and effective even in a new environment.

In the American colonies, most plantation owners propagated the puritan ethic and Protestantism in which slavery was sanctioned because of its missionary zeal to bring the gospel of Christ to the pagan slaves. The teachings of Christianity, used in this way, effected docility and obedience in the slave.

The slave responded to this foreign notion of Protestant Christianity by personalizing it in verbal expression. Visually, he could not do this because Protestants had always frowned upon religious imagery in the church as being worldly. Thus, there was little opportunity for the slave to express his creativity in graphic and plastic art for the church as he had done

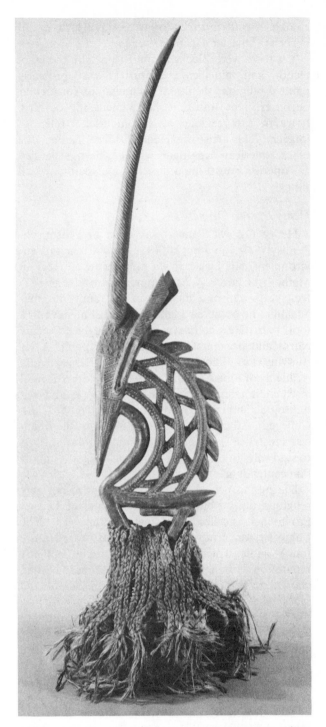

Figure 1.2. Bambara People, Mali, "Tyi Wara Headdress." Wood, raffia heigth 22 9/16". Courtesy of Illinois State University Museums, Normal, Illinois. Photo: David L. Kuntz.

in Africa where religion and art were inseparable. Moreover, the slave was afforded few opportunities to carve on his own or his master's time. However, he could be taught skills which trained him to be, for example, a typesetter, furniture maker, builder of the

church, metal smith, or other trades which would benefit the master's income.

Yet there were Blacks in the fine arts in the eighteenth and nineteenth centuries who probably painted religious themes as commissions for secular purposes. Not until the late nineteenth century, however, is there a black artist committed to religious imagery. This artist was Henry Ossawa Tanner, the black American expatriate, who has been acclaimed as America's most important religious painter of all times.

Henry Ossawa Tanner

Henry Ossawa Tanner was born in Pittsburgh, Pennsylvania, on June 21, 1859, into a religious environment. His father was a minister in the African Methodist Church. When Tanner was twelve or thirteen years old, and living with his family in Philadelphia, he observed a landscape artist at work in a local park. He was fascinated and moved to secure paints and brushes so he, too, could paint. After studying with Thomas Eakins at the Pennsylvania Academy of Fine Arts, and undertaking other formal instruction later in his youth, Tanner established himself as an artist. He also instructed art at Clark College in Atlanta, Georgia. In 1891 with the financial assistance of a benefactor, Tanner went to Paris to study art. In those days, Paris was the most important center of art in the world.

During this period his paintings included not only religious subjects but also genre[11] in which his teacher Eakins had excelled. One such painting was "The Banjo Lesson," now at Hampton Institute, Hampton, Virginia, which could have established Tanner's reputation as a superb artist in this area if he had chosen it. The painting is of two subjects—an old black man and a young black boy who is seated on the former's lap and learning to play the instrument. Tanner portrayed his black subjects with sympathy and objectivity as no other painter had done before. But he chose not to devote his artistic energies to genre painting; he chose instead to paint and interpret scenes from the Bible.

The subjects Tanner chose to paint are obvious from their titles: "The Annunciation," "Christ Before the Doctors," "The Good Samaritan," "The Wise and Foolish Virgins," and "Daniel in the Lion's Den" to name but a few. Although "Daniel in the Lion's Den" was not his first painting of a religious subject, it was his first to be prize-worthy. This painting was exhibited in the Paris Salon of 1896 and won an honorable mention; later it was awarded a silver medal at the Universal Exposition in Paris. In the following years there was a prize-winning reli-

gious painting by Tanner in each Salon competition. A copy by Tanner of the original "Daniel in the Lion's Den" is reproduced in figure 1.3 (along with a color slide).

If this painting strikes you as familiar, it is because the dramatic contrasts of light and shadow may remind you of similar paintings by the seventeenth century Dutch artist, Rembrandt. But Tanner went beyond Rembrandt's style to develop one of his own. There are elements of Impressionism,[12] and Post-Impressionism,[13] which still prevailed up to the turn of the century, in the loose, broad brush strokes of color and, as time passed, in the less sombre colors he used. But Tanner was not interested in delightful impressionistic scenes of the bourgeois at play or in isolating geometric components—cubes, cylinders and spheres—in nature. He was more concerned with the human qualities of biblical personalities, in de-sanctifying them and making them human beings with whom one could identify. His subjects were always based on reality and not on fantasy. For example, he observed and sketched lions in the Jardin des Plantes in preparation for "Daniel in the Lion's Den." He also traveled extensively in North Africa and the Holy Land where an old Yemenite Jew posed for the Nicodemus in his "Christ and Nicodemus on the Rooftop."

Like the painters of the Renaissance who placed their religious subjects in contemporary Italian settings, Tanner returned his subjects to the actual locations of the events, giving them an added dimension of believability.

"The Return from the Crucifixion" (1936) was Tanner's last painting. The small group of figures is seen in a bright, broad expanse of landscape. Christ's mother leads the group down the hill after the event of the Crucifixion. None of the heads of the figures is finely modeled; the loose strokes of color, placed as they are, force the eye to complete the forms. In this painting, Tanner reaffirmed an earlier statement he made, "Religious pictures must measure up to the requirements of good art or they can never command

11. *Genre* is the portrayal of scenes from every day life.

12. Impressionism is a movement that began in the 1860s in Paris, France. Its members—Claude Monet, Auguste Renoir, Henri de Toulouse-Lautrec, Edouard Manet and others—painted landscapes and figures, in an attempt to capture the first impression of nature, and this in relation to changing light.

13. Post-Impressionism was further experimentation that grew out of Impressionism. Its artists—Georges Seurat, Paul Signac, Paul Gauguin, Paul Cezanne and Vincent Van Gogh—represent diversified explorations which were scientific, expressionistic, and subjective. Representative works of these artists are in most general art history books and in the major museums.

Figure 1.3. Henry O. Tanner, "Daniel in the Lion's Den," ca. 1916. 44 1/4″ X 50″. Courtesy Los Angeles County Museum of Art, Mr. and Mrs. William Preston Harrison Collection.

respect."[14] He was always conscious of good composition and good taste which is why we recognize, even today, his works as masterpieces of fine art.

After Tanner

The painter William H. Johnson (1901-1970) spent most of his active years[15] painting and drawing land- and seascapes in Norway. His style was then expressionist.[16] He returned to the United States in 1939 and undertook a new direction in his method and style of painting. He adopted the "naif" or primitive manner—flat, two-dimensional compositions with strong, brilliant colors—and his subjects were now biblical. Later works portrayed black *genre* and

history. Johnson was not particularly a religious person; however, his paintings of this period manifest warm, religious sentiments. It is said that he recalled impressions of his childhood when he attended church regularly with his family and learned Bible stories and spirituals. In "Come Unto Me, Little

14. Evelyn Jackson Rilla, *American Arts,* Rand McNally & Company, Chicago, 1928, p. 211.

15. Johnson was hospitalized in a Long Island mental institution in 1947. He remained there until his death in 1970.

16. Expressionism can occur in any period since the personal emotions of the artist are most important. However, as a movement, it began in Northern Europe and from there spread to Germany in the early 1900s and later over the continent and to America.

Children," ca. 1939 (fig. 1.4) and others from this period of the religious series, Christ and the accompanying figures are black people. Christ is placed slightly off center, but He is obviously the central figure and is proportionately larger than those who surround Him. Also, the women and children are clothed in the style of current fashions of the 1930s.

Figure 1.4. William H. Johnson, "Come Unto Me Little Children," ca. 1939. 15 3/16″ X 15 3/4″ Courtesy of National Collection of Fine Arts, Smithsonian Institution, Washington, D.C.

Romare Bearden (b. 1914) in later years became a leading American artist. "He is Arisen," 1945 (fig. 1.5) was painted in his youth. The style is modern "cubistic,"[17] and already one can see the direction Bearden was to take in his later works: there are strong profiles which will become cut-out and painted African masks in his *collages*. There is great tension in this painting—the strong diagonal lines in opposition to one another and the many views of the resurrected Savior's head. Bearden was always an advocate of modern trends in art and felt the black artist should paint that which he knows best, his own experiences as a black person.

Allan Rohan Crite (b. 1910) has had a long productive career in art which began around the time of the Harlem Renaissance. His earliest exhibitions were held in the late 1920s. Crite's career has been devoted to portraying black people, and it includes genre and religious themes in the representational style.

"Adoration of the Magi," ca. 1936 (fig. 1.6), an ink drawing, demonstrates his talent in rendering human figures and his early attention to personalizing the religious experience. Black viewers can identify with the Virgin, Christ, wise men and other attendant figures in this drawing. His Christ is of the darker race in "City of God," an altar mural painted in St. Augustine's Church in Brooklyn, New York.

Crite's work is included in *Brush Drawing Meditations on the Prayer of Consecration* which was published in 1948. An exhibition of his religious drawings and prints was held in Boston in 1968. He has illustrated numerous books and pamphlets on religious subjects. A writer in his own right, his "Nativity of Jesus Christ," which he also illustrated, was printed in 1969. The narrative is written in English and Spanish reflecting the multi-ethnic neighborhood (black, white, and Puerto Rican) he lives in in Boston.

Horace Pippin completed the "Holy Mountain, III," in 1945. It was begun during World War II, an event which distressed this former soldier who had been severely wounded in the First World War. By this time he had completed paintings memorializing his wartime experiences. Peace. Where was it, when would it come? According to his biographers, Rodman and Cleaver, the artist found the prophecy of peace in the Bible which inspired him to affirm his faith in this painting. "Isaiah, XI, the 6th verse to the 10th gave me the picture, and to think that all the animals that kill the weak ones will Dwell together like the wolf will Dwell with the lamb, and the leopard shall lie down with the kid and the calf and the young lion and the fatling together. . . ."[18] He was aware of the devastation of the war in Europe and racial troubles in America's South. But, Pippin was confident there would be a peaceful future for mankind. (fig. 1.7)

Among the sculptures created by Carroll H. Simms (b. 1924) is "Christ and the Lambs," (fig. 1.8) which was commissioned in 1956 and it is a nine-foot high hammered bronze plaque which is mounted on the facade of the Tile Church, Coventry, England. The image of Christ, an expressionist rendering, projects from the surface of the plaque in low relief. The artist says the sculpture was inspired by a spiritual, "Listen to the Lambs" by Nathaniel Dett.

17. Cubism was initiated around 1908 and was the conscious breaking down of nature into its basic geometric components. The final aim of this movement was to reorganize these fundamental forms into new combinations. Pablo Picasso and Georges Braque are recognized as the leaders of this movement.

18. Selden Rodman and Carol Cleaver, *Horace Pippin, the Artist as a Black American*, Doubleday & Company, Inc., Garden City, New York, 1972, p. 85.

Figure 1.5. Romare Bearden, "He Is Arisen," 1945. Watercolor and India Ink, 26″ × 19 3/8″. Collection, The Museum of Modern Art, New York. Advisory Committee Fund.

Figure 1.6. Allen R. Crite, "Adoration of the Magi," ca. 1936. Ink Drawing 13" × 20 1/2". Courtesy of Fisk University, Nashville, Tennessee. Photo: J. Thomas Clark.

Figure 1.7. Horace Pippin, "Holy Mountain III," 1945. Oil on canvas, 25" X 30". Courtesy of Hirshhorn Museum, Smithsonian Institution, Washington, D.C.

39

Figure 1.8. Carroll H. Simms, "Christ and the Lambs," 1956. Terra cotta, 14″ × 8 1/2″. Courtesy of the artist.

Francis of Assisi, an Italian monk of the Middle Ages (ca. 500 A.D.-450 A.D.) who founded the Franciscan Order, is the subject of a terra cotta (fired clay) sculpture by Joseph Kersey (b. 1908). The artist has captured the monk, who was elevated to saint-

hood, in an attitude of serenity, and portrays him holding a pigeon, symbol of his preaching mission. (fig. 1.9)

Figure 1.9. Joseph Kersey, "St. Francis," ca. 1950, terra cotta, 16″. Courtesy of Joseph Kersey and Mr. Adolphus Ealey, Barnett-Aden Collection, Washington, D.C. Photo: Anacostia Neighborhood Museum, Smithsonian Institution, Washington, D.C.

David C. Driskell (b. 1931) is the son of a clergyman, who like Henry O. Tanner was exposed early to the Protestant religious tradition. Like William H. Johnson, Driskell is not primarily a religious artist, but one who has been inspired to create works of art on religious themes. "Jonah in the Whale," (fig. 1.10; color slide) reflects this religious inspiration, but it is in the modern style which characterizes Driskell's paintings and prints on secular themes.

The whale and Jonah are identifiable in composition. Wavy lines suggest the sea. These and other elements, like the calligraphic lines inside the whale's mouth, reflect Driskell's exposure to and experiences in Africa: traditional tribal sculptures and Arabic calligraphy, the latter of which one finds sculpted on house facades where Islamic culture is pervasive. He

Figure 1.10. David C. Driskell, "Jonah in the Whale," 1967-68. Color woodcut, 16″ X 12″. Courtesy of the artist. Photo: John Simmons.

demonstrates in this work, that religious feelings can be realized in the prevailing style of expression, which the artist then personalizes.

Since the nineteenth century Blacks Africanized traditional religious music with, for example, syncopated rhythm and "call and response." However, statuary and paintings depicting Christ and the Saints remained unchanged, with few exceptions, until the late 1960s.

The revolutionary idea of a black theology necessitated transformation of religious imagery. Black artists were commissioned by many churches to effect the changes, to create images with which a black congregation could identify. For example, in Detroit, Michigan (scene of one of the country's most devastating race riots in 1967) Glanton Dowell painted "Black Madonna and Child," for the renamed church, Shrine of the Black Madonna.

Visual expressions of Christ as a strong, persevering black man include Alvin Hollingworth's "The

Figure 1.11. Murray DePillars, "Black Christ." Pencil drawing. Courtesy of the artist.

Prophet" series, and Murray DePillars' "Black Christ" (fig. 1.11). The broad nose, thick lips, and kinky, Afro-styled hair identify DePillars' Christ as a black man. The traditional thorny crown is replaced by a thin wire headband which can be interpreted as a symbol of strength which overcomes injustice, persecution and defeat. According to the artist, "If we are to believe the life Christ lived, the pictures that were painted of him just don't fit the image."

In response to the movement of black awareness, particularly during the last decade, black artists have personalized religious expressions to make emphatic statements on blackness. In this context Christ is portrayed as a soul brother.

Slides

Figure 1.3. Henry O. Tanner, "Daniel in the Lion's Den," ca. 1916 (copy of the original by the artist); Los Angeles County Museum of Art, Mr. and Mrs. William Preston Harrison Collection.

Figure 1.10. David C. Driskell, "Jonah in the Whale," 1967-68, color woodcut, 16″ × 12″; courtesy of the Artist; Photo: J. Thomas Clark. Slide: J. Thomas Clark.

ART OF THE FOLK

There are many different kinds of folk songs, including that amazing contribution of Afro-Americans to American culture, the spirituals or "sorrow songs" as W. E. B. DuBois called them. Others you will read about and hear are: field calls, hollers, ring shouts, work songs. One of the authors[1] of this text has written this next section on folk music and some folk tales out of her own experiences.

As a child in southeastern North Carolina, I spent many happy days in Seventy-First Township with my grandparents. The McPherson homeplace was situated virtually in a child's paradise. There were wagon trails and wooded paths, springs and even a campsite said to have been used ever since the Civil War. In fact, the original church structure, built on a Yankee campsite in front of this property in 1865, still stands today. I often heard my grandparents speak of the days when Blacks in this community were invited to sit in the gallery of this church and sing the "old" spirituals. Together went friends and relatives to sing what they had learned as children. "I b'lieve I'll Testify," "Gimme dat ol' Time Religion," and "Nothin' but de Blood" ("I Know It Was the Blood")[2] were favorites. Without hymn books or instrumental accompaniment they moaned, groaned, and hummed out their musical legacy to the congregation at "the Campground" as it was fondly called.

Example 5

> B'lieve I'll testify while I have a chance,
> B'lieve I'll testify while I have a chance,
> B'lieve I'll testify while I have a chance,
> I may not have this chance anymore.

Example 6

> Gimme dat ol' time religion, Gimme dat ol' time religion,
> Gimme dat ol' time religion, It's good enough for me.
> It was good for my dear mother
> It was good for my dear mother
> It was good for my dear mother
> It's good enough for me.

Example 7

> I know it was de blood
> I know it was de blood
> I know it was de blood
> Saved Me.
> One day when I was lost, Jesus died upon the cross.
> I know'd it was the blood saved me.

Many years, in fact, generations passed between the time these spirituals were heard and learned by my grandparents in their youth and the time they sang them to me; yet, they were sung and remembered in a fashion similar to that of their antebellum ancestors. In the days when my grandparents were young, few received formal education, so what was learned was learned by ear and passed down from parent to child. In fact, the whole way of life of these people was based on a culture that had maintained itself by word of mouth. Very often as a child I used to ask where a particular sign or saying came from and the answer was always the same, "I don't know. I always heard it that way."

No one needed a hymn book to participate in singing in church. They had heard the text for so long it was almost a part of them. One didn't have to go to church to hear and learn the words and melodies. Mothers sang them as they scrubbed clothes on a washboard behind the house in tin tubs filled with rain water; touched up their freshly washed clothes with the smoothing iron (the old irons they used to set on a hot stove to heat) on a makeshift ironing board which was made by placing a board between two straight chairs; or pumped water before preparing the evening meal. And, fathers could be heard lifting their voices as they tilled the soil to plant grain, shucked corn,[3] or pulled fodder.[4]

1. Marian Brown, Professor of Humanities, Junior College at Jacksonville, Florida.

2. Example 5. "I b'lieve I'll testify." Example 6. "Gimme dat ol' Time Religion." Example 7. "Nothin' but de Blood." Provided by Vernon L. Smith. (On accompanying cassette)

3. Shucking corn referred to pulling off the outer covering from the ears.

4. Fodder—after all the ears that were needed were pulled from the stalks, and the stalks turned brown, the remaining dried stalks and leaves were pulled off and used as food for cattle.

This kind of work did not require a great deal of thought, only strong arms and backs. The people had done it for so long, it just came naturally. So while "going through the motions" there was time for reflection and very often what was sung showed a definite attitude about themselves or their particular situation, as the following text illustrates.

Down on me, Down on me,
Seem like everybody in this whol' wide worl'
Is down on me.[5]
 (repeat twice)

In actual church services the old spirituals often featured a leader answered by a group and were accompanied only by hand clapping, shakers, or scrapers, and feet rocking back and forth on the wooden church floor. Example 8, "Talkin' 'bout a good time,"[6] was taped during a recent church service; yet it was sung and accompanied by hand clapping and foot rocking in the old traditional style. The combination of different accented beats in the hand clapping and foot rocking patterns results in polymetric percussive accompaniment.

Example 8

Talkin' 'bout a good time, we're gon' have a time.
Talkin' 'bout a good time, we're gon' have a time.
Talkin' 'bout a good time, we're gon' have a time.
Talkin' 'bout a good time, we're gon' have a time.

When I see King Jesus, we're gon' have a time.
When I see King Jesus, we're gon' have a time.
 (repeat twice)

When I was a child, spirituals were sung in my church only on the First Sunday and then only during Communion service. At this time books were put away and the deacons or their wives led the congregation in singing the spiritual melodies sung by their parents long ago. It was almost as if we as a body entered into another spiritual plane when these songs were sung. The texts of these spirituals were stripped to the bare essentials in order to present a message directly and matter of factly. Consider such statements as "I Know it was the Blood saved me" and "I promised the Lord I would hold on." Because they contain only those words essential to the imagery they wish to create they become highly dramatic in their simplicity. Consequently the church literally "rocked" when these kinds of spirituals were sung.

"I Promised the Lord,"[7] is one of the spirituals I remember from the communion services of my childhood. I have heard it sung in Baltimore, Maryland, Durham, North Carolina, and Jacksonville, Florida almost as it was sung when I first heard it. This taped version is sung in shouting style, characterized by its moderately fast tempo, highly rhythmical orientation, and percussive quality. Traditionally, large groups of individuals danced the shout during the singing of this category of spiritual.

Example 9

I promised the Lawd that I would hold on, hold on, hold on.
Oh, I promised the Lawd that I would hold on,
Till he meet me in Galilee.

My Lawd, he done what he said, yes he did, oh, yes he did.
He healed the sick and he raised the dead.
Yes he did, oh, yes, he did.

Oh, if you don't believe I been redeemed,
Yes my Lawd, Oh, yes, My Lawd.
Just follow me down to Jordan's stream.
Yes, My Lawd, Oh, yes, My Lawd.

Another feature of the old spiritual singing style was free improvisation of melody and text. Within the given outline of a hymn tune or spiritual melody the congregation shifted back and forth between high and low tones, manipulated vocal lines by using a variety of ornamental devices, and interjected various syllables, words, and phrases. The overall effect was that of singing in harmony, while in fact the texture is accurately described as heterophony. A favorite hymn often sung in this fashion is "Jesus Keep Me Near the Cross."[8] By observing the printed version of this hymn and listening to it, we can see the liberties taken with melody and rhythm during performance.

Example 10

Jesus, keep me near the Cross,
There a precious fountain
Free to all—a healing stream,
Flows from Calvary's mountain.

In the Cross, in the Cross,
Be my glory ever;
Till my raptured soul shall find
Rest beyond the river.

5. "Down on Me," *Been in the Storm So Long*. Side II, Band 1, FS 3842, Folkways Records, New York.

6. Example 8. "Talkin' 'bout a good time," St. James Holiness Church, Durham, North Carolina. (On accompanying cassette.)

7. Example 9. "I Promised the Lord," St. James Holiness Church, Durham, North Carolina. (On accompanying cassette.)

8. Example 10. "Jesus Keep Me Near the Cross," New St. James Baptist Church, Jacksonville, Florida. (On accompanying cassette.)

Many times I walked the paths and trails-turned-roads on our home place; these were almost impassable by cars, but were used by all who resided in the area as they walked to work at the railroad, to catch the jitney to shop in town, and to visit surrounding neighbors. Along these paths I learned to hunt "High John de Conqueror" with my Grandmother Janie who wore it for rheumatism pain, looked for bitter root with my Grandfather Fred as he gathered herbs to make his annual spring tea, learned to plait wire grass[9] that grew all over the place, found brush brooms[10] for Grannykin, and gathered wild bullices[11] and sassafras to make grape wine and tea. These things were not different in kind from what my grandparents did as children. Just as they maintained the centuries-old music tradition and folkways of their fathers, my cousins and I maintained much of what we heard in the folklore they told us. We sang when we jumped rope as they had sung:

The rabbit hop, the rabbit jump
The rabbit stole my turnip top.
He jumped so high, he touched the sky.
He never came back 'til the 4th of July.

We also played such highly physical ring games as "Little Sally Walker" and "Mr. Postman Is Dead." We clapped, jumped, wiggled, and used many dance steps, some old and some new, as we kept time with the rhythmical beat of the words of the game. A very old ring game that is still played in the rural South is "Johnny Cuckoo." The lady is usually singing it in the same manner as her mother did, using performance practices maintained in the old spiritual tradition.[12]

The physical setup of my maternal relatives' "homeplace," as it is still affectionately called today, was in fact similar to a plantation, but on a smaller scale. The land was deeded to my great-grandmother by her father. She settled here after marriage; so did all her children and their families on tracts of land large enough for a home and whatever farming, if any, they wanted to do. So here we have the big house centrally located, in this case inhabited by mother and father, and the outlying homes of the children, all within calling distance.

It was here that I first heard sounds that I have since come to realize were similar to field hollers used during and immediately following slavery. My cousins and I hollered to call each other to play and adults hollered to relay messages from one house to another since there were no phones on the place at this time.

During slavery similar kinds of vocal sounds were used as a means of communication, a practical solution to the problem of getting around the master's rules which forbad physical intermingling and verbal exchange while working. Hearing another voice in the distance and the act of answering that voice helped create a sense of shared experience. Although they could not talk freely, they knew someone else was there—that they were not alone. In time the numerous seemingly wordless, meaningless field hollers became a medium for expressing personal statements about a feeling or a particular event.[13] Some have words while others may be wordless.

Call	Response
Woh hoo, woh hoo!	*Yeh hee, Yeh hee!*

A wordless cry such as this may have been used by the slaves to establish a feeling of community in the expansiveness of the fields as they worked.

Father's field call contains both wordless sounds and a message.[14] It was used to notify the workers that it was time to come in from the fields. At the close of the call you can hear the caller say ". . . Come on!"

Field hollers were not a category used only by adults as they worked. Children had their own special calls.[15] These have no words.

Each of these examples is distinguished by the way the voice is manipulated in producing sound, specifically by the usage of sliding tones, vocal turns, and a variety of vocal timbres such as throaty, husky, guttural, moanin', groanin', and hummin'.

Hollers and cries are not the only kinds of secular songs preserved from the slave culture. In the fall of 1972 a segment of CBS news, "On the Road with Charles Kuralt," showed a gang of "gandy dancers" or railroad workers in a section gang as they lined the track of a railroad. Although these workers were pictured in a modern setting, their usage of the work song concept was reminiscent of the African cultural heritage. Throughout the South as in Africa, singing

9. This grass grew in thick clumps. Its blades were long and coarse, and we plaited it very easily.

10. In the old days people didn't cultivate grass in their yards. What they did do was keep their yards cleanly swept. Every home had brush brooms which were nothing more than dried tree branches. The cleanly swept yards became blackboards as children practiced their letters and arithmetic tables and drew pictures of all their favorite storybook characters there.

11. Bullices are wild grapes.

12. "Johnny Cuckoo," *Been in the Storm So Long.* Side II, Band 4, FS 3842, Folkway Records, New York.

13. Field call, *Negro Folk Music of Alabama* (Secular). Side II, Band 5, FE 4417, Folkways Records, New York.

14. Father's Field call. Side II, Band 6, Folkways FE 4417.

15. Children's call. Side II, Band 7, Folkways FE 4417.

DAVID N. MIELKE

while working was a means of helping to pass the time. In work that depended upon large numbers of individuals it was necessary that everybody work together and move at the right time in order to accomplish the given task. Rhythmical singing helped synchronize movements associated with the particular work being done.

The work that slaves and later the freedmen did made it easy to continue the old pattern. Work that used large numbers of men—lining railroad tracks, cutting wood, even road gangs and working on docks—made it easy to transfer work rhythm and movements of the men into song. For example, the act of cutting wood produces a steady recurring sound. Two groups of men doing this kind of work produce a "double-ax cut" which becomes excellent accompaniment for words such as those found in the following example:[16]

> . . ., she won't write to po' me,
> Alberta, she won't write to po' me,
> She won't write me no letter,
> She won't send me no word,
> It makes a long, oh long-a time man,
> Oh, Lawdy feel bad.

> Captain George, he got the record and gone,
> Captain George, he got the record and gone,
> Captain George, he got the record and gone,
> Oh Lawdy, Lawdy,
> Captain George, Oh George, he got the record,
> Oh Lawdy, and gone.

Work songs such as this contain ideas from numerous sources: religious songs, blues, even various other work songs. Whatever the work gang overheard that was interesting was very likely to be woven into their singing. They commented on current events and even talked about the boss man, as in the above example. In addition, the lyrics very often became personalized, as in the line "Alberta, she won't write to po' me," which makes her imprisoned lover feel bad.

The "gandy dancers" from the CBS news segment are the last remnant of an old tradition. Before the advent of extensive technological advancement in this area men tamped the ties, graded the beds, laid and lined the tracks. A caller was essential to this kind of work and the work song it fostered. The captain of the crew gave the orders but it was the caller who saw that the men carried them out. The success of the caller or crew leader at his job was determined by his ability to improvise his text. He had to be talented in puting together a variety of ideas that kept his crew interested and ensured the appropriate physical and vocal response. He not only told everybody

what to do but also when to do it, as the following text illustrates:

> All right, captain want to line the track. Hah!
> Hold 'em right there!
> Get you six bars! Put two bars on this side over here!
> All right, shake it east.[17]

"O Lawd, Don' 'Low me to beat 'em"[18] is a hollerin' song. Unlike the previous work song, hollers grew out of and accompanied individual field labor. The rhythm of the holler is very free; its text is more introspective and the worker is given greater opportunity to display the ability to manipulate his voice. As a result, hollers feature extensive moanin', groanin', howlin' and shoutin'.

> Oh, Lawd, they don' 'low me to beat 'em;
> Got-a beg along.

> <u>Git up, Rhoady! Gee back there, Dempsey,</u>
> <u>I don' want to kill you this mornin'.</u>

> Oh Lawd, they don' 'low me to beat 'em;
> Got-a beg along.

> <u>Tighten up a little bit!</u>

> Oh Lawd, if my good woman had-a been here, good
> pardner,
> I wouldn't a-been here stumblin' and fallin', tryin' to
> make it back home.

> <u>Git up out that mud there!</u>
> <u>Look out there; I'll knock you to your knees torectly!</u>

> Oh, Lawd, I'm goin' back, good pardner, one day 'fo'
> long.
> I don't need no tellin', already know.

Note how the singer is directing himself to two different ideas at the same time. The sung portions are reflections on his relationship to the animals he is in charge of. He complains that he cannot exert force in getting them to respond as they should. He also comments on being separated from his lover. The underlined, shouted portions are directions to the team of work animals. Because of the force in which these are stated they could be categorized as epithets! Like work songs, hollers often become vehicles for expressing very personal feelings.

16. Example 11. "It Makes a Long Time Man Feel Bad," L 1 *Anglo-American Ballads*. Side B, Band 5, Archive of Folk Song of the Library of Congress.

17. Harold Courlander, *Negro Folk Music U.S.A.* (New York: Columbia University Press, 1963), pp. 95-96.

18. Example 12. "O Lawd Don' 'Low me to beat 'em," L 1 *Anglo-American Ballads*. Side B, Band 6, Archive of Folksong of the Library of Congress.

In 1948 my parents purchased a huge tract of land adjoining my great grandmother's acreage, built a home there and for six years Seventy-First Township was my home. My cousins and I hunted mud puppies and crayfish, discovered that wasp larvae ate dirt, saw A'nt Lula "tote" wooden buckets of water on her head from the spring, saw Granny Rena make lye-soap, watched Unca Bubba kill hogs and "put up"[19] the meat, smoked rabbit tobacco, played with doodle bugs, hunted honeycombs, found them and were stung, learned to gravel for potatoes from Poppa Fred's garden, and pull fodder for the animals, listened to folk tales and practiced many folk cures that we learned from ageless stories. A cure for warts was to pick them, let the blood fall on kernels of corn, then feed the corn to the chickens; this would make the warts disappear. We also learned that we could get rid of a stye on our eye by talking about it to someone. (It would go away because the person you talked to would get the stye.) A boil would disappear when marked with a cross; cobwebs would stop a bleeding wound and regular old chewing tobacco drew poison from insect stings, and when we gave each other measles and "chicken pops"[20] our grandmothers tied persimmon leaves to our limbs to draw out the bumps and laid mullein[21] leaves on our foreheads to break the fever.

During the late 1940s and early 1950s a polio epidemic hit much of the United States and parents were driven almost to the point of hysteria. Except for schools, public places were off limits to underage children. My great-grandmother, Grandma Lawya as she was called, was with us at the time and cautioned my mother not to worry for "she had everything under control." Her charm for warding off polio and all other germs was a small hand-made sack and sometimes a baby sock filled with camphor gum and asafetida worn around the neck. Armed with this, not only was I guarded against any infections, but school friends and playmates as well, especially when the sack was filled with fresh ingredients. Many a morning at school, I helped my classmates hunt for the source of the stench in the classroom when it was really my sack they were smelling. Nevertheless, as long as I was so armed, no days were missed from school because of illness.

The other all purpose cure we learned to count on was balm of gilead (we called it balm of gillum). My Granny Rena had a balm of gilead tree in her yard from which she got leaves to make this ointment. Although the smell was quite strong I learned to have great respect for its healing properties. Seldom a day passed that I didn't call out, "Poppa Fred, get the balm of gillum" as I was stung by "wasts"[22] and bees or stepped on red ant hills barefoot. In other words,

it ran neck and neck with Watkins liniment for first place in the cure-all category. Now everybody knows no household was ever without at least one bottle of this potent fluid. It was used to rub the sprains of cattle, and arthritis and rheumatism pains of people; you could even take a drop or two on sugar for various stomach disorders. The man who had the distinction of selling Watkins products deserves a place in the hall of fame. He traveled up hills and down valleys and wagon trails to peddle his body talc, cosmetics and patent medicines and to all who purchased his wares he was "The Watkins Man." Surely, a southern tradition.

There were many things you had to learn while growing up in the country—how to shoot a juvember,[23] skin a squirrel and shimmy up trees, cross a swamp on floating logs and, above all, how to hold back the tears when stung by a tobacco worm[24] when your playmates were looking. Very important, you had to learn all the signs and all the "hanty"[25] crooks and crannies and spirits to avoid. We learned them all—Rawhead and Bloody Bone[26] and all the others who had lurked in this vicinity for generations. There were houses with their very own special spirits who snuffed out lamps and snored and made so much racket at night that it was impossible for anyone to live there for more than a few months. You could easily tell when a family had discovered haunts in a house because horseshoes and new pieces of lumber and new steps would be seen going up.[27] There were even haunted trees like the enormous century-old oak, in front of the big house, that was frequented by a cap'n on a white horse.

The homeplace and my parent's acreage were bound in the rear by a creek. The two main roads which led into the property were to the right and front of my father's place and to the left and front of my great-grandmother's house. You could take your pick of entrances. One road passed the graveyard and the other was surrounded by heavy thickets of trees

19. Meat was preserved by packing it full of salt and pepper. It was then placed in a smoke house to dry out or "be cured."

20. Our name for chicken pox.

21. An herb with medicinal properties, it grew around every back door in the country.

22. Our pronunciation of wasps.

23. Sling shot.

24. These worms were vicious looking and had a vicious sting. They were found on tobacco growing in the field and could be as long as three inches.

25. Haunted.

26. I don't know what it was. We just knew it was something to avoid.

27. There is a saying that "hants" will not cross new lumber or horse shoes.

47

and underbrush. I remember well how my heart always beat faster when we traveled the latter. People were always saying it was hanty. Sometimes you could feel the car give in to extra weight as spirits stepped up on the running board to get a lift down the road.

The graveyard I mentioned housed four generations of family. It was nearer my Granny Kin's house and if you were lucky you could sit on her porch at night and see "lights" as they rose and fell among the pines on the hill. These lights were taken seriously for they were signs of those who had gone on. One time my Uncle Narvis was walking home late at night through the graveyard and a spirit took him by the hand and held it till he got to the edge of the field in front of his house. They had to put him to bed when he got home.

There were so many signs it's a wonder anybody learned them all. A shivering owl near your house at night and a howling dog forewarned death; a knock on the door by an unseen hand was a bad omen, someone was surely going to die; if you swept the yard after dark or washed on New Year's someone in your family would die. Even dreams yielded signs to be aware of. Muddy water, especially if you were in it, was a sign of trouble; fire meant that you would get in an argument; to dream of eggs foretold disappointment; and nakedness and young babies meant death. Today dreams are looked up in a dream book and the numbers they symbolize are given to the numbers runner. It is said that numbers that are dreamed have a higher chance of being a hit.

Our grandfathers went by the signs to plant their gardens. After the full moon was the best time for planting vegetables that sprouted above the ground, and after shelling peas or butter beans, the hulls were put in the road or in a path where they could be trampled on so the vines would continue to bear. The best time for killing hogs was also after the full moon. We were always conscious of the signs when we got teeth pulled. The lower the signs were in the body (according to the ruling periods of the Twelve Zodiac Signs), the less the bleeding, so the best time to have teeth pulled was when the signs were in the feet. The moon and stars figured so heavily in the lives of these people, few houses were ever without a farmer's almanac. People traveled for miles around to get one. Some people depended on their corns and rheumatism pains just as heavily. If their corns ached or "rheumatize" acted up the weather was "sho 'nuf" gonna get bad.

People used to do a lot of visiting in those days. A favorite time of ours was evening, when we'd gather 'round our grandparent's chimney and maybe place

sweet potatoes or "ground peas"[28] under the hot coals to bake slowly as we listened to tales of hants. The following story was one of my favorites. It's true. The young man in the story was my grandmother's brother.

* * * * *

Sheffield came home late one night and laid crossways on the bed with his feet resting comfortably on the cool wooden floor. The house he and his family lived in was well known throughout the township. It was haunted and everyone knew it. At night, few who slept there rested comfortably—dishes rattled, pots and pans fell and softly falling footsteps could be heard all over the place. His sister, Jane, often spoke of how she feared suffocating during the night because she burrowed herself under mounds of bed covers, regardless of the temperature, to escape being dragged from her bed by night visitors. This particular night for Sheffield would be one he'd not soon forget. As he lay on the bed, he heard footsteps coming nearer and nearer. The sound they made resembled someone walking in stocking feet. He lay still, too scared to jump up and run or even call out for someone to "light the lamp." The footsteps finally reached his bed and stopped where he thought was directly in front of him. Then he felt something like a weight being placed on first one foot then the other. Whatever or whoever it was was deliberately standing on his feet. The weight was heavier than anything he had ever felt, and he could not for the life of himself budge. Finally, the lump in his throat moved down a little and he hollered for help. His father, mother and all the children quickly ran to see what all the "racket" was about. They found Sheffield on his bed unable to move. His feet and legs would not budge. Paralyzed! In those days, every community had an Auntie, as everyone called her, who knew cures for all ailments. The lady in this position was respected by young and old, black and white. Her talents were many. She delivered babies, talked fire out of burns, nursed the sick and often helped wash and lay out many of those she had grannied as they came into the world. Aunt Kate rubbed Sheffield with mullein leaves, balm of gilead salve, made him a sack to wear around his waist filled with High John de Conqueror, and rubbed him in liniments of all kinds, but his legs and feet refused to go.

Finally, one day Peg came along and said "there ain't but one thing can hep this boy and it's buzzard oil." Just the thought of this made Sheffield sick to his stomach. Buzzards ate carrion so they had to smell like carrion especially if they were cooked and

28. Peanuts in the shell.

48

that's the only way that oil could be had. But Poppa John was getting mighty "tard"[29] of going 'round the neighborhood looking for a cure; besides he needed the strong backs and arms of every one of his children to help him in the field. In those days, buzzards were plentiful. You could look up mos' anytime and see one flying 'cross the sky. Lucky for Sheffield. Had this happened today, he might still be setting in a wheel chair.

Anyway, Poppa John shot the buzzard and cooked him in the big black pot Mamma Hattie used to boil her clothes in when she washed. The stench was everywhere, and all who knew them came to see the wonder that the buzzard oil was gonna do. They rubbed Sheffield down and put hot poltices on his legs and feet and sho 'nuf, he walked. After that no one took lightly the strength of the hants in the Malloy house.

* * * * *

Then there were the age-old animal tales of rabbits and bears and alligators who talked like humans. The smaller animals were symbols of wit and cunning as they always seemed to get the best of the larger, slower thinking and clumsy animals. During slavery, the slaves used this form of expression to poke fun at and mimic their masters, as well as to veil their preoccupation with attempts to win freedom.[30]

There were many tales about man's lust for gold. Another true tale centers around a spot I know well in Seventy-first Township. It was said for years that some money was buried around Miss Dolly's house, but the spot was haunted by the spirits of the men who put it there years ago. Two young men in the vicinity familiar with the tale were determined to get that money, so they began digging at midnight on the appointed date. As they dug deeper and deeper they were haunted by spirits who assumed beastly shapes. Now the key when you're digging for money is not to utter a word. No matter how frightened you become you must not speak. But at the sight of a bull who was charging at them, one of the men sang out, "Great God Almighty," and as he spoke, the box that their shovels had begun to scrape against was heard to drop deeper into the hole. By this time, scared out of their wits, they ran, never to take up their venture again. This story was told when I was a child, and about two years ago when I was in Fayetteville, my mother met the sister of one of those men on the street and she told my mother that one of her nephews had really found that money. Thus another tale is told.

The following is contributed by William H. Wiggins, Assistant Professor of Folklore and Afro-American Studies, Indiana University.

Afro-Americans have an oral tradition rich in folktales, jokes and toasts. In terms of form and structure, folktales and jokes tend to be freer, with their tellers using traditional motifs and humorous punch lines to maintain their audiences' attention. Toasts, on the other hand, have a finely structured meter skillfully built into a series of rhymed couplets which, like the folktale and joke, conclude with a humorous twist ending. Although examples of all three types are still collected by folklorists, there is an underlying cultural chronology associated with their various beginnings. The John and Brer Rabbit folktales were fashioned during slavery. In the former tales one hears the lash of slavery as John carries on his unending battle of wits with Massa. Many Afro-American jokes reflect black life after Emancipation. In this oral literature "the colored man" emerges as the hero who does cultural battle with the Irish, Jews and other ethnic groups to secure his rightful place in American society. The toasts of Shine and Stackolee come out of black America's urban communities. Armed with the staccato rhymes, hyperbole and limitless sound shades of black urban speech, Shine and Stackolee tirelessly reflect and rise above the oppression of modern ghetto life.

There are various sub-groupings within these three major catagories. Afro-American folktales include: John/Efan tales, animal stories, which have a strong trickster theme, protest tales which sound the Afro-American's anger, etiological tales which explain why things are as they are, for example, why Afro-Americans are black and have kinky hair, and ghost stories which frighten and entertain. Closely related to these forms of black folktales are anecdotes and memorats. They are past events which are retold when families and groups gather. Both may or may not be true, with the anecdote being generally humorous, the memorat generally not. An excellent example of the latter narration is the account of how Sheffield lost and regained the ability to walk. Racism and religion are two of the dominant themes of Afro-American jokes. In addition to the "colored man" cycle of jokes there is an equally large group of jokes centered around the Baptist-Methodist religious strain in Afro-American culture. Julius Lester's story of Stagolee reflects this rich cultural vein of black American religious humor. The toasts of Shine and Stackolee are related to other black urban conversational forms. The names change with

29. Tired.

30. "Brer Rabbit and the Alligator," *Negro Folk Music of Alabama* (Secular). Side II, Band 10. FE 4417. Ethnic Folkways Library.

the region, for example, "the dozens," "woofing," "sounding," and "signifying" are all verbal games of insult in which the objective is to keep your composure as you exchange ritualized, and in some instances rhymed, insults about your opponent's family, especially his or her mother. This battle of words is central in many of the toasts; for example, listen to the dialogue between Stackolee and Billy Lyons. They are engaged in a form of verbal contest also seen in such toasts as "The Signifying Monkey" and "Dolemite."

Folktales, jokes and toasts serve many social functions within the Afro-American community. Entertainment is one function provided by these three forms of oral literature. Dr. Marian Brown still recalls the enjoyment associated with the "favorite time" of listening to "tales of hants" at night while sweet potatoes and peanuts slowly roasted under the fireplace coals. They were also used for social instruction. John's trickery was often cited as a worthy behavior model for black youth to imitate. Folktales are also used to register social protest. For example, Julius Lester's Stagolee sounds a note of anger at whites not heard in the versions of Onah L. Spencer and Charles McCoy. Finally, certain black writers have made great literary use of black oral literature. In addition to Claude McKay's inclusion of folktales in *Banjo,* Cecil Brown, Ralph Ellison and John O. Killens are three other black writers who have included Afro-American folktales in their novels. In fact, Killens' third novel, *'Sippi,* is skillfully based on a civil rights joke of the 1950's. Given their diversity of form and function it is not difficult to see why folktales, jokes and toasts form such a major segment of Afro-American folk art and culture.

SHINE AND THE TITANIC*

From Book of Negro Humor, *ed. Langston Hughes.*

According to Negro belief, persons of color, even servants, were barred from the *Titanic* on its ill-fated maiden voyage. But folk versifiers insist that there was one Negro aboard. This is a Harlem variant of the Negro on the *Titanic,* as told to Langston Hughes on Eighth Avenue, 1956.

Shine, old cullud boy blacker than me,
Worked the wrong boat in the wrong sea.
Old *Titanic* hit a iceberg block,
Shook and shimmied and reared from shock.
Shine come up from the engine floor
Running so fast he broke down an iron door.
Captain told Shine, "Get on back downstairs!"
Shine told the captain, "You better say your prayers."
Captain's daughter hollered, "Lord, the water's up to my neck."

Shine said, "Baby, you better swim, by heck!"
Captain said, "Boy, I got pumps to pump the water down."
Shine said, "Pump on—but I won't be around."
Shine jumped overboard into the sea,
Looked back at the white folks and said, "Swim like me."
And he swimmed on.
Captain's daughter hist her dress over her head.
Shine said, "You'll catch pewmonia, baby, and be stone-cold dead."
And he swimmed on.
Captain's daughter yelled, "Shine, Shine save poor me,
And I'll give everything your eyes can see."
Shine said, "There's plenty on land, baby, waiting for me."
And he swimmed on.
Captain yelled, "Shine, my boy, I got a bank account.
Save poor me—and you'll get any amount."
Shine said, "More banks on land than there is on sea."
And he swimmed on.
Old Millionaire, age seventy-five,
Titanic deck yelling, "I want to stay alive, Shine,
Shine, hear my plea!"
Shine said, "Jump in the water, Grandpa, and swim like me."
And Shine swum on.
Five o'clock in the morning in Harlem and daybreak near,
Shine said, "How come they close up these bars so early when Shine just got here?"
And he walked on.
Newsstand on the corner, bought the *Daily News*
Nothing on the front page but *Titanic* Blues.
He walked on.
Got to his girl friend's house,
She cried, "How can it be?"
Shine said, "Yes, baby it's me."
And they carried on.

STACKALEE**

(Collected and arranged by Onah L. Spencer, from Negro Caravan, eds. Arthur Davis, Sterling Brown, and Ulysses Lee.)

It was in the year of eighteen hundred and sixty-one
In St. Louis on Market Street where Stackalee was born.
Everybody's talkin about Stackalee.
It was on one cold and frosty night
When Stackalee and Billy Lyons had one awful fight,
Stackalee got his gun. Boy, he got it fast!
He shot poor Billy through and through;
Bullet broke a lookin glass.

*"Shine and the Titanic" from *The Book of Negro Humor,* ed. by Langston Hughes, New York: Dodd, Mead & Company, 1966.

**"Stackalee" from *Negro Caravan,* eds. Arthur Davis, Sterling Brown, and Ulysses Lee. Arno Press.

Lord, O Lord, O Lord!
Stackalee shot Billy once; his body fell to the floor.
He cried out, Oh, please, Stack, please don't shoot me
no more.

The White Elephant Barrel House was wrecked that
night;
Gutters full of beer and whiskey; it was an awful sight.
Jewelry and rings of the purest solid gold
Scattered over the dance and gamblin hall.
The can-can dancers they rushed for the door
When Billy cried, Oh, please, Stack, don't shoot me no
more.
Have mercy, Billy groaned, Oh, please spare my life;
I've got two little babies and an innocent wife.

Stack says, God bless your children, damn your wife!
You stold my magic Stetson; I'm gonna steal your life.
But, says Billy, I always treated you like a man.
'Tain't nothin to that old Stetson but the greasy band.
He shot poor Billy once, he shot him twice,
And the third time Billy pleaded, please go tell my wife.
Yes, Stackalee, the gambler, everybody knowed his
name;
Made his livin hollerin high, low, jack and the game.
Meantime the sergeant strapped on his big forty-five,
Says now we'll bring in this bad man, dead or alive.
And brass-buttoned policemen all dressed in blue
Came down the sidewalk marchin two by two.
Sent for the wagon and it hurried and come
Loaded with pistols and a big gatling gun.
At midnight on that stormy night there came an awful
wail
Billy Lyons and a graveyard ghost outside the city jail.
Jailer, jailer, says Stack, I can't sleep,
For around my bedside poor Billy Lyons still creeps.
He comes in shape of a lion with a blue steel in his hand,
For he knows I'll stand and fight if he comes in shape of
man.
Stackalee went to sleep that night by the city clock bell,
Dreaming the devil had come all the way up from hell.
Red devil was sayin, you better hunt your hole;
I've hurried here from hell just to get your soul.

Stackalee told him yes, maybe you're right,
But I'll give even you one hell of a fight.
When they got into the scuffle, I heard the devil shout,
Come and get this bad man before he puts my fire out.
The next time I seed the devil he was scramblin up the
wall,
Yellin, come and get this bad man fore he mops up with
us all.
Then here come Stack's woman runnin, says, daddy, I
love you true;
See what beer, whiskey, and smokin hop has brought
you to.
But before I'll let you lay in there, I'll put my life in
pawn.
She hurried and got Stackalee out on a five thousand
dollar bond.
Stackalee said, ain't but one thing that grieves my mind,

When they take me away, babe, I leave you behind.
But the woman he really loved was a voodoo queen
From Creole French market, way down in New Orleans.

He laid down at home that night, took a good night's
rest,
Arrived in court at nine o'clock to hear the coroner's in-
quest.
Crowds jammed the sidewalk, far as you could see,
Tryin to get a good look at tough Stackalee.
Over the cold, dead body Stackalee he did bend,
Then he turned and faced those twelve jury men.
The judge says, Stackalee, I would spare your life,
But I know you're a bad man; I can see it in your red
eyes.
The jury heard the witnesses, and they didn't say no
more;
They crowded into the jury room, and the messenger
closed the door.

The jury came to agreement, the clerk he wrote it down,
And everybody was whisperin, he's penitentiary bound.
When the jury walked out, Stackalee didn't budge,
They wrapped the verdict and passed it to the judge.
Judge looked over his glasses, says, Mr. Bad Man
Stackalee,
The jury finds you guilty of murder in the first degree.
Now the trial's come to an end, how the folks gave
cheers;
Bad Stackalee was sent down to Jefferson pen for
seventy-five years.

Now late at night you can hear him in his cell,
Arguin with the devil to keep from goin to hell.
And the other convicts whisper, whatcha know about
that?
Gonna burn in hell forever over an old Stetson hat!
Everybody's talkin bout Stackalee.

Chorus or Refrain:

Everybody's talkin bout Stackalee
That bad man Stackalee,
Oh, tough man Stackalee.

Oh, oh, Lord, Lord, Lord,
All about an old Stetson hat.[31]

STACKOLEE

The Book of Negro Humor, *ed. Langston Hughes*

A Harlem variant recited by Charles McCoy who fre-
quented the bars near Wolfe's Clothing Store.

Stackolee was a bad man,
Everybody knowed.

"Stackolee" from *The Book of Negro Humor,* ed. by Lanston
Hughes, New York: Dodd, Mead & Company, 1966.

31. The variation in length of stanza is explained by the fact that a
folk singer shortens, slurs, or gives beats to a measure according to
his particular mood. (Collector's note.)

When they saw Stackolee coming
 Everybody gave him the road.
Stackolee ran into Billy,
 Billy Lyons had on Stackolee's hat.
Stack said to Billy, "Take off my Stetson,
 Billy, I got my gat."
Billy said, "Stack,
 Get hep to yourself."
Put his big black foot on Stack's Stetson
 And turned and left.
Stackolee shot Billy
 Dead in the head.
He grabbed a taxi
 And left Billy dead.
Bullets went right through
 Wolfe's store window glass.
Everybody said, "Yes!
 He shot Billy, yes!"
Stacko died when his taxi
 Sideswiped a truck.
He tried to go to heaven.
 Saint Peter said, "No luck!"
While Rev. Monroe was tolling
 His funeral bell,
Stackolee was on
 His way to hell.
Stack went with the devil
 And the devil's wife—
Would of went with the devil, too,
 But the devil had a knife.

The following was taken from Julius Lester's *Black Folktales*. It is one of the numerous versions of this "bad man" folk hero; it follows two earlier poetic versions. Even though the tale varies with the teller, there are some consistent characteristics of the bad man: he is highly individualistic, and only rarely given to group action; he is a person of prodigious strength, fast with the gun and usually very attractive to women. Julius Lester updates his Stagolee and almost reverently dedicates his *Black Folktales* to Zora Neale Hurston, "Who made me glad I am me," a real acknowledgment of the tradition from which he comes and "to H. Rap Brown," the direction in which he is traveling.

STAGOLEE

Stagolee was, undoubtedly and without question, the baddest nigger that ever lived. Stagolee was so bad that the flies wouldn't even fly around his head in the summertime, and snow wouldn't fall on his house in the winter. He was bad, Jim.

Stagolee grew up on a plantation in Georgia, and by the time he was two, he'd decided that he wasn't going to spend his life picking cotton and working for white folks. Uh-uh. And when he was five, he left. Took off

down the road, his guitar on his back, a deck of cards in one pocket and a .44 in the other. He figured that he didn't need nothing else. When the women heard him whup the blues on the guitar he could have whichever one he laid his mind on. Whenever he needed money, he could play cards. And whenever somebody tried to mess with him, he had his .44. So he was ready. A man didn't need more than that to get along with in the world.

By the time Stack was grown, his reputation had spread around the country. It got started one night in one of them honky-tonks down there in Alabama, and Stagolee caught some dude trying to deal from the bottom of the deck. Ol' Stack pulled out his .44 and killed him dead, right there on the spot. Then he moved the dead guy over to the center of the room and used the body as a card table. Another time, something similar happened, and Stack pulled the body over next to him, so a buddy of his, who was kinda short, would have something to sit on. Didn't take long for the word to get around that this was one bad dude! Even white folks didn't mess with Stagolee.

Well, this one time, Stagolee was playing cards with a dude they called Billy Lyons. Billy Lyons was one of them folk who acted like they were a little better than anybody else. He'd had a little education, and that stuff can really mess your mind up. Billy Lyons had what he called a "scientific method" of cardplaying. Stagolee had the "nigger method." So they got to playing, and, naturally, Stagolee was just taking all of Billy Lyon's money, and Billy got mad. He got so mad that he reached over and knocked Stagolee's Stetson hat off his head and spit in it.

What'd he do that for? He could've done almost anything else in the world, but not that. Stack pulled his .44, and Billy started copping his plea. "Now, listen here, Mr. Stagolee. I didn't mean no harm. I just lost my head for a minute. I was wrong, and I apologize." He reached down on the ground, picked up Stack's Stetson, brushed it off, and put it back on his head. "I didn't mean no harm. See, the hat's all right. I put it back on your head." Billy was tomming like a champ, but Stack wasn't smiling. "Don't shoot me. Please, Mr. Stagolee! I got two children and a wife to support. You understand?"

Stack said, "Well, that's all right. The Lawd'll take care of your children. I'll take care of your wife." And, with that, Stagolee blowed Billy Lyons away. Stagolee looked at the body for a minute and then went off to Billy Lyons's house and told Mrs. Billy that her husband was dead and he was moving in. And that's just what he did, too. Moved in.

Now there was this new sheriff in town, and he had gotten the word about Stagolee, but this sheriff was a sho' nuf' cracker. He just couldn't stand the idea of Stagolee walking around like he was free—not working, not buying war bonds, cussing out white folks. He just

"Stagolee" from *Black Folktales* by Julius Lester. Reprinted by permission of Richard W. Baron Publishing Company, Inc.

couldn't put up with it, so, when he heard that Stagolee had shot Billy Lyons, he figured that this was his chance.

Sheriff told his deputies, said, "All right, men. Stagolee killed a man tonight. We got to get him."

The deputies looked at him. "Well, sheriff. Ain't nothing wrong with killing a man every now and then," said one.

"It's good for a man's health," added another.

"Well," said the sheriff, "that's all right for a white man, but this is a nigger."

"Now, sheriff, you got to watch how you talk about Stagolee. He's one of the leaders of the community here. You just can't come in here and start talking about one of our better citizens like that."

The sheriff looked at them. "I believe you men are afraid. Afraid of a nigger!"

Deputies thought it over for half a second. "Sheriff. Let's put it this way. We have a healthy respect for Stagolee. A long time ago, we struck a bargain with him. We promised him that if he let us alone, we'd let him alone. And everything has worked out just fine."

"Well, we're going to arrest Stagolee," the sheriff said. "Get your guns, and let's go."

The deputies stood up, took their guns, and laid 'em on the shelf. "Sheriff, if you want Stagolee, well, you can arrest him by yourself." And they went on out the door and over to the undertaker's parlor and told him to start making a coffin for the sheriff.

When all the other white folks heard what the sheriff was going to do, they ran over to talk to him. "Sheriff, you can't go around disturbing the peace." But couldn't nobody talk no sense into him.

Now Stagolee heard that the sheriff was looking for him, and, being a gentleman, Stagolee got out of bed, told Mrs. Billy he'd be back in a little while, and went on down to the bar. He'd barely gotten the first drink down when the sheriff came stepping through the door.

He walked over to the bartender. "Barkeep? Who's that man down at the other end of the bar? You know there's a law in this town against drinking after midnight. Who is that?"

Bartender leaned over the counter and whispered in his ear, "Don't talk so loud. That's Stagolee. He drinks when he gets thirsty and he's generally thirsty after midnight."

Sheriff walked over to Stagolee. Stagolee didn't even look around. Sheriff pulled out his gun. Stack still didn't look around. Sheriff fired a couple of shots in the air. Stagolee poured himself another drink and threw it down. Finally, the sheriff said, "Stagolee, I'm the sheriff, and I'm white. Ain't you afraid?"

Stagolee turned around slowly. "You may be the sheriff, and you may be white, but you ain't Stagolee. Now deal with that."

The sheriff couldn't even begin to figure it out, no less deal with it, so he fell back in his familiar bag. "I'm placing you under arrest for the murder of Billy Lyons."

"You and what army? And it bet' not be the United States Army, 'cause I whupped them already."

"Me and this army," the sheriff growled, jabbing the pistol in Stack's ribs.

Before the sheriff could take another breath, Stagolee hit him upside the head and sent him flying across the room. Stagolee pulled out his gun, put three bullets in him, put his gun away, had another drink, and was on his way out the door before the body hit the floor.

The next day, Stagolee went to both of the funerals to pay his last respects to the sheriff and Billy Lyons, and then he settled down to living with Mrs. Billy. She really didn't mind too much. All the women knew how good-looking Stack was. And he was always respectful to women, always had plenty of money, and generally, he made a good husband, as husbands go. Stagolee had one fault, though. Sometimes he drank too much. About once a month, Stagolee would buy up all the available liquor and moonshine in the county and proceed to get wasted, and when Stagolee got wasted, he got totally wasted.

The new sheriff waited until one of those nights when Stagolee was so drunk he was staggering in his sleep, and he was lying flat in the bed. If Judgment Day had come, the Lord would have had to postpone it until Stagolee had sobered up. Otherwise, the Lord might've ended up getting Gabriel shot and his trumpet wrapped around his head. When the sheriff saw Stagolee that drunk, he went and got together the Ku Klux Klan Alumni Association, which was every white man in four counties. After the sheriff had assured them that Stagolee was so drunk he couldn't wake up, they broke in the house just as bad as you please. They had the lynching rope all ready, and they dropped it around his neck. The minute that rope touched Stack's neck, he was wide awake and stone cold sober. When white folks saw that, they were falling over each other getting out of there. But Stack was cool. He should've been. He invented it.

"Y'all come to hang me?"

The sheriff said that that was so. Stagolee stood up, stretched, yawned, and scratched himself a couple of times. "Well, since I can't seem to get no sleep, let's go and get this thing over with so I can get on back to bed."

They took him on out behind the jail where the gallows was built. Stagolee got up on the scaffold, and the sheriff dropped the rope around his neck and tightened it. Then the hangman opened up on the trap door, and there was Stack, swinging ten feet in the air, laughing as loud as you ever heard anybody laugh. They let him hang there for a half-hour, and Stagolee was still laughing.

"Hey, man! This rope is ticklish."

The white folks looked at each other and realized that Stack's neck just wouldn't crack. So they cut him down, and Stagolee went back home and went back to bed.

After that, the new sheriff left Stagolee in peace, like he should've done to begin with.

Stagolee lived on and on, and that was his big

mistake. 'Cause Stagolee lived so long, he started attracting attention up in Heaven. One day, St. Peter was looking down on the earth, and he happened to notice Stack sitting on the porch picking on the guitar. "Ain't that Stagolee?" St. Peter said to himself. He took a closer look. "That's him. That's him. Why, that nigger should've been dead a long time ago." So St. Peter went and looked it up in the record book, and, sure enough, Stagolee was supposed to have died thirty years before.

St. Peter went to see the Lord.

"What's going on, St. Peter?"

"Oh, ain't nothing shaking, Lord. Well, that's not totally true. I was just checking out earth, and there's a nigger down there named Stagolee who is way overdue for a visit from Death."

"Is that so?"

"It's the truth, Lord."

"Well, we have to do something about that." The Lord cleared his throat a couple of times and hollered out, "*Hey Death! Heeeey, Death!*"

Now Death was laying up down in the barn catching up on some sleep, 'cause he was tired. Having to make so many trips to Vietnam was wearing him out, not to mention everywhere else in the world. He just couldn't understand why dying couldn't be systematized. He'd tried his best to convince God either to get a system to dying or get him some assistants. He'd proposed that, say, on Mondays, the only dying that would be done would be, say, in France, Germany, and a few other countries. Tuesday it'd be some other countries, and on like that. That way, he wouldn't have to be running all over the world twenty-four hours a day. But the Lord had vetoed the idea. Said it sounded to him like Death just wanted an excuse to eventually computerize the whole operation. Death had to admit that the thought had occurred to him. He didn't know when he was going to catch up on all the paperwork he had to do. A computer would solve everything. And now, just when he was getting to sleep, here comes the Lord waking him up.

So Death got on his pale white horse. He was so tired of riding a horse he didn't know what to do. He'd talked to God a few months ago about letting him get a helicopter or something. But the Lord just didn't seem to understand. Death rode on off down through the streets of Heaven, and when folks heard him coming, they closed their doors, 'cause even in Heaven, folks were afraid of Death. And that was the other thing. Death was mighty lonely. Didn't nobody talk to him, and he was getting a little tired of it. He wished the Lord would at least let him wear a suit and tie and look respectable. Maybe then he could meet some nice young angel and raise a family. The Lord had vetoed that idea, too.

"What took you so long, Death?"

"Aw, Lord. I was trying to get some sleep. You just don't realize how fast folks are dying these days."

"Don't tell me you gon' start complaining again."

"I'm sorry, Lord, but I'd like to see you handle the job as well as I do with no help, no sleep, no wife, no nothing."

"Well, I got a special job for you today."

"Can't wait until tomorrow?"

"No, it can't wait, Death! Now hush up. There's a man down in Fatback, Georgia, named Stagolee. You should've picked him up thirty years ago, and I want you to send me a memo on why you didn't."

"Well, I got such a backlog of work piled up."

"I don't want to have to be doing your job for you. You get the lists every day from the Record Bureau. How come you missed this one? If he's escaped for thirty years, who knows who else has been living way past their time. Speaking of folks living past their time, St. Peter, have the librarian bring me all the files on white folks. Seems to me that white folks sho' done outlived their time. Anyway, Death, go on down there and get Stagolee."

Death headed on down to earth. A long time ago, he used to enjoy the ride, but not anymore. There were so many satellites and other pieces of junk flying around through the air that it was like going through a junkyard barefooted. So he didn't waste any time getting on down to Fatback, Georgia.

Now on this particular day, Stagolee was sitting on the porch, picking the blues on the guitar, and drinking. All of a sudden, he looked up and saw this pale-looking white cat in this white sheet come riding up to his house on a white horse. "We ain't never had no Klan in the daytime before," Stagolee said.

Death got off his horse, pulled out his address book, and said, "I'm looking for Stagolee Booker T. Washington Nicodemus Shadrack Nat Turner Jones."

"Hey, baby! You got it down pat! I'd forgotten a couple of them names myself."

"Are you Stagolee Booker T. Wash—"

"You ain't got to go through the thing again. I'm the dude. What's going on?"

"I'm Death. Come with me."

Stagolee started laughing. "You who?"

"I'm Death. Come on, man. I ain't got all day."

"Be serious."

Death looked at Stagolee. No one had ever accused him of joking before. "*I am* serious. It's your time to die. Now come on here!"

"Man, you ain't bad enough to mess with me."

Death blinked his eyes. He'd never run up on a situation like this before. Sometimes folks struggled a little bit, but they didn't refuse. "Stagolee, let's go!" Death said in his baddest voice.

"Man, you must want to get shot."

Death thought that one over for a minute. Now he didn't know how to handle this situation, so he reached in his saddlebags and pulled out his *Death Manual*. He looked up *resistance* and read what it said, but wasn't a thing in there about what to do when somebody threatens you. Then he looked up *guns,* but that wasn't

listed. He looked under everything he could think of, but nothing was of any help. So he went back to the porch. "You coming or not, Stagolee?"

Stagolee let one of them .44 bullets whistle past ol' Death's ear, and Death got hat. Death didn't waste no time getting away from there. Before he was sitting in the saddle good, he had made it back to Heaven.

"Lord! You must be trying to get me killed."

"Do what? Get you killed? Since when could you die?"

"Don't matter, but that man Stagolee you just sent me after took a shot at me. Now listen here, Lord, if you want that man dead, you got to get him yourself. I am not going back after him. I knew there was some reason I let him live thirty years too long. I'd heard about him on the grapevine and, for all I care, he can live three hundred more years. I am not going back—"

"O.K. O.K. You made your point. Go on back to sleep." After Death had gone, God turned to St. Peter and asked, "We haven't had any new applications for that job recently?"

"You must be joking."

"Well, I was just checking." The Lord lit a cigar. "Pete, looks like I'm going to have to use one of my giant death thunderbolts to get that Stagolee."

"Looks that way. You want me to tell the work crew?"

The Lord nodded, and St. Peter left. It took 3,412 angels 14 days, 11 hours, and 32 minutes to carry the giant death thunderbolt to the Lord, but he just reached down and picked it up like it was a toothpick.

"Uh, St. Peter? How you spell Stagolee?"

"Lord, you know everything. You're omnipotent, omiscient, omni—"

"You better shut up and tell me how to spell Stagolee."

St. Peter spelled it out for him, and the Lord wrote it on the thunderbolt. Then he blew away a few clouds and put his keen eye down on the earth. "Hey, St. Peter. Will you look at all that killing down there? I ain't never seen nothing like it."

"Lord, that ain't Georgia. That's Vietnam."

The Lord put his great eye across the world. "Tsk, tsk, tsk. Look at all that sin down there. Women wearing hardly no clothes at all. Check that one out with the black hair, St. Peter. Look at her! Disgraceful! Them legs!"

"Lord!"

And the Lord put his eye on the earth and went on across the United States—Nevada, Utah, Colorado, Kansas, Missouri—

"Turn right at the Mississippi River, Lord!"

The Lord turned right and went on down into Tennessee.

"Make a left at Memphis, Lord!"

The Lord turned left at Memphis and went on up through Nashville and on down to Chattanooga into Georgia. Atlanta, Georgia. Valdosta. Rolling Stone,

Georgia, until he got way back out in the woods to Fatback. He let his eye go up and down the country roads until he saw Stagolee sitting on the porch.

"That's him, Lord! That's him!"

And the Great God Almighty, the God of Nat Turner and Rap Brown, the God of Muddy Waters and B.B. King, the God of Aretha Franklin and The Impressions, this great God Almighty Everlasting, *et in terra pax hominibus,* and all them other good things, drew back his mighty arm—

"Watch your aim now, Lord."

And unloosed the giant thunderbolt. *Boom*!

That was the end of Stagolee. You can't mess with the Lord.

Well, when the people found out Stagolee was dead, you ain't never heard such hollering and crying in all your life. The women were beside themselves with grief, 'cause Stagolee was nothing but a sweet man.

Come the day of the funeral, and Stagolee was laid out in a $10,000 casket. Had on a silk mohair suit and his Stetson hat was in his hand. In his right coat pocket was a brand new deck of cards. In his left coat pocket was a brand new .44 with some extra rounds of ammunition and a can of Mace. And by his side was his guitar. Folks came from all over the country to Stack's funeral, and all of 'em put little notes in Stagolee's other pockets, which were messages they wanted Stagolee to give to their kinfolk when he got to Hell.

The funeral lasted for three days and three nights. All the guitar pickers and blues singers had to come sing one last song for Stagolee. All the backsliders had to come backslide one more time for Stagolee. All the gamblers had to come touch Stack's casket for a little taste of good luck. And all the women had to come shed a tear as they looked at him for the last time. Those that had known him were crying about what they weren't going to have any more. And those that hadn't known him were crying over what they had missed. Even the little bitty ones was shedding tears.

After all the singing and crying and shouting was over, they took Stagolee on out and buried him. They didn't bury him in the cemetery. Uh-uh. Stagolee had to have a cemetery all his own. They dug his grave with a silver spade and lowered him down with a golden chain. And they went on back to their homes, not quite ready to believe that Stack was dead and gone.

But you know, it's mighty hard to keep a good man down, and, long about the third day, Stagolee decided to get on up out of the grave and go check out Heaven. Stack just couldn't see himself waiting for Judgment Day. The thought of that white man blowing the trumpet on Judgment Day made him sick to his stomach, and Stagolee figured he was supposed to have his own Judgment Day, anyhow.

He started on off for Heaven. Of course it took him a long time to get there, 'cause he had to stop on all the clouds and teach the little angels how to play Pitty-Pat and Coon-Can and all like that, but, eventually, he got

near to Heaven. Now as he got close, he started hearing all this harp music and hymn singing. Stagolee couldn't believe his ears. He listened some more, and then he shrugged his shoulders. "I'm approaching Heaven from the wrong side. This can't be the black part of Heaven, not with all that hymn singing and harp music I hear."

So Stack headed on around to the other side of Heaven, and when he got there, it was stone deserted. I mean, wasn't nobody there. Streets was as empty as the President's mind. So Stack cut on back around to the other side of Heaven. When he got there, St. Peter was playing bridge with Abraham, Jonah, and Mrs. God. When they looked up and saw who it was, though, they split, leaving St. Peter there by himself.

"You ain't getting in here!" St. Peter yelled.

"Don't want to, either. Hey, man. Where all the colored folks at?"

"We had to send 'em all to Hell. We used to have quite a few, but they got to rocking the church service, you know. Just couldn't even sing a hymn without it coming out and sounding like the blues. So we had to get rid of 'em. We got a few nice colored folks left. And they nice, respectable people."

Stagolee laughed. "Hey, man. You messed up."

"Huh?"

"Yeah, man. This ain't Heaven. This is Hell. Bye."

And Stagolee took off straight for Hell. He was about 2,000 miles away, and he could smell the barbecue cooking and hear the jukeboxes playing, and he started running. He got there, and there was a big *Black Power* sign on the gate. He rung on the bell, and the dude who come to answer it recognized him immediately. "Hey, everybody! Stagolee's here!"

And the folks came running from everywhere to greet him.

"Hey, baby!"

"What's going down!"

"What took you so long to get here?"

Stagolee walked in, and the brothers and sisters had put down wall-to-wall carpeting, indirect lighting, and best of all, they'd installed air-conditioning. Stagolee walked around, checking it all out. "Yeah. Y'all got it together. Got it uptight!"

After he'd finished checking it out, he asked, "Any white folks down here?"

"Just the hip ones, and ain't too many of them. But they all right. They know where it's at."

"Solid." Stagolee noticed an old man sitting over in a corner with his hands over his ears. "What's his problem?"

"Aw, that's the Devil. He just can't get himself together. He ain't learned how to deal with niggers yet."

Stagolee walked over to him. "Hey, man. Get your pitchfork, and let's have some fun. I got my .44. C'mon. Let's go one round."

The Devil just looked at Stagolee real sadlike, but didn't say a word.

Stagolee took the pitchfork and laid it on the shelf.

"Well, that's hip. I didn't want no stuff out of you nohow. I'm gon' rule Hell by myself!"

And that's just what he did, too.

THE "DIRTY DOZEN"

Dan Burley

One of the quainter Negro contributions to American culture (and common to jazz musicians) is the ingrained custom among an increasing number to put one and all into what is vulgarly known as "The Dozens." An etymologist might be led to define "The Dozens" as "the Science of Disparaging One's Ancestors"; a sociologist, on the other hand, might term the habit of Negroes "Playing the Dozens" as being "part of the mores of an oppressed, downtrodden, hopeless people." A psychiatrist, in turn, might view "The Dozens" as "the terminology of a permanently diseased intellect that draws pleasure from uttering Freudian blasphemies about the parents and general ancestry of someone else."

Ancestor belittling is nothing new. It is as old as the world, particularly in the Far East. When I was in Burma, Egypt, India, and China some years back, it was common to hear jinrikisha men in the market place of Bombay, Cairo, Chungking, Rangoon, and Calcutta belabor one another with such terms of endearment as "Basest of illegitimate hyenas!" "Father of seventeen dogs!" "Bath servant!" "Seller of pig's tripe!" or "O Daughter of the Devil!" "O commodity on which money is lost!" "O thou especially not wanted!" in one treasured dialogue between a female beggar and another woman with whom she quarreled. Another sample of Oriental "Dozens" was "Ho! Thy maternal aunt had no nose!" "O thou brother of a naughty sister!" As is usual in America among Negroes or white insulted by Negro "Dozens Players" the above brought on fisticuffs and even worse.

Research reveals that "The Dozens" were of American slave origin and took the place of physical assault by the "field slaves" on the more favored "house slaves" on southern plantations. Knowing they would suffer the lash or be deprived of food if they harmed the often pampered house servants, the lowly cotton pickers, sugar-cane workers, and other laborers in the field vented their spleen on the hated uniformed black, brown, and yellow butlers, coachmen, lackeys, maids, and housekeepers by saying aloud all types of things about their parents and even their most remote ancestors. As this discomfort of the abused became known, the vilification steadily became more lewd, pointedly vulgar, and filthy. In the transition of the centuries to today the crude name-calling among the slaves and the newly freed Negroes, after 1863, steadily developed until in the period just before World War I

From *The Book of Negro Humor,* ed. by Langston Hughes, New York: Dodd, Mead & Company, 1966.

The Dozens had moved into the Negro folklore picture on the same level of development as the Negro Spiritual, The Blues, and the newly emerging Ragtime, later to become Jazz.

By 1917 they had been "refined" to the point where one talked about another's parents in highly explosive rhythmic phrases. It was during this period that some unknown blues pianist and singer composed an uncopyrighted tune called "The Dirty Dozens," complete with words, which because of their very nature never got on paper. But at barrel-house and buffet flat-house rent parties "The Dirty Dozens" became the rage. It was in the sparse repertoire of all the representative "Fives," "Rocks," and "Shavin' 'Em Dry" and "Lost World" piano players. In later years many established recording stars like the jazz musicians, Count Basie and Sam Price, waxed their wordless versions of "The Dozens" and earned heavy royalties. At the same time, old-time blackface comedians played "The Dozens" (dirty words omitted) on stage at popular vaudeville theaters.

Today "The Dozens" are universal among Negroes. Which brings to mind the yarn about the two white kids leaving a Negro neighborhood playground. On getting in their own back yard, one said: "Say Oswald, let's play we are colored and turn our caps around on our heads and put each other in the dozens!"

"Big Boy Leaves Home," the opening story in the collection *Uncle Tom's Children,* is one of Richard Wright's most powerful stories. It begins with the familiar "dozens game" you just read about in the preceding article. Four black teenagers have "cut" school and are enjoying themselves doing nothing. But they do it in their own way, kidding and taunting each other. The story quickly becomes serious because they go swimming in the bare on property belonging to a white couple. Read the entire story for the way in which Richard Wright describes how the lives of people could change suddenly from joy to terror in a Southern community before World War II. One of the ways the author accomplishes this is through his use of a natural part of black folk life— "the dozens."

BIG BOY LEAVES HOME

Richard Wright

Yo mama don wear no drawers . . .
Clearly, the voice rose out of the woods, and died away. Like an echo another voice caught it up:
Ah seena when she pulled em off . . .
Another, shrill cracking, adolescent:
N she washed' em in alcohol . . .

Then a quartet of voices, blending in harmony, floated high above the tree tops:
N she hung' em out in the hall . . .
Laughing easily, four black boys came out of the woods into cleared pasture. They walked lollingly in bare feet, beating tangled vines and bushes with long sticks.
"Ah wished Ah knowed some mo lines t tha song."
"Me too."
Yeah, when yuh gits t where she hangs em out in the hall yuh has t stop."
"Shucks, whut goes wid hall?"
"Call."
"Fall."
"Wall."
"Quall."
They threw themselves on the grass, laughing.
"Big Boy?"
"Huh?"
"Yuh know one thing?"
"Whut?"
"Yuh sho is crazy!"
"Crazy?"
"Yeah, yuh crazys a bed-bug!"
"Crazy bout whut?"
"Man, whoever hearda quall?"
"Yuh said yuh wanted something to go wid hall, didnt yuh?"
"Yeah, but whuts a quall?"
"Nigger, a qualls a quall."
They laughed easily, catching and pulling long green blades of grass with their toes.
"Waal, ef a qualls a quall, what *is* a quall?"
"Oh, Ah know."
"Whut?"
"Tha ol song goes something like this:

Yo mama don wear no drawers,
 Ah seena when she pulled em off,
N she washed em in alcohol,
 N she hung em out in the hall
N then she put em back on her *quall*!"

Zora Neale Hurston collected a number of folk tales in her home state of Florida and published them in *Mules and Men* (1935). She also included folk elements in her novels (see Chapter 1, "Sermon" from *Jonah's Gourd Vine*). "High John De Conquer" is a classic black folk tale which illustrates the indomitable spirit of a people with the will to survive. Julius Lester describes John as a "be" man—"be

here when the hard times come, and be here when the hard times are gone."[32]

Hurston published this tale in *American Mercury* during World War II (October, 1943), a terribly trying period for Americans, apparently as an example of courage and determination under duress—not the first time black writers have been cited for inspiration. Winston Churchill, in exhorting the British to resist the Nazis, read Claude McKay's (a contemporary of Zora Hurston) poem "If We Must Die" over the BBC.

HIGH JOHN DE CONQUER
Zora Neale Hurston

Maybe, now, we used-to-be black African folks can be of some help to our brothers and sisters who have always been white. You will take another look at us and say that we are still black and, ethnologically speaking, you will be right. But nationally and culturally, we are as white as the next one. We have put our labor and our blood into the common causes for a long time. We have given the rest of the nation song and laughter. Maybe now, in this terrible struggle, we can give something else—the source and soul of our laughter and song. We offer you our hope-bringer, High John de Conquer.

High John de Conquer came to be a man, and a mighty man at that. But he was not a natural man in the beginning. First off, he was a whisper, a will to hope, a wish to find something worthy of laughter and song. Then the whisper put on flesh. His footsteps sounded across the world in a low but musical rhythm as if the world he walked on was a singing-drum. The black folks had had an irrestible impulse to laugh. High John de Conquer was a man in full, and had come to live and work on the plantations, and all the slave folks knew him in the flesh.

The sign of this man was a laugh, and his singing-symbol was a drumbeat. No parading drum-shout like soldiers out for show. It did not call to the feet of those who were fixed to hear it. It was sure to be heard when and where the work was the hardest, and the lot the most cruel. It helped the slaves endure. They knew that something better was coming. So they laughed in the face of things and sang, "I'm so glad! Trouble don't last always." And the white people who heard them were struck dumb that they could laugh. In an outside way, this was Old Massa's fun, so what was Old Cuffy laughing for?

Old Massa couldn't know, of course, but High John de Conquer was there walking his plantation like a natural man. He was treading the sweat-flavored clods of the plantation, crushing out his drum tunes, and giving out secret laughter. He walked on the winds and moved fast. Maybe he was in Texas when the lash fell on a slave in Alabama, but before the blood was dry on the back he was there. A faint pulsing of a drum like a goat-skin stretched over a heart, that came nearer and closer, then somebody in the saddened quarters would feel like laughing, and say, "Now, High John de Conquer, Old Massa couldn't get the best of *him*. That old John was a case!" Then everybody sat up and began to smile. Yes, yes, that was right. Old John, High John could beat the unbeatable. He was top-superior to the whole mess of sorrow. He could beat it all, and what made it so cool, finish it off with a laugh. So they pulled the covers up over their souls and kept them from all hurt, harm and danger and made them a laugh and a song. Night time was a joke, because daybreak was on the way. Distance and the impossible had no power over High John de Conquer.

He had come from Africa. He came walking on the waves of sound. Then he took on flesh after he got here. The sea captains of ships knew that they brought slaves in their ships. They knew about those black bodies huddled down there in the middle passage, being hauled across the waters to helplessness. John de Conquer was walking the very winds that filled the sails of the ships. He followed over them like the albatross.

It is no accident that High John de Conquer has evaded the ears of white people. They were not supposed to know. You can't know what folks won't tell you. If they, the white people, heard some scraps, they could not understand because they had nothing to hear things like that with. They were not looking for any hope in those days, and it was not much of a strain for them to find something to laugh over. Old John would have been out of place for them.

Old Massa met our hope-bringer all right, but when Old Massa met him, he was going by his right name. He was traveling, and touristing around the plantations as the laugh-provoking Brer Rabbit. So Old Massa and Old Miss and their young ones laughed with and at Brer Rabbit and wished him well. And all the time, there was High John de Conquer playing his tricks of making a way out of no-way. Hitting a straight lick with a crooked stick. Winning the jackpot with no other stake but a laugh. Fighting a mighty battle without outside-showing force, and winning his war from within. Really winning in a permanent way, for he was winning with the soul of the black man whole and free. So he could use it afterwards. For what shall it profit a man if he gain the whole world, and lose his own soul? You would have nothing but a cruel, vengeful, grasping monster come to power. John de Conquer was a bottom-fish. He was deep. He had the wisdom tooth of the East in his head. Way over there, where the sun rises a day ahead of time, they say that Heaven arms with love and laughter those it does not wish to see destroyed. He who carries his heart in his sword must perish. So says the ultimate

"High John De Conquer" by Zora Neale Hurston. First published in the *American Mercury,* 1943. Reprinted by permission A. Watkins, Inc.

32. Julius Lester, *Black Folktales,* p. 93.

lay. High John de Conquer knew a lot of things like that. He who wins from within is in the "Be" class. *Be* here when the ruthless man comes, and *be* here when he is gone.

Moreover, John knew that it is written where it cannot be erased, that nothing shall live on human flesh and prosper. Old Maker said that before He made any more sayings. Even a man-eating tiger and lion can teach a person that much. His flabby muscles and mangy hide can teach an emperor right from wrong. If the emperor would only listen.

II

There is no established picture of what sort of looking-man this John de Conquer was. To some, he was a big, physical-looking man like John Henry. To others, he was a little hammered-down, low-built man like the Devil's doll-baby. Some said that they never heard what he looked like. Nobody told them, but he lived on the plantation where their old folks were slaves. He is not so well known to the present generation of colored people in the same way that he was in slavery time. Like King Arthur of England, he has served his people, and gone back into mystery again. And, like King Arthur, he is not dead. He waits to return when his people shall call again. Symbolic of English power, Arthur came out of the water, and with Excalibur, went back into the water again. High John de Conquer went back to Africa, but he left his power here, and placed his American dwelling in the root of a certain plant. Only possess that root, and he can be summoned at any time.

"Of course, High John de Conquer got plenty power!," Aunt Shady Anne Sutton bristled at me when I asked her about him. She took her pipe out of her mouth and stared at me out of her deeply wrinkled face. "I hope you ain't one of these here smart colored folks that done got so they don't believe nothing, and come here questionizing me so you can have something to poke fun at. Done got shamed of the things that brought us through. Make out 'tain't no such thing no more."

When I assured her that that was not the case, she went on.

"Sho John de Conquer means power. That's bound to be so. He come to teach and tell us. God don't leave nobody ignorant, you child. Don't care where He drops you down, He puts you on a notice. He don't want folks taken advantage of because they don't know. Now, back there in slavery time, us didn't have no power of protection, and God knowed it, and put us under watch-care. Rattlesnakes never bit no colored folks until four years after freedom was declared. That was to give us time to learn and to know. 'Course, I don't know nothing about slavery personal like. I wasn't born till two years after the Big Surrender. Then I wasn't nothing but a infant baby when I was born, so I couldn't know nothing but what they told me. My mama told me, and I know she wouldn't mislead me, how High John de Conquer helped us out. He had done teached the black folks so they knowed a hundred years ahead of time that freedom was coming. Long before the white folks knowed anything about it at all.

"These young Negroes reads they books and talk about the war freeing the Negroes, but Aye, Lord! A heap sees, but a few knows. 'Course, the war was a lot of help, but how come the war took place? They think they knows, but they don't. John de Conquer had done put it into the white folks to give us our freedom, that's what. Old Massa fought against it, but us could have told him that it wasn't no use. Freedom just *had* to come. The time set aside for it was there. That war was just a sign and a symbol of the thing. That's the truth! If I tell the truth about everything as good as I do about that, I can go straight to Heaven without a prayer."

Aunt Shady Anne was giving the inside feeling and meaning to the outside laughs around John de Conquer. He romps, he clowns, and looks ridiculous, but if you will, you can read something deeper behind it all. He is loping on off from the Tar Baby with a laugh.

Take, for instance, those words he had with Old Massa about stealing pigs.

Old John was working in Old Massa's house that time, serving around the eating table. Old Massa loved roasted young pigs, and had them often for dinner. Old John loved them too, but Massa never allowed the slaves to eat any at all. Even put aside the left-over and ate it next time. John de Conquer got tired of that. He took to stopping by the pig pen when he had a strong taste for pitmeat, and getting himself one, and taking it on down to his cabin and cooking it.

Massa began to miss his pigs, and made up his mind to squat for who was taking them and give whoever it was a good hiding. So John kept on taking pigs, and one night Massa walked him down. He stood out there in the dark and saw John kill the pig and went on back to the "big house" and waited till he figured John had it dressed and cooking. Then he went on down to the quarters and knocked on John's door.

"Who dat?," John called out big and bold, because he never dreamed that it was Massa rapping.

"It's me, John," Massa told him. "I want to come in."

"What you want, Massa? I'm coming right out."

"You needn't to do that, John. I want to come in."

"Naw, naw, Massa. You don't want to come into no old slave cabin. Youse too fine a man for that. It would hurt my feelings to see you in a place like this here one."

"I tell you I want to come in, John!"

So John had to open the door and let Massa in. John had seasoned the pig *down*, and it was stinking pretty! John knowed Old Massa couldn't help but smell it. Massa talked on about the crops and hound dogs and one thing and another, and the pot with the pig in it was hanging over the fire in the chimney and kicking up. The smell got better and better.

Way after while, when that pig had done simbled down to a low gravy, Massa said, "John, what's that you cooking in that pot?"

"Nothing but a little old weasly possum, Massa. Sick-

liest old possum I ever did see. But I thought I'd cook him anyhow."

"Get a plate and give me some of it, John. I'm hungry."

"Aw, naw, Massa, you ain't hongry."

"Now, John, I don't mean to argue with you another minute. You give me some of that in the pot, or I mean to have the hide off of your back tomorrow morning. Give it to me!"

So John got up and went and got a plate and a fork and went to the pot. He lifted the lid and looked at Massa and told him, "Well, Massa, I put this thing in here a possum, but if it comes out a pig, it ain't no fault of mine."

Old Massa didn't want to laugh, but he did before he caught himself. He took the plate of brownded-down pig and ate it up. He never said nothing, but he gave John and all the other house servants roast pig at the big house after that.

III

John had numerous scrapes and tight squeezes, but he usually came out like Brer Rabbit. Pretty occasionally, though, Old Massa won the hand. The curious thing about this is, that there are no bitter tragic tales at all. When Old Massa won, the thing ended up in a laugh just the same. Laughter at the expense of the slave, but laughter right on. A sort of recognition that life is not one sided. A sense of humor that said, "We are just as ridiculous as anybody else. We can be wrong, too."

There are many tales, and variants of each, of how the Negro got his freedom through High John de Conquer. The best one deals with a plantation where the work was hard, and Old Massa mean. Even Old Miss used to pull her maids' ears with hot firetongs when they got her riled. So, naturally, Old John de Conquer was around that plantation a lot.

"What we need is a song," he told the people after he had figured the whole thing out. "It ain't here, and it ain't no place I knows of as yet. Us better go hunt around. This has got to be a particular piece of singing."

But the slaves were scared to leave. They knew what Old Massa did for any slave caught running off.

"Oh, Old Massa don't need to know you gone from here. How? Just leave your old work-tired bodies around for him to look at, and he'll never realize youse way off somewhere, going about your business."

At first they wouldn't hear to John, that is, some of them. But, finally, the weak gave in to the strong, and John told them to get ready to go while he went off to get something for them to ride on. They were all gathered up under a big hickory nut tree. It was noon time and they were knocked off from chopping cotton to eat their dinner. And then that tree was right where Old Massa and Old Miss could see from the cool veranda of the big house. And both of them were sitting out there to watch.

"Wait a minute, John. Where we going to get some-

thing to wear off like that. We can't go nowhere like you talking about dressed like we is."

"Oh, you got plenty things to wear. Just reach inside yourselves and get out all those fine raiments you been toting around with you for the longest. They is in there, all right. I know. Get 'em out, and put 'em on."

So the people began to dress. And then John hollered back for them to get out their musical instruments so they could play music on the way. They were right inside where they got their fine raiments from. So they began to get them out. Nobody remembered that Massa and Miss were setting up there on the veranda looking things over. So John went off for a minute. After that they all heard a big sing of wings. It was John come back, riding on a great black crow. The crow was so big that one wing rested on the morning, while the other dusted off the evening star.

John lighted down and helped them, so they all mounted on, and the bird took out straight across the deep blue sea. But it was a pearly blue, like ten squillion big pearl jewels dissolved in running gold. The shore around it was all grainy gold itself.

Like Jason in search of the golden fleece, John and his party went to many places, and had numerous adventures. They stopped off in Hell where John, under the name of Jack, married the Devil's youngest daughter and became a popular character. So much so, that when he and the Devil had some words because John turned the dampers down in old Original Hell and put some of the Devil's hogs to barbecue over the coals, John ran for High Chief Devil and won the election. The rest of his party was overjoyed at the possession of power and wanted to stay there. But John said no. He reminded them that they had come in search of a song. A song that would whip Old Massa's earlaps down. The song was not in Hell. They must go on.

The party escaped out of Hell behind the Devil's two fast horses. One of them was named Hallowed-Be-Thy-Name, and the other, Thy-Kingdom-Come. They made it to the mountain. Somebody told them that the Golden Stairs went up from there. John decided that since they were in the vicinity, they might as well visit Heaven.

They got there a little weary and timid. But the gates swung wide for them, and they went in. They were bathed, robed, and given new and shining instruments to play on. Guitars of gold, and drums, and cymbals and wind-singing instruments. They walked up Amen Avenue, and down Hallelujah Street, and found with delight that Amen Avenue was tuned to sing bass and alto. The west end was deep bass, and the east end alto. Hallelujah Street was tuned for tenor and soprano, and the two promenades met right in front of the throne and made harmony by themselves. You could make any tune you wanted to by the way you walked. John and his party had a very good time at that and other things. Finally, by the way they acted and did, Old Maker called them up before His great workbench, and made them a tune and put it in their mouths. It had no words. It was a tune that you could bend and shape in most any way you

wanted to fit the words and feelings that you had. They learned it and began to sing.

Just about that time a loud rough voice hollered, "You Tunk! You July! You Aunt Diskie!" Then Heaven went black before their eyes and they couldn't see a thing until they saw the hickory nut tree over their heads again. There was everything just like they had left it, with Old Massa and Old Miss sitting on the veranda, and Massa was doing the hollering.

"You all are taking a mighty long time for dinner," Massa said. "Get up from there and get on back to the field. I mean for you to finish chopping that cotton today if it takes all night long. I got something else, harder than that, for you to do tomorrow. Get a move on you!"

They heard what Massa said, and they felt bad right off. But John de Conquer took and told them, saying, "Don't pay what he say no mind. You know where you got something finer than this plantation and anything it's got on it, put away. Ain't that funny? Us got all that, and he don't know nothing at all about it. Don't tell him nothing. Nobody don't have to know where us gets our pleasure from. Come on. Pick up your hoes and let's go."

They all began to laugh and grabbed up their hoes and started out.

"Ain't that funny?" Aunt Diskie laughed and hugged herself with secret laughter. "Us got all the advantage, and Old Massa think he got us tied!"

The crowd broke out singing as they went off to work. The day didn't seem hot like it had before. Their gift song came back into their memories in pieces, and they sang about glittering new robes and harps, and the work flew.

IV

So after a while, freedom came. Therefore High John de Conquer has not walked the winds of America for seventy-five years now. His people had their freedom, their laugh and their song. They have traded it to the other Americans for things they could use like education and property, and acceptance. High John knew that that was the way it would be, so he could retire with his secret smile into the soil of the South and wait.

The thousands upon thousands of humble people who still believe in him, that is, in the power of love and laughter to win by their subtle power, do John reverence by getting the root of the plant in which he has taken up his secret dwelling, and "dressing" it with perfume, and keeping it on their person, or in their houses in a secret place. It is there to help them overcome things they feel that they could not beat otherwise, and to bring them the laugh of the day. John will never forsake the weak and the helpless, nor fail to bring hope to the hopeless. That is what they believe, and so they do not worry. They go on and laugh and sing. Things are bound to come out right tomorrow. That is the secret of Negro song and laughter.

So the brother in black offers to these United States

the source of courage that endures, and laughter. High John de Conquer. If the news from overseas reads bad, and the nation inside seems like it is stuck in the Tar Baby, listen hard, and you will hear John de Conquer treading on his singing-drum. You will know then, that no matter how bad things look now, it will be worse for those who seek to oppress us. Even if your hair comes yellow, and your eyes are blue, John de Conquer will be working for you just the same. From his secret place, he is working for all America now. We are all his kinfolks. Just be sure our cause is right, and then you can lean back and say, "John de Conquer would know what to do in a case like this, and then he would finish it off with a laugh."

White America, take a laugh out of our black mouths, and win! We give you High John de Conquer.

Like Zora Hurston, Claude McKay included folk elements in his novels combining two cultures (West Indian and North American) in his own background. McKay was interested in the variegated strands of color that ran through black people from Africa to the New World. In his novel *Banjo,* McKay explored the "ditch" of Marseilles where ordinary seamen gathered together—drinking, womanizing, and philosophizing. In the chapter "Storytelling" the men swap embellished tales of their own prowess, then settle down to authentic folk stories of African and American origin. Bugsy, a black Southerner, tells a trickster tale; the hero is Sam instead of John but the tale fits the trickster pattern discussed on page 49.

BANJO

Claude McKay

"Now lemme tell you-all one story," said Bugsy.

"One time down home in Alabam' there was a white man's nigger whose name was Sam. He was a house darky and he was right there on the right side a the boss and the missus. But Sam wasn't noneatall satisfied to be the bestest darky foh the boss folks. He aimed to be the biggest darky ovah all the rest a darkies. So Sam started in to profitsy and done claimed he could throw the fust light on anything that was going to happen.

"Sam had some sort of a way-back befoh-slavery connection with thunder and lightning and he could predick when it was gwine to rain. But all the same he couldn't put himself ovah the field niggers, 'causen there was a confidential fellah among them who was do-

From *Banjo* by Claude McKay, copyright 1929 by Harper & Brothers; (©) 1957 by Hope McKay Virtue. Reprinted by permission of Harcourt Brace Jovanovich, Inc.

ing a wonderful business in hoodoo stuff. That other conjure man had Sam going something crazy.

"And so, to make the biggest impression on the boss folks and the plantation folks Sam started in hiding things all ovah the place and then challenge the other conjure man to find them. And when the other fellah couldn't find the things Sam would predick where they was.

"He found the guinea pig in the baby's cradle. He found the buck rabbit eating cheese in the pantry. The cock was missing from the hencoop and he found him scratching with the cat in the barn. Ole Mammy Joan lost her bandanna and Sam found it in the buggy house under the coachman's seat. She couldn't noneatall sleep a nights, and he found a big rat done made a nest in her rush baid.

"Sam's fohsightedness made him the biggest darky evah with the boss folks and the black folks, and the news about him spread all ovah the country. And one day a big boss of another plantation comed to visit the boss. And the boss bet the other a bale of cotton that his nigger Sam could find anything that he had away.

"The other boss took up the bet and had Sam blind-folded and shut up in one a the outhouses, and he made the darkies bring out one a them great big ole-time plantation pot. And he caught a coon and put it under the pot. And then they let Sam out and the boss asks him to tell what was under the pot.

" 'I feel a presumonition not to predick today, boss,' Sam said.

" 'But you gotta,' the boss said. 'I done put a bet on you and I know you can tell anything.'

"Sam shook his head and, looking at the pot, said, 'This coon is caught today.'

" 'Hurrah!' the boss cried. 'I knowed mah nigger could tell anything.' And he let the coon out from under the pot.

"At first Sam was kinder downhearted and scared. But soon as he saw the coon he got his head up and chested himself and started to strut off just so big and just that proud.

"And from that time the American darky started in playing coon and the white man is paying him for it."

"Ole Sis Goose" is an animal tale and it does of course have a moral. During slavery black people had no legal rights; they were considered chattle, not people. Their testimony was not even admitted as evidence in court during the post-Reconstruction period, and these restrictions held on tenaciously throughout a number of states, particularly in the South, until the Civil Rights movement of the fifties. The moral of "Ole Sis Goose" may be obvious, but the tale itself has always been a favorite because it has the ring of truth.

OLE SIS GOOSE

Ole Sis Goose wus er-sailin' on de lake, and ole Br'er Fox wus hid in de weeds. By um by ole Sis Goose swum up close to der bank and ole Br'er Fox lept out an cotched her.

"O yes, ole Sis Goose, I'se got yer now, you'se been er-sailin' on der lake er long time, en I'se got yer now, I'se gwine to break yer neck en pick yer bones."

"Hole on der', Br'er Fox, hold on, I'se got jes' as much right to swim in der lake as you has ter lie in der weeds. Hit's des' as much my lake es hit is yours, and we is gwine to take dis matter to der cotehouse and see if you has any right to break my neck and pick my bones."

And so dey went to cote, and when dey got dere, de sheriff, he wus er fox, en de judge, he wus er fox, and der tourneys, dey wus fox, en all de jurymen, dey was foxes, too.

En dey tried ole Sis Goose, en dey 'victed her and dey 'scuted her, and dey picked her bones.

Now my chilluns, listen to me, when all de folks in de cotehouse is foxes, and you is des' er common goose, der ain't gwine to be much jestice for you pore cullud folks.

Afro-American Folk Tale Collections and Related Works

Brewer, J. Mason. *Dog Ghosts and Other Texas Negro Folk Tales,* Austin: University of Texas Press, 1958.

———. *The Word on the Brazos: Negro Preacher Tales from the Brazos Bottoms of Texas.* Austin: University of Texas Press, 1953.

———. *Worser Days and Better Times: The Folklore of the North Carolina Negro,* Chicago: Quadrangle Books, 1965.

Christensen, A. M. H. *Afro-American Folk Lore, Told Round Cabin Fires on the Sea Islands of South Carolina,* New York: Negro Universities Press, 1969; originally published 1892.

Dorson, Richard M. *American Negro Folktales,* New York: Fawcett Publications, 1967; first published Indiana University Press, 1958.

———. *Negro Folktales in Michigan,* Cambridge: Harvard University Press, 1956.

———. *Negro Tales from Pine Bluff, Arkansas, and Calvin, Michigan,* Bloomington: Indiana University Press, 1958.

Hurston, Zora Neale. *Mules and Men,* New York: Harper & Row, 1970; originally published 1935.

Lester, Julius. *Black Folktales.* New York: Grove Press, 1969.

Anonymous, "Ole Sis Goose," collected by A. W. Eddins, from *Coffee in the Gourd,* Dallas, 1923, ed. J. Frank Dobie, Southern Methodist University Press. Used by permission of the Texas Folklore Society.

Figure 2.1. "Strip Quilt" (actually a knotted coverlet) made by Lucille LaBerde, Johns Island, S.C., 1970. Collection of Roslyn A. Walker, Normal, Illinois.

Folk Arts and Crafts

Afro-American folk arts and crafts include basketry, wood carving, quilt making, net knitting, iron work, and broom making; in short, items made by untrained artists and craftsmen. Some fine examples are shown in *Drums and Shadows* (Georgia Writers Project, republished, New York, 1972), and *Slave Songs of the Georgia Sea Islands* (Lydia Parrish, New York, 1942). Some pictures of baskets may be found in *Afro- American Art and Craft* (Judith Wragg Chase, New York, 1969), and an example of the quilts can be seen above.

When enslaved African craftsmen were ordered to make some item, needless to say, they manufactured it according to the ideas of the patron. When, however, they could make something for their own use, the pattern could conform to their memory of a design from their lost homes in Africa. In other words, there is a difference between items of Afro-American manufacture and those of Afro-American design. It is true that we can see a few so-called "slave made" things which are of Euro-American design; recently, however, quilts of Afro-American design have come to light showing very different features from Euro-American quilts. These Afro-American strip quilts have analogues in the woven kente cloth of the Ashanti and Ewe-speaking people in Ghana, West Africa. Although differences in workmanship and function exist for these articles, their design features are similar. Kente and Ewe cloth is woven in strips about four inches wide on a vertical loom; these long strips are rolled up as they are completed. The strips are then cut to a specified length and are sewn together to make the cloth. Afro-American quilt tops also have long strips, but they are made of patches of cloth which are sewn together. The finished quilt creates a visual impact similar to that of the West African cloth.[33]

Contemporary "Naif" Artists

"Primitive" or "naif" artists are self-taught, that is, they are without formal training in art. They are natural artists. They paint, sculpt, and draw things or events from memory or from dreams and usually depict those elements, or aspects of their experiences, which are most important to their own reality. The primary difference between their works and the works of more conventional artists is the denial of the third dimension, depth, which can be artificially created on a flat surface through the use of perspective. The so-called primitive artist makes no attempt to represent things as they exist in space. The works of these artists have a flat quality; human or animal figures and objects are not modeled with light and shade to create roundness; elements in a still-life or landscape appear to be placed one above the other in totem fashion; sequential events and motion occur in the same composition. On the other hand, attention is given naturally to the treatment of negative and positive space, to variation of texture, color and form to create harmonious, balanced compositions. Like all great masterpieces of art, theirs have timeless appeal.

Unlike artists who adopt this style, such as Marc Chagall or Henri Matisse, it is assumed the "naif" artist comes to this style directly and not in reaction to (or rebellion against) the learned conventions of High Art. Whenever the terms primitive and naif are employed, "child-like vision" or "simple" are also used to describe their works and often their creators. What is actually meant is that these artists capture the essence of things or events and pictorially state

33. For a review of Afro-American crafts, see Robert F. Thompson, "African Influences on the Art of the Americas" in Robinson, Foster and Ogilvie, *Black Studies in the University* (New Haven, 1969). For further information about Afro-American folk art see: Edith M. Dabbs, *Face of an Island* (New York, 1971); M. A. Twining, "African-Afro-American Artistic Continuity," *Journal of African Studies*, Vol. 2, No. 4, (Winter, 1975/76), pp. 569-578. This section contributed by Mary Arnold Twining, University of Buffalo.

Figure 2.2. Horace Pippin, "End of War: Starting Home," ca. 1931, oil on canvas, 25" × 32". Courtesy of Philadelphia Museum of Art: Given by Robert Carlen.

them with directness and without the conventional techniques of a trained artist.

Black American "naif" artists are as famous as their white counterparts like Grandma Moses and Grant Williams. Some, like Horace Pippin, who was discussed briefly in chapter 1, are more famous than others. There is rarely a book or exhibition of primitive art which does not include considerable mention of the black "naifs": Horace Pippin (1888-1947); Minnie Jones Evans (b.1892); "Sister" Gertrude Morgan (b.1900); Clementine Hunter (b.ca.1892); and William Edmondson (1882-1951).

Horace Pippin

Horace Pippin, born in West Chester, Pennsylvania, became one of America's most famous artists. Had he not been persistent, he may have stopped drawing at an early age. In his autobiography, he recounts having been frequently punished for drawing at inappropriate times, especially during spelling lessons. He would illustrate rather than spell the words which resulted in his having to stay after school. He also tells of having entered a "Draw Me" contest when he was about ten years old. His entry won a prize, a set of crayons, water paints and two brushes. With the crayons he drew pictures of biblical subjects which were shown and sold in a Sunday School festival.

Pippin received little formal education; he left school at the age of fifteen. Thereafter, he was employed as a handyman in a variety of jobs: he worked on a farm, unloaded coal, and was a porter. This last job occupied him for seven years until he enlisted in the United States Army.

His military experience began in July, 1917, during World War I. He was sent to France and fought with the 369th, an all-black regiment. In January, 1919, he was honorably discharged after one year's duty because he had been severely wounded in the arm and shoulder. He made sketches of battle scenes and stored memories of his and his fellow soldiers' experiences during the war, which inspired his first paintings. One of these paintings, "The End of the War: Starting Home," finished in 1933 (fig. 2.2), actually depicts black soldiers engaged in capturing Germans.

There were happier memories of growing up in Goshen to which the family had moved—the neighbors, the countryside, and Christmas mornings—which became subjects in his paintings. He also painted still-lifes and portraits, interiors of houses he knew in white neighborhoods; an example is "Victorian Interior" (fig. 2.3). Painting was a slow, painful

process because of his wounds. He averaged only one painting per year.

Pippin never had an art instructor; he was totally self-taught. According to him, "a man should have a love for . . . [art], because my idea is that he paints from his heart and mind. To me it seems impossible for another to teach one of art."

Horace Pippin died in 1947 at the age of fifty-nine.

Figure 2.3. Horace Pippin, "Victorian Interior," 1946. The Metropolitan Museum of Art, New York. Arthur H. Hearn Fund, 1958.

Minnie Jones Evans

Minnie Jones Evans was born in Pender County, North Carolina in 1882. According to her discoverer and biographer, Nina Howell Starr, a photo-journalist, Minnie Evans had visions and heard voices. Once she was told "to draw or die." On Good Friday, 1935, she responded to this divine call. But, this must have been a command to *serious* work, for as a child Minnie Evans, like Horace Pippin, devoted a lot of time to drawing pictures. Her punishment was a rap on the hand by an annoyed teacher.

Her first drawings were in pen and ink and very linear (figs. 2.4 and 2.5). Later, she experimented with oil paints and collage. Her paintings have a surreal or irrational, dream-like quality. In terms of imagery and color, East Indian, Chinese and Western aboriginal elements are suggested although the subjects may be animals, faces or scenes from the Bible. According to the artist, her imagery derives from "nations I suppose might have been destroyed before the flood. No one knows anything about them, but God has given it to me to bring them back into the world." Indeed, these pictorial manifestations of her

Figure 2.4. Minnie Evans, "Untitled." First Drawing, 1935. (Copy of the original drawing by the artist.) Ink on paper, 6″ × 9″. Courtesy of Nina Howell Starr, representative of Minnie Evans.

Figure 2.5. Minnie Evans, "Untitled." Second Drawing. 1935. (Copy of the original drawing by the artist.) Ink on paper, 6″ × 9″. Courtesy of Nina Howell Starr, representative of Minnie Evans.

lost world defy explication even by the artist. As she is reported to have said, the images are just as strange to her as they are to anybody else.

She has never supported herself solely by her art (but few artists do!). Until her marriage in 1908, Minnie Evans worked at oystering. Later she became the Gate Keeper or admissions collector at Airlie Gardens, an estate in North Wilmington, North Carolina, where she has worked for more than twenty-five years. About fifteen years ago, the artist was brought to world attention by Nina Howell Starr.

William Edmondson

Another divinely inspired "naif" artist is William Edmondson (1882-1951) who lived in Nashville, Tennessee. During the years prior to his discovery by a Manhattan photographer, Louise Dahl-Wolfe, Mr. Edmondson was a hospital orderly and handyman. According to him, he was told in a vision to preach and to carve. His preaching was not to be performed in the pulpit; he is said to have sung the Lord's praises while carving pieces of limestone into angels, birds, preachers and lambs of God in his front yard.

Edmondson talked about the "miracles" which only he could perform. In his own words, as it was reported in *Time* magazine (November 1, 1937), he declared, "Cain't nobody do dese but me, I cain't help carvin' I jes does it. Its like when you're leavin' here you're goin' home. Well, I know I'm goin' to carve. Jesus has planted the seeds of carvin' in me."

In 1937, a year after his discovery, this semi-literate sculptor was given a one-man show at the Museum of Modern Art in New York. The following comment was made in an article in *Newsweek* magazine of that same year: "His carving landed him among high-ranking artists this week when the important Museum of Modern Art, New York, accorded him a one-man sculpture show." Many of his sculptures were sold and are now in important museum and private collections. Prior to this exhibition, no one had bought any of his works; his neighbors were certainly more impressed with his preaching-singing than with his carving.

Edmondson worked directly into the stone without preliminary sketches on paper or in clay, or chalk marks on the stone. The carvings were intended to be tombstones. One of his stone carvings is reproduced in fig. 2.6, "Mother and Child," 1920. For illustrations of William Edmondson's "Preacher," 1969, and other works of the artist, see *Visions in Stone: The Sculpture of William Edmondson* by Edmond L. Fuller, 1973.

Clementine Hunter

Nachitoches, Louisiana, on the Cane River, is famous for an early eighteenth century plantation called Melrose. It was built in 1750 by Marie Terese Coin-Coin, a Congo-born slave who upon being freed was given a land grant by the French Crown. On this land she built "Yucca" as the plantation and its main house were then called. The architecture is of historical interest as it was built in the style of the thatch-roofed huts in her native country. Her grandson, Louis Metoyer built another main house in 1833. Unfortunately, the family's fortune collapsed in the 1840's and the plantation passed into white hands. It was renamed Melrose.

Nachitoches is also famous for one of its citizens, a black woman artist. This is Clementine Hunter (b. ca. 1892) who had been a cook in the main house of the Melrose Plantation. Since 1929 the plantation has been a rest/work haven for authors and artists. One day Mrs. Hunter picked up some paint brushes which had been left behind by one of the visitors. With them she painted a picture on a window shade which had been given to her by a visiting artist. Painting pictures was at first merely a pastime. However this pastime became something else: according to the artist, if some image came into her mind she was compelled to paint it.

One of her often repeated subjects is a "honky-tonk" or road house which is located near the plantation. The painting, "Saturday Night," depicts the red building with its whirling window fan and the people who frequent it, drinking, fighting and making love. Of this road house Mrs. Hunter comments, "You can hear them over there on Saturday nights; sometimes there is a killing." The road house is not her only subject; she has painted scenes relating to the church such as processions, crucifixions and biblical personalities. In a recent oil painting, "Nativity," Clementine Hunter depicts the Holy Mother and Child seated under a palm tree and three men bearing gifts of fruit to the church. Winged angels hover above watching the procession (fig. 2.7; color slide).

"Sister" Gertrude Morgan

"Sister" Gertrude Morgan was born in 1900 and for the past thirty-odd years she has lived in New Orleans, Louisiana. In her paintings, she expresses her religious convictions. The themes of her paintings are inspired by the Book of Revelations which she feels personally commands her to "Become the lamb through which the Lord speaks." For many years, she preached and sang the Gospel on the streets of

Figure 2.6. William Edmondson, "Mother and Child," 1920. Limestone, Height 11″. Courtesy of Museum of American Folk Art.

Figure 2.7. Clementine Hunder, "Nativity," 1975. Oil on canvas, 16″ X 20″. Courtesy of Mr. and Mrs. James L. Hunt, Baton Rouge, Louisiana. Photo: Simuel W. Austin.

Figure 2.8. Sister Gertrude Morgan, "Madame and Husbands on the Lawn Exercising," ca. 1969, tempera on cardboard, 3 1/2″ X 6 3/4″. Courtesy Robert and Phyllis Klotman Collection, Bloomington, Indiana. Photo: Lawrence F. Sykes.

New Orleans accompanying herself on the guitar and tambourine. She also used to perform at Preservation Hall.

A few years ago, the Lord commanded her to cease preaching on the streets and to speak the Gospel through another medium. She began a pictorial autobiography of her daily struggle with religion and her need to "beat down the devil." In her paintings Sister Gertrude includes herself dressed in white, like a "Mother" of the church. In "Madame-Husbands on the Lawn Exercising," she appears as the wife of the Lord and Christ (fig. 2.8, color slide).

The artist uses whatever materials are readily available: crayons, tempera, and odd pieces of cardboard and paper. Once an unknown, Sister Gertrude has become famous and her paintings collector's items through special exhibitions held throughout the country.

"Naif" artists? Yes. But, naive only in terms of not having experienced formal art training. Today many artists, having experienced formal art training, try to achieve in quality what these artists do naturally—recreate their worlds, real or fantastic, in pictures and sculptures characterized by freshness of vision and directness in manner.

Slides

Figure 2.4. Minnie Evans, "Untitled," 1944. Collection Roslyn A. Walker, Normal, Illinois.

Figure 2.7. Clementine Hunter, "Nativity," 1975 oil on canvas, 16″ × 20″ Courtesy, Mr. & Mrs. James L. Hunt, Baton Rouge, Louisiana. Photo: S. W. Austin.

Figure 2.8. Sister Gertrude Morgan, "Madame and Husbands on the Lawn Exercising," 3-1/2″ × 6-3/4″ Courtesy Robert and Phyllis Klotman Collection, Bloomington, Indiana. Photo: Lawrence F. Sykes.

THE SPIRITUAL IN SONG AND STORY

Most plantation art work—handwrought grills on stairways and porches, beautiful basketry and quilts—was done by unknown slave artisans, like those unknown bards whose praises James Weldon Johnson sings in the following poem. But there were some black artists during slavery whose names and work were known. One of those was Joshua Johnston, who painted this "Portrait of a Cleric" (fig. 3.1) sometime between 1804 and 1824, the period in which most of his work as a painter was done.

Figure 3.1. Joshua Johnston (ac. 1796-1824) "Portrait of a Cleric (Rev. Daniel Coker?)," oil on canvas, 28" X 22". Courtesy of the Bowdoin College Museum of Art, Brunswick, Maine.

O BLACK AND UNKNOWN BARDS*

James Weldon Johnson

O black and unknown bards of long ago,
How came your lips to touch the sacred fire?
How, in your darkness, did you come to know
The power and beauty of the minstrel's lyre?
Who first from midst his bonds lifted his eyes?
Who first from out the still watch, long and lone,

Feeling the ancient faith of prophets rise
Within his dark-kept soul, burst into song?

Heart of what slave poured out such melody
As "Steal away to Jesus"? On its strains
His spirit must have nightly floated free,
Though still about his hands he felt his chains.
Who heard great "Jordan roll"? Whose starward eye
Saw chariot "swing low"? And who was he
That breathed that comforting, melodic sigh,
"Nobody knows de trouble I see"?

What merely living clod, what captive thing,
Could up toward God through all its darkness grope,
And find within its deadened heart to sing
These songs of sorrow, love and faith, and hope?
How did it catch that subtle undertone,
That note in music heard not with the ears?
How sound the elusive reed so seldom blown,
Which stirs the soul or melts the heart to tears.

Not that great German master in his dream
Of harmonies that thundered amongst the stars
At the creation, ever heard a theme
Nobler than "Go down, Moses." Mark its bars
How like a mighty trumpet-call they stir
The blood. Such are the notes that men have sung
Going to valorous deeds; such tones there were
That helped make history when Time was young.

There is a wide, wide wonder in it all,
That from degraded rest and servile toil
The fiery spirit of the seer should call
These simple children of the sun and soil.
O black slave singers, gone, forgot, unfamed,
You—you alone, of all the long, long line
Of those who've sung untaught, unknown, unnamed,
Have stretched out upward, seeking the divine.

The term spiritual is used to categorize the complete body of Afro-American religious songs created during the slave era. For a long time it was theorized that spirituals were conceived solely from a narrow religious perspective coincident with the slave's introduction to Christianity. However, recent studies show that the true meanings of spirituals are not found primarily in their surface materials but in the events and activities which created them—physical abuse, inadequate living conditions, involvement

*From *St. Peter Relates an Incident* by James Weldon Johnson. Copyright © 1917 by James Weldon Johnson. All rights reserved. Reprinted by permission of The Viking Press.

with secret meetings of African cult societies, and, of course, the ever present desire to be free.

Because slave society was pre-literate, whatever signs, symbols, beliefs, and values the slaves possessed were necessarily maintained and communicated orally. Spirituals became a major source of this information. They were used as entertainment, as emotional outlet, and as avenues for social commentary. Thus, as a form of creative expression, spirituals were a prime source for ensuring social and cultural stability within plantation society.

Consider the text of the song "One Mornin' Soon."[1] The surface meanings of the words and phrases "My Lawd," "I Heard the Angel Singing," "The Cross," and "Yo' soul'll be lost" are based on biblical imagery. However, what appears to be a warning for the Christian becomes, in light of these recent findings, an admonition to the slave to exercise care in dealing with this particular situation.

> One morning soon,
> One morning soon, my Lawd,
> One morning soon,
> I heard the angel singing.
> Better min' my brother,
> How you walk on the cross,
> I heard the angel singing,
> Yo' foot might slip
> And yo' soul'll be lost,
> I heard the angel singing.

Because of the manner in which the text is presented, this song is characterized as a warning spiritual. Before the insurrections of the 1820s and 1830s slaves were permitted to visit neighboring plantations. As a result of the activities of insurrectionists, patrols were formed to curb traveling from one plantation to another without proper passes. Warning spirituals cautioned against these dreaded night patrols or "patterolers," as they were called. They also warned members of African cult societies as well as those slaves planning to join the Underground Railroad.

A unique feature of these warning spirituals is the use of such phrases as "sooner in the morning," and, as in this case, "one morning soon." The slave used soon or sooner as a rhetorical device to express the urgency of his situation and the immediacy of his plans.

> One morning soon,
> One morning soon, My Lawd.
> One morning soon,
> I heard the angel singing.

As the slave became familiar with biblical scripture, its imagery afforded great opportunity for him to create extensive metaphors. Whatever the character or event chosen as a subject, he infused it with his unique sensitivity. For example, a favorite reference was angels, whom he often characterized as the messengers and soldiers of God, symbols of power and transformation. The phrase "I heard the angel singing" is used in this spiritual to emphasize the slave's decision to make a change in his present status. Further evidence of the broad function of spirituals in the everyday lives of slaves lies in the fact that "One morning soon" is identified as having been used by slaves in Jamaica when they revolted against the British.

There are numerous songs which portray similar surface imagery. For example, "You Gonna Reap" gives the illusion that this spiritual is based on Christian doctrine, specifically the system of natural justice which is reflected in the phrase, "You'll reap what you sow."

> You gonna reap just what you sow,
> You gonna reap what you sow.
> Sowing on the mountain, sowing in the valley,
> You'll reap what you sow.

In the spiritual "I Want to be Ready" the surface material expresses belief in and hope for eternal life.

> I want to be ready,
> I want to be ready,
> I want to be ready to walk in
> Jerusalem just like John.

"While I Couldn't Hear Nobody Pray" and "I've Got to Walk This Lonesome Valley" are based on the intensely personal experience of seeking, finding, and finally coming to know the Lord.

> I couldn't hear nobody pray, I couldn't hear nobody
> pray,
> Way down yonder, by myself, I couldn't hear nobody
> pray.
>
> You got to walk this lonesome valley.
> You got to walk it by yourself, Oh,
> Nobody else can walk it for you.
> You got to walk it by yourself.

The seeming acceptance of Christianity and use of its symbols and imagery were necessary expedients. The slave was resourceful enough to conclude that if

1. "One Mornin' Soon." *Songs of the American Negro Slave.* Side II, Band 2. FD 5252. Folkways Records.

he was to accomplish successfully his goal of freedom he would have to use a sanctioned means of expression and communication. He found this in the new religion which was approved by both the slave owner and the overseer.

From the beginning, however, the slave modified the elements of Christianity to fit his particular needs. He chose its most radical and revolutionary concepts as guiding principles for his life—the deliverance of the Hebrews from Egypt as in "Go Down Moses" and Daniel from the lion's den as in "Didn't My Lawd Deliver Daniel." Its biblical symbols and imagery—God, the prophets, even geographical areas—became symbols of deliverance.

By using Christianity as an agent of mask and symbol, the slave was afforded an avenue of criticism, complaint, warning, and alarm without fear of reprisal. The text of "I'm Troubled in Mind" illustrates how biblical symbols were used to express the need for change in existing conditions. Phrases often used with this connotation were "I'm gonna cross over into campground [Jordan]" and "Roll, Jordan, Roll." This concept was also expressed in recurring usage of the word "Jesus" as in the text which follows:

Chorus: I'm troubled, I'm troubled, I'm troubled in mind,
If Jesus don't help me, I surely will die.
1. O Jesus, my Saviour, on Thee I'll depend,
When troubles are near me, you'll be my true friend.
2. When ladened with trouble and burdened with grief,
To Jesus in secret I'll go for relief.
3. In dark days of bondage to Jesus I prayed,
To help me to bear it, and He gave me his aid.[2]

References to the use of these early religious texts as message bearers by the Underground Railroad and leaders of insurrections are numerous. "Steal Away" is identified as having been used by Nat Turner to call his fellow conspirators together; "Go Down, Moses" was a signal used by Harriet Tubman to summon passengers for the Underground Railroad, and "Good News, Member" signaled that a break for freedom had been successful. Of the category of message-bearing texts, "Foller de drinkin' gou'd" is unique. The story goes that a white man, "Peg Foot", traveled throughout the south, hiring himself out as a laborer on numerous plantations. After winning the confidence of slaves, he would tell them how to follow the map in the sky, marked by the Big Dipper, to freedom. In the spring, after his departure,

scores of blacks would slip away, following the trail blazed by the footprints of "Peg Foot" and the map in the sky.

When the sun comes back and the first quail calls
Foller de drinkin' Gou'd.
For the old man is waiting for to carry you to freedom,
If you foller de drinkin' gou'd.

The river bank will make a very good road
The dead trees show you the way.
Left foot, peg foot, travellin' on,
Foller de drinkin' gou'd.[3]

Three themes that appear often in the spirituals are (1) the desire for freedom, (2) belief that justice shall be meted out to the oppressor, and (3) a formula for actually achieving freedom. Each of these themes appears individually in the songs which follow. The first "Link O' Day"[4] is a response to being sold. The text admonishes slaves to run away before the light of day:

Massa bin an' sol' yuh O'.
To go up in de country
'Fo' de link o' day.

Run yuh! Run yuh!
'Fo' de link o' day. (2×)

Dere gwine-a come a time O!
When we's gwine all be free,
We's gwine all be free.

It is overwhelming that in the midst of the events and conditions inherent in the institution of slavery there was a glint of hope expressed in many of the spirituals. The slave believed deliverance would come!

O 'rise! for thy light is a-comin'
O 'rise! for thy light is a-comin'
O 'rise! for thy light is a-comin'
My Lord says He's comin' bye'n'bye.

Didn't my Lord deliver Daniel, deliver Daniel, deliver Daniel?
Didn't my Lord deliver Daniel, and why not every man?

"You Gonna Reap,"[5] presents the theme of freedom

2. J. B. T. Marsh, *The Story of the Jubilee Singers; With Their Songs* (Revised edition; New York: Negro Universities Press, 1881), p. 173.
3. Irwin Sibler, *Songs of the Civil War* (New York: Columbia University Press, 1960), p. 278.
4. "Link O' Day," *Songs of the American Negro Slave.* Side I, Band 1, FD 5252, Folkways Records, New York.
5. "You Gonna Reap," Side I, Band 4, Folkways FD 5252.

and a tactic for obtaining it using one concept of mask and symbol.

> You gonna reap just what you sow,
> You gonna reap what you sow,
> Sowing on the mountain, sowing in the valley,
> You'll reap what you sow.

Use of mask and symbol in these early songs is related to the African characteristic of double meaning which is different from Western usage. Although mask and symbol appear universally in folk songs, in the African language they are more than mere devices for veiling direct statements. Rather, mask and symbol are prized as forms of artistic expression and, among some African people, their usage and mastery are considered measures of intelligence. The griots[6] used mask and symbol as devices for making commentary and criticism on various aspects of manners. At the same time they used these creatively as vehicles for expressing empirical truths.

In the New World the slave internalized his usage of mask and symbol, and it became a means of deception and protection from the wrath of the slave owners. Deception was one way to freedom. It enabled the slave to comment on his relationship to the slave-owner, his role as property, and his desire for freedom without fear of being punished. Through allusion he outsmarted the oppressor by leading him to believe he accepted his secondary status in society. This attitude is expressed in the following lyrics:

> Got one mind for the boss to see.
> Got another mind for what I know is me.

Thus, the significance of mask and symbol in early black religious songs does not rest solely on its being an African retention, but on the slave's recognition of its potential for his own use. In addition, the subtle use of language increased the impact of the spirituals on the listener and helped to unify the slaves by binding them through secrecy to their oneness of purpose.

> I'm telling you, brother, to keep on fighting,
> Telling you, brother, keep on fighting,
> Fighting on the mountain, fight harder in the valley,
> You will reap what you sow.

Such phrases as "Keep on fighting" and "Keep the lights burning" are representative of stock ideas that were used repeatedly through the years to affirm the need to persevere in the fight for freedom.

"I stood on the River,"[7] uses mask and symbol to summon aid in gaining freedom.

> I stood on the river of Jordan
> To see dem ships come sailing over,
> Stood on the river of Jordan
> To see dem ships sail by.
>
> O brother, won't you help me,
> O my brother, won't you help me pray?
> To see dem ships sail by.

In the first stanza of the spiritual, "I Stood on the River" is used to depict the desire to make a change in the existing order. The reference to ships here also suggests that the creator of these lines was expressing his knowledge of colonizing societies which solicited for the return of slaves to their homeland. In the second stanza the singer is calling for fellow slaves to join him in a unified effort to gain return passage to Africa.

The early religious music of the slave was an oral manifestation of concepts and beliefs that the slave formulated as guiding principles in his life. The act of creating spirituals as well as the act of participating in singing them helped establish a feeling of community and provided a semblance of equilibrium by helping the slave redefine who he was in relation to the function dictated him by his environment.

Spirituals were not religious simply because they used biblical imagery. They were religious because they attempted to affirm the existence of the group by giving them something to believe in.

Discography

Spirituals

Swing Low, Sweet Chariot. Leontyne Price, *RCA Victor* LSC2600.

Let My People Go. Howard Roberts Chorale, *Columbia* MS7189.

Jester Hairston and His Chorus (Arr. folksongs), *Murbo* MLP6000.

Negro Folk Songs for Young People. Great Negro blues, work songs, and spirituals. (7533) Folkways/Scholastic, 906 Sylvan Ave., Englewood Cliffs, N.J. LCR 67 1851.

The DePaur Infantry Chorus (Swing Low), *Columbia* Col A1-45.

Been in the Storm So Long (Spirituals and Shouts, Children's Game Songs), *Ethnic Folkways* FS 3842.

Marian Anderson: He's Got the Whole World in His Hand, *RCA* (School).

Been Here and Gone (Music Dept.), *Folkways* FS 2659.

6. Griot—word of French origin [Senegal, Ivory Coast] is an African troubadour, who sings the praises of ancestors and the history of famous hunters and kings; he can also be paid to sing the praise of someone still alive and to celebrate that person's family/family name.

7. "I Stood on the River," Side I, Band 6, Folkways FD 5252.

Been in the Storm So Long, *Folkways* FS 3842.

Negro Folk Music of Africa and America (Music Department), *Folkways* FE 4500.

Leontyne Price: Swing Low, Sweet Chariot—Fourteen Spirituals, *RCA* LSC 2600,

Paul Robeson: Songs of Free Men, Spirituals, *Odyssey* 32160268.

Negro Folk Songs for Young People Sung by Leadbelly, *Folkways* FC 7533 (School).

William Dawson: Spirituals, *Victor* 4556.

Robert Nathaniel Dett: Spirituals. *Victor* M-879.

Roland Hayes: Spirituals (sop: Inez Matthews), *Period* SPL-580.

Marian Anderson: He's Got the World (spirituals), *Victor* LSC-2592.

Inez Matthews: Spirituals. *Period* 580.

Paul Robeson: Spirituals. *Columbia* ML 4105.

Folk Music of the United States. Afro-American Spirituals, Work Songs, and Ballads. *Library of Congress* AAFS L3.

The Fisk Jubilee Singers. Directed by John W. Work, *Folkways* FA 2372.

Folk Music of the United States. Negro Religious Songs and Services. *Library of Congress* AAFS L10.

Let My People Go. Black Spirituals, African Drums, Howard Roberts Chorale. *Columbia* MS 7189.

Marian Anderson (Spirituals), *RCA Victor* LSC 2592.

My Lord What a Mornin'. Harry Belafonte Singing Spirituals, *RCA Victor* LSP 2022.

Spirituals, Howard University Chior, Warner Lawson, Director, *RCA Victor* LM-2126.

Songs of the Soul and Spirit, Pearl Williams Jones, Singer-Pianist, Location: 1265-3268.

W. E. B. Du Bois' important collection of personal essays, *The Souls of Black Folk*[8] published in 1903, not only contained a complete chapter on the "sorrow songs," as he called the spirituals, but also used a spiritual as an epigraph to each chapter, along with a selection from some significant western poet (Tennyson, Byron, Lowell, Schiller, Browning, Barrett). Very much in the belletristic style of the day, Du Bois' book is a unique example of the possibilities of artistic fusion of the two cultures he discusses in chapter 1—the Negro and the American. There is a certain hauteur in the manner, characteristic of the scholar whose brilliance often went unrecognized by his white peers, as well as his inferiors. Beneath the poetic citation preceding each chapter a line of music appears, but the spiritual from which it is taken is not always identified. The following is a key to the rich dual culture which this gifted Afro-American combined in his literary methodology.

Chapter I of *The Souls of Black Folk* is of special importance because in it Du Bois enunciates his theory of double consciousness, a condition forced on black Americans, whom Richard Wright (in his novel *The Outsider*) later described as being in, not of, the land of their birth. Both the musical and the poetic excerpts support the central idea of the chapter.

OF OUR SPIRITUAL STRIVINGS*
W. E. B. Du Bois

O water, voice of my heart, crying in the sand,
 All night long crying with a mournful cry.
As I lie and listen, and cannot understand
 The voice of my heart in my side or the voice of the
 sea,
 O water, crying for rest, is it I, is it I?
 All night long the water is crying to me.

Unresting water, there shall never be rest
 Till the last moon droop and the last tide fail,
And the fire of the end begin to burn in the west;
 And the heart shall be weary and wonder and cry like
 the sea,
 All life long crying without avail,
 As the water all night long is crying to me.

Arthur Symons

Between me and the other world there is ever an unasked question: unasked by some through feelings of delicacy; by others through the difficulty of rightly framing it. All, nevertheless, flutter round it. They approach me in a half-hesitant sort of way, eye me curiously or compassionately, and then, instead of saying directly, How

*"Of Our Spiritual Strivings" from *The Souls of Black Folk* by W. E. B. Du Bois. Fawcett Publications, Inc.

8. W. E. Burghardt DuBois, *The Souls of Black Folk*, Fawcett World Library, New York, N.Y.

does it feel to be a problem? they say, I know an excellent colored man in my town; or, I fought at Mechanicsville; or, Do not these Southern outrages make your blood boil? At these I smile, or am interested, or reduce the boiling to a simmer, as the occasion may require. To the real question, How does it feel to be a problem? I answer seldom a word.

And yet, being a problem is a strange experience,—peculiar even for one who has never been anything else, save perhaps in babyhood and in Europe. It is in the early days of rollicking boyhood that the revelation first bursts upon one, all in a day, as it were. I remember well when the shadow swept across me. I was a little thing, away up in the hills of New England where the dark Housatonic winds between Hoosa and Taghkanic to the sea. In a wee wooden schoolhouse, something put it into the boys' and girls' heads to buy gorgeous visiting cards—ten cents a package—and exchange. The exchange was merry, till one girl, a tall newcomer, refused my card,—refused it peremptorily, with a glance. Then it dawned upon me with a certain suddenness that I was different from the others; or like, mayhap, in heart and life and longing, but shut out from their world by a vast veil. I had thereafter no desire to tear down that veil, to creep through; I held all beyond it in common contempt, and lived above it in a region of blue sky and great wandering shadows. That sky was bluest when I could beat my mates at examination-time, or beat them at foot-race, or even beat their stringy heads. Alas, with the years all this fine contempt began to fade; for the worlds I longed for, and all their dazzling opportunities, were theirs, not mine. But they should not keep these prizes, I said; some, all, I would wrest from them. Just how I would do it I could never decide: by reading law, by healing the sick, by telling the wonderful tales that swam in my head,—some way. With other black boys the strife was not so fiercely sunny: their youth shrunk into tasteless sycophancy, or into silent hatred of the pale world about them and mocking distrust of everything white; or wasted itself in a bitter cry, Why did God make me an outcast and a stranger in mine own house? The shades of the prison-house closed round about us all: walls strait and stubborn to the whitest, but relentlessly narrow, tall, and unscalable to sons of night who must plod darkly on in resignation, or beat unavailing palms against the stone, or steadily, half hopelessly, watch the streak of blue above.

After the Egyptian and Indian, the Greek and Roman, the Teuton and Mongolian, the Negro is a sort of seventh son, born with a veil, and gifted with a second-sight in this American world,—a world which yields him no true self-consciousness, but only lets him see himself through the revelation of the other world. It is a peculiar sensation, this double-consciousness, this sense of always looking at one's self through the eyes of others, of measuring one's soul by the tape of a world that looks on in amused contempt and pity. One ever feels his twoness,—an American, a Negro; two souls,

two thoughts, two unreconciled strivings; two warring ideals in one dark body, whose dogged strength alone keeps it from being torn asunder.

The history of the American Negro is the history of this strife,—this longing to attain self-conscious manhood, to merge his double self into a better and truer self. In this merging he wishes neither of the older selves to be lost. He would not Africanize America, for America has too much to teach the world and Africa. He would not bleach his Negro soul in a flood of white Americanism, for he knows that Negro blood has a message for the world. He simply wishes to make it possible for a man to be both a Negro and an American, without being cursed and spit upon by his fellows, without having the doors of Opportunity closed roughly in his face.

This, then, is the end of his striving: to be a co-worker in the kingdom of culture, to escape both death and isolation, to husband and use his best powers and his latent genius. These powers of body and mind have in the past been strangely wasted, dispersed, or forgotten. The shadow of a mighty Negro past flits through the tale of Ethiopia the Shadowy and of Egypt the Sphinx. Throughout history, the powers of single black men flash here and there like falling stars, and die sometimes before the world has rightly gauged their brightness. Here in America, in the few days since Emancipation, the black man's turning hither and thither in hesitant and doubtful striving has often made his very strength to lose effectiveness, to seem like absence of power, like weakness. And yet it is not weakness,—it is the contradiction of double aims. The double-aimed struggle of the black artisan—on the one hand to escape white contempt for a nation of mere hewers of wood and drawers of water, and on the other hand to plough and nail and dig, for a poverty-stricken horde—could only result in making him a poor craftsman, for he had but half a heart in either cause. By the poverty and ignorance of his people, the Negro minister or doctor was tempted toward quackery and demagogy; and by the criticism of the other world, toward ideals that made him ashamed of his lowly tasks. The would-be black *savant* was confronted by the paradox that the knowledge his people needed was a twice-told tale to his white neighbors, while the knowledge which would teach the white world was Greek to his own flesh and blood. The innate love of harmony and beauty that set the ruder souls of his people a-dancing and a-singing raised but confusion and doubt in the soul of the black artist; for the beauty revealed to him was the soul-beauty of a race which his larger audience despised, and he could not articulate the message of another people. This waste of double aims, this seeking to satisfy two unreconciled ideals, has wrought sad havoc with the courage and faith and deeds of ten thousand people,—has sent them often wooing false gods and invoking false means of salvation, and at times has even seemed about to make them ashamed of themselves.

Away back in the days of bondage they thought to see in one divine event the end of all doubt and disappointment; few men ever worshipped Freedom with half such unquestioning faith as did the American Negro for two centuries. To him, so far as he thought and dreamed, slavery was indeed the sum of all villainies, the cause of all sorrow, the root of all prejudice; Emancipation was the key to a promised land of sweeter beauty than ever stretched before the eyes of wearied Israelites. In song and exhortation swelled one refrain—Liberty; in his tears and curses the God he implored had Freedom in his right hand. At last it came,—suddenly, fearfully, like a dream. With one wild carnival of blood and passion came the message in his own plaintive cadences:—

"Shout, O children!
Shout, you're free!
For God has bought your liberty!"

Years have passed away since then,—ten, twenty, forty; forty years of national life, forty years of renewal and development, and yet the swarthy spectre sits in its accustomed seat at the Nation's feast. In vain do we cry to this our vastest social problem:—

"take any shape but that, and my firm nerves
shall never tremble!"

The Nation has not yet found peace from its sins; the freedman has not yet found in freedom his promised land. Whatever of good may have come in these years of change, the shadow of a deep disappointment rests upon the Negro people,—a disappointment all the more bitter because the unattained ideal was unbounded save by the simple ignorance of a lowly people.

The first decade was merely a prolongation of the vain search for freedom, the boon that seemed ever barely to elude their grasp,—like a tantalizing will- o'-the-wisp, maddening and misleading the leadless host. The holocaust of war, the terrors of the Ku Klux Klan, the lies of carpetbaggers, the disorganization of industry, and the contradictory advice of friends and foes, left the bewildered serf with no new watchword beyond the old cry for freedom. As the time flew, however, he began to grasp a new idea. The ideal of liberty demanded for its attainment powerful means, and these the Fifteenth Amendment gave him. The ballot, which before he had looked upon as a visible sign of freedom, he now regarded as the chief means of gaining and perfecting the liberty with which war had partially endowed him. And why not? Had not votes enfranchised the freedmen? Was anything impossible to a power that had done all this? A million black men started with renewed zeal to vote themselves into the kingdom. So the decade flew away, the revolution of 1876 came, and left the half-free serf weary, wondering, but still inspired. Slowly but steadily, in the following years, a new vision began gradually to replace the dream of political power,—a powerful movement, the rise of another ideal

to guide the unguided, another pillar of fire by night after a clouded day. It was the ideal of "booklearning"; the curiosity, born of compulsory ignorance, to know and test the power of the cabalistic letters of the white man, the longing to know. Here at last seemed to have been discovered the mountain path to Canaan; longer than the highway of Emancipation and law, steep and rugged, but straight, leading to heights high enough to overlook life.

Up the new path the advance guard toiled, slowly, heavily, doggedly; only those who have watched and guided the faltering feet, the misty minds, the dull understandings, of the dark pupils of these schools know how faithfully, how piteously, this people strove to learn. It was weary work. The cold statistician wrote down the inches of progress here and there, noted also where here and there a foot had slipped or someone had fallen. To the tired climbers, the horizon was ever dark, the mists were often cold, the Canaan was always dim and far away. If, however, the vistas disclosed as yet no goal, no resting-place, little but flattery and criticism, the journey at least gave leisure for reflection and self-examination; it changed the child of Emancipation to the youth with dawning self-consciousness, self-realization, self-respect. In those sombre forests of his striving his own soul rose before him, and he saw himself,—darkly as through a veil; and yet he saw in himself some faint revelation of his power, of his mission. He began to have a dim feeling that, to attain his place in the world, he must be himself, and not another. For the first time he sought to analyze the burden he bore upon his back, that dead-weight of social degradation partially masked behind a half-named Negro problem. He felt his poverty; without a cent, without a home, without land, tools, or savings, he had entered into competition with rich, landed, skilled neighbors. To be a poor man is hard, but to be a poor race in a land of dollars is the very bottom of hardships. He felt the weight of his ignorance,—not simply of letters, but of life, of business, of the humanities; the accumulated sloth and shirking and awkwardness of decades and centuries shackled his hands and feet. Nor was his burden all poverty and ignorance. The red stain of bastardy, which two centuries of systematic legal defilement of Negro women had stamped upon his race, meant not only the loss of ancient African chastity, but also the hereditary weight of a mass of corruption from white adulterers, threatening almost the obliteration of the Negro home.

A people thus handicapped ought not to be asked to race with the world, but rather allowed to give all its time and thought to its own social problems. But alas! While sociologists gleefully count his bastards and his prostitutes, the very soul of the toiling, sweating black man is darkened by the shadow of a vast despair. Men call the shadow prejudice, and learnedly explain it as the natural defence of culture against barbarism, learning against ignorance, purity against crime, the "higher"

against the "lower" races. To which the Negro cries Amen! and swears that to so much of this strange prejudice as is founded on just homage to civilization, culture, righteousness, and progress, he humbly bows and meekly does obeisance. But before that nameless prejudice that leaps beyond all this he stands helpless, dismayed, and well-nigh speechless; before that personal disrespect and mockery, the ridicule and systematic humiliation, the distortion of fact and wanton license of fancy, the cynical ignoring of the better and the boisterous welcoming of the worse, the all-pervading desire to inculcate disdain for everything black, from Toussaint to the devil,—before this there rises a sickening despair that would disarm and discourage any nation save that black host to whom "discouragement" is an unwritten word.

But the facing of so vast a prejudice could not but bring the inevitable self-questioning, self-disparagement, and lowering of ideals which ever accompany repression and breed in an atmosphere of contempt and hate. Whisperings and portents came borne upon the four winds: Lo! we are diseased and dying, cried the dark hosts; we cannot write, our voting is vain; what need of education, since we must always cook and serve? And the Nation echoed and enforced his self-criticism, saying: Be content to be servants, and nothing more; what need of higher culture for half-men? Away with the black man's ballot, by force or fraud,—and behold the suicide of a race! Nevertheless, out of the evil came something of good,—the more careful adjustment of education to real life, the clearer perception of the Negroes' social responsibilities, and the sobering realization of the meaning of progress.

So dawned the time of *Sturm and Drang:* Storm and stress to-day rocks our little boat on the mad waters of the world-sea; there is within and without the sound of conflict, the burning of body and rending of soul; inspiration strives with doubt, and faith with vain questionings. The bright ideals of the past,—physical freedom, political power, the training of brains and the training of hands,—all these in turn have waxed and waned, until even the last grows dim and overcast. Are they all wrong,—all false? No, not that, but each alone was over-simple and incomplete,—the dreams of a credulous race-childhood, or the fond imaginings of the other world which does not know and does not want to know our power. To be really true, all these ideals must be melted and welded into one. The training of the schools we need to-day more than ever,—the training of deft hands, quick eyes and ears, and above all the broader, deeper, higher culture of gifted minds and pure hearts. The power of the ballot we need in sheer self-defence,—else what shall save us from a second slavery? Freedom, too, the long-sought, we still seek,—the freedom of life and limb, the freedom to work and think, the freedom to love and aspire. Work, culture, liberty,—all these we need, not singly but together, not successively but together, each growing and aiding each,

and all striving toward that vaster ideal that swims before the Negro people, the ideal of human brotherhood, gained through the unifying ideal of Race; the ideal of fostering and developing the traits and talents of the Negro, not in opposition to or contempt for other races, but rather in large conformity to the greater ideals of the American Republic, in order that some day on American soil two world-races may give each to each those characteristics both so sadly lack. We the darker ones come even now not altogether empty-handed: there are today no truer exponents of the pure human spirit of the Declaration of Independence than the American Negroes; there is no true American music but the wild sweet melodies of the Negro slave; the American fairy tales and folklore are Indian and African; and, all in all, we black men seem the sole oasis of simple faith and reverence in a dusty desert of dollars and smartness. Will America be poorer if she replace her brutal dyspeptic blundering with light-hearted but determined Negro humility? or her coarse and cruel wit with loving jovial good-humor? or her vulgar music with the soul of the Sorrow Songs?

Merely a concrete test of the underlying principles of the great republic is the Negro Problem, and the spiritual striving of the freedmen's sons is the travail of souls whose burden is almost beyond the measure of their strength, but who bear it in the name of an historic race, in the name of this the land of their fathers' fathers, and in the name of human opportunity.

And now what I have briefly sketched in large outline, let me on coming pages tell again in many ways, with loving emphasis and deeper detail, that men may listen to the striving in the souls of black folk.

Revival meetings almost always included the singing of spirituals. During the ritual, the believer is reborn, the sinner is saved, and the unbaptized is washed in the waters and consecrated to God's service. The Revival or Big Meeting was often the only kind of gathering the slave was able to attend. Like the log-burning at Christmas time—the bigger the log the longer the holiday—it represented some time away from toil, some temporary freedom from drudgery. The tradition persisted after emancipation and continues today.

James Weldon Johnson describes a Big Meeting in his novel, *The Autobiography of an Ex-Colored Man,* published anonymously in 1912. The protagonist, whose father is a southern white man and his mother a black woman, has decided at this point in the story not only to identify with his mother's race but also to record and publicize the musical culture of the Afro-American. He is traveling in the South and finds a wealth of material in the revival "festivities." Young people are dressed in their best, food—especially fried chicken and roast pork—is

plentiful, and famous preachers come from miles around to "take turns warning sinners of the day of wrath." The drama of the ceremony, the sermon, comes first and then the music:*

This big meeting which I was lucky enough to catch was particularly well attended; the extra large attendance was due principally to two attractions, a man by the name of John Brown, who was renowned as the most powerful preacher for miles around; and a wonderful leader of singing, who was known as "Singing Johnson." These two men were a study and a revelation to me. They caused me to reflect upon how great an influence their types have been in the development of the Negro in America. . . .

John Brown was a jet-black man of medium size, with a strikingly intelligent head and face, and a voice like an organ peal. He preached each night after several lesser lights had successively held the pulpit during an hour or so. As far as subject-matter is concerned, all of the sermons were alike: each began with the fall of man, ran through various trials and tribulations of the Hebrew children, on to the redemption by Christ, and ended with a fervid picture of the judgment-day and the fate of the damned. But John Brown possessed magnetism and an imagination so free and daring that he was able to carry through what the other preachers would not attempt. He knew all the arts and tricks of oratory, the modulation of the voice to almost a whisper, the pause for effect, the rise through light, rapid-fire sentences to the terrific, thundering outburst of an electrifying climax. In addition, he had the intuition of a born theatrical manager. Night after night this man held me fascinated. He convinced me that, after all, eloquence consists more in the manner of saying than in what is said. It is largely a matter of tone pictures.

The most striking example of John Brown's magnetism and imagination was his "heavenly march"; I shall never forget how it impressed me when I heard it. He opened his sermon in the usual way; then, proclaiming to his listeners that he was going to take them on the heavenly march, he seized the Bible under his arm and began to pace up and down the pulpit platform. The congregation immediately began with their feet a tramp, tramp, tramp, in time with the preacher's march in the pulpit, all the while singing in an undertone a hymn about marching to Zion. Suddenly he cried: "Halt!" Every foot stopped with the precision of a company of well-drilled soldiers, and the singing ceased. The morning star had been reached. Here the preacher described the beauties of that celestial body. Then the march, the tramp, tramp, tramp, and the singing were again taken up. Another "Halt!" They had reached the evening star. And so on, past the sun and moon—the intensity of religious emotion all the time increasing—along the milky way, on up to the gates of heaven. Here the halt was longer, and the preacher described at length the

gates and walls of the New Jerusalem. Then he took his hearers through the pearly gates, along the golden streets, pointing out the glories of the city, pausing occasionally to greet some patriarchal member of the church, well-known to most of his listeners in life, who had had, "the tears wiped from their eyes, were clad in robes of spotless white, with crowns of gold upon their heads and harps within their hands," and ended his march before the great white throne. To the reader this may sound ridiculous, but listened to under the circumstances, it was highly and effectively dramatic. I was more or less a sophisticated and non-religious man of the world, but the torrent of the preacher's words, moving with the rhythm and glowing with the eloquence of primitive poetry, swept me along, and I, too, felt like joining in the shouts of "Amen! Hallelujah!"

John Brown's powers in describing the delights of heaven were no greater than those in depicting the horrors of hell. I saw great, strapping fellows trembling and weeping like children at the "mourners bench." His warnings to sinners were truly terrible. I shall never forget one expression that he used, which for originality and aptness could not be excelled. In my opinion, it is more graphic and, for us, far more expressive that St. Paul's "It is hard to kick against the pricks." He struck the attitude of a pugilist and thundered out: "Young man, your arm's too short to box with God!"

Interesting as was John Brown to me, the other man, "Singing Johnson," was more so. He was a small, dark-brown, one-eyed man, with a clear, strong, high-pitched voice, a leader of singing, a maker of songs, a man who could improvise at the moment lines to fit the occasion. Not so striking a figure as John Brown, but, at "big meetings," equally important. It is indispensable to the success of the singing, when the congregation is a large one made up of people from different communities, to have someone with a strong voice who knows just what hymn to sing and when to sing it, who can pitch it in the right key, and who has all the leading lines committed to memory. Sometimes it devolves upon the leader to "sing down" a long-winded or uninteresting speaker. Committing to memory the leading lines of all the Negro spiritual songs is no easy task, for they run into the hundreds. But the accomplished leader must know them all, because the congregation sings only the refrains and repeats; every ear in the church is fixed upon him, and if he becomes mixed in his lines or forgets them, the responsibility falls directly on his shoulders.

For example, most of these hymns are constructed to be sung in the following manner:

*From *The Autobiography of an Ex-Colored Man* by James Weldon Johnson. Copyright 1927 by Alfred A. Knopf, Inc., and renewed 1955 by Carl Van Vechten. Reprinted by permission of Alfred A. Knopf, Inc.

Leader. Swing low, sweet chariot.
Congregation. Coming for to carry me home.
Leader. Swing low, sweet chariot.
Congregation. Coming for to carry me home.
Leader. I look over yonder, what do I see?
Congregation. Coming for to carry me home.
Leader. Two little angels coming after me.
Congregation. Coming for to carry me home. . . .

The solitary and plaintive voice of the leader is answered by a sound like the roll of the sea, producing a most curious effect.

In only a few of these songs do the leader and the congregation start off together. Such a song is the well-known "Steal away to Jesus."

The leader and the congregation begin with part-singing:

Steal away, steal away,
Steal away to Jesus;
Steal away, steal away home,
I ain't got long to stay here.

Then the leader alone or the congregation in unison:

My Lord he calls me,
He calls me by the thunder,
The trumpet sounds within-a my soul.

Then all together:

I ain't got long to stay here.

The leader and the congregation again take up the opening refrain; then the leader sings three more leading lines alone, and so on almost ad infinitum. It will be seen that even here most of the work falls upon the leader, for the congregation sings the same lines over and over, while his memory and ingenuity are taxed to keep the songs going.

Generally the parts taken up by the congregation are sung in a three-part harmony, the women singing the soprano and a transposed tenor, the men with high voices singing the melody, and those with low voices a thundering bass. In a few of these songs, however, the leading part is sung in unison by the whole congregation, down to the last line, which is harmonized. The effect of this is intensely thrilling. Such a hymn is "Go down, Moses." It stirs the heart like a trumpet-call.

"Singing Johnson" was an ideal leader, and his services were in great demand. He spent his time going about the country from one church to another. He received his support in much the same way as the preachers—part of a collection, food and lodging. All of his leisure time he devoted to originating new words and melodies and new lines for old songs. He always sang with his eyes—or, to be more exact, his eye—closed, indicating the tempo by swinging his head to and fro. He was a great judge of the proper hymn to sing at a particular moment, and I noticed several times, when the preacher reached a certain climax, or expressed a certain sentiment, that Johnson broke in with a line or two of some appropriate hymn. The speaker understood and would pause until the singing ceased.

As I listened to the singing of these songs, the wonder of their production grew upon me more and more. How did the men who originated them manage to do it? The sentiments are easily accounted for; they are mostly taken from the Bible; but the melodies, where did they come from? Some of them so weirdly sweet, and others so wonderfully strong. Take, for instance, "Go down, Moses." I doubt that there is a stronger theme in the whole musical literature of the world. And so many of these songs contain more than mere melody; there is sounded in them that elusive undertone, the note in music which is not heard with the ears. I sat often with the tears rolling down my cheeks and my heart melted within me. Any musical person who has never heard a Negro congregation under the spell of religious fervour sing these old songs has missed one of the most thrilling emotions which the human heart may experience. Anyone who without shedding tears can listen to Negroes sing "Nobody knows de trouble I see, Nobody knows but Jesus" must indeed have a heart of stone.

The influence of the Church as a spiritual and culturally binding force is vividly portrayed in James Baldwin's novel *Go Tell It on the Mountain* (1953). Not only does Baldwin use a spiritual as title for the book, he introduces each of his chapters with excerpts from gospel and spiritual texts. This is significant for two reasons: (1) it emphasizes the extent to which music has been a cultural force in the lives of black Americans and (2) it illustrates Baldwin's recognition of the need to compensate for the inherent inadequacy of words to convey the essence of a lifestyle that is so active and emotionally responsive to life.

The novel focuses on the life of Johnny Grimes and his immediate family, their involvement with the church as a social and spiritual force, the struggle for individual fulfillment, and the striving to meet family and parental expectations. Yet, it is what Baldwin does not say but alludes to that aids the reader in a deeper understanding of the plight of Johnny. For Baldwin the introductory texts themselves are not as important as what they suggest in terms of the situations that gave them birth—the heat of emotional and spiritual fervor, the travail of the preacher as he moves toward the climax of the sermon, the walk to the mourner's bench to seek the Lord and the ultimate plunge into a spiritual abyss emerging reborn. The essence of these episodes Baldwin captures in his title. Each verse of the spiritual encompasses the

emotion of the protagonist: seeking, telling and eventually finding.

1. When I was a seeker,
 I sought both night an' day
 I ask' de Lord to help me,
 An' He show me de way.

 Go tell it on de mountain,
 Ober de hills an' eberywhere;
 Go tell it on de mountain
 Dat Jedus Chris' is a-born

2. He choose me for a watchman,
 And placed me on de wall,
 An' if I am a Christian,
 I am de least ob all

3. In de time of David,
 Some call' Him a King,
 And if a chil' is true born,
 Massa Jedus will hear him sing.

For the individual who has been caught in the spiritual fervor of an evangelistic service, it is easy to speak about the atmosphere which creates the music and vice versa. Congregational singing is not merely a time-filler. The act of singing represents a communal effort by the people to give praise to Him who has helped them safely through another week with all its ups and downs. This Creator, this Ever-present Help in times of trouble, is very near and real to them. Their vocal praise becomes highly personalized because they speak to him in everyday terms. His power and might are expressed not only in terms of what He is able to do or what they want Him to do, but in terms of what He has already done, as in "I've Got to Tell It":

I've got to tell it, Got to tell it.
Got to tell you how Jesus changed my life,
I've got to tell it—got to tell it—
Got to tell you how Jesus changes my life.[9]

Thus, the effect of the music is the result of each individual contributing the essence of all his experiences—his sorrows, hopes, fears, anxieties and redemption—in relationship to this. Thus, the participant is at once an individual, yet Everyman. This makes the songs live and establishes the universal appeal of the music.

Thus, Baldwin's book which has some elements of individual autobiography, is autobiographical for everyone who has at one time been involved with the religious aspect of black culture.

GO TELL IT ON THE MOUNTAIN*

Everyone had always said that John would be a preacher when he grew up, just like his father. It had been said so often that John, without ever thinking about it, had come to believe it himself. Not until the morning of his fourteenth birthday did he really begin to think about it, and by then it was already too late.

His earliest memories—which were in a way, his only memories—were of the hurry and brightness of Sunday mornings. They all rose together on that day; his father, who did not have to go to work, and led them in prayer before breakfast; his mother, who dressed up on that day, and looked almost young, with her hair straightened, and on her head the close-fitting white cap that was the uniform of holy women; his younger brother, Roy, who was silent that day because his father was home. Sarah, who wore a red ribbon in her hair that day, and was fondled by her father. And the baby, Ruth, who was dressed in pink and white, and rode in her mother's arms to church.

The church was not very far away, four blocks up Lenox Avenue, on a corner not far from the hospital. It was to this hospital that his mother had gone when Roy, and Sarah, and Ruth were born. John did not remember very clearly the first time she had gone, to have Roy; folks said that he had cried and carried on the whole time his mother was away; he remembered only enough to be afraid every time her belly began to swell, knowing that each time the swelling began it would not end until she was taken from him, to come back with a stranger. Each time this happened she became a little more of a stranger herself. She would soon be going away again, Roy said—he knew much more about such things than John. John had observed his mother closely, seeing no swelling yet, but his father had prayed one morning for the 'little voyager soon to be among them,' and so John knew that Roy spoke the truth.

Every Sunday morning, then, since John could remember, they had taken to the streets, the Grimes family on their way to church. Sinners along the avenue watched them—men still wearing their Saturday-night clothes, wrinkled and dusty now, muddy-eyed and muddy-faced; and women with harsh voices and tight, bright dresses, cigarettes between their fingers or held tightly in the corners of their mouths. They talked, and

*Excerpt from Go Tell It on the Mountain by James Baldwin. Reprinted by permission of the author.

9. Aleta Robinson, "I've Got to Tell It." The New National Baptist Special Five-In-One Song Book for Use in all Christian Religious Services. Lucie E. Campbell, Superior, E. W. D. Isaac, Convention. Chicago: Holt Music House and Publishers, Inc.

laughed, and fought together, and the women fought like the men. John and Roy, passing these men and women, looked at one another briefly, John embarrassed and Roy amused. Roy would be like them when he grew up, if the Lord did not change his heart. These men and women they passed on Sunday mornings had spent the night in bars, or in cat houses, or on the streets, or on rooftops, or under the stairs. They had been drinking. They had gone from cursing to laughter, to anger, to lust. Once he and Roy had watched a man and woman in the basement of a condemned house. They did it standing up. The woman had wanted fifty cents, and the man had flashed a razor.

John had never watched again; he had been afraid. But Roy had watched them many times, and he told John he had done it with some girls down the block.

And his mother and father, who went to church on Sundays, they did it too, and sometimes John heard them in the bedroom behind him, over the sound of rat's feet, and rat screams, and the music and cursing from the harlot's house downstairs.

Their church was called the *Temple of the Fire Baptized*. It was not the biggest church in Harlem, nor yet the smallest, but John had been brought up to believe it was the holiest and best. His father was head deacon in this church—there were only two, the other a round, black man named Deacon Braithwaite—and he took up the collection, and sometimes he preached. The pastor, Father James, was a genial, well-fed man with a face like a darker moon. It was he who preached on Pentecost Sundays, and led revivals in the summer-time, and anointed and healed the sick.

On Sunday mornings and Sunday nights the church was always full; on special Sundays it was full all day. The Grimes family arrived in a body, always a little late, usually in the middle of Sunday school, which began at nine o'clock. This lateness was always their mother's fault—at least in the eyes of their father; she could not seem to get herself and the children ready on time, ever, and sometimes she actually remained behind, not to appear until the morning service. When they all arrived together, they separated upon entering the doors, father and mother going to sit in the Adult Class, which was taught by Sister McCandless, Sarah going to the Infants' Class, John and Roy sitting in the Intermediate, which was taught by Brother Elisha.

When he was young, John had paid no attention in Sunday school, and always forgot the golden text, which earned him the wrath of his father. Around the time of his fourteenth birthday, with all the pressures of church and home uniting to drive him to the altar, he strove to appear more serious and therefore less conspicuous. But he was distracted by his new teacher, Elisha, who was the pastor's nephew and who had but lately arrived from Georgia. He was not much older than John, only seventeen, and he was already saved and was a preacher. John stared at Elisha all during the lesson, admiring the timbre of Elisha's voice, much deeper and manlier than his own, admiring the leanness, and grace, and strength, and darkness of Elisha in his Sunday suit, wondering if he would ever be holy as Elisha was holy. But he did not follow the lesson, and when sometimes, Elisha paused to ask John a question, John was ashamed and confused, feeling the palms of his hands become wet and his heart pound like a hammer. Elisha would smile and reprimand him gently, and the lesson would go on.

Roy never knew his Sunday school lesson either, but it was different with Roy—no one really expected of Roy what was expected of John. Everyone was always praying that the Lord would change Roy's heart, but it was John who was expected to be good, to be a good example.

When Sunday school service ended there was a short pause before morning service began. In this pause, if it was good weather, the old folks might step outside a moment to talk among themselves. The sisters would almost always be dressed in white from crown to toe. The small children, on this day, in this place, and oppressed by their elders, tried hard to play without seeming to be disrespectful of God's house. But sometimes, nervous or perverse, they shouted, or threw hymnbooks, or began to cry, putting their parents, men or women of God, under the necessity of proving—by harsh means or tender—who, in the sanctified household, ruled. The older children, like John or Roy, might wander down the avenue, but not too far. Their father never let John and Roy out of his sight, for Roy had often disappeared between Sunday school and morning service and had not come back all day.

The Sunday morning service began when Brother Elisha sat down at the piano and raised a song. This moment and this music had been with John, so it seemed, since he had first drawn breath. It seemed that there had never been a time when he had not known this moment of waiting while the packed church paused—the sisters in white, heads raised, the brothers in blue, heads back; the white caps of the women seeming to glow in the charged air like crowns, the kinky, gleaming heads of the men seeming to be lifted up—and the rustling and the whispering ceased and the children were quiet; perhaps someone coughed, or the sound of a car horn, or a curse from the streets came in; then Elisha hit the keys, beginning at once to sing, and everybody joined him, clapping their hands, and rising, and beating the tambourines.

The song might be: *Down at the cross where my Savior died!*

Or: *Jesus, I'll never forget how you set me free!*

Or: *Lord, hold my hand while I run this race!*

They sang with all the strength that was in them, and clapped their hands for joy. There had never been a time when John had not sat watching the saints rejoice with terror in his heart, and wonder. Their singing caused him to believe in the presence of the Lord; indeed, it was no longer a question of belief, because they made that presence real. He did not feel it himself, the joy they

felt, yet he could not doubt that it was, for them, the very bread of life—could not doubt it, that is, until it was too late to doubt. Something happened to their faces and their voices, the rhythm of their bodies, and to the air they breathed; it was as though wherever they might be became the upper room, and the Holy Ghost were riding on the air. His father's face, always awful, became more awful now; his father's daily anger was transformed into prophetic wrath. His mother, her eyes raised to heaven, hands arked before her, moving, made real for John that patience, that endurance, that long suffering, which he had read of in the Bible and found so hard to imagine.

On Sunday mornings the women all seemed patient, all the men seemed mighty. While John watched, the Power struck someone, a man or woman; they cried out, a long, wordless crying, and, arms outstretched like wings, they began the Shout. Someone moved a chair a little to give them room, the rhythm paused, the singing stopped, only the pounding feet and the clapping hands were heard; then another cry, another dancer; then the tambourines began again, and the voices rose again, and the music swept on again, like fire, or flood, or judgment. Then the church seemed to swell with the Power it held, and, like a planet rocking in space, the temple rocked with the Power of God. John watched, watched the faces, and the weightless bodies, and listened to the timeless cries. One day, so everyone said, this Power would possess him; he would sing and cry as they did now, and dance before his King. He watched young Ella Mae Washington, the seventeen-year-old granddaughter of Praying Mother Washington, as she began to dance. And then Elisha danced.

At one moment, head thrown back, eyes closed, sweat standing on his brow, he sat at the piano, singing and playing; and then, like a great black cat in trouble in the jungle, he stiffened and trembled, and cried out. *Jesus, Jesus, oh Lord Jesus!* He struck on the piano one last, wild note, and threw up his hands, palms upward, stretched wide apart. The tambourines raced to fill the vacuum left by his silent piano, and his cry drew answering cries. Then he was on his feet, turning, blind, his face congested, contorted with this rage, and the muscles leaping and swelling in his long, dark neck. It seemed that he could not breathe, that his body could not contain this passion, that he would be, before their eyes, dispersed into the waiting air. His hands, rigid to the very fingertips, moved outward and back against his hips, his sightless eyes looked upward, and he began to dance. Then his hands closed into fists, and his head snapped downward, his sweat loosened the grease that slicked down his hair; and the rhythm of all the others quickened to match Elisha's rhythm; his thighs moved terribly against the cloth of his suit, his heels beat on the floor, and his fists moved beside his body as though he were beating his own drum. And so, for a while, in the centre of the dancers, head down, fists beating, on, on, unbearably, until it seemed the walls of the church would fall for very sound; and then, in a moment, with a cry, head up, arms high in the air, sweat pouring from his forehead, and all his body dancing as though it would never stop. Sometimes he did not stop until he fell—until he dropped like some animal felled by a hammer—moaning, on his face. And then a great moaning filled the church.

There was sin among them. One Sunday, when regular service was over, Father James had uncovered sin in the congregation of the righteous. He had uncovered Elisha and Ella Mae. They had been "walking disorderly"; they were in danger of straying from the truth. And as Father James spoke of the sin that he knew they had not committed yet, of the unripe fig plucked too early from the tree—to set the children's teeth on edge—John felt himself grow dizzy in his seat and could not look at Elisha where he stood, beside Ella Mae, before the altar. Elisha hung his head as Father James spoke, and the congregation murmured. And Ella Mae was not so beautiful now as she was when she was singing and testifying, but looked like a sullen, ordinary girl. Her full lips were loose and her eyes were black—with shame, or rage, or both. Her grandmother, who had raised her, sat watching quietly, with folded hands. She was one of the pillars of the church, a powerful evangelist and very widely known. She said nothing in Ella Mae's defence, for she must have felt, as the congregation felt, that Father James was only exercising his clear and painful duty; he was responsible, after all, for Elisha, as Praying Mother Washington was responsible for Ella Mae. It was not an easy thing, said Father James, to be the pastor of a flock. It might look easy to just sit up there in the pulpit night after night, year in, year out, but let them remember the awful responsibility placed on his shoulders by almighty God—let them remember that God would ask an accounting of him one day for every soul in his flock. Let them remember this when they thought he was hard, let them remember that the Word was hard, that the way of holiness was a hard way. There was no room in God's army for the coward heart, no crown awaiting him who put mother, or father, sister, or brother, sweetheart, or friend above God's will. Let the church cry amen to this! And they cried: "Amen! Amen!"

The Lord had led him, said Father James, looking down on the boy and girl before him, to give them a public warning before it was too late. For he knew them to be sincere young people, dedicated to the service of the Lord—it was only that, since they were young, they did not know the pitfalls Satan laid for the unwary. He knew that sin was not in their minds—not yet; yet sin was in the flesh; and should they continue with their walking out alone together, their secrets and laughter, and touching of hands, they would surely sin a sin beyond all forgiveness. And John wondered what Elisha was thinking—Elisha, who was tall and handsome, who played basketball, and who had been saved at the age of eleven in the improbable fields down south. *Had* he

sinned? Had he been tempted? And the girl beside him, whose white robes now seemed the merest, thinnest covering for the nakedness of breasts and insistent thighs— what was her face like when she was alone with Elisha, with no singing, when they were not surrounded by the saints? He was afraid to think of it, yet he could think of nothing else; and the fever of which they stood accused began also to rage in him.

After this Sunday Elisha and Ella Mae no longer met each other each day after school, no longer spent Saturday afternoons wandering through Central Park, or lying on the beach. All that was over for them. If they came together again it would be in wedlock. They would have children and raise them in the church.

This was what was meant by a holy life, this was what the way of the cross demanded. It was somehow on that Sunday, a Sunday shortly before his birthday, that John first realized that this was the life awaiting him— realized it consciously, as something no longer far off, but imminent, coming closer day by day.

Sterling Brown's "Strong Men" from *Southern Road* (1932) incorporates lines from some of the spirituals already discussed. Notice how the poet unifies the poem through the use of these lines and the recurring theme from Carl Sandburg: "The strong men keep coming on." The repetition of that line and the parallel structure of the major stanzas— "They dragged; they chained; they huddled"—move the poem toward an undeniable conclusion. All the assaults on black people lead paradoxically to a growing strength; this is a people that begins strong and gets stronger in spite of all the breaking, the scourging, the branding, the hemming in and the prohibitions: the shalt nots.

STRONG MEN*

The strong men keep coming on.
Sandburg.

They dragged you from homeland,
They chained you in coffles,
They huddled you spoon-fashion in filthy hatches,
They sold you to give a few gentlemen ease.

They broke you in like oxen,
They scourged you,
They branded you.
They made your women breeders,
They swelled your number with bastards. . . .
They taught you the religion they disgraced.

You sang:
 Keep a-inchin' along
 Lak a po' inch worm. . . .

You sang:
 Bye and bye
 I'm gonna lay down dis heaby load. . . .

You sang:
 Walk togedder, chillen,
 Dontcha git weary. . . .
 The strong men keep a-comin' on
 The strong men git stronger.

They point with pride to the roads you built for them,
They ride in comfort over the rails you laid for them.
They put hammers in your hands
And said—Drive so much before sundown.

You sang:
 Ain't no hammah
 In dis lan',
 Strikes lak mine, bebby
 Strikes lak mine.

They cooped you in their kitchens,
They penned you in their factories,
They gave you the jobs that they were too good for,
They tried to guarantee happiness to themselves
By shunting dirt and misery to you.

You sang:
 Me an' muh baby gonna shine, shine
 Me an' muh baby gonna shine.
 The strong men keep a-comin' on
 The strong men git stronger. . . .

They bought off some of your leaders
You stumbled, as blind men will . . .
They coaxed you, unwontedly soft-voiced. . . .
You followed a way.
Then laughed as usual.

They heard the laugh and wondered;
Uncomfortable;
Unadmitting a deeper terror. . . .
 The strong men keep a-comin' on
 Gittin' stronger . . .

What, from the slums
Where they have hemmed you,
What, from the tiny huts
They could not keep from you—
What reaches them
Making them ill at ease, fearful?
Today they shout prohibition at you
"Thou shalt not this"
"Thou shalt not that"
"Reserved for whites only"
You laugh.

One thing they cannot prohibit—
 The strong men . . . coming on

*"Strong Men" by Sterling Brown from *Southern Road,* reprinted by permission of the author.

The strong men gittin' stronger.
Strong men. . . .
Stronger. . . .

John Oliver Killens' novel *Youngblood* (1954) opens with the birth of the twentieth century and the birth of Laurie Lee Barksdale who later marries Joe Youngblood. Their family is the center of the novel, and the reality of their existence is often brutal and ugly. Yet the novel is a celebration of life, of blackness, love and strength. Killens uses the spiritual to point up the theme and significance of each section of the novel, as well as to show the importance of black music in the lives of the people.

Part I. In The Beginning
Didn't my Lord deliver Daniel
And why not everyman?—

> From: "Didn't My Lord Deliver Daniel"

Part II. No Hiding Place
I went to the rock to hide my face
The rock cried out—No hiding place—

> From: "No Hiding Place"

Part III. Jubilee
One of these mornings about five o'clock
This old world's gonna reel and rock
Pharoah's Army go drowned—

> From: "Oh Mary Don't You Weep"

Part IV. The Beginning
And before I'd be a slave
I'd be baried in my grave
And go home to my Lord
And be free—

> From: "O Freedom"

The lives of the Youngbloods are a series of births and rebirths, and the structure of the novel grows organically out of this pattern. Death occurs, but it is seen the larger context of spiritual and racial renewal. Therefore, Joe Youngblood's death is not an end but a beginning and it logically appears in the section entitled "The Beginning." The following excerpt is the last chapter of the book. The scene depicts the funeral of Joe Youngblood and the coming of age of his and Laurie Lee's son, Robby. Yet the tone is not funereal. Life will go on, but not as it has in the past. There is a sense that the *quality* of life will be different and better. The language the author uses reflects that change; it is implicit in his description of the growing solidarity and strength of the people.

Notice the tone and pace of the final paragraph in which verbs expressing a sense of community and well being are linked together in a movement that gathers momentum as the sentence builds: "And people *coming* over, strangers and friends, and *shaking* their hands and *hugging* and *kissing* and *giving* them strength. . . ." The last part of the sentence links the eternal cycle of nature with the growing awareness that the people are a part of that continuum: ". . . and over in the west the *sun* going down, and the *moon* would come up and the *moon* would go down and tomorrow the *sun* would come up again."

One needs to read the entire book to appreciate the writer's narrative ability and the artistic technique involved in drawing on the richness of black musical tradition to shape and structure the fictional form.*

Joe Youngblood's funeral was held on a Wednesday afternoon at four o'clock, and the people came from all over the county, all over the state. Colored folk came, and a few white people. They started gathering in the church yard about half past two and before three thirty the church was packed and all downstairs in the Sunday School part, and out in the yard and out on the street, and the sun shone all day long that day.

About four fifteen the big gray hearse pulled up and behind the hearse was the Youngblood family and in front of the hearse the six pall bearers in a big black car and big cars small cars all around the block. The pall bearers took the long gray casket up the church steps. And Rob went up the steps with Mama on one arm and Ida Mae on the other, all of them dressed in black, and Jenny Lee with Augustus Mackey, and Dale Barksdale and Bertha Barksdale from Tipkin, Georgia, and even Laurie Lee's Cousin Mark all the way from Detroit, Michigan, and Richard Myles and Josephine Myles, and Lulabelle Mackey and Sarah Mae Raglin and Benjamin Raglin, and Willabelle Braxton and Ella Mae Braxton and a whole host of other friends and relations. But all of it had an unreal quality to Rob, because he had not yet accepted the fact that his Daddy was dead. All week long ever since it happened he had gone through the motions like a man in a stupor.

That Sunday morning at Willabelle's house when the undertakers first came, he had been the one to talk with them, along with Richard Myles. Then at one point Mama had come into the room and said to everybody in a soft quiet manner, "Let's get ready. We're going to move him back home."

"How about taking the body to the undertaker parlor, Miss Laurie?" Mr. Mansion said.

"I want you to take him to Three Forty-Six, Middle Avenue," Mama said softly and firmly.

"But Miss Laurie Lee—"

"If you don't we will," Mama said quietly. "I want him at home where he's supposed to be." Mama spoke just like Daddy was still alive.

"Yes, Mam, Miss Laurie."

They took him home and embalmed him there and people started coming Sunday evening, and all day Monday, and all day Tuesday the people came to see the family, and was there anything at all that they could do? Just say the word—and to view the body and express their sorrow and anger as well. And flowers came and telegrams too from the Deacon Board of Pleasant Grove Baptist, from the Willing Workers' Club and the Douglass Lodge and the NAACP of Georgia and the Crossroads NAACP, and from Mr. and Mrs. Cross Jr. a mountain of flowers. And also from the workers at the hotel and Dr. Riley from the University.

And they found out that the Klan had burned a cross in their front yard sometime Saturday night and the neighbors had destroyed it and moved it away.

Monday night Oscar and Junior had come and brought some flowers, and when they were leaving they told Rob and Gus they would be at the funeral, but Gus had followed them down the steps and out into the darkness of Middle Avenue. After he walked about a half of a block with them he stopped, and they stopped, waiting. "Excuse me, Oscar," Gus said, "But I don't think you ought to go to the funeral—you and Junior."

"How come, Gus?"

"Well, it's like this here—You don't have to prove nothing to nobody by coming to the funeral."

Oscar waved his hand at a buzzing mosquito. The hot sticky night lay heavy and damp on his face and his neck.

"We ain't trying to prove nothing," Junior said.

"It ain't that," Gus said "It ain't that at all. If a whole heap of white folks were gon be there it would be something else." He paused. "But goddammit, Oscar, we want y'all to bring some more of them white workers at the hotel into the union, but if y'all go to the funeral, y'all ain't gon be able to touch em with a ten foot pole."

Oscar and Junior stood there staring at Gus, not saying a word.

"Good-night, Oscar and you too, Junior," Gus finally said. "Think it over a little bit." And when Gus had gone back to the house he had told Rob about it. And then they remembered the union meeting that had been called for the following night, and Gus said it would naturally have to put off, and he and Bruh would go around and tell everybody and give them a new date. "What you think about Tuesday week?" And Rob thought hard and long but not too long about Tuesday week. He looked around in the backyard at the lightning bugs blinking like crazy and he smelled the washbench, sour and soapy, and he should be ashamed of himself thinking about holding some kind of union meeting tomorrow night and his Daddy lying dead in the front room, but he remembered his Daddy at the breakfast table just last Monday morning and he knew what Daddy had thought of the union and Walk Together Children and maybe he should ask Mama about it, but he was a man now and growing faster than ever before and reaching desperately and angrily for his Daddy's height. "No, Gus, don't put off any meeting. You and Bruh and ask Bill to help you—go around and tell everybody the meeting isn't off. Tell all of them to be there. Tell them all to keep it on the Que-tee." And Gus and Rob had argued quietly about it, till finally Gus said, "Okay—okay. But you don't have to be there. Every little thing will be taken care of."

And now they were sitting in the jam-packed church and it was hot and sticky and fans were waving all over the place and the white-robed choir was singing sweetly:

When they ring those golden bells for you and me
Can't you hear those bells a-ringing
Can't you hear the angels singing
'Tis the glory hallelujah jubilee
In that far off sweet forever
When we cross that shining river
And they ring those golden bells for you and me. . . .

And the warm sweet voices dying away now, singing the chorus softer and softer, and handkerchiefs out all over the church, and he was supposed to be with Mama and give her support, and Mama's nails digging into his shoulders through his dark suit, and it was Daddy lying in that long gray casket with mountains of flowers surrounding him, and he couldn't keep denying it.

Last night Mama seemed to suddenly realize that Daddy was dead. She had gone into his death room filled with the sad sweet scent of flowers and death, and she had opened the casket and gazed upon her lover, and suddenly it came to her that this night was their very last together. It was as if she didn't really think of him as dead, but that on tomorrow he was going on a long and endless journey and never return. And the years they had shared together were the only years she remembered now, and all of the years had been hard years but all of them had been good years too, and she would never hear his soft deep laughter nor the soft booming thunder of his voice, and he would never call her Lil Bits again nor sing that song Walk Together Children, and the bitterest part was they would never walk together again—Walk together—never—never—And the never never never part of it reached right out and seized her heart and twisted it till the pain was unbearable and Mama woke everybody up in the house. Nobody was asleep. "Oh—Lord! Oh—Lord! Our last night together! Our last night together! I want to go with you, Joe! I want to go with you, Joe! Lord have mercy! Don't leave me behind!"

Rob and Miss Lulabelle tried to quiet her down. "Joe is dead, darling," Miss Lulabelle said. "Joe is dead, Laurie Lee. He wouldn't want you to break yourself up like this. Now lie down, honey and try to get some rest and behave yourself."

"All right, Lulabelle, all right. I'm going to lie down."

But then she seemed to suddenly remember and she went into the front room and she took the biggest bunch of flowers there, and she dragged them through the kitchen as Rob and Lulabelle Mackey watched and she threw Mrs. Cross Junior's beautiful expensive spray into the backyard. "They killed my Joe! They killed my Joe, the two-faced devils, and then had the nerve to send flowers to him! We don't want no flowers from them! We don't need them! We don't need them!"

"Take hold of yourself, Laurie Lee Youngblood. Please, sugar pie," Miss Lulabelle said.

"They tried to kill you too," Mama said to Rob. "We don't need them. All right, Lulabelle, I'll be quiet." And then Mama looked up into Rob's face and it was— "Oh, Rob! Oh, Rob, darling! My children ain't got no more Daddy!" And Jenny Lee who had been trying to sleep next door at Miss Jessie Mae's ran into the kitchen.

And now the remarks of the Grand Worthy Chancellor of the Frederick Douglass Lodge of Georgia. "Joseph Youngblood, a charter member . . ."

And then Willabelle dressed in white got up and walked up on the rostrum and sang.

When you come to the end of your journey . . .
. . . He'll understand and say—well done. . . .

Rob was so filled up now he didn't hardly know where he was or what he was doing, but he wondered why his mind kept moving and wouldn't stay put, wouldn't concentrate on his Daddy's funeral. This was his Daddy's funeral! He was thinking of the night Joe Louis beat Costelli and afterwards down on Harlem Avenue talking to the man, Larry McGruder, who lived up above the barber shop. Monday night after Daddy died and things had gotten quiet and peaceful between the two races, the little hunchback man had gone back to live over the barber shop again, and late that night about three in the morning a bunch of crackers had broken into his room and taken him to the woods and they beat him and flogged him and left him for dead, but he hadn't died.

And Miss Sallie Roundtree, Chairman of the Deaconess Board, reading the Obituary:—

"Joseph Youngblood was born in eighteen hundred and ninety-eight in Glenville, Georgia . . . one of church's most faithful members ever since. . . . Installed as a deacon . . . Joseph Youngblood married Laurie Lee Barksdale from Tipkin, Georgia. . . . They lived together as man and wife until he passed—two devoted children. . . . Joseph and Laurie Lee lived a full happy life together. . . ."

He saw Mama wipe the tears from her eyes as more tears followed, and Daddy was dead! Daddy was dead! And he was supposed to give Mama strength.

The organ played and the choir sang softly; softer and softer—one verse only—and all over the church the people humming:

Oh Freedom—Oh Freedom
Oh-oh Freedom over me
And before I be a slave
I'll be buried in my grave
And go home to my *Lord*
And be free. . . .

And Rob, seated between Mama and Ida Mae and listening now to the remarks of the NAACP by Josephine Rollins Myles, who was almost bursting wide open with child, could feel Mama strengthening even as his arm was about her shoulders, and she seemed to be tapping the strength of unseen power as the funeral services went on and on and on. . . .

"NAACP in the sight of God dedicates itself to the principles by which Joseph Youngblood lived . . . for which he died . . . and under the leadership of his lifelong companion, Laurie Youngblood, and others like her we shall bring together the colored people of Crossroads and the State of Georgia . . . the hundreds and the thousands . . . and the decent-thinking white people. . . ."

And the tears no longer flowing from his mother's eyes. Getting stronger and stronger and somehow transferring some of her secret strength to Rob, and he was the one who was supposed to keep her from falling apart.

And the reading of telegrams from all over the country, and it seemed that everybody in the whole world knew about Joe Youngblood.

Vaguely Rob saw Reverend Ledbetter rise and walk slowly forward as the choir sang softly, *Abide With Me—Fast Falls the Eventide*. And he saw Reverend Ledbetter open his Holy Bible, and Rob's eyes came down and rested on the long gray casket again with the flowers everywhere and he thought about his father, working in the mills and the time he broke his back at the mills and his Daddy's soft friendly eyes and playing ball with Daddy in the vacant lot, and "Son, your mother is the wonderfullest woman in the whole wide world," and Daddy in the payline standing up to the crackers, and the other Monday morning at the breakfast table talking about building a union at the hotel and everything else, and many of the workers had taken time off to come to the funeral—Mr. Ogle couldn't hold them—

After Gus had left him the other night he had thought hard about it—the union meeting—and had taken it to bed with him—the union and Daddy—and he hadn't slept a wink, and all the next day thinking about it, even as he went about helping in the final preparations for his Daddy's funeral, and he didn't understand how he could think of anything else but his Daddy dead. And finally that night he knew what he would do, and what his Daddy would want him to do, and he told Jenny Lee and she agreed and now he wished he had told Mama too, but he had told her afterwards. He went late to the meeting and things got quiet when he walked in, and it looked like all the folks who worked at the hotel were there, the colored folks, except Leroy and Will and a few other

backsliders, and even Oscar and Junior were there along with a couple of other crackers they brought. They discussed and fussed and argued and talked. Almost everybody said something. "We better watch our step at first. Mr. Ogle ain't gon like it a bit." And—"Shame on Mr. Ogle. We ain't betting together for his benefit." And—"Yet and still we got to be careful. He right about that." And they took a pledge like in a secret order. Rev. Ledbetter gave it to them. Everybody joined the union except two or three colored and they had to think about it just a little bit longer. And the youngest one there was elected the chairman—Young Youngblood. And Hack Dawson treasurer and Willabelle secretary and Oscar and Gus on the Executive Committee, and all through it all he had a funny feeling he could hear his Daddy's booming laughter, he could see him smiling and Walk Together Children. And they would build the union strong, get everybody in.

But his Daddy was dead! His Daddy was dead, and he was attending his Daddy's funeral. And the next time Rob looked up toward the pulpit again his eyes were wet, and he was aware of Reverend Ledbetter reading from the Holy Bible.

"I take my text from the written word of the Gospel according to Saint John, the eleventh chapter and the twenty fifth verse—'Jesus said unto her, I am the resurrection and the life: He that believeth in me, though he die, yet shall he live' . . ." He slowly closed the Holy Bible.

"Though he die, yet shall he live—yet shall he live. An though Deacon Youngblood has passed on to that land where all is peace and time stands still, though he has died, yet shall he live. Yet shall he live in the hearts of his devoted family, in the spirit of Pleasant Grove Baptist Church, in the Deacon Board, praise the Lord. Joseph Youngblood lives in all of us. His spirit lives in the Frederick Douglass Lodge of Georgia. His spirit lives in the National Association for the Advancement of Colored People. His spirit lives wherever men and women come together to serve our Lord and Savior, Jesus Christ, and the cause of freedom. . . ."

"Amen—Amen!"

"Joe Youngblood! Joe Youngblood! Have Mercy, Jesus!"

"Yes, My Lord!"

"And brothers and sisters, I say to you this afternoon with a heart full of sorrow, for Deacon Youngblood was a man I looked upon as a brother and friend in the fullest sense, and yet I say to you and particularly to the grief-stricken family—this is not the time for tears—and yet we do cry, dear Lord, for we are human beings, weak and unknowing, down here on Your bountiful earth and we do not always understand the complexities of Thy infinite wisdom. We do not understand, oh merciful Savior, the reason that our brother and brave Christian soldier was smitten down by the enemy in the heat of the day just as the battle is about to begin—

"But Oh make a joyful noise unto God all the earth—this is a day for rejoicing and hallelujah and reaffirmations and rededications—for who is there among us can say that Joe Youngblood has died in vain? Who can say he has not left with us a strength and spirit and determination that will bring together the Godfearing, freedom-loving people of Crossroads, Georgia and the whole State of Georgia. This then is the reason— This is the purpose. The Lord works in mysterious ways His wonders to perform—Glory to His Name.

"Joseph Youngblood has gone to sing in that heavenly choir with John Brown and Harriet Tubman and Fred Douglass and Sojourner Truth and Abraham Lincoln, but his truth is marching on!

"Sleep on, dear brother—sleep on, Brother Youngblood, and take your rest—and rest you in the firmest knowledge that we shall carry on and on till that great morning when the stone the builders rejected is become the head of the corner. . . .

"Sleep on, Brother Youngblood. Though you die, yet shall you live—yet shall you live. . . ."

The tears fell now, unnoticed, from Rob's eyes, and all of the tears were not tears of sorrow—The remarks of the various people about his Daddy, especially the sermon of Reverend Ledbetter and the feeling and spirit of all his folks packing the hot stuffy church and standing along the sides and in the back and down in the Sunday School and out in the church yard and the faces at last night's union meeting and especially his mother next to him now and the man in the casket and Harriet Tubman and John Brown and Frederick Douglass lifted him up to a greater understanding and a firm determination that Daddy's life shall not have been given in vain—And yet he cried—He heard Miss Hannah begin the introduction on the organ—Nearer My God to Thee—but he didn't want to hear any sad songs now. Let them play a Jubilee—

Neer—row my God to Thee
Neer—row to Thee
Neer—row my God to Thee
Neer—row to Thee

And now the undertakers uncovering the body for the people to see for the last time, and first came the family. And when Rob rose with Mama on one side and Ida Mae on the other, her eyes filled with tears, he felt his knees give in for a moment, and Mama's hand tightened on his arm, and he had to fight hard to steady himself, as they moved toward the casket. They stood for a moment looking down on his calm quiet face, his eyes sealed now finally in death, but they seemed to be smiling like they always smiled, and he looked so natural just like he was asleep, and the realization that this was the last time they would ever look upon him was too much to bear. He felt his mother's shoulders shaking now and the sobs came forth from her small heavy bosom. "Lord, have mercy! Lord, have mercy! No more Joe, Jesus—No more Joe!"

And he said softly, "Mama . . . Mama . . ." but he couldn't say more, because he had to fight so hard to keep himself from crying. And Jenny Lee walked up

with Gus Mackey and she looked at her father long and hard and she wiped her eyes and she looked some more, and she said very quietly—"No more Daddy. . . ." And the family moved away and made way for the others to view the body, and the heat and the dampness and the sweet awful smell of the beautiful flowers, and the choir still singing in almost a whisper, *Safe in the arms of Jesus—Safe on His gentle breast* . . . and people weeping all over the church . . . and anger now on most of their faces.

Outside the procession has started toward Lincoln Cemetery. And the long line of cars all kinds of descriptions and over a thousand people on foot. They reach the pavement now of the business section and down Jeff Davis Boulevard they march, quietly and solemn . . .

The sun beat down like the middle of the day. White folks standing along the sidewalks and looking out of the office buildings at the angry, dangerous-looking-faces-gleaming-with-sweat of the colored people in the line of march.

"Shouldn't let them march through town like this—stopping up the traffic," an important-looking white man said to another.

"They sure is a mean looking bunch, and great-day-in-the-morning, so many of em! Enough to scare you half to death—"

"They look like soldiers going off to war—" the white lady said to the tall white gentleman in the palm beach suit. . . .

"I sure am sorry I saw this sight," the gentleman said. "I'm the worst sleeper in the whole wide world. Tonight when I'm asleep I'll be hearing black feet marching all over Georgia."

And one cracker said to another cracker, "I ought to have my shotgun. You sure would see some black birds scatter."

And the other cracker said, "You better say you reckin." And he shook his head from side to side.

And all along the way the white folks stood with looks of awe and concern on their faces as the colored folks marched slow and unsmiling and four abreast through the heart of the town and all along the way colored folks joining and swelling the ranks. Men and women and children.

At Hotel Oglethorpe a cook left the kitchen without anybody knowing and the stocky-shouldered middle-aged white man went quietly in his white uniform past the watchman. "I be back directly." And his heart beat faster as he walked up the alley and turned right on Cherry Street and walked quickly in his cook's uniform toward Jeff Davis Boulevard and he stood there on the edge of the sidewalk till it all passed by. The courthouse clock went bong and he wiped his eyes and looked up quickly and it was six thirty and he realized he had been off the job forty-five minutes and he hurried back to work.

And out at the cemetery hundreds and hundreds of people everywhere. . . .

And

Ashes to ashes
Dust to dust

And she saw them lower him into the ground, and it was all over now, she thought to herself. And Mama leaned heavily against Rob and she started to say, It's all over, son. It's all over now. . . . But she looked around her and she saw all the faces, people they knew and people they didn't know. . . . black and brown and light-skin faces, all of them angry . . . and somehow she felt a union of strength with them because they were her people and she was angry too. She looked at Rob and her eyes sought out Jenny Lee Youngblood and her mind made a picture of Joe Youngblood at the breakfast table on a Monday morning—*I used to think that this old world was coming to an end, but now I know that it just begun and all we got to do is walk together children.* . . .

She felt Rob's arm tighten around her shoulders and Rob Youngblood and Jenny Lee Youngblood and Joe! Joe! Joe! and Richard Myles and Ray Morrison and Ida Mae and Lulabelle and Gus and Willabelle and Sarah Mae and Ellis Jordan and Leroy Jenkins and Benjamin Raglin and Hack Dawson and—So many many people . . . all her folks . . . and over on the outer edge of the crowd she saw Dr. Riley and Junior Jefferson.

"It's just begun, son," she whispered to Rob.

"What you say, Mama?" And Rob a man now a full grown man, growing bigger and bigger.

Reverend Ledbetter came over to where they were standing and he took the widow into his arms. "Don't be disheartened, Sister Youngblood. You have two of the finest children in the whole State of Georgia. A fine young man and a fine young woman, and Richard Myles he's your youngun too. And look all around you at your brothers and sisters, thousands of them, and, Great God Almighty, fighting mad, and we're going to make them pay one day soon, the ones that're responsible. There's going to be a reckoning day right here in Georgia and we're going to help God hurry it up."

And people coming over, strangers and friends, and shaking their hands, and hugging and kissing and giving them strength, and over in the west the sun going down, and the moon would come up and the moon would go down and tomorrow the sun would come up again.

The title of Ronald Fair's novel, *Many Thousand Gone* (1965), like the title *Go Tell It on the Mountain,* calls attention to the spiritual from which it is taken, and it sets up certain expectations in the reader. The words of the spiritual are printed before Part One of the novel and once we understand what those words mean, we will know what to look for in the story that follows.

1. No more auction block for me
 No more, no more
 No more auction block for me
 Many thousand gone.

2. No more peck o'corn for me, etc.
3. No more driver's lash for me, etc.
4. No more pint o' salt for me, etc.
5. No more hundred lash for me, etc.
6. No more mistress' call for me, etc.

The singer says no more auction-block for him—that is, no more slavery. Many thousands of slaves have "gone"—freed themselves from bondage, and implicit in this statement: many more will cast off that yoke. The novel is not an ante-bellum tale. The "slaves" are twentieth century black people who have never been told the truth, that the North won the Civil War. We have to suspend our disbelief. How could there be any place in America, no matter how backward, where such information could have been concealed, where black people have to "escape" *from* in order to be free just as they did under slavocracy? Or is Jacobsville in Jacobs County, Mississippi, a metaphor for the whole twentieth century South, where real freedom is an unrealized dream for black people and a prospect never to be considered seriously by the whites in control?

The following section concludes the novel. The truth that there is a real world of freedom beyond the walls of Jacobs County has come to the black inhabitants via a bootlegged copy of *Ebony* magazine, which in addition to showing that black people have achieved freedom and affluence not only equal but also superior to that of many whites in Jacobsville, reveals that one of their own escapees has achieved such success. The news has fired up the most exploited, compliant and accepting Blacks in town, including Josh, the sheriff's "boy" who has risen to a position of leadership. In fact, he, like his biblical counterpart, is about to see that those walls come tumbling down.*

Now Sheriff Pitch, like most of his neighbors, had never had much education; he hadn't been to college, he hadn't even been to high school, and one would have expected, as the marshals mistakenly did, that such a man would be no match for a group of well-organized college graduates. Had the marshals given their role in Jacobsville more thought, they might have been able to forsee what was to happen. But they didn't, and so it came about that Marshal Wright found himself that night securely locked behind bars in the Jacobsville jail, along with the other five marshals and the postal inspector. The vulgar, illiterate sheriff had outwitted the entire United States government because all the time he had known something they didn't know. He knew he was at war with the Yankee forces; he knew he was fighting the same war his great-grandfather had fought.

Outsmarting the marshals had been so easy that the sheriff was almost disappointed. He had expected some resistance.

At three o'clock he had sent word to Marshal Wright that he had a man in custody as one of the murder suspects, and would like the marshal's assistance. Wright and two other marshals rode into town, walked into the jail, and were disarmed at gun point by the sheriff. The rest of the marshals were brought in by the state troopers and similarly disarmed, with no more resistance than a mild verbal protest. The postal inspector, of all people, sensed that something was wrong. When the two deputies came for him he resisted until one well-placed blow at the base of the skull rendered him unconscious.

It was now eight o'clock. It would be dark soon, and the sheriff and his deputies and three of the state troopers were preparing to leave the jail to join the other troopers and most of the town's white men at the fork in the road. From there, half of them would go to the church to get Preacher Harris and the other half would go after Granny Jacobs.

They were going to set an example for all Negroes the world over. They were going to roast Granny and Preacher Harris alive, slowly, as they would barbecue a hog, and then they were going to destroy every single possession owned by any Negro in Jacobs County. If they couldn't have their Negroes the way they wanted them, they didn't want them at all. So they were going to chase them out. They were going to set three thousand Negroes free, and those who wouldn't leave would die tonight.

"After tonight," the sheriff had said to one of his deputies earlier that day, "I don't want to see another black bastard in Jacobs County ever again—not if I live to be five hundred years old."

Of course the marshals knew nothing about what was to happen that night. The sheriff had insisted right along that they had been incarcerated for their own protection and that he and the troopers, all by themselves, could handle any difficulties that might arise. He told them that the townspeople had massed and he would disperse the mob.

"Now I know these people," he said. "I'll stop them. They don't take no too kindly to you northerners trying to change their ways, and they'd shoot you just like you was niggers. It's for your own protection, boy, that we'll have to keep you locked up until this is all over."

"I'd suggest you keep going after you're finished with whatever you're going to do," Marshal Wright said angrily, "because you're the first one I'm coming after."

"No—I don't think you'll do that. The decent people here won't stand for their sheriff being put in jail by a Yankee. I don't think you'll do anything like that. Besides, you just better hope I come back, or you might not get out at all. Never can tell how an angry mob will act. Why, they might even decide to string me up. Some people just ain't got no gratitude. Here I'm tryin' to save your life and you're threatening me. Well, I can't

*From *Many Thousand Gone,* copyright © 1965 by Ronald L. Fair. Reprinted by permission of Harcourt Brace Jovanovich, Inc.

90

stand around all day arguing with you. I got to get out and stop all the troubles you brought down here. C'mon boys, let's go to work. Now you just stay put 'til we get back.''

Outside, the sheriff said, ''Hurry up, now. We can't keep the people waitin' out there all night, can we?'' He and his deputies and the three troopers got into the two squad cars at the curb in front of the jail.

''Sheriff!'' Bobbie Joe Willis called, running across the street from his hardware-grocery store. ''Wait a minute, now.''

''Hurry up, Bobbie Joe,'' the sheriff said. ''We got important business, boy.''

''Now goddamit, Sheriff, I'm tired of this shit. Every time there's a lynchin' somebody breaks into my shed and steals something. Last time they took all the ropes and kerosene I had, and this time I go out back and I find the lock busted just like always and every stick of dynamite I own gone. Dammit, that stuff costs money, and they don't need dynamite just to string up a few niggers.''

''Dynamite! You hear that, boys?'' Sheriff Pitch said. ''We might even have a big boom tonight.'' He patted Bobbie Joe on the back. ''It'll show up out there. I'll ask the boys to put it back for you—well, most of it, anyway.''

They waited impatiently for the sheriff to arrive. Nearly all of the town's four hundred white men were present. They passed whisky around and talked about lynching over the years, keeping it cheerful and trying to shorten the wait. It was like a church picnic.

''Pa,'' a young straw-head boy about twelve said. ''When we gonna start?''

''When the sheriff says we start,'' his father said.

''Why don't we just go on ahead and get them niggers now? Why we gotta wait for him, Pa?''

'' 'Cause.''

'' 'Cause what, Pa?''

'' 'Cause we gotta do what he says. We gotta obey the law and we can't do nothin' 'til he says we can.''

''Oh,'' the boy said.

The father turned to a friend and said apologetically. ''It's his first real lynchin' and he ain't too bright about it yet.''

The men laughed.

''Always wait for the sheriff,'' a man said, putting his arm around the boy's shoulder. ''See, that way we don't never get the wrong one. We made that a law, so to speak, a long time ago, because we was lynchin' the wrong niggers right and left and Mr. Jacobs got mad as hell. So now we wait for the sheriff to tell us who it is. And he don't make no mistakes. But it don't matter none this time. You can take that shotgun of yours, boy, and just shoot all you want tonight.''

The boy clutched his shotgun affectionately, and smiled.

A man climbed on top of a car and tried to get the attention of the crowd. ''Listen to me a minute. Now we all know that this just might be the last time we have any fun like this. So I say we tell the sheriff that we wanta

have somethin' real special tonight. Know what I mean?''

''You goddamn right we know what you mean.''

''Yeah, what the hell you think we out here for, anyway?''

The boy continued stroking his shotgun. His father nudged him. ''Pay attention, son.''

''Now I say—since the niggers ain't gonna be here no longer—we oughta take all of these young boys and some of the old ones too—some of us old ones—and let 'em have plenty of time.''

The boys in the crowd cheered.

''Why else do you think we made the women stay home?'' an old man shouted.

''Of course,'' the man said, getting down from the car, ''that'll be a secret just between us men.''

The cars sped through the woods. As they neared the fork in the road they saw a bright orange glow in the sky coming from the direction of the Jacobs mansion.

''What the hell!'' the sheriff said, flooring the accelerator.

The road was lined with trees and they couldn't yet see the house, but as they reached the fork, it came into view. It was completely engulfed in flame. They stopped the cars and ran to join the others. They heard a woman scream. The fire raged on and she kept on screaming. When she stopped at last, the men waited, expecting to hear her voice again. Slowly, then, tree by tree, the long row of willows leading away from the house broke into flame.

''What'll we do now, Sheriff?''

''Yeah, we can't just stand here. There's a white woman and a white child in that house, burnin' to death.''

The sheriff was dumbstruck. He was shocked into inactivity.

''Our niggers couldn't do this,'' he finally said, so softly that the deputy standing next to him could not hear him. ''Our niggers are good niggers. They're just like little children. They wouldn't do this to us. *They couldn't do this to us!*'' he suddenly shouted.

A man jumped up on top of the squad car. ''There's something burning back that way,'' he said, pointing in the direction of town.

Instinctively they all looked back and waited. And they saw what they had feared; the sky lighted up over Jacobsville.

''The niggers are burnin' our town!''

They scattered, heading back to Jacobsville, some on foot, some in cars. There was an explosion, and a tree fell blocking the road two hundred yards in front of the foremost car. And then the forest began burning. All around them Negroes were running with torches, lighting the trees.

''They're trying to burn us alive,'' a trooper shouted.

''The damn fools,'' the sheriff said. ''They'll kill us and them both. Don't they know can't nobody get out of here, not even them.''

He began yelling at them: ''Stop! You'll kill your own people too. Stop! Crazy goddamn niggers! They're in

the woods! Kill them! Kill the black bastards!'' He ran as close to the burning brush as he could, and began shooting at the shadows that moved among the trees.

''Mr. Sheriff!'' Josh shouted.

''Josh, boy. Where are you?''

''Over here,'' Josh called from behind the leaping flames.

Sheriff Pitch turned in the direction of the voice. He squinted painfully, trying to see through the glare.

''Get me out of here, Josh! Get me out of here, son!''

Josh raised the rifle the sheriff had given him only two years ago and sighted in on the sheriff's head.

''Hurry, Josh! Get me out of here!''

Josh lowered the weapon, wiped the tears away from his face. ''I wish to God I could, Mr. Sheriff,'' he called out. ''I wish to God . . .'' He wiped his nose, raised the rifle again and squeezed one round that ripped through the top of the sheriff's head. He lowered the gun and started running toward town. As he ran he counted twenty explosions. Then everything was quiet except for cracking timber and his own breathing and the sound of his feet beating the ground in rapid, even cadence.

''Good-by, Mr. Sheriff,'' he said sadly.

When Josh reached town the jail, which stood off by itself, was the only building not burning. The white women and children who had been left behind were vainly trying to save their homes. The bank was completely consumed. The vault had been blown and looted and the big door could be seen glowing white hot in the flames. The grocery store had been emptied and the body of the grocer lay on the floor, charred even blacker than his assailants.

''Get to the lake!'' Josh shouted. He grabbed two women and shoved them gently away from the building. ''Get to the lake or y'all be blown to pieces. That gas station's gonna blow this whole town to pieces. Get to the lake!''

''Josh!'' a woman shouted, pulling on his arm. ''Where's my husband?''

''I don't know. Everythin's burnin'. I don't know where nobody is. But y'all better get out of here. James Edward! J. D.!'' Two youths appeared immediately. Josh handed one of them his shotgun. ''Get these ladies and children to the lake with the rest of the folks.''

The boys began rounding up the white children.

Josh ran on. When he arrived at the jail, a Negro stepped from behind the building. Josh nodded and the man began throwing kerosene on the walls. When he had emptied the can he struck a match and set the jail on fire and ran.

Josh waited until the flames had consumed one whole side of the building. Then he casually reached into his pocket, took out a set of keys, unlocked the door, and hurried inside to set his emancipators free.

Many Thousand Gone is subtitled *An American Fable*. A fable is a short narrative that is supposed to teach a moral lesson. In 1965 when it was published, many American cities seemed to be reaping what op-

pression and racism had sown—riots, lootings, burnings. In 1964 James Baldwin published a nonfiction work called *The Fire Next Time*. That title and the biblical quotation from which it was taken have something important to add to the moral lesson Ronald Fair tries to teach in his fable: ''God gave Noah the rainbow sign, no more water, the fire next time.''

''Contribution,'' a one-act play by Ted Shine, takes place in a southern town; the time is during the era of the sit-ins. Each of the three characters in the play is representative of his or her generation. Eugene Love, Mrs. Love's grandson, is a radical college student; Katy Jones, a neighbor, is a domestic (usually called ''girl'') probably in her forties, raising her children alone on the miniscule salary she receives from (white) Mrs. *Comfort*—Katy plays everything safe; and Mrs. Grace Love, a grandmother in her seventies who knows more about the South than most of the townfolk, white or black.

Mrs. Love turns out to be more radical and more militant than her grandson Eugene. She sings several spirituals as she goes about her ''lofty'' work of baking up her ''loving'' contributions to the cause of change. ''Where He Leads Me,'' ''His Eye Is On The Sparrow'' and ''In The Sweet Bye and Bye'' all take on special meaning. They not only emphasize the theme of the play, but they also help to illuminate Grace Love's character which cannot possibly be understood from the picture of age and accommodation she presents by her external appearance:

WHERE HE LEADS ME

1. I can hear my Savior calling,
 I can hear my Savior calling,
 I can hear my Savior calling,
 ''Take thy cross and follow, follow Me.''

 Where He leads me I will follow,
 Where He leads me I will follow,
 Where He leads me I will follow,
 I'll go with Him, with Him all the way.

2. I'll go with Him thro' the garden,
 I'll go with Him thro' the garden,
 I'll go with Him thro' the garden,
 I'll go with Him, with Him all the way.

3. I'll go with Him thro' the judgment,
 I'll go with Him thro' the judgment,
 I'll go with Him thro' the judgment,
 I'll go with Him, with Him all the way.

4. He will give me grace and glory,
 He will give me grace and glory,
 He will give me grace and glory,
 And go with me, with me all the way.

HIS EYE IS ON THE SPARROW

1. Why should I feel discouraged
 Why should the shadows come
 Why should my heart be lonely,
 And long for heav'n and home
 When Jesus is my portion
 My constant friend is He
 His eye is on the sparrow
 And I know He watches me
 His Eye is on the sparrow
 And I know He watches me

Refrain:
 I sing because I'm happy
 I sing because I'm free
 For his eye is on the sparrow
 And I know He watches me

2. "Let not your heart be troubled"
 His tender word I hear
 And resting on His goodness
 I lose my doubts and fears
 Tho' by the path He leadeth
 But one step I may see
 His eye is on the sparrow
 And I know he watches me
 His eye is on the sparrow
 And I know He watches me

3. Whenever I am tempted
 Whenever clouds arise
 When songs give place to sighing
 When hope within me dies
 I draw the closer to Him
 From care He sets me free
 His eye is on the sparrow
 And I know he cares for me
 His eye is on the sparrow
 And I know he cares for me.

SWING LOW, SWEET CHARIOT

 Swing low, sweet chariot
 Coming for to carry me home
 Swing low, sweet chariot
 Coming for to carry me home.

1. I looked over Jordan, and what did I see
 Coming for to carry me home
 A band of angels coming after me
 Coming for to carry me home.

2. If you get there before I do
 Coming for to carry me home
 Tell all my friends I'm coming too
 Coming for to carry me home.

3. The brightest day that ever I saw
 Coming for to carry me home
 When Jesus wash'd my sins away
 Coming for to carry me home.

4. I'm sometimes up and sometimes down
 Coming for to carry me home
 But still my soul feels heavenly bound
 Coming for to carry me home.

STEAL AWAY

 Steal away, steal away, steal away to Jesus
 Steal away, steal away home, I hain't got long to
 stay here.

1. My Lord calls me
 He calls me by the thunder
 The trumpet sounds it in my soul
 I hain't got long to stay here.

2. Green trees are bending
 Poor sinners stand trembling
 The trumpet sounds it in my soul
 I hain't got long to stay here.

3. My Lord calls me
 He calls me by the lightning
 The trumpet sounds it in my soul
 I hain't got long to stay here.

4. Tombstones are bursting
 Poor sinners are trembling
 The trumpet sounds it in my soul
 I hain't got long to stay here.

IN THE SWEET BYE AND BYE

1. There's a land that is fairer than day
 And by faith we can see it afar
 For the Father waits over the way
 To prepare us a dwelling place there.

 In the sweet bye and bye
 We shall meet on that beautiful shore
 In the sweet bye and bye
 We shall meet on that beautiful shore.

2. We shall sing on that beautiful shore
 The melodious songs of the blest
 And our spirit shall sorrow no more
 Not a sigh for the blessing of rest.

3. To our bountiful Father above
 We will offer the tribute of praise
 For the glorious gift of his love
 And the blessings that hallow our days.

"Contribution" was first presented by the Negro Ensemble Company, New York, in the Spring of 1969 with Claudia McNeil in the role of Mrs. Grace Love. For the complete play, see pages 365-389 of *Black Drama, An Anthology,* edited by William Brasmer and Dominick Consolo, published by Charles E. Merrill (Columbus, Ohio, 1970); or *Contributions,* three one-act plays by Ted Shine published by Dramatists Play Service, Inc., which also includes "Plantation" and "Shoes" as well as "Contribution."

POETRY, PROSE, AND THE BLUES

Out of the "black folk tradition of the South . . . has come one of the world's great folk poetries—*the blues*." A. X., Nicholas *Woke Up This Mornin': Poetry of the Blues.*

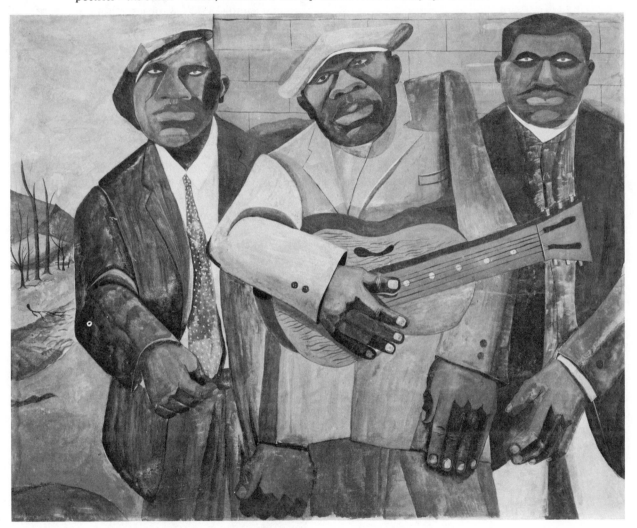

Figure 4.1. Romare Bearden, "Folk Musicians," (c. 1941-42). Gauche and Casein on composition board, 36 3/8″ X 46 5/8″. Collection Nanette Rohan Bearden.

The blues is to the black man what conventional popular music is to the white man. It is an expression of the separateness of Blacks but unlike most other music with such a high degree of ethnicity, it has unparalleled universality.

What is this music called blues? What are its musical characteristics? Where did it come from? What kind of philosophical, economic, social and musical conditions gave rise to the blues? What mysterious qualities have made the blues so popular that it has become a part of all American popular music? How has the blues manifested itself in jazz, art music, rhythm and blues, rock and roll, country and western? Who are the performers, composers, audiences who keep the blues alive and constantly revitalized? What of the future of the blues?

These are just a few of the questions to which this chapter will address itself.

In *The Story of the Blues* Paul Oliver gives a particularly moving though romantic definition of the blues:

> Seen from any point of view, the blues is both a state of mind and a music which gives voice to it. Blues is the wail of the forsaken, the cry of independence, the passion of the lusty, the anger of the frustrated and the laughter of the fatalist. It's the agony of indecision, the despair of the jobless, the anguish of the bereaved and the dry wit of the cynic. As such, the blues is the personal emotion of the individual finding through music a vehicle for self-expression. But it is also a social music; the blues can be entertainment, it can be the music for dancing and drinking by, the music of a class within a segregated group. So the blues can be the creation of artists within a folk community, whether it's in the deep, rural South or in the congested ghettos of the industrial cities. Blues is the song of the casual guitarist on the back stoop, the music of the piano-player in the barrel-house, the juke-box rhythm and blues hit. It's the ribald dozens of the medicine show, the floor-show of the edge of town club, the show-biz of the traveling troupe and the latest number of a recording star. Blues is all these things and all these people, the creation of renowned, widely-recorded artists and the inspiration of a man known only to his community, perhaps only to himself.[1]

What are the musical characteristics of the blues? Most blues utilize a twelve measure structure consisting of three chords. Because of the exceptionally personal nature of the blues and its extraordinary flexibility, the measure structure might include seven, ten, eleven, thirteen, seventeen or any other amount of measures. (Form, structure, internal arrangement are always subservient to content in the blues and most other African derived musics.) The chord sequence might also vary greatly without causing the blues to lose its identity. For instance, many blues even have a bridge or release section. The (B) section of the bridge is the section where new or contrasting material is introduced, (i.e.,

```
    A           B           A
 —  12  —    —  8  —    —  12  —
```

arbitrary number or bars.)

Examples of such compositions are "Bill not Phil" by Bill Harris, "Traneing In" by John Coltrane and many others.

In most instances instrumental blues in the jazz tradition tends to be more predictable and regular in structure (symmetrical) with the exception of blues by Ornette Coleman and those of similar persuasion. (Many *avant-garde* players tend toward the same irregularities, asymmetricalities and freedom indigenous to many vocal blues.) We shall also see as the

chapter progresses that "Classic Blues," "City Blues" and other more sophisticated forms have settled into regular formal structures (twelve or sixteen measure patterns) often at the expense of vitality, spontaneity and the demands of content.

While blues instrumentalists of the jazz genre have tended to accept certain regularities with regard to the number of measures in a blues (i.e., 12, 8, 16, etc.), "Watermelon Man," Herbie Hancock—16 bars—"Stolen Moments," Oliver Nelson—16 bars, they have been less wedded to the sanctity of the original simple I IV V progression. Some of the substitute chords for the instrumental blues follows. (See example 1, p. 97.)

Some examples of altered blues are: "Dahomey Dance," John Coltrane; "Honesty," David Baker; "Sippin at Bells," Miles Davis; "When Will the Blues Leave," Ornette Coleman.

Likewise, jazzmen have been much less rigid in their adherence to the 4/4 / 12/8 metric scheme prevalent in vocal blues. Virtually every meter and combination of meters has been used in jazz blues, i.e., 6/8, 3/4, 5/4, 7/4, 5/4 + 6/4, 7/8 + 5/8 ad infinitum.

Some sample compositions include:
3/4 "Valse Hot"—Sonny Rollins
3/4 "Kentucky Oysters"—David Baker
3/4 "Terrible T"—David Baker
 Compound 6/4—5/4
 "Four—Five—Six"—Lanny Hartley
 Amalgam 4/4 / 3/4 / 2/4 / etc.
 "Blues in Orbit"—George Russell
12/8
 "All Blues"—Miles Davis
 "Roly Poly"—David Baker
 "Foot Prints"—Miles Davis
 "Senor Blues"—Horace Silver
 "Mohawk"—J. J. Johnson

The next musical consideration is that of melody. Perhaps it would be best to first examine vocal blues.

As would be expected the range of most vocal blues melodies because of voice limitations is much narrower (range and general placement within the range) than instrumental blues with two, three, four or more octave instruments. Most vocal blues melodies, with the exceptions of falsettos and other dramatic note displacements, rarely exceed an octave. Many of these blues melodies are strongly reminiscent of the sorrow songs and other four and five note melodies.

Vocal blues melodies while highly personal usually derive their personality from the lyrics and/or style

1. Paul Oliver, *The Story of the Blues* (New York: Chilton Book Co., 1969), p. 6

Example 1

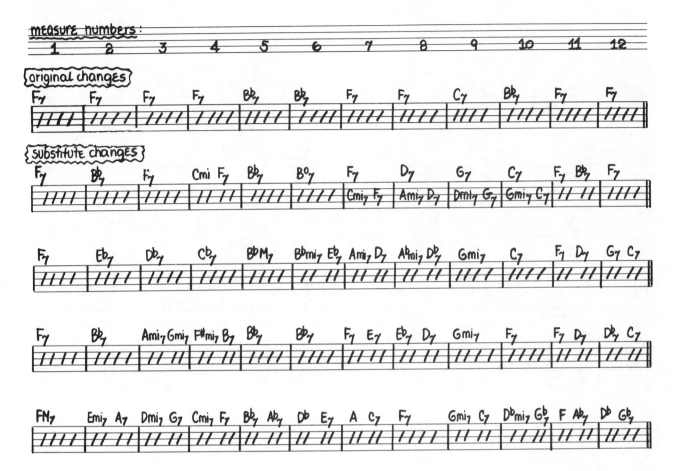

rather than the originality of the musical line, which is often trite, predictable and derivative. Often a single melody will serve hundreds of disparate verses and compositions. Blues melodies usually follow the tenets of other vocal forms of melody, i.e., essentially diatonic (pertaining to the standard major and minor scales and to the tonality derived from these scales), symmmetrical, relatively predictable, and *singable*.

Jazz instrumental blues melodies are often wider in range than vocal melodies (although often much narrower in expressive range). Of course, the wider range of harmonic variation permits a commensurately greater variety of melody types, asymmetrical, angular, wide range, dissonant, and unpredictable. Jazz melodies of the blues variety are usually quite distinctive and individual and much less likely to resemble all other blues melodies. Of course, there are many exceptions such as riff type melodies ("Now's the Time," "Jumpin With Symphony Sid") and many ultra-funky melodies ("Sack O' Woe," "Cool Blues"). Exceptions notwithstanding, the individuality of jazz blues is even apparent in works by

the same composer, e.g., T. Monk's "Straight No Chaser," "Misterioso," "Blue Monk"; or C. Parker's "Bongo Bop," "Au Privave," "Barbados," "Buzzy"; or George Russell's "Stratusphunk," and David Baker's "Blues for Bird," "Roly Poly," and "Brother." (See example 2, p. 98.)

The vocal blues are usually on horizontal scales, such as the blues scale, the major scale or some simple modal or pentatonic scale. (A horizontal scale is a scale which is used to color an entire area of harmonic activity as in the instance of blues.) The C blues would use one scale to color all of the chords in the tune. (See examples 3 and 4, p. 99.)

These scales are usually much easier to hear and the paucity of materials makes improvisation a lot less difficult and much more accessible to the novice as well as the professional blues singer. These horizontal scales, of course, offer the possibilities of the use of chordal melodies drawn from scale tones.

The blues instrumentalist in jazz usually draws on a much wider variety of scales, although the blues, major and modal scales are still the most popular for realizing blues changes. (The horizontal scales are

97

Example 2

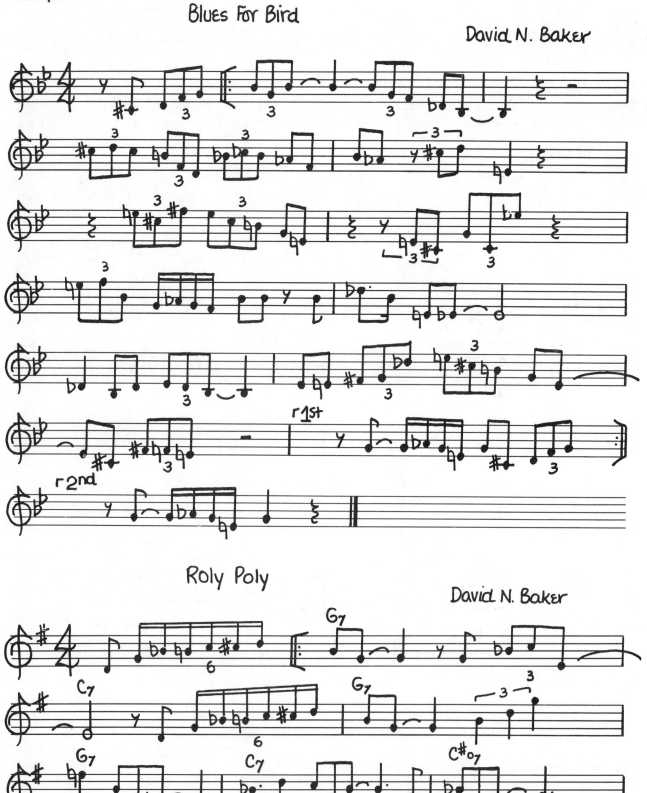

98

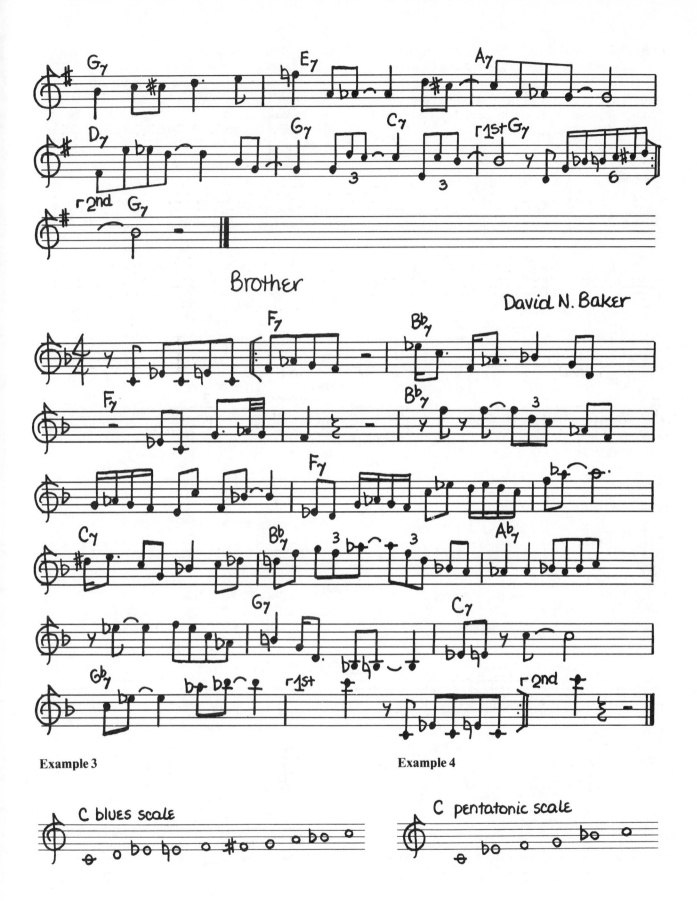

Brother

David N. Baker

Example 3

Example 4

C blues scale

C pentatonic scale

particularly popular among the soul jazz proponents, i.e., Horace Silver, Ramsey Lewis, Lou Donaldson, the Turrentine brothers, the Adderleys, et al.) Some of the other scales with widespread currency and the manner in which they are used to color the blues chords follow. (See example 5.)

Increased possibilities for harmonic variation, of course, offer a broader base for using different scales. (See example 6.)

As with melodic and scalar possibilities, rhythmic possibilities are much less vast for the blues singer than the blues instrumentalist. Traditionally the instrumentalist (in whatever field) is usually thought capable of handling a greater variety of rhythmic

Example 5

Example 6

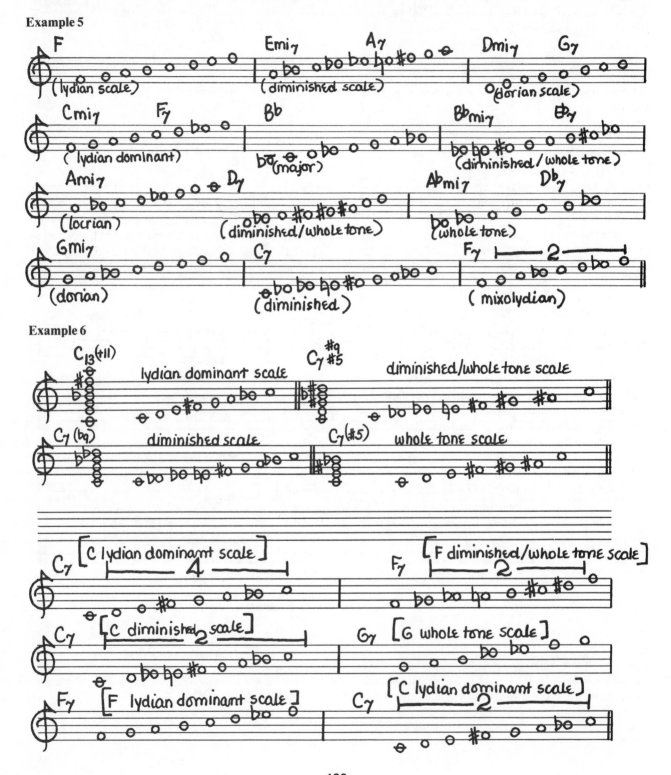

100

structures than the vocalist; consequently, instrumental blues (jazz) music is usually much richer in rhythmic materials and variety and contrast.

In the area of timbre, the jazz blues instrumentalist has tended to borrow from the blues vocalist. In fact, the instrumentalist has tended to borrow all of those things which were originally considered the domain of vocal music. Things such as slides, fall-offs, slurs, grunts, yelps, rips, yodels and other such inflections have been added to the instrumental color pallet. The instrumentalist has also added such idiosyncratic spinoffs from vocal practices as: lip trills, shakes, various articulations, flutter tongue, muting effects, harmonics, and multiphonics (playing two notes simultaneously on an instrument traditionally thought of as single lined, i.e., trumpet).

This wide choice of possibilities, of course, offers the blues vocalist and instrumentalist a great deal of room for personalization. This last is, of course, one of the major factors which helps to define blues and jazz.

As near as can be ascertained, the blues did not exist in slavery although the group work songs of that era did provide an important link. The work songs with their inevitable call-and-response patterns helped to provide a form for the blues. But the work song with its inherent rigidity lacked two vital elements, indigenous to even the earliest blues types, personalization and flexibility.

A second and perhaps even more important contributory element to the blues was the holler. The holler, unlike the work song, was not intended as a means of group expression. The holler, in its earliest form, was a means of communication, intensely personal and usually wordless. It was functional. The cry was usually pitched high and with sharp syllables to enable it to be heard across vast distances.

So personal was the holler that around the countryside a man could be easily identified by the pitch, timbre and shape of his holler. As the holler evolved, it became a kind of freely structured, usually modally derived phrase, often melismatic (many pitches to a single syllable), but still highly personal. According to Paul Oliver, the adopted sound preference of these later hollers was the pentatonic scale with a $b3$ and a $b7$ (i.e., D E F G A B C or the dorian scale).

The earliest blues, like the hollers, were modal in character and showed a decided preference for the $b3$ and $b7$ (flatted third and flatted seventh). Even though the blues, from the beginning, was essentially a solo form, it retained the essential characteristics of the work song—a call-and-response pattern (couplet and refrain). Prior to World War I it evolved into the relatively inflexible twelve measure three line form

that we now know. By its very nature, and the nature of the blues people, the form remained subservient to the content *but* the model was established.

The blues could only have been born after a concept of leisure time, however illusory, emerged. The blues from the beginning has been a means of self-expression, a man alone singing of personal tragedies, or chronicling his own heroic feats imagined or otherwise. During slavery the concept of a black man alone with his thoughts was inconceivable.

In all probability the blues made their first public appearance at the juke joints, Saturday night fish fries, country suppers, "bar-be-cues," and other social gatherings of black people. At any rate, by the time of the first major migration to the cities by Blacks, the blues was firmly established.

Boogie Woogie

Boogie Woogie was the first and to date the only exclusively piano music to issue from the blues. Boogie Woogie, a term which is used to describe the blues piano playing that thrived roughly between the years 1920 and 1945, was a highly popular music in tenements. The very name "Boogie" was another name for the "house rent party." Both terms describe a phenomenon that took place in the crowded tenements of Chicago, Detroit, New York and virtually every city with a large black population. Because poverty was a way of life, black people learned quickly to depend on each other to band together and to work toward common goals. One such goal was that of simply being able to pay the rent. With unemployment at a normally high level (at least for Blacks), men long accustomed to surviving under the most adverse conditions ingeniously devised a technique that served the combined purposes of raising the rent and providing a means of social intercourse.

The "House Rent Party" ("The Parlor Social," "The Boogie") was a party given by a tenant as a means of raising his rent. For the nominal sum of "two bits" or "four bits," the tenant's neighbors were treated to an evening of boogie woogie piano by some local hero, some southern culinary treat such as catfish and Kentucky oysters (bring-your-own-drinks) as well as some "hangin out." Of course, such parties were reciprocal—"you come help me pay my rent and I'll come help you pay yours."

The blues pianist, unlike most other instrumentalists, had a great deal of mobility mainly because he didn't have to carry his instrument with him. For this reason the blues piano player was often somewhat of a cosmopolite, traveling when the mood, or the local Sheriff, struck him.

Some of the more famous boogie woogie players were: Meade Lux Lewis, Albert Ammons, Cripple Clarence Layton, Jimmy Yancey, and Sugar Chile Robinson.

Logically enough, the first generation of blues pianists who were born in the 1890s were influenced by ragtime, but the second generation were exclusively *blues* players.

Some of the characteristics of boogie woogie are:

1. It was born in gin mills, lumber camps, rent parties.
2. There was not much subtlety to the music— poor to bad instruments and unschooled instrumentalists.
3. Volume was produced by physical strength.
4. Form was always a blues; songs had no real beginning or ending, much like African music.
5. Emphasis on rhythm rather than melody.
6. Return to breaks to create tension and to rest the left hand.
7. The left hand which never varied could have been an outgrowth of "stride" piano.
8. Boogie patterns were personalized much like the field hollers and hawking cries.
9. The left hand ostinato (a repeated figure) served as a forerunner of rhythm and blues.
10. Unpianistic music.
11. Percussive and rugged.
12. Uneven and unpredictable.

> In recent years there has appeared a lot of pretentious nonsense about the unconventional length of the "conventional 12 bar blues." Those who rave about this unusual "folk pattern" would have a tough time explaining Clarence's peculiar phrase and period lengths. In his version of "Pinetop's Boogie," his first three choruses are respectively eleven, ten and twelve measures in length. In the latter part of the piece, Clarence favors a fourteen bar construction, with a final chorus of 14 1/2 for good measure. Odd phrase lengths were likewise in his previous solo art recording of "Streamline Train" and "Had A Dream," and in "I Don't Know," in which pairs of 19 and 20 bar choruses are followed by one of 19 1/2. Quite evidently, Clarence did not set out either to make his music screwy, or mathematically complicated; he just played the notes to express what he felt, and couldn't be bothered to count out the number of beats. After all, Clarence does not even regard himself as a pianist, but simply as a singing entertainer who has made good money in his day: "Man I've made as much as $3.00 a night," he has said. (From 3 boogie woogie blues pianist.)[2]

13. Eight eighth notes to the bar or at least an eighth note feeling.
14. Use of octaves, trills, etc.
15. A *two* voiced music.
16. Rhythm and color were more important than chords.
17. Right hand embroidered and supplied filligree.
18. Blues scale with chromaticism.
19. Many other melodies transformed to boogies (i.e., "Bumble Bee Boogie," "Begin the Beguine Boogie," "Chopstick Boogie").

> "The piano was one of the last instruments to be mastered by Negro performers, and it was not until the advent of boogie woogie that Negro musicians succeeded in creating a piano music that was within the emotional tradition of Negro music."[3]

The music declined because of commercial limitations and refinements on the one hand, and on the other, when it got too far from the environment that spawned it. It is axiomatic that refinement and elaboration in any art are accompanied by a corresponding decline in vitality, ruggedness, spirited abandon, ingeniousness and intensity of expression.

The Pervasive Influence of the Blues

The blues has had a profound influence on popular music. It is without a doubt the most widely used song form in black popular music and jazz. As a form and an influence, the blues can be found in much music of the theatre, and in country and western music. It is the foundation of much gospel music, most rhythm and blues compositions, much rock and roll music, all boogie woogie, as well as other universally popular song forms, and it has shown a decided influence on some European Art music.

A cursory examination of all the recorded jazz music would probably reveal an unbelievably high percentage of blues and blues-influenced compositions, as well as blues-influenced performances. The yield would be higher in certain eras than in others. During the halcyon days of Bebop it was rare to find a 78 and later an L.P. without a blues on it.

2. William Russell, *The Art of Jazz,* p. 96.
3. LeRoi Jones, *Blues People,* p. 90.

It is not an accident that almost without exception the players who have influenced the flow of jazz have been great blues players and/or composers well-rooted in blues: Louis Armstrong, Jelly Roll Morton, Count Basie, Earl Hines, Lester Young, Charlie Parker, Dizzy Gillespie, Thelonious Monk, Sonny Rollins, Charles Mingus, Ornette Coleman, Archie Shepp, and others.

These men and others, often as not, chose the blues as vehicles for improvisation for many reasons, some of which follow:

1. The blues is a highly flexible form with exceedingly simple harmonic structure (three chords).
2. It allows extreme latitude for musical expression issuing out of this simplicity.
3. The blues provides a compositional type common to the background of every would-be jazz player irrespective of era, musical persuasion or stylistic preference.
4. The blues is a form that can be rendered as simple or as complex as the individual performer/composer desires.
5. The ubiquity of the blues (via radio, T.V., church, jukebox, nightclub, etc.) provides a form with which most aspiring jazz players are at least superficially conversant.

In addition to those compositions actually employing a formal blues structure, there are countless compositions which borrow heavily on the other components of blues—e.g., "Worksong" by Nat Adderley, "Moanin" by Bobby Timmons, "Hummin" by Nat Adderley, "Sister Sadie" by Horace Silver and others.

Many jazz players—Oscar Peterson, Horace Silver, Wes Montgomery, Milt Jackson, Stanley Turrentine, and others—show a decided propensity for converting pop compositions to blues types. This metamorphosis is usually brought about by the imposition of the blues scale, blue notes, certain characteristic inflections and phrases, and the unique use of characteristic rhythms. Whatever the means used to effect the change, all good jazz players evince some aural evidences of their blues roots.

Most gospel music gives evidence of its blues roots. The form itself (as 8, 12 or 16 measure AAB) enjoys widespread popularity among gospel oriented musicians. While perhaps not so widespread as in jazz, the blues scale turns up time and time again in gospel compositions and improvisations. In many instances if the words were omitted from some gospel renditions even those who know would have trouble distinguishing blues from gospel, particularly a ren-

dition by Aretha Franklin or Ray Charles with wordless vocals. The inflections and coloristic devices (shouts, hollers, bends, twists, slides, slurs, etc.) that reflect the blues tradition are shared by both gospel and blues.

Needless to say, the spirit, although sacred rather than secular, and performance practices are too similar to be mere coincidence. Both represent very personal expressions of and reflections on the problem of daily existence. Both musics find realization in group and solo forms directly traceable to African precedents.

Both rhythm and blues and its stepchild, rock and roll, grew out of the country, via the city, blues. The term *rhythm and blues* was coined in the 1940s. It replaced such terms as "race, "ebony" and "sepia," all used to designate a genre of music aimed specifically at the black population. The music that fell under this general heading was multifaceted, but there were certain characteristics more or less indigenous to all of it.

Among those characteristics were:

1. A blues based music.
2. A great deal more emphasis on the instrumental accompaniment.
3. Music with a strong gospel influence.
4. Amplified guitar.
5. Music in step with the dancing craze which was then sweeping the country.
6. A music aimed at capitalizing on the growth of the radio as the principal medium for popular music.
7. A reaction to the complete indifference of the media power structure to blues, country music, jazz or any other that could be construed to be minority music.

As was indicated earlier rhythm and blues was a multifaceted entity whose history includes:

1. The off-shoots of the Kansas City blues bands, such as the bands of Lucky Millinder, Tiny Bradshaw and Buddy Johnson, Sonny Thompson and Cootie Williams.
2. The houserocking blues shouters issuing from the Kansas blues bands, such as Joe Turner, Eddie "Cleanhead" Vinson, Wynonie Harris, Bullmoose Jackson and Walter Brown. In this area we also find a new generation of female blues singers, such as Dinah Washington, Ruth Brown, Little Esther, Big Maybelle and Faye Adams.
3. The first real blues instrumental groups including Bill Doggett ("Honky Tonk" and

"Heavy Juice"), Sonny Thompson ("Long Gone"), Lynn Hope ("Tenderly"), Roy Milton and Paul Williams ("Hucklebuck"), Jimmy Forrest ("Night Train"), Willis Jackson ("Gator Tail"), Louis Jordan ("Saturday Nite Fish Fry," "Run Joe," "Ain't That Just Like a Woman"), Joe Liggins ("Honeydripper"), et al.

4. The sweet blues singers such as Charles Brown ("Drifting Blues"), Cecil Gant ("I Wonder"), Ivory Joe Hunter ("I Almost Lost My Mind," "I Need You So"), Percy Mayfield ("Please Send Me Someone to Love"), and Nat "King" Cole ("Route Sixty-Six," "Straighten Up and Fly-Right"). The country blues men who had begun their migration to Chicago, Detroit, New York, etc., and continued to offer their distinct brand of the blues now buttressed by instrumental groups with amplification. These included Son House, Muddy Waters, John Lee Hooker and Little Walter.

In the 1950s, the trend toward alternatives to the insipid, melodramatic, overly sentimental moon-June-croon compositions of popular music continued. Rhythm and blues as a genre continued to gain in popularity as one of these alternatives.

The 1950s saw young whites starting to dance to rhythm and blues. This fact in turn forced the disc jockeys and record stores to program rising numbers of gospel influenced vocal groups patterning themselves after *The Ink Spots* and the *Mills Brothers*. These groups, more often than not, named after birds (Orioles, Crows, Penguins, Ravens, Flamingos, Robins, Wrens) showed at least superficial blues characteristics: call-and-response patterns, high falsetto leads, and simple harmonies.

The rhythm and blues vocal styles like their predecessors were harsh, emotional, explicit and exciting.

This decade saw the birth of rock and roll, helped considerably by the insidious practice called covering (the practice of lifting, often verbatim, the arrangement, composition and style of another artist for a "covering" record release). This practice usually committed by whites against blacks (e.g., Kay Starr from *The Chords* "Wheel of Fortune," *Crewcuts* from *The Chords* "Sh-Boom," Bill Haley from Joe Turner "Shake, Rattle and Roll," Elvis Presley from Willie Mae Thorton "Hound Dog") was perhaps the first attempt on the part of the white recording industry to move into the *now* commercially and economically successful rhythmic black oriented music.

The major black voices of this decade in rhythm and blues were Chuck Berry ("Maybellene"), Bo Diddley ("I'm a Man"), Little Richard ("Lucille," "Tutti Frutti," "Good Golly Miss Molly"), Fats Domino ("Ain't That a Shame," "Blue Berry Hill"), Sam Cooke ("You Send Me"), and Ray Charles ("I've Got a Woman"). By 1959, *blues and rhythm* had become a major force in popular music.

During the 1960s rhythm and blues continued to flourish but more often than not under the title "soul music." Gospel style singing and sophisticated rhythm and blues production began to influence the genre. Detroit and Chicago were two of the main centers. Some of the more prominent performers and performing groups were:

Detroit
The Temptations
Smoky Robinson and the Miracles
The Four Tops
Marvin Gaye
Stevie Wonder
Mary Wells Marvelettes
Martha and the Vandellas
The Supremes
Aretha Franklin

Chicago
Curtis Mayfield and the Impressions
Jerry Butler
Howlin' Wolf

Others
James Brown
Ray Charles
Sly and the Family Stone
Otis Redding
Joe Tex
Wilson Pickett
Sam and Dave
Percy Sledge

Rock and roll, as was indicated earlier, had its inception during the 1950's. Although much eviscerated and diluted, it can be said to have come out of the blues via rhythm and blues.

Country and western music, while drawing on many wide and diverse sources, still makes much use of the blues form and other blues characteristics. While in many instances the blues qualities have been seriously attenuated or softened by these other influences, it further attests to the strength of the blues that they remain readily recognizable: blue notes, black inflected lines, call-and-response patterns, and rhythmic cliches.

In "art music" since the 1920s composers have turned periodically to the blues form and blues

aesthetic for inspiration. These attempts, though usually less than successful musically and aesthetically, attest to the durability and importance of the blues. Such composers as Ravel ("Blues for Violin and Piano"), Gershwin ("Porgy and Bess," "Three Preludes," "Rhapsody in Blue," "Concerto in F" all blues inflected), Gunther Schuller ("Woodwind Quintet," "The Visitation," "Seven Sketches"), Leonard Bernstein ("Westside Story"), Stravinsky ("Ebony Concerto," "L'histoire du Soldat"), and others show a blues influence. Most thirdstream composers (thirdstream—a marriage between jazz and classical techniques) and composers of liturgical jazz turn to the blues for an easily accessible form, as well as for the color, feel, and spirit of the blues.

While the aforementioned instances of the pervasive influence of the blues are extensive, they do not pretend to be exhaustive but rather point to a representative cross section of the various types of music touched by the blues.

The Language of the Blues

Of the numerous books written about the blues, few if any, have dealt with anything other than its language (style and construction), its symbolism, its political, socio-economic aspects and its personalities. By far the most authoritative works have been about language and symbolism in the blues. For this reason, these subjects receive little attention here.

A few generalizations about the blues in vocal form follow:

1. The blues is basically a call-and-response form (African retention).
2. The typical blues text has a stanza of three lines arranged—

A	A¹	B
Statement	Statement Repeated	Resolution of first two statements

(The statements are usually, although not always, rhymed.)

 In keeping with the personalization endemic to blues and jazz the second statement A^1 is rarely an exact repeat but rather is altered by the addition of some sort of exclamation in whatever slang is currently popular—such as "yeah," "ha," "mercy," "go head on," "I wants to holler," or "hep us out."
3. Vocal blues are rarely narrative in the usual sense; instead each stanza is a complete or relatively complete story in itself. Often verses are linked together that have no relationship to each other.
4. The text is often built around "in-language" of Blacks.

 a. hip and current dialect and jargon.
 b. use of double entendre.
5. Texts are usually topical and lack self-consciousness.
6. The blues is extremely personal in that the performer sings about himself and his involvements to a combination of stock phrases and topical cliches combined from blues to blues. Even when the performer works out of the latter bag, his sense of style will give it the personal touch. Since the lyrics are non-narrative and lines have little relevance beyond the single verse, often the blues singer will grab the first line that rhymes. For example:

verse	I took my girl to the circus to see what she could see (2X)
last line	when she caught me lookin she took a poke at me

or

last line	when the monkey waved his tail at her she said he looked like me

or

last line	she found herself another dude and said she'd set me free

or

last line	when she spotted a heavy stud she handed him her key

or

last line	when she saw what the elephant had she wouldn't come home with me

As must now be obvious, any of the above lines, as well as thousands of others will resolve the situation set forth in the first two lines. Because the next verse is not dependent on what has transpired in the previous verse, the resolution does not help or hinder the flow or sense of the blues. In other words the resolution just doesn't make any difference. All blues singers have a common repository of stock phrases and resolutions, chosen primarily because of their rhyming possibilities.

7. Performance is usually solo in order to maximize freedom.
8. While the blues performer is likely to choose virtually any subject as a topic, the subject matter most often involves relationships between men and women or man and a hostile environment.

The blues is an introspective, harshly realistic music. The sturdy realism of the uprooted black folk is the spirit of the blues. The blues has intensity and directness as compared with the language of the American popular song which has lost much of its freshness and its ability to convey strong emotion.

Writing about blues verse, Paul Oliver says: "To appreciate the music without appreciating the content is to do an injustice to the blues singers and to fail to comprehend the full value of their work."[4]

Blues text is a very important part of the music. Bluesmen seldom sing about events that do not involve them personally and individual expression is the essence of blues:

Blues is above all the expression of the individual Negro. Declaring his loves, his hates, his disappointments, his experiences, the blues singer speaks for himself alone. The highly personal nature of the content of his songs makes them appear exceedingly remote from the world of the European listener, though the sentiments expressed in them may be fundamentally universal ones. A blues singer seldom considers his themes apart from himself, seldom narrates incidents in which he has not actively participated. He does not view his subject as an objective outsider but rather from within. Statements and reported accounts that are concerned solely with the lives and experiences of others with whom he has no direct contact are, therefore, rare, for the blues singer does not comment on a world as seen through a window but as a member circulating within it. It is a peculiar feature of the blues that this highly subjective approach does not manifest itself in over-Romanticism. Unable to sing with completely dispassionate objectivity, he sings with uncontrolled emotion. Above all he is a realist, intimately concerned with his subjects but having no illusions about them: neither carried away with transports of sentiment nor totally insensible and devoid of feeling; he is not repulsed by the uglier side of the world in which he lives but accepts the bad with the good.[5]

The Performers

It would be impossible to list all of the performers in vocal blues and instrumental blues, but for our purposes it is possible to enumerate some of the more important blues singers and instrumentalists across the history of black music.

These performers in vocal and instrumental music have come from diverse geographical, musical and philosophical situations. Each period in black music since the early 1920s has produced its great blues performers. Jazz produced great instrumentalists and blues great singers. It would be easier from our standpoint to start with the great blues instrumentalists who have issued from jazz.

Although few if any historians would type Louis Armstrong as a blues player *per se,* it is a fact that the spirit of the blues is pervasive in much of the playing of his early years. His uncanny ability to invest even the most pedestrian "pop" tune with an air of jazz spontaneity is attributable largely to his feeling for the blues. Aside from his extensive and skillful use of the blues scale and blue notes, Armstrong's playing and singing contained a great deal of those things which we perceive as indigenous to the blues and roots oriented black music.

Armstrong's free and imaginative use of vibrato (particularly what Gunther Schuller in *Early Jazz* refers to as terminal vibrato), his wide repertory of shakes, trills, his use of elision, slides, slurs, fall-offs, and his impeccable sense of swing, all suggest that if his playing did not come out of the blues, at the very least, it drew very heavily from the same sources.

Most of the great and near great jazz bands of the late 1920s and 1930s emerging from the Southwest (Kansas City, Denver, etc.) were blues oriented bands. That is, their repetoire consisted primarily of blues and blues type compositions. The presence of a heavy blues tradition virtually assured a modicum of experience with blues to the young musician from these areas. A cursory examination of the recordings of Count Basie, Walter Paige and the Blue Devils, Alphonse Trent, Benny Moten, and others will reveal an overwhelming diet of blues and blues influenced music.

While the number of brilliant blues/jazz soloists to come out of this era and area is too vast to warrant an exhaustive approach, it behooves us to at least examine the work of the Count Basie soloist, who is usually given the title of "the first great blues instrumentalist."

Lester Young was the most important soloist to come from the ranks of the Count Basie band. He was the first of the great instrumental blues players. He was largely responsible for the re-establishment of the rhythmic priorities in jazz, priorities inextricably linked to the blues. Young's most important contributions were basically melodic, his experimentation with sustained rubato phrasing and evenly articulated eighth notes was something entirely new to jazz. Young's musical thought flowed freely over barline, not unlike his contemporaries in vocal blues. His lyricism extended the traditional riff-style blues melodies common to soloists of his time.

Young's lyric style often impressed many of his contemporaries with its sophistication in comparison with anything that had gone before. There is

4. Paul Oliver. *The Meaning of the Blues,* p. 32.
5. Oliver, p. 326.

undeniably a sense in which Young's approach to a chord progression was more ingenious than that of any of his predecessors. Where Coleman Hawkins would exploit every note in the chord, racing up and down the arpeggios, Young would pass along the same harmonic path by means of omission, implication and suggestion endowing even the familiar blues changes with a strange orientation by the use of neglected intervals, economy of notes and great pungency of wit. It is no wonder that Young has been called the great epigramaticist of jazz. His was the spirit of the blues singer—directness, economy of means, irony, musical double entendre.

Harmonically speaking, Young was the first to incorporate most of the revolutionary devices of the thirties into his own style. Whether or not he introduced them is of little consequence, for he was the only jazz player who possessed the tastefulness required to make them musically convincing.

In many of Young's solos of the mid-thirties, one may detect the instinctive groping toward chromatic progressions of descending minor sevenths, which was to become a cliche in modern jazz blues playing some fifteen years later. There has been much speculation and dispute among critics as to whether or not Young was actually thinking in terms of minor seventh progressions, or if he merely liked the sound of something Benny Goodman had done as his partner on the Teddy Wilson-Billie Holiday recording of *I Must Have That Man.*

In retrospect it seems only natural that Young's inventiveness would dictate a preference for tunes which moved in the conventional cycles of resolving sevenths (e.g., "Blues," "Sweet, Georgia Brown," and thousands of pop tunes). Most of what is truly fascinating about his music stems from the fact that, restricted by the harmonic boundaries of the blues and most jazz and pop tunes of his time, he always managed to replace conventional structures with fresh, colorful shapes sounding at times perversely complex, but which, in fact, have the true greatness of simplicity which is so characteristic of the blues.

Issuing directly out of the southwest, instrumental blues and the Lester Young tradition, is another saxophonist, Charles Christopher ("Bird") Parker. Parker served his apprenticeship in great blues bands like that of Jay McShann. At one time or another he came into contact with all of the great blues shouters and players of the southwest who were his contemporaries.

Despite Parker's many innovations he was and remained throughout his career a blues player. If one were to examine his recording output, he would probably find that the blues comprised well over half of "Bird's" recorded works. In addition to this, of his tunes which have become a part of standard jazz repetoire a great many of them have been blues: "Now's the Time," "Billie's Bounce," "Cheryl," "Bird's Blues," "Happy Bird Barbados," "Cool Blues," to mention a few.

Aside from these more obvious manifestations, Parker's use of the blues scale, blues patterns and the like allowed him to invest any composition with the vitality, urgency and earthiness of the blues. It is perhaps this attitude about the blues that he was able so successfully to communicate to later generations of players. We can hear this musical phenomenon as filtered through Parker in the playing of most of the major players of this generation, Cannonball Adderley, John Coltrane, J. J. Johnson, Archie Shepp, Ornette Coleman, and others.

Continuing the southwest tradition and the Lester Young-Charlie Parker blues lineage is another young southern saxophonist, Ornette Coleman. Coleman was born in Fort Worth, Texas, March 19, 1930. He was exposed very early to the blues by singers and various groups with their ingeniously improvised instruments: kazoos, combs with tissue paper, washtub basses, spoons, etc. He learned from records the various rhythm and blues tunes as they came out and began making blues gigs. He along with his young friends "investigated" the honky tonks where the various rhythm and blues groups played. His young contemporaries included the later to be famous tenorman King Curtis. He consciously imitated the rhythm and blues heroes of the day, such as Lynn Hope, Big Jay McNeely, Arnett Cobb, Louis Jordan, and Gene Ammons. The blues lessons that he learned during these formative years have never been abandoned. He spent some time in Pee Wee Crayton's Rhythm and Blues band.

It seems very natural, in light of Coleman's background, that blues should be a pervasive influence on his music. Despite the juxtapositions of usually segregated elements, his playing has never been any further out than that of a country bluesman. His bluesy, folklike playing and composing have had far reaching effects on legions of young *avant garde* musicians—Charles Tyler, Archie Shepp, Albert Ayler, and others.

Having discussed instrumentalists, we now need to deal with two different classifications of blues singers. While in many instances the distinctions are arbitrary and/or artificial, there is a great deal of merit to this approach. First it will facilitate our handling of individual singers by allowing us to often group them according to similarities in technique, approach, material; secondly, it will enable us to set

some loose definitions and characteristics, to serve as points of departure.

The following chart, although drastically over-simplified, represents a comparison between rural and city blues.

Rural	City (Urban, Classic)
Folk Negro Society	City Society
Product of an agrarian society and attendant subject material.	Urban environs and topics of the city.
Folklore	Entertainment
South	North
Usually pure and extension of folklore and folk song.	Showed appropriation of a great many elements of popular music. (Popular theatre and/or vaudeville).
Blues singer usually found in three contexts. a. Singing for themselves and their immediate friends. b. Blind and/or otherwise disabled blues men. c. Slightly commercial performers, i.e., picnic, dances, etc.	Blues singers found in nightclubs, bars, social affairs.
Usually men.	Women and men but originally mainly women.
In-group directed.	Audience directed.
Broader variety of subjects.	Often sex-oriented, though veiled.
Songs of boll-weevils, draught, crops, etc.	Songs of bedbugs, roaches, rats, "The Block."
Bad diction, faulty rhyme, unconventional word usage.	Sophisticated, smooth diction and speech.
Bleak, austere but often fused with hope.	Hard, cruel, stoical and often speaks of hopelessness.
Stringing together of stock phrases (lines often disconnected and unrelated).	Emphasis often on lyrics that tell a story.
Rough style.	Smooth theatrical style.
Harsh, uncompromising, raw.	Contains the diverse and conflictive elements of black music, plus smooth emotional appeal of performance.
Improvised.	Standardized (formalized), etc.
Less structured, "free" form.	Classical 8, 12, or 16 measure blues.
Use of pedal points, one or two chord drones, prolonged and indefinite rate of harmonic change.	Standard Blues Changes I IV I V IV I
Unaccompanied voice or mostly solo with guitar accompaniment, and/or improvised instruments.	Instrumental accompaniment, conventional instruments.
Spontaneous expression of thought and mood.	Written material, formal orchestration, musical arrangements.
Spontaneous beginnings, fade-away endings.	Clear cut beginnings and endings.
Structural elaboration usually accidental.	More elaborate structures (tags, endings, modulations, introductions, etc.).
Expressive rubato (free rhythm) and erratic tempi.	Wide tempo choices but rigidity once established.
Melody straight, range relatively narrow and confined. Nasal quality with restricted use of melisma. (Many notes to a single word.) Less inhibited and much abandonment.	Melody influenced by instrumental practices—wide range and extensive use of melisma. Regularity of phrases becoming standardized and often stultified.
Rhythms crude, simple, primitive and erratic.	Rhythms sophisticated, refined and often standardized.

Rural	City (Urban, Classic)
Scale choices relatively limited—usually blues, pentatonic and Major.	Greater scale choices—blues, pentatonic, Major, diminished, etc.
Greater use of vocal ornamentation to relieve the monotony of solo voice and solo instrument.	Stricter vocal techniques.
Solo or improvised groups.	Groups usually organized.
Usually "in-group" black.	More readily adapted by white world.

Theoretically emancipation provided for the black man in this country his first concept of leisure time. Whatever time could be extracted from the sun-up to sunset sharecropping existence of the Southern Black was indeed a novelty. The birth of the blues depended on this concept of man's being able to be alone and personalize his feeling in song. Early blues developed as a music to be sung for pleasure.

The blues was conceived by freed men and ex-slaves. It was music conceived in and born out of the conditions which prevailed for the black man in America. It was and is a music inextricably linked to the general movement of black Americans into the central culture of America. The blues, like the African music out of which it, in the final analysis, comes, goes back for its impulse and emotional meaning to the individual, to his completely personal life and death. For this reason, the blues could retain its vitality, spontaniety and immediacy as a genre. Although techniques were codified and verses became standardized, the music remained personal because it began with the performers themselves and not with preconceived and formalized notions about performance practices.

When black men began their exodus to the North they brought the blues with them. It was this fusion of the older traditions and the new experience that produced the urban blues.

Musically, the urban or city or classic blues drew on a great many elements from wide and diverse sources including minstrelsy and vaudeville. The so-called classic blues made its first appearance around 1910 concurrent with ragtime. The classic blues heralded the entrance of black men into the world of professional entertainment.

Classic blues, in its earliest state, represented a kind of codification of the disparate elements of country or primitive blues. The following is a list of some important male and female blues singers, as well as an essential discography and bibliography.

Discography

Blues

Anthology of Rhythm and Blues. Columbia—CS-9802.
Blues Roots. Arhoolie—Poppy 60003.
Ray Charles: Genius Sings the Blues. Atlantic—S-8052.

Hank Crawford: Mr. Blues Plays Lady Soul. Atlantic—S-1523.
W. C. Handy Blues. Folkways—FG-3540.
History of Rhythm and Blues. Atlantic—8-record set.
John Lee Hooker: Real Blues. Chess—1508.
That's My Story: John Lee Hooker Sings the Blues. Riverside—12-321.
Lightnin' Hopkins: Greatest Hits. Prestige—7592.
The Legendary Son House. Columbia—CL 2414.
Shaky Jake: Mouth Harp Blues. Prestige—Bluesville 1027.
The Immortal Blind Lemon Jefferson. Milestone—2004.
Blind Willie Johnson. Folkways—FG 3585.
Robert Johnson, King of the Delta Blues Singers, Columbia—CL 1654.
B. B. King: Indianola, Mississippi Seeds. ABC—S-713.
Huddie Ledbetter: Keep Your Hands Off Her. Verve—FVS9021.
Cripple Clarence Lofton. Vogue—LDE 122.
Memphis Slim: Just Blues. Prestige—Bluesville 1018.
Negro Folk Music of Alabama (game songs and others). Ethnic Folkways Library—4417-18, 4471-74.
Negro Folklore fron Texas State Prisons. Elektra—EKS-7290.
Negro Folk Music of Africa and America. Folkways—FE-4500.
Negro Prison Songs from the Mississippi State Penitentiary. Tradition—TLP 1020.
Ma Rainey: Blues the World Forgot. Biograph—12001.
Roots of the Blues. Atlantic—1348.
Bessie Smith: Story. Columbia—CL 855-858.
Bessie Smith, The World's Greatest Blues Singer. Columbia—GP 33.
Roosevelt Sykes: The Honeydripper. Prestige—Bluesville 1014.
Sonny Terry/Brownie McChee. Fantasy—3254.
Joe Turner: Boss of the Blues. Atlantic—1234.
Dinah Washington: Best in Blues. Mercury—20247.
Jimmie Witherspoon: Evenin' Blues. Prestige—7300.
Muddy Waters: After the Rain. Cadet—CS-320.
Nancy Wilson: Hurt So Bad. Capitol—ST353.
Howlin' Wolf: Moanin' in the Moonlight. Chess—1434.
Women of the Blues. RCA Victor—LPV 534.
Jimmie and Mama Yancey: Pure Blues. Atlantic—1283.

Collections

Discography—For the Blues

Country Blues Classics. Vol. 1, 2, 3 Blues Classics (A) B C 5/6/7.
The Rural Blues. RBF Records (A) RF202.
Conversation with the Blues (documentary). Decca (E) LK 4664.
Screening the Blues. CBS (E) (M) 63288.
Blues Roots. The Atlanta Blues RBF (A) RF15.

Modern Chicago Blues. (An Anthology).
Blues Southside Chicago. (Chicago Chess Recording Vol. 1, 2, 3).
Blues Singer. Folkways FJ 28V4, Vol. 4.
Boogie Woogie. Folkways FJ 2810, Vol. 10.
The Blues. Folkways FJ 2802, Vol. 2.

Boogie Woogie

Honky Tonk Train. Riverside (E) RLP 8806.
Barrelhouse Blues and Boogie Woogie—1, 2. Storyville (F) SLP 1.55/183.
Giants of Boogie Woogie. Riverside 12-106.
Boogie Woogie. Folkways FJ 2810, Vol. 10.

Blues Instrumentalist (Jazz)

Louis Armstrong Plays the Blues. London (E) AL 3501.
Lester Young—The Immortal Lester Young. Savoy MG 12068.
Charles Parker—Historical Masterpieces. PLP 701.
The Happy Bird. PLP 404.
Ornette Coleman—Change of the Century. Atlantic 1327.
The Shape of Jazz to Come. Atlantic 1317.

Female Blues Singers

Ida Cox. Ida Cox Sings the Blues. London (E) AL3517
Gertrude "Ma Rainey" Pridgett. The Immortal Ma Rainey. Milestone (A) MLP 2001.
Bessie Smith. The Bessie Smith Story Vol. I. CBS (E) BPG 62377.
The World's Greatest Blues Singer. Col. GP 33.
Sippie Wallace. Sippie Wallace Sings the Blues. Storyville (E) 671.198.
Mamie Smith.
Billie Holiday. Shades of Blue. Sunset SUS 5147.
Dinah Washington. Golden Hits. Mercury SR 60788-60789
Ruth Brown. Late Date with Ruth Brown. Atlantic 1308.
Carmen McRae.

Some Important Male Blues Singers

Elmore James. The Best of Elmore James. Sue (E) 1LP 918.
Robert Johnson. Robert Johnson—King of the Delta Blues Singers. CBS (E) BPG 62456.
Charlie Patton. Charlie Patton & The Country Blues. Origin (A) OJL—1.
Robert Pete Williams. Free Again-Bluesville. (A) BVLP 1026.
Blind Lemon Jefferson. Penitentiary Blues. London (E) AL 3546.
Lightning Hopkinss. The Roots of Lightnin' Hopkins. Verve—Folkways (E) VLP 5003.
Bukka White. Bukka White Sky Songs Vol. 2. Arhoolie (A) F1020.
Johnny Shine.
Skip James. Skip James—Greatest of the Delta Blues Singers. Storyville (E) 607.
Chester "Howlin' Wolf" Burnett. "Moonin' in the Moonlight." Chess (A) 1434.
John Lee Hooker. The Blues—John Lee Hooker. Crown (A) CLP 5157.
Arthur "Big Boy" Crudup. Big Boy Crudup. RCA (F) 130.284.
McKinley "Muddy Waters" Morganfield. The Best of Muddy Waters. PYE (E) NPL 28040.

Huddie "Leadbelly" Ledbetter. Leadbelly: The Library of Congress Recordings. Elektra (E) EKL30.
William "Peetie Wheatstraw" Bunch. Peetie Wheatstraw Blues Classic. (A) BC4.
Roosevelt Sykes. Mr. Sykes Blues 1929-1932. Riverside (E) RLP 8819.
Blind Willie McTell. Blind Willie McTell—1940. Storyville (E) 670.186.
Francis Hillman "Scrapper" Blackwell. Blues Before Sunrise '77.' (E) RLP 8804.
LeRoy Carr. Blues Before Sunrise. CBS (E) BPG 62206.
Jimmy Rushing. Listen to the Blues. Vanguard Everyman Series SRV 73007.
Jimmy Witherspoon
Joe Turner. Bass of the Blues. Atlantic (E) 590006.
Big Joe Williams. Piney Wood Blues. Delmark (A) DL-602.
B. B. King. Blues in my Heart. Crown (A) 5309.

Bibliography

Bronzy, William 'Big Bill' and Yannick Bruynoghe. *Big Bill Blues:* Wm. Broonzy's Story, Cassell, 1955.
Charles, Samuel B. *The Country Blues.* Rinehart, 1959. *The Poetry of the Blues.* Oak Publications. *The Blues Men.* Oak Publications, 1967.
Dixon, Robert and John Godrich. *Blues and Gospel Records 1902-1942, a Discography.* London: Rust, 1969 (revised).
Garland, Phyl. *The Sound of Soul.* Henry Regnery Co., Chicago.
Handy, Wm. C. *Father of the Blues.* Macmillan, 1942.
Hentoff, Nat and Albert McCarthy, eds. *Jazz.* Grove Press, New York, 1959.
Hopkins, Jerry. *The Rock Story.* Signet, 1970, New York.
Jones, LeRoi. *The Blues People,* Apollo Edition, Wm. Morrow & Co. 1963, New York.
Keil, Charles. *The Urban Blues,* University of Chicago, 1966.
Laing, Iain. *Jazz in Perspective: The Background of the Blues* Hutchinson 1947.
Leadbitter, Mike and Neil Slaven. *Blues Records,* 1943-66, a Discography. London, Hanover, 1969, New York, Oak Publications.
Lomax, John A. and Alan Lomax. *Negro Folk Songs as Sung by Leadbelly,* Macmillan, 1936, New York.
Oliver, Paul. *Bessie Smith,* Cassell, 1959. *Blues Fell This Morning,* Cassell, 1960. *Conversation With the Blues,* Cassell, 1965. *Screening the Blues,* Cassell, 1968. *Savannah Syncopators,* Stein and Day, 1970. *The Story of the Blues,* Chilton Book Company, 1969.
Ramsey, Frederic. *Been Here and Gone,* University Press, 1960. Rutgers, New Brunswick.
Roxon, Lillian. *Rock Encyclopedia,* Grosset and Dunlap, 1969, New York.
Shelton, Robert. *The Country Music Story,* Bobbs-Merrill, 1965, New York.
Silverman, Jerry. *Folk Blues,* Oak Publications, 1968, New York.
Stearns, Marshall. *The Story of Jazz,* Sidgwick and Jackson, 1957.

When we think of blues poetry, the name of Langston Hughes (1902-1967) races to mind. Of all the young writers who began their careers during the

twenties, that important period of cultural and spiritual re-awakening in black arts known variously as the Harlem Renaissance/the Negro Renaissance/the Black Renaissance, Hughes was the one who put into words the "declaration of independence" of black artists, a "manifesto," black critic Arthur P. Davis calls it:

> We younger Negro artists who create now intend to express our individual dark-skinned selves without fear or shame. If the white folks seem pleased, we are glad. If they are not, it doesn't matter. We know we are beautiful. Ugly too. The tom-tom cries and the tom-tom laughs. If colored people are pleased, we are glad. If they are not, their displeasure doesn't matter either. We build our temples for tomorrow, strong as we know them, and we stand on top of the mountain, free within ourselves. (The *Nation,* June 23, 1926.)

Davis says that Hughes was the most independent person he ever knew. "His independence stemmed, like his coolness, from a strong belief in himself and in his work. He was not arrogant, but he possessed to a great degree the kind of creative egotism that every successful artist must have."[6]

Black historian Nathan Huggins (*Harlem Renaissance,* 1972) credits Hughes (and Sterling Brown) with attempting—in this period of black awareness—to develop unique black artistic forms, Hughes did draw spiritual sustenance from black culture and shaped poetic forms from real black experience, using black music to expand his conception of poetry. The blues was not music for the front parlor; it was "evil," funky, down home, unacceptable to those who were boot-strap risers or Sunday go-to-meetin' folk. A. X. Nicholas explains why:

> The old bluesmen (Leadbelly, Charlie Patton, Blind Lemon Jefferson, Big Bill Broonzy, et al.) were country bards—wandering from road to lonesome road, from town to Southern town in search of "home." When bluesmen migrated from the rural South to the urban North, they sat down to sing in the honky-tonks, speakeasies and any other place where whiskey and women could be found. Hence, the blues became associated with the "shady" side of life, and the old, church-going folks labeled them "devil songs."[7]

White folks cleaned up the blues before they recorded it. Mamie Smith, the first black to record blues, cut a record only because Sophie Tucker, at some critical moment, wasn't available. There were three great Smiths in blues annals—Mamie, Clara, and Bessie—but Bessie's blues was too black to be on genteel records for some time: record buyers were not quite ready for her. But when record companies discovered black consumers, "race" records were born. In the twenties, the first Harlem recording company, fathered by W. C. Handy's partner in music publishing, Harry Pace, opened its doors for business. Black Swan Records were made by the Pace Phonograph Corporation, which reportedly enjoyed "phenomenal" early success.

Langston Hughes loved to hear black music wherever it was played or sung. He also loved to read black newspapers[8] and to stand on streetcorners, listening to black people talk. In the long span of his career (over forty years), he recorded black idiom in stories, poems, novels and plays. His most famous character was a barstool philosopher, Jess B. Semple, known as "Simple," written into life in the pages of the *Chicago Defender,* a widely read black newspaper. Simple became so popular that the newspaper sketches grew into book-length collections: *Simple Speaks His Mind* (1950), *Simple Takes a Wife* (1952), *Simple Stakes a Claim* (1957), *The Best of Simple* (1961), *Simple's Uncle Sam* (1965); and also blossomed into a play, *Simply Heavenly* (1957). Hughes died on May 22, 1967. Ted Joans outlines the career of this prolific black writer and pays homage to him in his poem "Passed on Blues: Homage to a Poet," which appears in his book, *Black Pow-Wow: Jazz Poems* (New York, 1969). Joans's book is dedicated to "Langston Hughes and allyall."

Clearly the best person to explain blues poetry is Langston Hughes himself. In his book, *Fine Clothes to the Jew,* published in 1927, he begins with "A Note on Blues."

> The first eight and the last nine poems in this book are written after the manner of the Negro folk-songs known as *Blues.* The *Blues,* unlike the *Spirituals,* have a strict poetic pattern: one long line repeated and a third line to rhyme with the first two. Sometimes the second line in repetition is slightly changed and sometimes, but very seldom, it is omitted. The mood of the Blues is almost always despondency, but when they are sung people laugh.[9]

The dual nature of the blues can be observed in the following poems by Hughes and in blues poems by

6. Arthur P. Davis, "Langston Hughes: Cool Poet," *CLA Journal,* Vol. XI, No. 4, June, 1968.

7. A. X. Nicholas, ed., *Woke Up This Mornin,'* *Poetry of the Blues* (New York: Bantam Books, 1973), p. 5.

8. Langston Hughes has remarked that the "Negro press was his favorite reading"—that it kept him in touch with the real world of black people. "In my time I have been all around the world and I assure you there is nothing printed in the world like the American Negro Press. It is unique, intriguing, exciting, exalting, low-down and terrific. It is also tragic and terrible, brave, pathetic, funny and full of tears. It's me and my papa and my mama and Adam Powell and Hazel Scott and Rev. Martin King, Eartha Kitt, and folks who are no blood relation of mine but are brothers and sisters in skin." (Foreword to *Simple Stakes A Claim,* pp. 9-10).

9. Langston Hughes, *Fine Clothes to the Jew,* p. 13.

other writers. See if you can recognize the poetic pattern he mentions and its relationship to the vocal blues already discussed in the first section of this chapter. Observe also the general but not absolute use of the iambic meter (˘ ´), the pentameter line (five feet), and the caesura (pause) in each line.[10] The book, *Fine Clothes to the Jew,* begins with the poem "Hey!" and ends with the poem "Hey! Hey!"

Hey!*

Sun's a settin'
This is what I'm gonna sing. }A
Sun's a settin'
This is what I'm gonna sing: }A¹
I feels de blues a comin'
Wonder what de blues'll bring? }B

Hey! Hey!

Sun's a risin', [caesura]
This is gonna be ma song.
Sun's a risin', [caesura]
This is gonna be ma song.
I could be blue but [caesura]
I been blue all night long.

There are many kinds of blues, most of which Hughes fits into the following categories: family blues, loneliness blues, left-lonesome blues, broke-and-hungry blues, and the desperate going-to-the-river blues. In the family blues, the man and woman have quarreled and there's no way to patch up the quarrel, but in the loneliness blues, there's no one to quarrel with. If you can't sleep, can't eat and your "baby's" gone away, you've got the left-lonesome blues; and if you're a "stranger in a strange town" with no job and no prospects, you've got the broke-and-hungry blues. But, if you have the going-to-the-river blues, you're at the point of desperation. One important fact about the blues, however, is that it was created by a people determined to survive, and one method of survival is humor. Hughes says in his essay "Songs Called the Blues" that "sad as Blues may be, there's almost always something humorous about them—even if it's the kind of humor that laughs to keep from crying."[11] The following is an example of the going-to-the-river blues:

Goin' down to de railroad,
Lay my head on de track
I'm goin' to de railroad,
Lay my head on de track—
But if I see de train a-comin'
I'm gonna jerk it back.[11]

The next poem is an example of the left-lonesome blues. Observe the use of iambic pentameter in the lines A and A¹:

SUICIDE*

My sweet good man has
Packed his trunk and left.
My sweet good man has
Packed his trunk and left.
Nobody to love me:
I'm gonna kill ma self.

I'm gonna buy me a knife with
A blade ten inches long.
Gonna buy a knife with
A blade ten inches long.
Shall I carve ma self or
That man that done me wrong?

'Lieve I'll jump in de river
Eighty-nine feet deep.
'Lieve I'll jump in de river
Eighty-nine feet deep.
Cause de river's quiet
An' a po', po' gal can sleep.

"Stony Lonesome" by Hughes fits into the loneliness category. There is nobody left for Buddy Jones to quarrel with—Cordelia's in the stony ground.

STONY LONESOME**

They done took Cordelia
Out to stony lonesome ground.
Done took Cordelia
To stony lonesome,
Laid her down.
They done put Cordelia
Underneath that
Grassless mound.
 Ay-Lord!
 Ay-Lord!
 Ay-Lord!
She done left po' Buddy
To struggle by his self.
Po' Buddy Jones,
Yes, he's done been left.
She's out in stony lonesome,
Lordy! Sleepin' by herself.
 Cordelia's
 In stony
 Lonesome
 Ground!

*Reprinted by permission of Harold Ober Associates Incorporated. Copyright © 1927 by Alfred A. Knopf, Inc. Renewed.

**Copyright 1942 by Alfred A. Knopf, Inc. Reprinted from *Selected Poems,* by Langston Hughes, by permission of Alfred A. Knopf, Inc.

10. A. X. Nicholas points out that "blues poetry emanates from an oral, rather than a written tradition, and, therefore, has an irregular iambic pentameter" (Introduction to *Woke Up This Morning,* p. 1). That point should be kept in mind in reading the rest of the blues poems in this chapter and others referred to in the bibliography.

11. The *Langston Hughes Reader* (New York, 1958), p. 160.

Hughes's "Early Evening Quarrel" is a Family Blues poem. Notice that the dialogue, rare in vocal blues or in blues poetry, is a kind of call and response. Italics indicate the new voice: first Hattie speaks, then Hammond, and so on. But Hattie has the last word.

EARLY EVENING QUARREL*

Where is that sugar, Hammond,
I sent you this morning to buy?
I say, where is that sugar
I sent you this morning to buy?
Coffee without sugar
Makes a good woman cry.

I ain't got no sugar, Hattie,
I gambled your dime away.
Ain't got no sugar, I
Done gambled that dime away.
If you's a wise woman, Hattie,
You ain't gonna have nothin to say.

I ain't no wise woman, Hammond. I am evil and mad.
Ain't no sense in a good woman
Bein treated so bad.

I don't treat you bad, Hattie,
Neither does I treat you good.
But I reckon I could treat you
Worser if I would.

Lawd, these things we women
Have to stand!
I wonder is there nowhere a
Do-right man?

The sound of the blues can be heard in a number of the tales about Jess B. Semple, Hughes's character mentioned earlier. "Simple" is a black man in Harlem suffering all the ills a person who is both black and poor in America is heir to. With a difference. He is not so simple; he is wise in the ways of the world and he is a *race* man from foot to brain. Although Simple may fracture the language (e.g., "Negro hysterians," "incontemptible" and "touchous" women, listen "fluently," interracial "seminaries"), he often knows more about the ways of the world and has deeper insight into human experience than his educated ("colleged"), well-spoken friend Boyd. The two of them sit in the Wishing Well, or Paddy's Bar, stand on the corner or repair to Simple's landlady's establishment and discuss politics, racism, war, unemployment, and Simple's love life: Isabel, his first wife; Zarita, his "good-time" friend; Joyce, his lovable but sometimes pretentious fiancee. Simple, like Blind Lemon Jefferson, Charlie Patton, and Big Bill Broonzy, migrated North; he has experienced southern "justice" as well

as the contradictions of the "promised land." He is, in LeRoi Jones's (Imamu Baraka) terms, one of the Blues People. The opening story in *The Best of Simple* which gives us his history from the feet up, might be expressed, for example, as the "Sore 'n Achin Foot Blues" with lines like these:

My feets achin so's I cn hardly stan,
My feets achin, yeah, so's I cn hardly stan,
But ah ain't gonn trade em
Cause they done saved me from the man.

In "The Atomic Age" Simple sings the "Last Hired First Fired" Blues; in "Manna from Heaven," the "Carry and Clean" Blues. Several of the tales are specifically about the blues; in one with that title (from *Simple's Uncle Sam*) we have Simple's own explanation of the blues and how he is himself connected with the tradition:

"The blues can be real sad, else real mad, else real glad, and funny, too, all at the same time. I ought to know. Me, I growed up with the blues. Facts is, I heard so many blues when I were a child until my shadow was blue. And when I were a young man, and left Virginia and runned away to Baltimore, behind me came the shadow of the blues." (p. 17)

After Jess marries Joyce he gets rid of that "left-lonesome" feeling, a feeling which takes in a whole category of the blues, as Langston Hughes defined them. Of course, women figure prominently in the blues as singers and subjects to be sung about (Boyd can remember all three Smiths, Bessie, Clara, and Mamie, the great blues singers; Simple even admits that he's heard Ma Rainey). "So many blues is about womens," Simple says. Perhaps Hughes had that in mind when he began Simple's life story with a "woman"—Virginia.

"And who is Virginia? You never told me about her." [Asks Boyd]
"Virginia is where I was borned," said Simple. "I would be borned in a state named after a woman. From that day on, women never give me no peace." (*Simple Speaks His Mind*, pp. 3-4)

And when he does wish he was a "singerman," it's so that he can sing the blues. Jesse B. Semple, the Bluesman, has himself become as classic as the blues, and reading about him—his times and bad times—can tell us more about ourselves.[12]

12. The above appeared in *The Journal of Narrative Technique,* Jan. 1972, in an article by Phyllis R. Klotman entitled "Jess B. Semple and the Narrative Art of Langston Hughes," and a version of it in *Phylon,* "Langston Hughes' Jess B. Semple and the Blues," Vol. 36, No. 1, 1975.

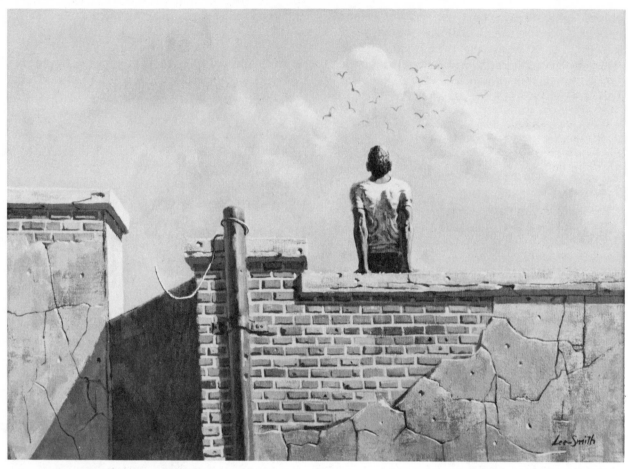

Figure 4.2. Hughie Lee-Smith, "Boy On The Roof," ca. 4′ × 2 1/2′. Courtesy of the artist. Photo: Mecki McCarthy.

The following two poems are from Sterling Brown's *Southern Road,* published originally in 1932. "Tin Roof Blues" is in the classic three-line structure, but the lines are several feet longer. The poem reverses the pattern of movement known as the "Great Migration," which was from South to North and country to city. The speaker has had enough of the friendless city and is going back home. The word "dicties" in stanza four was, before the sixties, used to describe a black middle-class bourgeois ("bougie") striver, usually someone inclined to look down on poorer black people and avoid them.

TIN ROOF BLUES*

I'm goin' where de Southern crosses top de C. & O.
I'm goin' where de Southern crosses top de C. & O.
I'm goin' down de country cause I cain't stay here no
 mo'.

Goin' where de Norfolk Western curves jes' lak de river
 bends,
Where de Norfolk Western swing around de river bends,
Goin' where de people stacks up mo' lak friends.

Leave 'is dirty city, take my foot up in my hand,
Dis do-dirty city, take my foot up in my hand,
Git down to de livin' what a man kin understand.

Gang of dicties here, an' de rest wants to git dat way,
Dudes an' dicties, others strive to git dat way,
Put pennies on de numbers from now unto de jedgement
 day.

I'm got de tin roof blues, got dese sidewalks on my
 mind,
De tin roof blues, dese lonesome sidewalks on my mind,
I'm goin' where de shingles covers people mo' my kind.

Some poems fit into the blues category because they are variations on the blues or because their subject matter is blues people. "Ma" Gertrude Rainey (she preferred Madamme) was called the "Mother of the Blues." Born in 1886 (died in 1939) in Columbus, Georgia, she was a legendary figure in the South as Sterling Brown's poem indicates.

*Sterling Brown, "Tin Roof Blues" from *Southern Road,* reprinted by permission of the author.

114

MA RAINEY*

1

When Ma Rainey
Comes to town,
Folks from anyplace
Miles aroun',
From Cape Girardeau,
Poplar Bluff,
Flocks in to hear
Ma do her stuff,
Comes flivverin' in,
Or ridin' mules,
Or packed in trains,
Picknickin' fools. . . .
That's what it's like,
Fo' miles on down,
To New Orleans delta
An' Mobile town,
When Ma hits
Anywheres aroun'.

2

Dey comes to hear Ma Rainey from de little river set-
 tlements,
From blackbottom cornrows and from lumber camps;
Dey stumble in de hall, jes' a-laughin' an' a-cacklin',
Cheerin' lak roarin' water, lak wind in river swamps.

An' some jokers keeps deir laughs a-goin' in de crowded
 aisles,
An' some folks sits dere waitin' wid deir aches an'
 miseries,
Till Ma comes out before dem, a-smilin' gold-toofed
 smiles
An' Long Boy ripples minors on de black an' yellow
 keys.

3

O Ma Rainey,
Sing yo' song;
Now you's back
Whah you belong,
Git way inside us,
Keep us strong. . . .
O Ma Rainey,
Li'l an' low;
Sing us 'bout de hard luck
Roun' our do';
Sing us 'bout de lonesome road
We mus' go. . . .

4

I talked to a fellow, an' the fellow say,
"She jes' catch hold of us, somekindaway.
She sang Backwater Blues one day:

 'It rained fo' days an' de skies was dark as night,
 Trouble taken place in de lowlands at night.

 'Thundered an' lightened an' the storm begin to roll
 Thousan's of people ain't got no place to go.

 'Den I went an' stood upon some high ol' lonesome
 hill,
 An' looked down on the place where I used to live,

 An' den de folks, dey natchally bowed dey heads an'
 cried,
 Bowed dey heavy heads, shet dey moufs up tight an'
 cried,
 An' Ma lef' de stage, an' followed some de folks out-
 side.''

Dere wasn't much more de fellow say:
She jes' gits hold of us dataway.

According to LeRoi Jones (Imamu Baraka), "singers like Gertrude 'Ma' Rainey were responsible for creating the classic blues style. She was one of the most imitated and influential classic blues singers, and perhaps the one who can be called the *link* between the earlier, less polished blues styles and the smoother theatrical style of the later urban blues singers." See his chapter, "Classic Blues," in *Blues People,* p. 89.

Many black writers have acknowledged the importance of black music and black musicians to the black community. In Langston Hughes's novel *Not Without Laughter* (1930), Sandy's father Jimboy and his aunt Harriet symbolize the secular side of black music—the blues, while his grandmother Hagar and her other daughters Anjee (Sandy's mother) and Tempy represent the sacred—spirituals and gospels. Tension is set up between the adults at either end of the musical continuum, but Sandy draws benefit from both. Rather than fragmenting his growth or splintering his personality, they enrich his life and help to give him a sense of pride in and understanding of the variety and complexity of black tradition. Black critic Sherley Anne Williams says that "music is a metaphor and symbol standing in both its secular and sacred form not only for the immediate Black experience as in [Claude] McKay [*Home to Harlem,* 1928] and Hughes, but for history and heritage and the acceptance of one's self in a positive and regenerating relationship to that heritage."[13]

Even earlier than *Home to Harlem* and *Not Without Laughter,* James Weldon Johnson centered his only novel, *The Autobiography of an Ex-Coloured Man,* around the problems of a black (mulatto) musician who finally decides to pass into

*Sterling Brown, "Ma Rainey" from *Southern Road,* reprinted by permission of the author.

13. Sherley Anne Williams, *Give Birth to Brightness* (New York: The Dial Press, 1971), p. 140.

the white world and give up his black heritage. (See Chapter 3, "The Spiritual in Song and Story," for an excerpt from Johnson's novel in which the musician attends a revival meeting in the South and is impressed by the extraordinary musicianship of the participants.) Ms. Williams contends that it is the "Black musician in trouble" who most often appears in the literature. And there is some support for that contention:

> This growing body of work extends the theme first broached in the novels of Johnson and McKay, the poetry of Sterling Brown and the poetry and fiction of Langston Hughes. In their tentative explorations of the relationship between Black life and Black music—the trials and joys of being Black in the white man's world—they lay the foundation for the portrayal of the musician who brings together the sublime and beautiful, the complex and brutal pieces of his experience in his music and finally is torn apart himself by the very complexity and brutality which he has helped to ameliorate.[14]

Richie ("Eagle") Stokes, who is modeled on the life of Charlie ("Bird") Parker, is a musician who is finally torn apart by the complexity and brutality of his experiences. In the novel *Night Song* (1961) by John A. Williams, "Eagle" plays his life out and is eventually destroyed by heroin, but drugs are more result than cause of his tormented life coming to an end. His close friend Keel explains, midway through the novel, what Richie Stokes, his talents and his genius, mean to black people:

> "Everybody uses Eagle. Everybody. And for my money, that night you were just another one of those shysters out destroying Eagle, who is—believe it or not—so much a part of us. . . . Some people preserve statues and old drawings on cave walls, but we have to have Eagle. He's us. He's fire and brain; he's stubborn and shabby; proud and without pride; kind and evil. His music is our record: blues, why goddamnit, his best music always came from blues. Isn't that terribly like all of us? Building on the blues, building with such speed and intricacy that we don't even know it's blues right on? We don't understand it, but we have short patience with cats who try to imitate him. Eagle is our aggressiveness, our sickness, our self-hate, but also our will to live in spite of everything. He symbolizes the rebel in us."[15]

Although Sonny, in James Baldwin's short story "Sonny's Blues," is not modeled on Charlie Parker (Sonny is a pianist), "Bird" is the musician he most admires. Like "Eagle" Stokes in *Night Song,* Sonny—a black musician—is also involved in drugs. In fact, as the story opens, his older brother—a proper, middle-class schoolteacher in Harlem—has just read in the papers that Sonny has been "busted."

Before the two brothers see each other again, many things happen to them: Sonny goes through the horror of rehabilitation for drug addiction (the "cure"), while the older brother and his wife live through the tragic loss of their only daughter, a two-year-old child, to polio.

The two brothers are very different even as they grow up in the same, closely knit family, lose their parents, go to war. But they desperately yet unsuccessfully try to understand each other's needs. Understanding comes to them finally after many years in a moment of revelation that occurs in an unlikely place—a small, dimly lit nightclub where Sonny is known and respected. The following excerpt begins when the two brothers enter the club and the world of black music. That music becomes the means by which Sonny communicates not only his pain but also the anguish they all suffer—they as brothers to each other and as brothers in a collective racial experience. Suffering transcended becomes art. Sonny is the real genius, the black musician, the "light bearer":

> Sonny's music and his life become one and he is fused with the musical group in a relationship which sustains one because it sustains all. And finally, through the music, Sonny's brother begins to understand not so much Sonny, as himself, *his* past, *his* history, *his* traditions and that part of himself which he has in common with Sonny and the long line of people who have gone before them.[16]

The entire story appears in *Going to Meet the Man* (1965). There are five other tales by Baldwin in that collection which are well worth the reading.*

> We went to the only nightclub on a short, dark street, downtown. We squeezed through the narrow, chattering, jampacked bar to the entrance of the big room,

*Excerpt from "Sonny's Blues" by James Baldwin. Reprinted by permission of the author. ("Sonny's Blues" first appeared in *Partisan Review,* Summer, 1957.)

14. Sherley Anne Williams, pp. 142-43.

15. John A. Williams, *Night Song* (Chatham, New Jersey: The Chatham Bookseller, 1961), pp. 125-26. A screenplay of *Night Song* was co-authored and directed by black film director Herbert Danska in 1964, starring Dick Gregory as Eagle and Robert Hooks as Keel. The original version was apparently cut (mercilessly) and released under the title, *Sweet Love, Bitter,* in 1967. The title was subsequently changed to *It Won't Rub Off, Baby* (a remark Eagle makes in the novel and in the film) and then reverted to *Sweet Love, Bitter.* The film is currently available to educational groups at a modest rental fee. For a detailed description of the film's checkered life, see Norman Kagan, "The Sweet Love Bitter Affair," *Filmmakers Newsletter,* March 1972.

16. Sherley Anne Williams classifies the musician with "the Black Hero as Light Bearer" in *Give Birth to Brightness.* This quote is from p. 149 of that very interesting critical work.

where the bandstand was. And we stood there for a moment, for the lights were very dim in this room and we couldn't see. Then, "Hello, boy," said a voice and an enormous black man, much older than Sonny or myself, erupted out of all that atmospheric lighting and put an arm around Sonny's shoulder. "I been sitting right here," he said, "waiting for you."

He had a big voice, too, and heads in the darkness turned toward us.

Sonny grinned and pulled a little away, and said, "Creole, this is my brother. I told you about him."

Creole shook my hand. "I'm glad to meet you, son," he said, and it was clear that he was glad to meet me *there,* for Sonny's sake. And he smiled, "You got a real musician in *your* family," and he took his arm from Sonny's shoulder and slapped him, lightly, affectionately, with the back of his hand.

"Well. Now I've heard it all," said a voice behind us. This was another musician, and a friend of Sonny's, a coal-black, cheerful-looking man, built close to the ground. He immediately began confiding to me, at the top of his lungs, the most terrible things about Sonny, his teeth gleaming like a lighthouse and his laugh coming up out of him like the beginning of an earthquake. And it turned out that everyone at the bar knew Sonny, or almost everyone; some were musicians, working there, or nearby, or not working, some were simply hangers-on, and some were there to hear Sonny play. I was introduced to all of them and they were all very polite to me. Yet, it was clear that, for them, I was only Sonny's brother. Here I was in Sonny's world. Or, rather: his kingdom. Here, it was not even a question that his veins bore royal blood.

They were going to play soon and Creole installed me, by myself, at a table in a dark corner. Then I watched them, Creole, and the little black man, and Sonny, and the others, while they horsed around, standing just below the bandstand. The light from the bandstand spilled just a little short of them and, watching them laughing and gesturing and moving about, I had the feeling that they, nevertheless, were being most careful not to step into that circle of light too suddenly: that if they moved into the light too suddenly, without thinking, they would perish in flame. Then, while I watched, one of them, the small black man, moved into the light and crossed the bandstand and started fooling around with his drums. Then—being funny and being, also, extremely ceremonious—Creole took Sonny by the arm and led him to the piano. A woman's voice called Sonny's name and a few hands started clapping. And Sonny, also being funny and being ceremonious, and so touched, I think, that he could have cried, but neither hiding it nor showing it, riding it like a man, grinned, and put both hands to his heart and bowed from the waist.

Creole then went to the bass fiddle and a lean, very bright-skinned brown man jumped up on the bandstand and picked up his horn. So there they were, and the atmosphere on the bandstand and in the room began to change and tighten. Someone stepped up to the micro-phone and announced them. Then there were all kinds of murmurs. Some people at the bar shushed others. The waitress ran around, frantically getting in the last orders, guys and chicks got closer to each other, and the lights on the bandstand, on the quartet, turned to a kind of indigo. Then they all looked different there. Creole looked about him for the last time, as though he were making certain that all his chickens were in the coop, and then he—jumped and struck the fiddle. And there they were.

All I know about music is that not many people ever really hear it. And even then, on the rare occasions when something opens within, and the music enters, what we mainly hear, or hear corroborated, are personal, private, vanishing evocations. But the man who creates the music is hearing something else, is dealing with the roar rising from the void and imposing order on it as it hits the air. What is evoked in him, then, is of another order, more terrible because it has no words, and triumphant, too, for that same reason. And his triumph, when he triumphs, is ours. I just watched Sonny's face. His face was troubled, he was working hard, but he wasn't with it. And I had the feeling that, in a way, everyone on the bandstand was waiting for him, both waiting for him and pushing him along. But as I began to watch Creole, I realized that it was Creole who held them all back. He had them on a short rein. Up there, keeping the beat with his whole body, wailing on the fiddle, with his eyes half closed, he was listening to everything, but he was listening to Sonny. He was having a dialogue with Sonny. He wanted Sonny to leave the shoreline and strike out for the deep water. He was Sonny's witness that deep water and drowning were not the same thing—he had been there, and he knew. And he wanted Sonny to know. He was waiting for Sonny to do the things on the keys which would let Creole know that Sonny was in the water.

And, while Creole listened, Sonny moved, deep within, exactly like someone in torment. I had never before thought of how awful the relationship must be between the musician and his instrument. He has to fill it, this instrument, with the breath of life, his own. He has to make it do what he wants it to do. And a piano is just a piano. It's made out of so much wood and wires and little hammers and big ones, and ivory. While there's only so much you can do with it, the only way to find this out is to try; to try and make it do everything.

And Sonny hadn't been near a piano for over a year. And he wasn't on much better terms with his life, not the life that stretched before him now. He and the piano stammered, started one way, got scared, stopped; started another way, panicked, marked time, started again; then seemed to have found a direction, panicked again, got stuck. And the face I saw on Sonny I'd never seen before. Everything had been burned out of it, and, at the same time, things usually hidden were being burned in, by the fire and fury of the battle which was occurring in him up there.

Yet, watching Creole's face as they neared the end of the first set, I had the feeling that something had hap-

pened, something I hadn't heard. Then they finished, there was scattered applause, and then, without an instant's warning, Creole started into something else, it was almost sardonic, it was *Am I Blue*. And, as though he commanded, Sonny began to play. Something began to happen. And Creole let out the reins. The dry, low, black man said something awful on the drums, Creole answered, and the drums talked back. Then the horn insisted, sweet and high, slightly detached perhaps, and Creole listened, commenting now and then, dry, and driving, beautiful and calm and old. Then they all came together again, and Sonny was part of the family again. I could tell this from his face. He seemed to have found, right there beneath his fingers, a damn brand-new piano. It seemed that he couldn't get over it. Then, for a while, just being happy with Sonny, they seemed to be agreeing with him that brand-new pianos certainly were a gas.

Then Creole stepped forward to remind them that what they were playing was the blues. He hit something in all of them, he hit something in me, myself, and the music tightened and deepened, apprehension began to beat the air. Creole began to tell us what the blues were all about. They were not about anything very new. He and his boys up there were keeping it new, at the risk of ruin, destruction, madness, and death, in order to find new ways to make us listen. For, while the tale of how we suffer, and how we are delighted, and how we may triumph is never new, it always must be heard. There isn't any other tale to tell, it's the only light we've got in all this darkness.

And this tale, according to that face, that body, those strong hands on those strings, has another aspect in every country, and a new depth in every generation. Listen, Creole seemed to be saying, listen. Now these are Sonny's blues. He made the little black man on the drums know it, and the bright, brown man on the horn. Creole wasn't trying any longer to get Sonny in the water. He was wishing him Godspeed. Then he stepped back, very slowly, filling the air with the immense suggestion that Sonny speak for himself.

Then they all gathered around Sonny and Sonny played. Every now and again one of them seemed to say, amen. Sonny's fingers filled the air with life, his life. But that life contained so many others. And Sonny went all the way back, he really began with the spare, flat statement of the opening phrase of the song. Then he began to make it his. It was very beautiful because it wasn't hurried and it was no longer a lament. I seemed to hear with what burning he had made it his, with what burning we had yet to make it ours, how we could cease lamenting. Freedom lurked around us and I understood, at last, that he could help us to be free if we would listen, that he would never be free until we did. Yet, there was no battle in his face now, I heard what he had gone

through, and would continue to go through until he came to rest in earth. He had made it his: that long line, of which we knew only Mama and Daddy. And he was giving it back, as everything must be given back, so that, passing through death, it can live forever. I saw my mother's face again, and felt, for the first time, how the stones of the road she had walked on must have bruised her feet. I saw the moonlit road where my father's brother died. And it brought something else back to me, and carried me past it, I saw my little girl again and felt Isabel's tears again, and I felt my own tears begin to rise. And I was yet aware that this was only a moment, that the world waited outside, as hungry as a tiger and that trouble stretched above us, longer than the sky.

Then it was over. Creole and Sonny let out their breath, both soaking wet, and grinning. There was a lot of applause and some of it was real. In the dark, the girl came by and I asked her to take drinks to the bandstand. There was a long pause, while they talked up there in the indigo light and after awhile I saw the girl put a Scotch and milk on top of the piano for Sonny. He didn't seem to notice it, but just before they started playing again, he sipped from it and looked toward me, and nodded. Then he put it back on top of the piano. For me, then, as they began to play again, it glowed and shook above my brother's head like the very cup of trembling.

Bibliography

In addition to the blues poems in this chapter, other blues poems can be found in:

Sterling Brown, *Southern Road*. Boston: Beacon Press, paperback edition, 1974. Includes: "Memphis Blues," "New St. Louis Blues," "Riverbank Blues," etc.

Stephen Henderson, *Understanding the New Black Poetry*. New York: William Morrow & Co., Inc., 1973. Henderson's book contains an excellent analysis of black poetry and includes a number of blues poems.

Langston Hughes, *The Weary Blues*. New York: Alfred A. Knopf, 1926.

———. *Fine Clothes to the Jew*. New York: Alfred A. Knopf. 1927.

———. *Selected Poems of Langston Hughes*. New York: Alfred A. Knopf, 1959.

———. *Shakespeare in Harlem*.

A. X. Nicholas, *Woke Up This Morning: Poetry of the Blues*. New York: Bantam Books, 1973. Nicholas has transcribed the words of such blues singer-poets as: Leadbelly, Ma Rainey, Charlie Patton, Blind Lemon Jefferson, Bessie Smith, Big Bill Broonzy, Son House, Skip James, Leroy Carr, Bukka White, Howlin' Wolf, Lightnin' Hopkins, Robert Johnson, Muddy Waters, John Lee Hooker, and B. B. King.

Discography: Langston Hughes: Simple Stories read by Ossie Davis. Caedmon, TC1222.

THE MUSIC AND POETRY OF JAZZ

JAZZ IS MY RELIGION*

Ted Joans

JAZZ is my religion and it alone do I dig the jazz clubs are my houses of worship and sometimes the concert halls but some holy places are too commercial (like churches) so I don't dig the sermons there I buy jazz sides to dig in solitude Like man/Harlem, Harlem U.S.A. used to be a jazz heaven where most of the jazz sermons were preached but now-a-days due to chacha cha and rotten rock'n'roll alotta good jazzmen have sold their souls but jazz is still my religion because I know and feel the message it brings like Reverend Dizzy Gillespie/ Brother Bird and Basie/ Uncle Armstrong/ Mister Monk/ Deacon Miles Davis/ Rector Rollins/ Priest Ellington/ His Funkness Horace Silver/ and the great Pope John, John COLTRANE and Cecil Taylor They Preach A Sermon That Always Swings!! Yeah jazz is MY religion Jazz is my story it was my mom's and pop's and their moms and pops from the days of Buddy Bolden who swung them blues to Charlie Parker and Ornette Coleman's extension of Bebop Yeah jazz is my religion Jazz is a unique musical religion the sermons spread happiness and joy to be able to dig and swing inside what a wonderful feeling jazz is/YEAH BOY!! JAZZ is my religion and dig this: it wasnt for us to choose because they created it for a damn good reason as a weapon to battle our blues! JAZZ is my religion and its international all the way JAZZ is just an Afroamerican music and like us its here to stay So remember thatJAZZ is my religion but it can be your religion too but JAZZ is a truth that is always black and blue Hallelujah I love JAZZ so Hallelujah I digJAZZ so Yeah J A Z Z
IS M Y RELIGION

Ted Joans's poem, "Jazz Is My Religion," improvises on the theme stated in the title. It is not in any stanzaic pattern, but it is a kind of secularized but reverential celebration of jazz, its message (sermon), and its high priests (e.g., Dizzie Gillespie, Charlie Parker, Count Basie, Louis Armstrong, John Coltrane, Duke Ellington.) The movement of the words on the page reflects the development of black instrumental music from blues to be-bop to jazz.

In every era the word jazz has meant something

different, even to its practitioners but throughout its 70 odd years there seem to exist some verities.

First, jazz is a black music. The black man gave this music, the idea of the music, the way of playing the music, the language, the vocabulary—the essence of jazz to the world; every advancement and major innovation has come from the black man. Gunther Schuller says in his book *Early Jazz*, "Since rhythm and inflection are the elements that most obviously distinguish jazz from the rest of Western music, it is highly revealing to study them in relationship to African ancestry. In examining the nature of jazz rhythm we discover that its uniqueness derives from two primary sources: a quality jazz musicians call 'swing' and the consistent democratization of rhythmic values. Both characteristics derive exclusively from African musical antecedents."[1]

Popular conception has it that jazz is the meeting of African rhythms and European harmonies. Now, the attendant notion is that whatever dignity jazz has, comes as a result of the European half of the equation. This would explain in part why—whenever jazz is accepted by the establishment as concert music—it is usually diluted. Much of this *acceptable* jazz is testimony to how the African elements of the music can be completely neutralized.

As Gunther Schuller points out:

It is evident that many more aspects of jazz derive directly from African musical-social traditions than has been assumed. Every musical element, rhythm, harmony, melody, timbre and the basic forms of jazz—is essentially African in background and derivation. After all, centuries-old traditions that are not merely artistic cultivations but an inseparable part of every day life are not abandoned so easily. Acculturation took place, but only to the limited extent that the Negro allowed European elements to be integrated into his African heritage. Until the 1920s he took only those European ingredients that were necessary for his own music's survival. Thus one can say that within the loose framework of European tradition, the American Negro was able to preserve a significant nucleus of his African heritage. And it is

1. Gunther Schuller, *Early Jazz: Its Roots and Musical Development* (New York: Oxford Universities Press, 1968), p. 6.

that nucleus that has made jazz the uniquely captivating language that it is.[2]

As to why all of the major innovators is jazz have been black, Frank Kofsky in *Black Nationalism and the Revolution in Music*, suggests the following:

> Just as it is far more likely that a French rather than an English novelist will be the originator of some potent new stylistic departure in French letters, so it is to be expected that the major revolutionary developments in jazz—the abrupt discontinuities in modes of improvisation flow from the hands and instruments of blacks. Ghetto blacks, if you will, "speak jazz" [or blues or gospel] as their "native tongue" as Italians "speak opera," whereas for most whites it is a "language" that must be acquired, sometimes not without a great deal of painful effort and highly disciplined study. Hence consider the difference in situations of two youths, one black, one white, in their early twenties. The black youth, having unconsciously assimilated much of the jazz tradition as a part of his culture, can take this tradition more or less for granted when he begins his career in music. As a result, all of his energies and talents can be given over to the elaboration of a personal style of his own—one that may be revolutionary in its impact on his peers. The white youth on the other hand, must devote his efforts not so much to becoming a unique voice, but to the necessary prior problems of simply mastering the jazz vernacular, *acquiring* the tradition. The first youth, therefore, finds the way open to becoming a creator; the second is satisfied if he can achieve something better than run-of-the-mill competence.
>
> It is esentially for this reason that most whites who enter the jazz world do so as imitators of black innovators.[3]

Improvisation is the essence of jazz. A composition may be written by a jazz composer, contain jazz rhythms, melodies, harmonies, etc., and be performed by a jazz band *but* until improvisation takes place it is not jazz. Unlike most western art music, it is creative rather than recreative.

Another constant in this music is the emphasis on personal expressiveness. Because it is a creative music, jazz depends on the individual performer for its impetus; therefore, there is an inherent stigma attached to not being yourself. In all areas the jazz musician is urged to assume the posture of a pragmatist (i.e., no right or wrong way, only that which works or doesn't work).

Jazz musicians, for instance, have added countless new musical color possibilities and color combinations to the orchestral pallet because of this attitude. Western trained musicians who were more restricted by traditional concepts of sound production had been stalemated in this area since the time of Rimsky-Korsakoff. Classically trained musicians were more interested in refining a particular tone quality. They had an ideal in mind, that is, a specific,

and exclusive "right" quality. *Any* deviation was unacceptable. Only for the sake of novelty did Western musicians condescend to explore other tonal nuances of the instruments.

Diametrically opposed to this decidedly Western concept is the African concept of instrumental music with its vast ramifications. The concept of a right or wrong sound is alien to African musical philosophy. As with pitch and rhythm, considerable latitude is afforded the African musician in the area of sound and/or timbre. Any direct or imitative statement whether in music or language is considered crude and unimaginative. Obliquity and ellipsis assume a place of paramount importance. Because of the attitude which encourages the individual musician to produce a multiplicity of sounds, limited only by his own imagination, the resultant music is kaleidescopic in its variety.

This desire to maximize personal expressiveness is evident and in the way in which jazz performers use the instruments. One result has been the expansion of the emotional properties of instruments. Jazz musicians who are less tradition bound are able to move the instruments outside the restrictions and confines of Western music. Because many jazz musicians conceive of their instruments as extensions of the human voice, all of the vocal nuances that were formerly the exclusive property of the voice have been incorporated into instrumental technique. The attendant flexibility and latitude permit the performer and/or composer to express himself more fully. As the voice is generally considered capable of expressing a greater range of emotion, so the jazz man's liberated instruments possess a greater range of emotional expression.

The possibilities for communication have been vastly enriched as a result of the expansion of range and development of new color possibilities. Music is conditioned by the materials with which one must work. When the instrument for which a composer is writing has a range of an octave, then the creative force is limited by the possibilities inherent in that range. The same situation exists with tonal color. With the expansion of tonal and range possibilities, techniques of communication of emotion are given a wider degree of latitude. Generally speaking the more materials available to an artist the wider the range of possibilities of expression.

Next, as in most other forms of black music, rhythm has been and remains a focal point. In other words, in black music, rhythm is first in the hierarchy, unlike Western art music where it is usually

2. Schuller, p. 62.
3. Frank Kofsky, *Black Nationalism and the Revolution in Music,* pp. 17, 19, 20.

120

relegated to a position below both melody and harmony. Black music is based on the constant conflict of rhythm. Rhythm in this context becomes significant for its own sake. This notion of the primacy of rhythm is indigenous to all African and African-derived societies. This concept as it translates into the Afro-American experience means decisive, strong non-contrived rhythmic music.

In speaking of the importance of rhythm in African music, A. M. Jones says: "Rhythm is to the African what harmony is to Europeans and it is in the complex interweaving of contrasting rhythmic patterns that he finds his greatest aesthetic satisfaction;" and further, "whatever be the devices used to produce them, in African music there is practically always a clash of rhythms; this is a cardinal principle."[4]

All black music seems to have a decided propensity for vertical polymeter and polyrhythm. This characteristic is manifested in the music of black people regardless of their geographic distribution. A direct result of this concept of primacy of rhythm is a music of rhythmic complexity and variety. In a society where harmony is the primary consideration in the hierarchy of musical materials, then harmony is the most advanced both conceptually and developmentally as it is in Western music. An analogous situation exists with black music and rhythm. Rhythmic concepts within the jazz genre have been advanced, altered and reinterpreted in each era by specific black jazz musicians.

Finally jazz music always presupposes audience involvement. This is not to say that other music is not aimed at the audience, but jazz and most other forms of black music involving improvisation exist through interaction with the listener.

Rather than focus on the history of jazz, which is available in many excellent sources, this chapter will deal with how the music progressed at the hands of the following creative giants: Louis Armstrong, Lester Young, Charlie Parker, Dizzy Gillespie, John Coltrane, Ornette Coleman and George Russell.

All of the figures chosen are major figures in the jazz continuum, but there are many others. Why then these men? There are many important players whose sphere of influence has been limited primarily to performers on the same instrument; there are many others whose influence has been mainly in the areas of composing/arranging or whose playing is so idiosyncratic and ultrapersonal as to preclude imitation. The men included in this chapter are geniuses whose influences have transcended their instruments and consequently altered the flow of jazz.

These seven giants have a number of things in common, many of which possibly contributed to their

transforming the aesthetic. All are black men of urban persuasion. All are, for the most part, self-taught. In many instances their innovations are directly related to their lack of formal training. In fact, the absence of academic regulation may have enabled them to view familiar problems in a new light and to bring to bear fresh insights. This should not be construed as a lack of awareness of tradition but rather as an unwillingness to be fettered by arbitrarily imposed boundaries and delimiting factors from whatever source.

All of the men listed here are men with a highly developed intuitive sense. The knowledge that they acquired was functional. In his own way each is superbly gifted with single-minded devotion to problem solving. Every one of them has been able to isolate, address himself to and solve problems without succumbing to irrelevancies which inevitably erode the creative energies of lesser lights.

Not surprisingly, all of these men have their roots deep in the blues tradition. All at some point during their formative years were a part of groups that played the blues. All have shown a decided propensity for the blues in their playing and/or writing. Some of the reasons for this affinity to the blues are:

1. The blues is an extremely flexible form with exceedingly simple harmonic structure—three chords.
2. It allows extreme latitude for musical expression issuing out of this simplicity.
3. The blues provides a compositional type common to the background of every would-be jazz player irrespective of ear, musical persuasion or stylistic preferences.
4. The blues is a form that can be rendered as simple or as complex as the individual performer/composer desires.
5. The ubiquity of the blues (via radio, T.V., church, jukebox, nightclubs) provides a form with which most aspiring jazz players are at least superficially conversant.

Exposure to years of blues and blues-inflected melodies, from the hollers, shouts and worksongs of the 19th century through Bessie Smith, Louis Armstrong, Count Basie, Duke Ellington, Billie Holiday, countless boogie woogie players, Charlie Parker, Dizzy Gillespie, Nat King Cole to the bass lines of Marvin Gaye and James Brown, has resulted in a kind of a communal legacy without which jazz music *would* be something very different.

The blues has proved to be one important common thread in the jazz continuum, and it is absolutely

4. A. M. Jones, "African Rhythm," *Africa,* XXIV January, 1954, p. 8.

natural and fitting that it would be a common link between the men who are largely responsible for the evolution of jazz.

Each of our figures has had to solve his problems and make innovations in a basically hostile environment. The problems have included everything from exploitation on the part of club owners, managers, recording companies, and fellow musicians to lack of acceptance, malignment, physical abuse, peer group rejection and limited access to the general population. That each was able to transform the aesthetic while "paying incredible dues" is testimony to the strength of these men as well as the resiliency of the music.

At some point in their productive years all of these innovators were band leaders. This, of course, means that they had a control situation in which they could experiment and work out new ideas without the constraints imposed by another leader. It must also be observed that the most important contributions were made within the confines of a small group. Throughout the history of music with notable exceptions (Ellington, Ives, Stravinsky and others), the major innovations have occurred in small chamber-type ensembles; the larger groups have played the role of synthesizing and/or popularizing these innovations. Traditionally, big bands and orchestras have suffered a time lag.

All of the musicians treated here are essentially melody instrument players as opposed to accompanists. Perhaps the vantage point of a melody player was necessary to provide the proper overview and perspective to stimulate innovation and change, at least in a manner which affects all of the musical components. All of the men are or were superb melodists as well as exceptional composers—composer meaning anyone who creates music whether written or not.

All were full time professional musicians working, plying their trade and facing daily or nightly musical problems which they had to address with energy and imagination. It seems that the genius often has to contend with such conditions.

All seven men made their decision for music at an early age and began serving their apprenticeship, acquiring vocabulary, skills, language, and the like. This, of course, means that most of the fundamentals were internalized early, leaving room for their intuitions to begin leading them toward their ultimate innovations. Each possessed uncanny observational skills along with the ability to deal on a practical level with observed theoretical phenomena.

With notable exceptions even the black innovators have seldom been capable of generating more than a single great contribution in their lifetimes: "Their

single innovation usually comes early in their careers—typically, during the twenties—and after that they persist in following the same lines. Again, it seems as if the psychic energy required to produce the innovation acts to weld the loyalty of the artist to his style and prevent him from moving forward from that point of stasis."[5] Incidentally, of the jazz artists treated here, Kofsky credits only Coltrane with having been able to modify his mature style.

Each of the geniuses expanded the operational limits of his particular instrument. All altered the existing parameters of that instrument and by extension other instruments.

Each was already in New York City by the time he exercised his greatest influence. Many factors contributed to this particular phenomenon. By the early 1930s New York was the center of the jazz world. After that time virtually all of the great jazz minds congregated there. Here the creative mind could find equally fertile and hungry minds with which to share ideas and exchange musical philosophies however radical or innovative.

Also, because of this heavy concentration of musicians and activity one could readily get an overview of what was going on at any given time in the jazz world. Itinerant musicians were in and out, studios flourished, work was usually available and the constant pressure to create existed. New York for all practical purposes was the mecca.

The music of all these men epitomizes the maximum achievement of expression and emotional strength, and while a number of them have been virtuosos of the highest order, their techniques have always been inseparable from the ideas they had to express. In every instance rhythmic vitality and boldness have ear-marked the music of these giants, and that seems only natural and fitting in a music in which rhythm has always been the focal thrust.

Finally each is a link in an unbroken musical chain. Each stands squarely on the shoulders of those who preceded him. But more important, even when the public and other musicians have assumed that a break in the chain had taken place, the innovator was aware of his indebtedness and place in the continuum.

Louis Armstrong—The Man

Daniel Louis Armstrong, probably the most significant jazz man across the entire history of jazz, was born on July 4, 1900, in New Orleans and died just two days past his birthday on July 6, 1971, in New York City. At the age of thirteen he was placed

5. Frank Kofsky, *Black Nationalism and the Revolution in Music,* pp. 20, 21.

in a home for orphaned black children where he remained for a year and a half. There he learned to play the bugle and joined the band and chorus.

He played in the band of trombonist Kid Ory, then joined Fate Marable's Orchestra in 1920. In 1922 he joined Oliver's Creole Jazz band in Chicago, and in 1923 he made the first of more than 1,500 recordings. The following year he moved to New York City to join Fletcher Henderson at the Roseland Ballroom. In 1925 he returned to Chicago billed as "The World's Greatest Trumpet Player," and that same year he began to record under his own name. The next four years saw him recording with "The Hot Five" and "The Hot Seven." These records are among the great classics in jazz and proved to be catalytic in turning jazz from an ensemble to a solo-oriented music.

Gunther Schuller eloquently expressed his assessment of the music of Louis Armstrong in the following:

> When on June 28, 1928, Louis Armstrong unleashed the spectacular cascading phrases of the introduction to *West End Blues,* he established the general stylistic direction of jazz for several decades to come. Beyond that, this performance also made quite clear that jazz could never again revert to being solely an entertainment or folk music. The clarion call of *West End Blues* served notice that jazz had the potential capacity to compete with the highest order of previously known musical expression. Though nurtured by the crass entertainment and nightclub world of the prohibition era, Armstrong's music transcended this context and its implications. This was music for music's sake, not for the first time in jazz, to be sure, but never before in such a brilliant and unequivocal form. The beauties of this music were those of any great compelling musical experience: expressive fervor, intense artistic commitment, and an intuitive sense for structural logic, combined with superior instrumental skill. By whatever definition of art—be it abstract, sophisticated, virtuosic, emotionally expressive, structurally perfect—Armstrong's music qualified.[6]

In 1929, Armstrong returned to New York with his own band where he continued to record and spread his fame via radio and live performance.

In 1932 he toured Scotland and Northern England, and appeared at the London Palladium, going in 1933 to the Netherlands and Scandanavia. He was the first popular entertainer in jazz, the first jazz player to receive international fame and the first person to make a continuous impact on Europe as far as jazz was concerned. In 1935 he became interested in big bands but ultimately returned to the more compatible surroundings of a small ensemble. In 1944 he played the first jazz concert in the Metropolitan Opera House. His world tours in the 1950s and 1960s earned him the title of the "Ambassador of Good Will." In 1964 he had the biggest hit of his career with "Hello Dolly."

Among his most important solo performances are such solos as "West End Blues," "Potato Head Blues," "Weather Bird," "Muggles," "Beau Koo Jack," "Cornet Chop Suey," "Struttin' With Some Barbeque," "Heebie Jeebies," "Ding Dong Daddy" and "Shine."

Louis Armstrong—The Innovator

Louis Armstrong, trumpeter, composer, vocalist, raconteur and innovator was the most influential and imitated jazz musician of the first fifty years of jazz. His innovations were many and varied and transcended his chosen instrument. Gunther Schuller says "Through Louis Armstrong and his influence jazz became a truly twentieth-century language. And it no longer belonged to New Orleans, but to the world."[7]

Armstrong's emergence as a soloist, capable of holding a listener's attention, proved the existence of an alternative to the group improvisation that was the rule at the time. He started thinking about improvisation as something other than a restatement and embellishment of the melody. He extended the role of the soloist. His presence provided the impetus for a great deal of compositional activity. This activity was, of course, absolutely necessary if jazz was to progress beyond the stage it had reached with King Oliver and his contemporaries.

Armstrong introduced an array of subtly differentiated vibratos, shakes and rips into the jazz language. He was one of the first men in jazz to use the vibrato as an expressive device. These expressive devices, many of which sound like African vocal techniques, give the music an exciting personal, alive quality.

> To the vibrato were soon added two other Armstrong trademarks, the "shake" and the "terminal vibrato." The shake was simply a more extreme way of enlivening and swinging the tone. The terminal vibrato was frequently used on longer notes, which started relatively "straight," and gradually "loosened up," to end in a wide vibrato or shake or, in its most extreme form, in a "rip"—In the ensuing years Armstrong made an increasing and, in the thirties, often excessive use of these devices. Through him they became an integral technique of trumpet and, by extension, brass playing.[8]

What Schuller might have observed further is that these techniques are now an integral part of the playing of *all* instrumentalists including most players in the contemporary Western art music idioms.

6. Schuller, p. 89.
7. Schuller, p. 88.
8. Schuller, p. 97.

Armstrong was probably one of the first instrumentalists in jazz to break away from melodies tied to instrumental limitation. He effected this in a number of ways. First, he linked the pitches in the overtone series together which resulted in scalar rather than triadic playing (see example 1). He carried on the African tradition of thinking in terms of vocally conceived lines and sang just as he played.

Armstrong was the first player to think in terms of a non-reiterative rhythmic role. That is, most other soloists thought in monorhythmic terms, duplication of the rhythms of the piano, bass and drums. Consistent with Rev. A. M. Jones's assessment of black music, that all African and African-derived music is based on a constant conflict of rhythm, Armstrong's playing established a way of playing, setting up conflict with the basic time unit. He is usually credited with moving phrases and figures away from the prevalent "ricky tick" time feel.

In addition to his many innovations in jazz, he made many breakthroughs in trumpet technique. He extended the range of that instrument. During a time when high C was considered extraordinary, Armstrong was playing high F's (a perfect 4th above). He moved away from the bugle-like melodies endemic to the construction of brass instruments (see example 2). He advanced the instrumental technique far beyond that of his contemporaries, and he added to the instrumental pallet by making use of greater contrasts, greater subtlety of tone, more refined technique.

All of the above innovations add up to a much broader expressive range because they allow the soloist expanded operational parameters, therefore, the possibility for more interesting lines, shapes and musical ideas.

Louis Armstrong influenced virtually every jazz musician who followed him. He had an effect on the entire vocabulary and syntax of jazz; he influenced the flow of jazz by transforming the language as well as by setting up the directions subsequently taken by the music.

Lester Young—The Man

Lester Young was born in Woodville, Mississippi, on August 27, 1909, and the family moved to New Orleans remaining there until Lester was ten. He died in New York City on March 15, 1959. Young received his early training from his father William H. (Billy) Young. From age ten Lester, his brother Lee and sister Irma traveled with their father through Kansas, Nebraska, and South Dakota playing carnivals. (Lester had begun as a combination drummer and handbill carrier switching to alto at an early age.) Jim Crow laws and attitudes chased Young to the North and to Art Bronson and a band called the Bostonians. Later he joined Walter Page and the Blue Devils spending considerable time in Kansas City. In 1933 or 1934 he joined Count Basie's band, after which an abortive attempt with Fletcher Henderson led him to Andy Kirk's band and back to Count Basie. Young remained with Count Basie until 1940 when he began heading his own group. He did a stint with Al Sears' band touring USO Shows and in 1943 rejoined Basie. This was followed by fifteen months in the army which culminated in a one year sentence in the detention barracks at Camp Gordon, Georgia.

The last ten years of Young's life is described by Leonard Feather in the *Encyclopedia of Jazz:*

> From the time he reentered civilian life until his death, Young alternated between leading his own small combo, one that usually was poorly integrated and sometimes included inferior musicians, and Norman Granz's Jazz at the Philharmonic unit. The last three years of his life were marked by a series of catastrophies including hospitalization for alcholism, nervous breakdowns, and problems of malnutrition. There were a few brief attempts to return to full-scale activity. He had just come back from a nightclub engagement in Paris when he died of a combination of ailments in his New York Hotel.[9]

9. Leonard Feather, *The New Edition of the Encyclopedia of Jazz* (New York, Bonanza Books, 1962), p. 471.

Example 1

Example 2

(all notes played open, that is, using no valves)

Etc.

Records

Giant of Jazz, Sunset SUS 5181
The Immortal Lester Young, Savoy 4—MG 12068
Lester Young, Savoy M6 12155
The Masters Touch, Savoy MG 12071
Pres at His Best, Emarcy SRE 66010

Lester Young—The Innovator

Lester Young was the first of the great instrumental blues players. He was largely responsible for the re-establishment of rhythmic priorities of jazz. Until Young, with rare exception, most jazz players were essentially reiterative in their approach to rhythm. That is, the soloist usually reinforced or reiterated the basic pulse as articulated by the rhythm section. For instance, in most swing bands the piano, bass, drums, and guitar duplicated each other rhythmically playing 4 beats to the bar and the soloist further duplicated the section.

Young was rarely content to duplicate the rhythm section's efforts choosing rather to play against, float above, lag behind or surge ahead. His use of rhythm was to prove the model for the young be-boppers who were to bring his ideas to fruition.

His ideas of rhythm moved together with his harmonic concepts. Young was one of the first jazz men to use a horizontal approach to the realization of chords. A horizontal approach is one in which the improvisor chooses to use a single scale to color a number of chords rather than having a specific scale relate to a specific chord (see example 3).

Young pioneered the vibrato-less sound. As Louis Armstrong had perceived his vibrato as an expressive device, ridding the jazz player of the continual vibrato, Young went even further dropping the vibrato or minimizing it almost to the point of negligibility. The virtually vibrato-less sound was to be the hallmark of the be-bop soloist. The technical demands of the music demanded an unencumbered sound.

Lester Young began seriously to examine the use of the coloristic properties of the tenor, implicitly suggesting that other instrumentalists do the same. For instance, his use of alternate fingering purely for the purpose of varying the color of a particular note was unprecedented (see example 4).

Recordings support the fact that Young also exploited the different color possibilities of the extreme registers of the saxophone—something that contemporary players like John Coltrane, Archie Shepp, Cannonball Adderley, were to do consistently 25 years later. This concern with timbral options is very much in evidence in the playing of many of today's *avant garde* players.

Lester Young, the supreme lyricist, pointing toward the playing of such later giants as Miles Davis, Sonny Rollins, Tommy Flanagan, Cannonball Adderley, had begun to think in terms of creating new melodic lines submissive only to the harmony (chords) of the original song. The be-boppers were to develop this characteristic into an art with their propensity for and skill in writing new melodies built on existing harmonies. While the technique of thematic transformation was by now commonplace, Lester's approach represented a new development.

Young, looking ahead to Charlie Parker, began to widen the expressive range of tenor and subsequently all instruments by his technique of utilizing extreme contrasts, such as fluid, coruscating lines and repetitive *riff*-like figures; exuberant shouts and intimate whispers; high register and low register explorations. In addition his playing was characterized by the use of surprises, wry twists and tongue-in-cheek humor. Lester Young's playing was the epitome of maximum expressiveness with minimum notes. His playing was characterized by long all-inclusive melodic lines, the use of odd intervals, irregular phrase lengths, exotic note choices, understatement, relaxation and emotional strength without histrionics—*all* musical characteristics much in advance of their time, characteristics that were later developed in the playing of such be-boppers as Charlie Parker, Dizzy Gillespie and Thelonius Monk.

Example 3

Example 4

John Birks ("Dizzy") Gillespie—The Man

Dizzy Gillespie, trumpeter, singer, leader, composer, pioneer, was born on October 21, 1917, in Cheraw, South Carolina. Along with Charles Parker, Gillespie is usually acclaimed as one of the Twin Fountainheads of Be-bop. He toured with the Teddy Hill band from 1937 to 1939 as well as with Earl Hines, Cab Calloway and others. After leading his own combo, he organized a big band which he took on a short tour in 1945. Another band organized in 1946 remained intact until 1950. Between 1950 and 1960 he returned to the small group format. In 1956 he toured internationally for the State Department in the first-of-a-kind tour.

He has played often with large orchestras and bands on extended works (i.e., "Gillespiana" by Lalo Schifrin, "Perceptions" by J. J. Johnson, "Tunisian Fantasy" by Lalo Schifrin, and "The New Continent" also by Schifrin).

In 1965 Gillespie had a reunion with Gil Fuller (chief arranger for one of his earlier big bands) at the Monterey Jazz Festival. A recording of "The Shadow of Your Smile," with Fuller and the festival orchestra and Dizzy as soloist, was nominated for a NARAS award in March 1966. In the business he is usually conceded the title of "The world's greatest jazz trumpet player."

Dizzy Gillespie—The Innovator

"Dizzy" Gillespie trumpeter, percussionist, singer, composer, band leader, arranger, comic, politician, man of the world, humanitarian, and teacher is a man whose innovations have too often been taken for granted. Charlie Parker, the other member of the twin fountainhead, has often been proposed as the creator of be-bop music with Gillespie as the popularizer. Only recently have responsible critics begun to refute this erroneous notion. (Jazz men have long known better.) While it is true that Gillespie seems to have been better equipped to deal with daily problems, it can in no way negate his tremendous contribution to jazz and indeed to world music. In any assessment of jazz and its innovators Gillespie would have to be one of the five or six major figures.

Gillespie and Parker were the two main figures to provide direction and purpose for the new music. If one were to extract from the current jazz vocabulary the things invented by these two men, the language would virtually cease to exist. Something of Gillespie exists in the playing of every jazz practitioner alive today. Whether something as simple as standard II V_7 formulae, the clichés which comprise the bulk of the language, turn-arounds, cycles, stylistic devices, personal inflections, or something less tangible such as a certain musical attitude or posture or phrasing imperatives, Gillespie has left, and continues to leave, an indelible imprint.

Gillespie, perhaps even more than Parker, was responsible for bringing to popularity certain very sophisticated scales such as the diminished scales, the lydian augmented and the lydian scales. (See George Russell's *Lydian Concept of Tonal Organization*.) The manner in which Gillespie chose to relate these and other scales to particular chords became the model for subsequent generations of jazz musicians. Many of these scales are just now starting to have real currency among contemporary players, some twenty-five years after Gillespie first used them.

Gillespie was the jazz musician largely responsible for translating the be-bop language into big band terms. To be sure, Billy Eckstein, by surrounding himself with the young turks of the embryonic new music and by virtue of his commitment, had acted as a catalyst. It remained Dizzy's task however, as the music's leading brass performer, a skillful composer/arranger, and a forceful, excellent leader who helped invent the language, style and posture of be-bop and who intimately understood the inner workings of a large ensemble, to bring all of the components together. Sometimes this was effected simply by his unerring instinct for choosing his companion arranger/composers and sidemen (e.g., Gil Fuller, Tadd Dameron, John Lewis).

Gillespie helped to bring Latin American and West African rhythms into jazz. Across the history of jazz, its practitioners have flirted with Spanish and Latin rhythms, instruments, melodies (e.g., W. C. Handy, Earl Hines, and others), but never with the conviction, authority, and expertise with which Gillespie approached the music in his big bands of the late 40s. One could find Afro-Cuban compositions such as "Manteca," "Cubano be, Cubana bop," by George Russell, "Night in Tunisia," etc., and Gillespie had hired Chano Pozo, a very important Afro-Cuban percussionist, as a part of his rhythm section. All of this was some ten or fifteen years ahead of the time when it would be fashionable and ultra hip.

Gillespie and Parker did much to reestablish the "break" as an integral part of jazz. The "break," an instrumental interlude or solo spot unaccompanied and usually anywhere from 2 to 8 bars in length, had been very popular in the early days of jazz but had fallen from favor during the swing era. At the hands of Gillespie and Parker, the break took on new meanings and was eagerly anticipated as one of the most exciting sections of a be-bop performance. It happened at the end of the theme statements, be-

tween solos, at ends of interludes and even within a single solo. Some of the most exciting examples can be found on any version of "Night in Tunisia," or the various big band albums by Gillespie usually following the interlude which prepares the way for Gillespie's grand entrance.

His influence on trumpet players specifically and brass players in general cannot be overestimated. As Armstrong had pushed the range of the trumpet up to around high F, Gillespie added at least another 5th. It would probably be more accurate to say that in his playing the efforts of Roy Eldridge and others were brought to fruition.

Gillespie vastly expanded the technical resources of the trumpet. He proved that the trumpet was capable of anything which the saxophone, clarinet, piano or any other instrument could do. His technical prowess is still breathtaking after all these years. Gillespie was one of the first brass players to do lipcurls (example 5), lip glisses upward (example 6), use the entire range of the instrument consistently, and use alternate fingerings for expressive purposes (example 7).

As with Parker, Dizzy's influence is ubiquitous.

Records

Now's the Time, Verve V6 8005
Bird and Diz, Verve V6 8006
Charlie Parker—Jazz Perennial, Verve V6 8009
An Evening at Home with the Bird, Savoy MG 12152
The Genius of Charlie Parker, Savoy 12014
The Bird Returns, Savoy MG 12179
Charlie Parker, P. C. 3054
Festival, V6 Verve 8008
Charlie Parker Memorial, Savoy MG 12000, Volume I
Charlie Parker Memorial, Savoy MG 12009, Volume II
The Happy Bird, Parker PLP 404
Historical Masterpieces, Parker PLP 701
The Charlie Parker Story #2, Verve MGV 8001

Charlie Parker—The Man

Charlie Parker was born on August 29, 1920, in Kansas City, Kansas, and moved to Kansas City, Missouri, at the age of seven. He died on March 12, 1955. As a young man in Kansas City he was exposed to most of the great jazz players of the swing era. He listened a great deal to Lester Young, Buster Smith, Ben Webster and Coleman Hawkins. He also was thoroughly exposed to the blues via the Kansas City blues bands (such as Count Basie, Jesse Stone, and Andy Kirk) and the blues shouters, such as Joe Turner and Jimmy Rushing and to such boogie woogie players as Pete Johnson.

His early playing experiences included a stint with the blues based Jay McShann band. The first recorded solos of Parker are from transcriptions of this band made in 1940 at a Wichita, Kansas, radio station.

Parker first came to New York in 1939, left shortly thereafter with McShann but returned for good in 1941. Between 1942 and 1944 Parker was actively involved in the experimentation going on in the jam sessions at Minton's and Monroe's Uptown House. In 1944 he was a part of the Billy Eckstein big band.

His first recordings as a leader were made in 1945 and quickly became classics. The tunes were all Parker originals: "KoKo," "Now's the Time," "Billie's Bounce," "Meandering," "Warming Up a Riff."

In 1946 Parker spent seven months in Camarillo State Hospital in California for drug addiction. After his release he was to make many records with every possible combination from small groups, to big bands, latin bands, string orchestras, vocal choirs, but very few of these matched the consistency and brilliance of those small group records of the mid- and late 1940s.

Example 5

Example 6

Example 7

Charlie Parker—The Innovator

Charlie Parker, like Louis Armstrong and Lester Young before him, had a pervasive influence on all music. His influence extends into all areas of jazz and all media of jazz expression including composition. It is no surprise to the jazz intelligentsia that Parker's influence has not been limited to jazz music. Virtually every commercial, jingle, TV background and much contemporary European derived art music owes some demonstrable debt to the innovations of Charlie Parker. Charles Mingus has said, "If Charlie Parker were alive he would think he was in a house of mirrors."

His innovations manifest themselves in virtually every aspect of music. He, along with Dizzy Gillespie, Thelonius Monk, and a handful of others, helped to broaden the harmonic pallet via:

1. The use of higher intervals in chords (see example 8).
2. The use of passing chords (see example 9).
3. The use of chord substitutions (more complex chords) (example 10).
4. Use of more sophisticated scales (wider range of scalor options) (example 11, p. 129).
5. A more extensive use of linking devices such as turnbacks (usually a two measure progression consisting of four chords used to create movement, help define the form of the composition, and link one chorus to another), cycles (a root movement of ascending perfect fourths or descending perfect fifths), II V_7 formulae (the progression of a minor seventh chord resolving up a fourth or down a fifth to a dominant seventh chord) and other musical adhesives (example 12).
6. Greater expressive use of dissonance.

He was instrumental in broadening the emotional expressive pallet. He effected changes by adapting for instrumentalists, techniques long assumed to be exclusively within the province of blues vocalist, i.e., grunts, shouts, slides, slurs, rips, bends, varied vibrato, growls, shakes, moans, cries.

He also made use of a much wider variety of tonal possibilities and a greater use of contrasting elements and efforts (i.e., fast vs slow, loud vs soft, harsh vs elegant, high vs low, consonant vs dissonant, static vs motion).

Like Louis Armstrong in an earlier era, he further expanded technical options. He was perhaps the first real virtuoso of jazz. By presenting an alternative to existing practices, he showed that it was possible to assimilate complex techniques into improvisations without sacrificing expressiveness. He helped to prove that a greater technical and physical range can result in a broader range of emotion and feeling.

Example 8

Example 9

Example 10

Example 11

Example 12

In the area of rhythm, Parker was partially responsible for establishing the eighth note as the basic time unit of the jazz solo. He employed a far greater variety of rhythms than any soloist who preceded him. He further extended the options through the use of polyrhythms establishing a basic conflict between soloist and rhythm section, and the realization of lines of great rhythmic subtlety.

More than any jazz soloist before him he showed the possibilities of combining long-range, unifying techniques with a maximum of expression. He showed that, by mixing melody, harmony, rhythm and tone as inseparable components, a real style could emerge. Like Armstrong and Young he perceived of sound as an extension of the idea to be expressed.

John Coltrane—The Man

John Coltrane, perhaps the most influential jazz performer of the last twenty years, was born on September 23, 1926, in Hamlet, North Carolina, and died on July 17, 1967, in New York City. He was a performer on alto, tenor and soprano saxophone and a composer of considerable merit and impact.

John Coltrane served his apprenticeship with the bands of Dizzy Gillespie, Johnny Hodges, and rhythm and blues artist Earl Bostic. During these years he assimilated and honed to sharp perfection the be-bop language and paid his dues and respects to the blues from which he sprang. Like the legions of great tenor players to come through the rhythm and blues and near rhythm and blues bands of the 40s and 50s (i.e., Gene Ammons, Illinois Jacquet, Arnette

Cobb, King Curtis, Dexter Gordon, Wardell Grey, et al.), Coltrane was well steeped in the meanings and importance of the blues.

Coltrane first began to gain prominence during his tenure (1955-1960) with the Miles Davis Band. Of his many albums with Miles Davis, two seem particularly prophetic—*Straight No Chaser* and *Milestones*—*Straight No Chaser* because of the unmistakable coming to fruition of his famous "Sheets of Sound" style and *Milestones* because of the emergence of the infant modal school of playing.

In 1960 Coltrane formed his own quartet and that year he also found a modicum of public acceptance with his Atlantic album *My Favorite Things*. During the ensuing years his playing underwent many important changes and his sphere of influence widened appreciably—his influence is felt in the sound of virtually every jazz voice today. Coltrane's mature career falls roughly into three overlapping periods.

I. *Vertical or change running period*. This period is represented by albums such as *Giant Steps* (Atlantic 1311), *Blue Trane* (Blue Note BLP 1577). This period was characterized by a decided propensity for tunes with a super abundance of changes, simple tunes made complex by sophisticated systems (often evolved by Coltrane) of substitutions, so-called "sheets of sound" playing which Coltrane employed sixteenth, thirty-second notes, asymmetrical phrases, cascading runs in seeming attempts to exhaust the realization possibilities of any given harmonic situations. Often in a given situation Coltrane would not only try to play all of the scale alternatives to a given chord, but also to add substitutions plus their scales *ad infinitum,* all of this in a very short span of time.

II. *Modal Period.* This period is represented by such albums as *My Favorite Things* (Atlantic 1361), *Ole Coltrane* (Atlantic 1373), *Crescent* (Impulse 66), and *Coltrane Plays Chim Chim Cheree* (Impulse 85).

This period is also characterized by a predilection for modal compositions (tunes based on few chords, or scales or tunes which can be horizontalized e.g., "Summertime," "My Favorite Things"). During this period Coltrane often played lengthy improvisations based on a mode or modes rather than on chords. During this period he also began to re-examine in depth the blues (a tune type that is most often treated in a modal or horizontal fashion). His albums from the period include one album of just blues (*Coltrane Blues,* Atlantic 1382) and a couple of albums of ballads. The fact that the chords move much more slowly allowed Coltrane to apply a modal approach here too.

III. *Experimental Period.* This period is represented by such albums as *A Love Supreme* (Impulse 77), *Ascension* (Impulse 96), *Expression* (Imp AS91), *Cosmic Music* (Imp 9148), *Live in Seattle* (Imp AS9202-2) etc.

This period found 'Trane experimenting on many levels. He experimented more and more with the instrumentation of his groups, at times using two bassists, two drummers, additional saxophones, etc. He experimented with what George Russell (and others) call panmodality (playing freely through a multiplicity of keys or modes). Playing without predetermined structures was another area of exploration, but perhaps his most fruitful experimentations were in the areas of sound or timbral explorations via the use of extreme registers, multiphonics (two or more notes sounding simultaneously on an instrument normally thought of as capable of producing *only* single lines e.g., trumpet, saxophone), harmonics (overtones of the instrument usually lighter in sound and often difficult to produce), alternate fingerings (different combinations of values or keys for producing the same tone—the timbre and pitch are usually altered as a result of the different choices), varied methods of sound production, etc.

John Coltrane—The Innovator

John Coltrane's influence is felt in the sound of virtually every jazz voice today. His innovations include expanding the harmonic vocabulary via:

1. An extremely sophisticated system of substitutions as on "Giant Steps," "Countdown" and "But Not for Me" (example 13).

2. Chord superimposition, that is stacking chords and scales on top of each other. Coltrane also, during his vertical period, tended to use a greater quantity of chords in a given span of time. It is an aphorism that beyond a certain point any quantitative change will produce a qualitative change. So it was with the music of Coltrane. The change brought by bombarding the listener with vertically dense sections was not merely one of degree but in fact a change of kind or order.

3. Establishing a wider range of scalar options (i.e., diminished scales, Indian, Oriental, Eastern, pentatonic). ". . . This innovation of Indian and modal ideas led to greater freedom for jazz soloists in the '60s taking the music away from improvisations on songs or song patterns and allowing it to move toward a wholly new musical feeling."[10] While Coltrane was not the first to explore and employ the multiplicity of scales that comprised the vocabulary, probably no other jazz player has so consistently and diligently examined and re-examined them in search of the truths they might yield. It is perhaps this feeling of relentless searching more than another trait that attracted his many disciples to him.

4. Employing more sophisticated linking devices (turnarounds, cycles, patterns, formulae).

John Coltrane was largely responsible for many of the changes in attitude vis-a-vis rhythm. He helped to change the basic unit of the jazz solo from eighth notes to sixteenth notes. Uneven or asymmetrical phrases, including 7, 9, 11, 13, 17, note groupings quickly became standard primarily because of John Coltrane (example 14).

10. Leonard Feather, *Encyclopedia of Jazz in the Sixties* (Bonanza, a division of Crown Publishers, Inc. by arrangement with Horizon Press, 1966), p. 99

Example 13

Example 14

Coltrane's approach to melody, harmonic timbre and rhythm forced the rhythm sections which accompanied him to reassess their function and positions. Much as the music of Charlie Parker had necessitated a completely different kind of rhythmic base so it was with the music of Coltrane. The long musical excursions (sometimes 45 minutes or more), the explorations at both ends of the instrument, the complex almost arhythmic phrases and runs, the sometimes unorthodox use of space, the implied pedal points, the multi-leveled solo constructions, the relentless drive, all contributed to a musical situation in which the rhythm section could no longer be content with *just* an accompanying role. Total musical involvement with all instruments being relatively equal and contributing equally to the flow of the music was one of the results. Elvin Jones (Drums), McCoy Tyner (Piano), and Jimmy Garrison (Bass) were, primarily because of their musical discoveries with Coltrane, to serve as the models for future jazz rhythm players.

As a saxophone player, Coltrane expanded the saxophone's tonal and technical resources and by extension, the emotional scope. His explorations with multiphonics (playing two or more notes simultaneously on a single line instrument), the extreme registers, unusual timbral and color possibilities (i.e., alternate fingerings used for their sound altering possibilities, harmonics, overtone series effects, different means of altering the sound via breath, mouthpiece placement, reed strength, articulation, sound for the sake of sound) were of high specificity for the saxophonist *but* pointed to similar possibilities for other instruments as well.

Coltrane, virtually singlehandedly, brought the soprano sax to unprecedented popularity. "That instrument, rarely used successfully by modern jazz men, gained a new quality in Coltrane's hands that Pete Welding described as 'Sinuous and Serpentine,' " employing "a pinched, high pitched near-human cry of anguish that is most effective . . . he used a device that sends chills along my spine. He seems to be playing a slithering, coruscating melody line over a constant drone note."[11]

It is possible that Coltrane's bringing to popularity of the soprano sax has opened the door for the acceptance of other instruments, normally thought to be outside of jazz purview.

John Coltrane's brief career was one of constant evolution and the innovations of each period of his development have had ramifications for the playing of virtually every contemporary jazz player.

Records

Live in Seattle, Impulse AS 9202-2
Cosmic Music, Impulse 9148
Coltrane Blues, Atlantic 1382
Expression, Impulse AS9120

Ornette Coleman—The Man

Ornette Coleman was born March 19, 1930, in Fort Worth, Texas. He is a performer on alto and tenor saxophone, trumpet, violin and certain Eastern instruments. He is equally well known for his considerable compositional skills. He is largely self-taught. When he was a teenager, his high school band buddies included King Curtis (tenor Sax—rhythm and blues star), Charles Moffett (jazz drummer), and Prince Lasha (*avant garde* saxophonist). Ornette served his apprenticeship in various Southwest rhythm and blues bands playing in the style of rhythm and blues greats Big Jay McNeely, Lynn Hope, Louis Jordan, Gene Ammons, and fellow Texan Arnette Cobb. The blues was to prove an all pervasive influence on his music.

According to A. B. Spellman, a tenor saxophonist named Red Connors introduced Ornette to be-bop music. He had the opportunity to hear and play with the many jazz greats who comprised a never-ending stream of musicians passing through and often becoming stranded in Fort Worth.

He spent time on the road with Silas Green's carnival band and the rhythm and blues band of Clarence Samuels.

In the late 1940s and early 1950s he spent time in New Orleans around such later to be jazz stalwarts as Melvin Lassiter, Alvin Batiste and drummer Ed Blackwell, leaving with rhythm and blues bandleader Pee Wee Crayton enroute to Los Angeles.

Los Angeles was Ornette's home for the next nine years where he worked day gigs and "woodshedded" (practiced). Ultimately he put together a group of sympathetic compatriots including trumpeter Don Cherry and saxophonist James Clay.

His first recording, *Something Else,* attracted little attention but did portend things to come. The compositions, all Ornette's, were strongly reminiscent of the early be-bop compositions of Charlie Parker. The instrumentation was also that of the early be-bop bands. Some of the tunes, as in be-bop, were also based on existing tunes (i.e., "Jayne," "Out of Nowhere," "Chippie," "I Got Rhythm," "Alpha" and "When Will the Blues Leave").

11. Feather, p. 99.

Tomorrow is the Question, Ornette's second album, edited at Lenox, Mass., caused quite a stir and served notice that a new voice had arrived. Ornette's stay at the Lenox school of jazz in 1959 afforded valuable contacts and earned him powerful advocates for his cause and music. George Russell, John Lewis, Gunther Schuller, Jimmy Guiffre, and Nat Hentoff were among those established jazz figures who believed in the music of Ornette Coleman.

Ornette's first gig (job) in New York was at the Five Spot and, as George Russell had predicted, New York's jazz scene was thoroughly shook up.

Between 1960 and 1962 Coleman recorded seven albums for Atlantic, six with Don Cherry. After a New York City town hall concert in late 1962 he retired briefly from public performance. During the following two or three years he added trumpet and violin to his instrumental repertoire. In 1965 he opened at the Vanguard and later went to Europe with a trio including David Izenson on bass and his old school mate Charles Moffett on drums.

Since that time Ornette has established himself as a father figure of the new music. He expanded his talents to include compositions in the Western art music tradition and performances by and with major symphony orchestras in the United States. He has been the recipient of a Guggenheim and has continued to diversify.

Among his more representative records are:

Contemporary

Something Else (3551)
Tomorrow is the Question (3569)

Atlantic

The Shape of Jazz to Come (1317)
Change of the Century (1327)
This is our Music (1353)
Free Jazz (1364)
Ornette (1378)
Ornette on Tenor (1394)

Ornette Coleman—The Innovator

Ornette Coleman served as one of the prime catalysts in the birth of the *avant garde*. Ornette's break with the past, while not without precedent, was perhaps the most pronounced. He was destined to bear the brunt of the attack of the establishment. Coleman represented a return to the simplicity of folklike materials, the use of panmodality (embracing all modes), the use of free forms, vocally oriented playing, non-Western intonation concepts and a completely melodic referent (using the melody rather than the chords as the point of departure for improvisations).

Despite what was widely interpreted as a complete break with conventionality, Coleman still retained a stable rhythmic element—in the rhythm section and a basically blues and be-bop approach to melody.

He was one of the first players to jettison vertical structures in favor of a pan-modal approach. By 1959-60, Miles had already begun his examinations of modes as an alternative to vertical structures. Coltrane was a step away from his first modal exploration and George Russell had already evolved his masterwork dealing with scales, modes and their application and ramifications; yet Ornette intuitively arrived at a way of playing which bypassed modal playing in favor of the all embracing pan-modal approach.

Coleman has said on numerous occasions that if he had to play the same changes over and over on a particular composition that he may as well have his solos written out. Oddly enough other musicians were searching diligently for a way out of the cul-de-sac of chord running. Modes provided one answer, tone rows and other set systems provided another, but perhaps the most obvious way out escaped almost everyone. One way to quit running changes is to stop running changes.

This seemingly innocuous decision was to have far reaching and lasting consequences. As Leonard Feather so perceptively observes, "by ignoring rather than modifying changes and regular meter, Coleman opened entire realms of possibilities to jazz musicians in '60s. By 1966 scores of saxophone players and composers had listed him as an influence and showed in their playing that they were making use of his style and of the freedom that he had first employed."[12]

Simply put, Ornette provided an alternative. He discarded many long held notions about the sanctity of Western concepts with regard to pitch, rhythm, harmony, and form.

His concept of pitch is much closer to African antecedents than to his jazz contemporaries. In the course of a piece of music, many different pitches can be sounded as variants of a central pitch; that is, the note "A" might appear in a piece of music 100 times and each time vary in pitch according to the musical circumstances, the personal feelings of the performer, context, the accompanying rhythm, etc. It is not as though this phenomenon does not exist in Western music, *but* there is a difference in degree. For instance, the classically trained musician will vary pitch according to traditional functions, such as when a note is a leading tone (7th degree) he'll play

12. Feather, p. 98.

132

sharper than when it's a 4th degree, or he'll play it one way when it's the 3rd of a simultaneous sounding triad, another when it's the 5th, *but* the latitude for variation is considerably more narrow than in African and many Eastern musics.

"Intonation is a matter of context and expression to Coleman. You can play sharp in tune and you can play flat in tune, he has said, and a D in a context representing sadness should not sound like a D in a passage of joy. [A modern classicist would say that Coleman uses 'microtones.'] This of course has nothing to do with 'good' intonation, and if there be any doubt about that, there are enough key notes and phrases in Coleman's solos on exact pitch to dispel that doubt."[13]

Again Ornette provided an alternative to the prevalent concerns with symmetry. This was true not only in his improvisations but also in his compositions. Blues compositions that lasted 14 measures and improvisations on them that run 11 measures, 9 measures, etc., are oddly enough reminiscent of descriptions of the boogie woogie piano playing of Cripple Clarence Lofton. The music moves so naturally, making its own forms and shapes refusing to bend to arbitrarily imposed formal and metric schemata.

"Further, an opening theme may set a mood, fragments of melody, an area of pitch, or rhythmic patterns, as points of departure for the player to explore. It need not set up patterns of chords or patterns of phrasing. Or if it does, these may be expanded, condensed, used freely—it does not necessarily take eight measures to explore an idea that took eight measures to state, and an improvisation initially built on a melody itself need not also follow a harmonic outline that melody might suggest."[14]

In the realm of rhythm Coleman also offered an alternative. Pan-rhythmic (embracing all rhythms) playing could be used to describe his music. The freedom that characterized melodies and harmonies also was endemic to his rhythm. Unlike Don Ellis he didn't choose the route of multimetric (music in which there are frequent changes in consecutive measures) schemata; nor did he choose the route of polymeter (a music in which two or more different time signatures are used simultaneously, written or otherwise) although both approaches very naturally happened in his music. His melodies and phrases dictate the metric scheme. Putting it another way, any metric markings in his music would have to be *ex post facto*.

One of the main consequences of the above musical innovations is the widening of the emotional and expressive parameters, and it is perhaps this factor which must clearly establish Coleman as one of the giants of our time.

George Allan Russell—The Man

George Russell, composer, drummer, pianist, leader, philosopher was born on June 23, 1923, in Cincinnati, Ohio. He attended Wilberforce University High School. Between October 1945 and December 1946 he evolved the principles of *The Lydian Chromatic Concept* of tonal organization while a patient at St. Joseph's Hospital, Bronx, New York.

He composed and conducted one of the first compositions "Cubano be-Cubana bop" combining jazz and Latin influences in a Carnegie Hall concert with Dizzy Gillespie's large orchestra. From March 1949 to September 1949, he studied composition with composer Stephen Volpe. In 1953 his master work *The Lydian Chromatic Concept of Tonal Organization for Improvisation* was published.

In 1958 he received *Metronome Magazine's* Outstanding Composer Award. In 1959 Russell taught at the School of Jazz in Lenox, Massachusetts where he taught the concept. The faculty included John Lewis and Bill Evans (piano), Percy Heath (bass), Connie Kay, Max Roach (drums), Kenny Dorham and Herb Pomeroy (trumpet), Jimmy Guiffre (saxophone), Bobby Brookmeyer (trombone), Bill Russo (arranging), Marshall Sterns and Gunther Schuller (history). Among the students were Ornette Coleman, Don Cherry, Gary McFarland, Mike Gibbs, Nico Bunick, Larry Ridley, Joe Hunt and David Baker. In late 1959 Russell organized his acclaimed jazz sextet which included across its span of longevity such players as *trumpeters* Al Kiger, Don Ellis, Don Cherry and Thad Jones, *saxophonists* David Young, Paul Plummer, John Pierce, Eric Dolphy and Jan Gabarek, *trombonists* David Baker, Garnett Brown and Brian Trentham, *bassists* Ted Snyder, Chuck Israels, Steve Swallow and Cam Brown and *drummers* Joe Hunt, Pete LaRoca and Tootie Heath. A number of excellent albums document the evolution of his sextets. In 1961 he was awarded the first place composer award from *Down Beat* magazine. That same year his Decca album *New York, New York* won the "Oscar Du Disque De Jazz" as the best jazz album to be released in France in 1961.

13. Martin Williams, "Ornette Coleman," *The Jazz Tradition* (Oxford University Press, 1971), p. 211.
14. Williams, p. 210.

In 1964 his sextet toured Europe with George Wein's Newport All Stars. In 1965 he toured Sweden for the Swedish Concert Bureau with a large orchestra featuring Swedish musicians.

In 1966 Saba record, *George Russell Sextet at Beethoven Hall,* won the award as the best jazz album made in Europe in 1966.

During the late 1960s he taught the concept in Sweden, Norway and Denmark.

In 1969 he was appointed to the faculty of the New England Conservatory of Music, Boston, Massachusetts to teach the Lydian chromatic concept.

Since that time he has continued to teach, perform and compose on many fronts. He was the recipient of a 1969 Guggenheim Fellowship and in 1972 recorded with Bill Evans for Columbia Records a highly acclaimed album entitled *Living Time.*

Records

Sextet at Beethoven Hall, SABA 15059
Sextet, Riverside RS 3043
At the 5 Spot, Decca DL 9220
The Stratus Seekers, Riverside 412
Stratusphunk, Riverside RLP 341
Othello Ballet Suite, Flying Dutchman FDS 122
Jazz in the Space Age, Decca DL 9219
Living Time, Columbia KC 31490
Sextet in KC, KDL 4183
Ezzthetic, Riverside 375
The Outerview, Riverside 440

George Russell—The Innovator

George Russell is perhaps the first composer in jazz to transform the performing aesthetic. This was accomplished primarily through his astounding book, *The Lydian Chromatic Concept of Tonal Organization for Improvisation.* It is the foremost theoretical contribution of our time and one of the first emanating from jazz. The text is destined to become the most influential musical philosophy of the future. John Lewis, eminent leader of the Modern Jazz Quartet, says that it is "the most profound theoretical contribution to come from jazz."

The materials in this book represent, in part, a codification of techniques evolved across the history of jazz. Because of this book, these techniques are now accessible to jazz and non-jazz composers and performers alike. Entire bodies of music now utilize the harmonic and melodic implications of Russell's theory. It offers a philosophical and musical basis for stylistic pluralism.

George Russell is the first composer/arranger since Duke Ellington to solve consistently the problem of the written versus the improvised in big band writing.

He also helped establish the fact that freedom can be achieved through a combination of discipline and intuition.

In keeping with his advocacy of pan-modality, pan-rhythm and pan-melody he formed and led one of the first pan-stylistic groups. In that group he made use of the complete stylistic spectrum (i.e., Dixie, swing be-bop, free, etc.) In addition to totally *avant garde* concepts, changes, chords, scales, themes, etc., remained as improvisational referentials and options. Perhaps one of the main values of this group was that it served as a paradigm.

Russell helped to broaden the musical pallet in terms of form by his attitude of *never* making content subservient to form. In his music virtually any formal structure might emerge; e.g., AABA, ABCDA, ABAAC, or "through-composed" music (music in which a recapitulation does not occur).

His flexibility with regard to meter, rhythm, instrumental combinations, timbral considerations helped to convince jazz musicians that other options existed.

All of jazz and indeed all contemporary music owes a demonstrable debt to these seven creative geniuses of jazz.

Bibliography

Feather, Leonard. *Encyclopedia of Jazz in the Sixties.* New York: Bonanza Books, 1966.
Jones, A. M. "African Rhythm," *Africa* XXIV, January 1954.
Jones, LeRoi. *Blues People.* New York: William Morrow & Co., Apollo Editions, 1963.
Kofsky, Frank. *Black Nationalism and the Revolution in Music.* New York: Pathfinders Press, Inc., 1970.
Mellers, Wilfrid. *Music in a New Found Land.* New York: Alfred A. Knopf, 1967.
Schuller, Gunther. *Early Jazz.* New York: Oxford University Press, 1968.
Williams, Martin. *The Jazz Tradition.* New York: Oxford University Press, 1970.

Jazz Discography

Brass Bands. Music from the South (Vol. 1).
Country Brass Bands. Folkways FA 2650.
Music of New Orleans: Eureaka Brass Band. Folkways FA 2642.

Early Period
The Young Louis Armstrong. Riverside RLP 12-101.
King Oliver. Epic LN 3208.
Jazz, Vol. 3. Folkways FJ 2803.
Jazz, Vol. 11. Folkways FJ 2811.
Fletcher Henderson. Fletcher Henderson. Riverside RLP 1055.
Jelly Roll Morton:
Jazz, Vol. 3. Folkways FJ 2803.

Jazz, Vol. 11. Folkways FJ 2811.
The Original Dixieland Jazz Band. Riverside RLP 156/157.

Big Bands
The Birth of Big Band Jazz. Riverside RLP 12-129.
A History of Jazz: The New York Scene. RBF RF 3.
Jazz: Big Bands (1929-34). Folkways FP 69.
Jazz, Vol. 8. Folkways FJ 2808.
Jazz Odyssey, Vol. 2: The Sound of Chicago. Columbia CL 32, Disc 3, Side 1.
Bennie Moten—Count Basie in Kansas City: Bennie Moten's Great Band of 1930-1932.
Don Redman: Don Redman—Master of the Big Band (McKinney's Cotton Pickers). RCA, Victor LPV 520.
Duke Ellington: The Beginning, Vol. 1, 1926-1928. Decca 9224.

Ragtime
The Golden Age of Ragtime. Riverside (12-110).
Ragtime Piano Roll Classics. Riverside 12-126.

Boogie Woogie
Jazz Volume 10, Boogie Woogie. Folkways 2810, LP 2J 5 V10.

Be-bop
Historical Masterpieces. Charlie Parker. Charlie Parker Record PLP 701.
The Happy Bird, Charlie Parker. Charlie Parker Records PLP 408.
The Charlie Parker Story. Verve M6V 8001.
Study in Brown. Clifford Brown & Max Roach. Emarcy Mo36037.

Mainstream (Post-Bebop.)
Milestones. Miles Davis. Columbia CS 9428.
A Touch of Satin. J. J. Johnson. CL 1737.
Sonny Rollins. Sonny Rollins. Blue Note 1558.
The John Lewis Piano. Atlantic 1272.
Giant Steps. John Coltrane. Atlantic 1311.
Kind of Blue. Miles Davis. Columbia CS 8163.

Soul Jazz
Blowin' the Blues Away. Horace Silver. Blue Note 4017.
The Cannonball Adderley Quintet at the Lighthouse. Riverside RLP 344.
Why Am I Treated So Bad. Cannonball Adderley. Capitol T2617.
Going Out of My Head. Wes Montgomery. Verve V8 8642.

Ethnic Jazz
Sketches of Spain. Miles Davis & Gil Evans. Columbia CS 8271.
Olé Coltrane. John Coltrane. Atlantic 1373.

Thirdstream
City of Glass. Stan Kenton. Capitol W736.
Outstanding Jazz Compositions of the 20th Century. Columbia C2S831.
The Golden Striker. John Lewis. Atlantic 1334.
Intents and Purposes. Bill Dixon Orchestra. RCA—LSP 3844.

Avant-Garde
Eastern Man Alone. Charles Tyler. ESP 1059.
Unit Structures. Cecil Taylor. BLP 4237.
Change of the Century. Ornette Coleman. Atlantic SD 1327.

Outward Bound. Eric Dolphy. NJLP 8236.
Ezzthetics. George Russell. Riverside 375.
A Love Supreme. John Coltrane. Impulse A77.
Ascension. John Coltrane. Impulse A95.

Liturgical Jazz
A Love Supreme. John Coltrane. Impulse A77.
Jazz Suite on the Mass Texts. Paul Horn and Lalo Schifrin. RCA Victor LPM 3414.
Prodigal Son. Phil Wilson Quartet. Freeform records No. 101.

Recommended Additional Listening
Glenn Miller Concert. RCA Victor, LPM 1193.
Big Band and Quartet in Concert. T. Monk. Columbia CS 8964.
Study in Brown. Clifford Brown and Max Roach. Emarcy M6 36037.
How High the Moon. Norman Granz. Verve M6, Vol. 1.
Wonderland. Charles Mingus. Solid State Stereo SS18019.
The Band of Distinction. Count Basie. Clef Records, M6 C-722.
Piano Jazz. Vol. 1. Barrel House and Boogie Woogie. Brunswick 54014.
Great Jazz Pianist. Camden Cal. 328.
Giants of Boogie Woogie. Riverside 12-106.
Mulligan Meets Monk. Thelonious Monk. Riverside 247.
Hub Tones. Freddie Hubbard. Blue Note 4115.
Mingus/Oh Yeah. Charlie Mingus. A1377.
Sliding Easy. Curtis Fuller. UAL 4041.
Stratusphunk. George Russell. Riverside 341.
Point of Departure. Andrew Hill. Blue Note 4167.
Porgy and Bess. Miles Davis. CL 1274.
Miles Smiles. Miles Davis. CS 9401.
Heavy Sounds. Elvin Jones. Impulse A-9161.

Much has already been said about the use of black music to expand the forms of traditional poetry, to make it more flexible and responsive to black idioms and black experience. Langston Hughes and Sterling Brown used the blues to develop a style of their own (see Chapter 4, Poetry and the Blues). Hughes also took advantage of be-bop and jazz. Blues form is much more easily set down and explained, however, than jazz. Improvisation is the essence of jazz music, but it is difficult to "take a ride" on a word. Some of the poets in this chapter call themselves Jazz Poets. In fact, an album (BR Records, 461) released in 1967 was entitled "New Jazz Poets" and included a number of writers (e.g., Calvin Hernton, Ishmael Reed, David Henderson) whose style and subject matter differ greatly. Stephen Henderson, in his book *Understanding the New Black Poetry,* suggests that when black poetry is most "distinctly and effectively *Black,*" it derives its structure from black speech and black music. In discussing "Black Music as Poetic Reference" he identifies ten ways in which black music is used by black poets:

1. The casual, generalized reference
2. The careful allusion to song titles

3. The quotations from a song
4. The adaptation of song forms
5. The use of tonal memory as poetic structure
6. The use of precise musical notation in the text
7. The use of an assumed emotional response incorporated into the poem: the "subjective correlative"
8. The musician as subject/poem/history/myth
9. The use of language from the jazz life
10. The poem as "score" or "chart"[15]

The poets represented in this chapter may use one or more of the above devices. Most often you will notice numbers 2, 5, 6, 8 and 9. In addition, David Baker has suggested that some rather specific techniques of jazz music are recognizable in jazz poetry. Substitution, for example, which occurs when one chord is used in place of another chord with the same meaning—often done for emphasis (see Carl Wendell Hines, "Two Jazz Poems": "i send down cool sounds!/but there are no ears to hear me./my lips they quiver in aether-emptiness!/there are no hearts to love me."); riffing, which is repeating a line that becomes a leitmotif; timbral, which is the use of a sound for the sake of itself, like onomatopoeia (related to Device number 5); and call and response, which occurs in the music when one instrument "speaks" and another responds.

Device number 2. Careful allusion to song titles.

This device occurs in "Dear John, Dear Coltrane" by Michael Harper. Henderson mentions that Harper "not only uses the title of the composition as an epigraph, but quotes from the companion poem that Coltrane wrote for the album, building upon the phrase 'a love supreme' in a manner suggesting a musician improvising on a motif."[16] We have already observed the use of song titles in prose and poetry in previous chapters; e.g., "O Black and Unknown Bards," in almost all of the blues poems in Chapter 4, in novels like Ronald Fair's *Many Thousand Gone*, and short stories like "Sonny's Blues."

Device number 5. The use of tonal memory as poetic structure.

Henderson says this device forces the reader to incorporate into the poem's structure his memory of a song or parts of a song. Don L. Lee's title poem from his book, *Don't Cry, Scream* (Broadside Press, 1969) is an example of this device, as is Sterling Brown's "Ma Rainey," which appears in Chapter 4. Sarah Fabio's "Tribute to Duke" uses this and several other devices. Henderson says that in "Tribute to Duke" there is "room for at least two spoken voices, both of which evoke specific recollections of the Ellington repertoire. The technique includes the use of song titles [number 2] as well as descriptions of the sound [number 6] and empathetic comment from the second voice (call and response). In addition there are places where medleys or individual songs are either to be played in the background or imagined—recalled—by the audience/reader [number 5]. While the poem is sufficient in itself, it assumes a great familiarity with Ellington's music. At times, the second voice becomes a set of directions or a score [number 10]."[17]

Device number 6. The use of precise musical notation in the text.

Henderson comments on W. E. B. Du Bois's use of musical epigraphs (spirituals) in *The Souls of Black Folk* and its importance to the comprehension and appreciation of the essays in that book. The effect of these musical notations has already been discussed in Chapter 3. Included in this chapter is Langston Hughes's "Jazztet Muted," from *Ask Your Mama: 12 Moods for Jazz* which, like the title poem, is accompanied by "linear notes" that act as a gloss for the text. (See also "The Africa Thing.")

Device number 7. The use of an assumed emotional response incorporated into the poem: the "subjective correlative."

In "Tribute to Duke," not only the titles of songs, like "Black Beauty," "Creole Rhapsody," and "Sophisticated Lady" elicit a response, but also the linear notes, which gloss the poem, elicit an emotional response which is analogous to the reader's experience with the music. *I got the blues* is a flat statement, but "Ohh, Ooh, Oh, moaning low," is the *feeling* of the blues.

Device number 8. The musician as subject/poem/history/myth.

Most of the poems in this chapter contain explicit (Frank Marshall Davis's "Louis Armstrong" and "Charlie Parker") or implicit references to famous jazz musicians. When "Bird" or "Yardbird" (Carl Wendell Hines's "Two Jazz Poems" and Hughes's "Jazztet Muted") is alluded to, even if the musician himself is not the subject of the poem, we know that Charlie Parker is the referent and that his experience, although particularized, will in most cases be symbolic of the black musician. Notice Hines's last stanza: from the preacher of the "Black Gospel of Jazz" he (the musician) loses himself in the notes and chords, literally and figuratively takes flight, then

15. Stephen Henderson, *Understanding the New Black Poetry* (New York, 1973, William Morrow Co.), p. 47. The entire introduction is an excellent guide to understanding the unique characteristics of black poetry.

16. Henderson, p. 49.

17. Henderson, pp. 56-57.

returns perhaps ("or/comes back") to find himself as a black man. Much the same may be said for Harper's "Brother John." Here, not one but three musicians (Bird, Miles, Trane) are subject/poem/history mythicized for they are the embodiment of "the Black Man." Each has his link to black manhood—Bird of the ornithology-world, "mute," "unspeakable" Miles and finally "Brother John"—which becomes the leitmotif of the poem (riffing). Harper says:

> My poems are rhythmic rather than metric; the pulse is jazz, the tradition generally oral; my major influences musical; my debts mostly to the musicians [John Coltrane, Miles Davis, Billie Holiday, Bud Powell, etc.] who taught me to see about experience, pain, and love, and who made it artful and archetypal.[18]

Device number 9. Language for the jazz life or associated with it, commonly called "hip" speech.

The speech of jazz musicians has long been a rich source of creative language expression. Almost all black poetry has been affected by it, as have American speech patterns (particularly of young people, black and white). "Tribute to Duke" contains a number of examples: "funky," "going through changes," "riffing," "get it on," and "break it down."

TWO JAZZ POEMS*

Carl Wendell Hines, Jr.

#
yeah here am i
am standing
at the crest of a tallest
hill with a trumpet
in my hand & dark
glasses
on.
 bearded & bereted i proudly stand!
 but there are no eyes to see me.
 i send down cool sounds!
 but there are no ears to hear me.
 my lips they quiver in aether-emptiness!
 there are no hearts to love me.
surely though through night's grew fog mist
of delusion & dream
& the rivers of tears that flow
like gelatin soul-juice
some apathetic bearer of
paranoidic peyote visions (or some
other source of inspiration) shall
 hear the song i play. shall
 see the beard & beret. shall
 become inflamed beyond all hope
with emotion's everlasting fire
& join me
 in

 eternal
 Peace.
& but yet well
who knows?
 #
there he stands. see?
like a black Ancient Mariner his
wrinkled old face so
full of the wearies of living is
turned downward with
closed eyes. his frayed-collar
faded-blue old shirt turns
dark with sweat & the old
necktie undone drops
loosely about the worn
old jacket see? just
barely holding his
sagging stomach in. yeah.
his run-down shoes have
paper in them & his
rough unshaven face shows
pain
in each wrinkle.

but there he stands. in
self-brought solitude head
still down eyes
still closed ears
perked & trained upon
the bass line for
across his chest lies an old
alto saxophone—
supported from his neck by
a wire coat hanger.

gently he lifts it now
to parted lips. see? to
tell all the world that
he is a Black Man. that
he was sent here to preach
the Black Gospel of Jazz.

now preaching it with words of
screaming notes & chords he
is no longer a man, no not even
a Black Man. but (yeah!)
a Bird!—
one that gathers his wings & flies
 high
 high
 higher
until he flies away! or
comes back to find himself
a Black Man
again.

*"Two Jazz Poems" by Carl Wendell Hines, Jr., from *American Negro Poetry,* ed. Arna Bontemps, reprinted by permission of the author.

18. Michael Harper, *Dear John, Dear Coltrane* (cover), University of Pittsburgh Press, 1970.

DEAR JOHN, DEAR COLTRANE*

Michael S. Harper

 a love supreme, a love supreme
 a love supreme, a love supreme

Sex fingers toes
in the marketplace
near your father's church
in Hamlet, North Carolina—
witness to this love
in this calm fallow
of these minds,
there is no substitute for pain:
genitals gone or going,
seed burned out,
you tuck the roots in the earth,
turn back, and move
by river through the swamps,
singing: a love supreme, a love supreme;
what does it all mean?
Loss, so great each black
woman expects your failure
in mute change, the seed gone.
You plod up into the electric city—
your song now crystal and
the blues. You pick up the horn
with some will and blow
into the freezing night:
a love supreme, a love supreme—

Dawn comes and you cook
up the thick sin 'tween
impotence and death, fuel
the tenor sax cannibal
heart, genitals and sweat
that makes you clean—
a love supreme, a love supreme—

Why you so black?
cause I am
why you so funky?
cause I am
why you so black?
cause I am
why you so sweet?
cause I am
why you so black?
cause I am
a love supreme, a love supreme:

So sick
you couldn't play Naima,
so flat we ached
for song you'd concealed
with your own blood,
your diseased liver gave
out its purity,
the inflated heart
pumps out, the tenor kiss,

tenor love:
a love supreme, a love supreme—
a love supreme, a love supreme—

TRIBUTE TO DUKE**

Sarah Webster Fabio

Rhythm and Blues
sired you; gospel's
your mother tongue:
that of a MAN
praying in the
miraculous language
of song—soul
communion with
his maker,
a sacred offering
from the
God-in-man
to the God-of-man.

You reigned King
of Jazz before
Whiteman imitations
of "Black-Brown and
Beige" became the
order of the day.
Here, now, we but add
one star more to
your two-grand
jewel-studded crown
for that many tunes
you turned the world
onto in your
half-centuried
creative fever riffed
in scales of color
from "Black Beauty"
to "Creole Rhapsody"
and "Black and Tan
 Fantasy."
All praises
to Duke,
King of Jazz

To run it down
for you. That
fever that came on
with that "Uptown Beat"
caused Cotton when
he came to Harlem
that first time to
do a "Sugar Hill
Shim Sham."

Ohh, Ooh, Oh,
moaning low,
I got
the blues.

Sometimes I'm
up; sometimes
I'm down.

Sometimes I'm
down; sometimes
I'm up.

Oh happy day
 When Jesus washed
 my sin away.
(musical background
 with a medly of
 tunes)

Boss, boss
 tunes in
 technicolor
SOUL—
 Black-
 Brown-
 Beige-
 Creole-

 Black
and

 Tan
is

the color
of my fantasy.
When things
got down
and really
funky
fever, fever,
light
my fire.

*From *Dear John, Dear Coltrane* by Michael Harper. University of Pittsburgh Press, 1970. Reprinted by permission of the author.

**Sarah Webster Fabio, "Tribute to Duke," reprinted by the kind permission of the author.

When things got down
and funky
you bit into the blues
and blew into the air,
"I Got It Bad and
That Ain't Good,"
And from deep
down into your
"Solitude," you
touched both
"Satin Doll" and
"Sophisticated Lady"
wrapped them in
"Mood Indigo" and made
each moment
"A Prelude
to a kiss."

Way back then, Man,
you were doing
your thing.
Blowing minds with
riffs capping
whimsical whiffs of
lush melody—
changing minds
with moods and
modulations,
changing minds,
changing faces,
changing tunes,

changing changes,
tripping out with
Billy to "Take the
A Train," making it
your theme—
your heat—
coming on strong
with bold
dissonance
and fast, fast, beat
of the early, late
sound of our time.

"Harlem Airshaft"
"Rent Party Blues"
Jangling jazzed tone
portraits of life
in the streets.
"Harlem"—a symphony
of cacaphonous sound,
bristling rhythms,
haunting laments
trumpeting into the air
defiant blasts blown solo
to fully orchestrated
folk chorus.
World Ambassador,

Down,
down
down
Nee-eev-eer
treat me
kind
and gentle—
BLOW
(music in the
background)
the way you
should
BLOW, MAN
Ain't
I
Got
it
Bad.

Break it down.
Break
it down
Right on down
to
the
Real
nitty gritty.
("Solitude"
as background
sound)
Blow,
blow,
blow

Do your thing.

Change, change, change
your 'chine
and Take
The
A Train.

Ain't
got no
money
Ain't got no bread
Ain't got
no place
to lay my Afro head.
I got
those low down
blues.
Chorus: Hot-and-Cold-
Running-Harlem
"Rent Party Blues."

translating Life
into lyric; voice
into song; pulse
into beat
the beat, the beat,
a beat, a beat, a beat,
beat, beat, beat, beat
Do it now.
Get down.
"A Drum Is a Woman,"
and what more
language does
a sweetback need
to trip out to
"Mood Indigo,"

Right on, Duke
Do your thing,
your own thing.
And, Man,
the word's out
when you get down
Bad
it's good,
Real good,

And as you
go
know
you're tops,
and whatever
you do,
"We love you
madly."

Break it down,
down
down
down
Right on down
to the
Real
nitty gritty.
(drums in the
background become
drum solo)

(Theme song)

Take
The
A
Train.

Right on.

Right
on
out
of
this
funky
world.

JAZZTET MUTED*

Langston Hughes

IN THE NEGROES OF THE QUARTER Bop
PRESSURE OF THE BLOOD IS SLIGHTLY
 HIGHER blues
IN THE QUARTER OF THE NEGROES into
WHERE BLACK SHADOWS MOVE LIKE
 SHADOWS very
CUT FROM SHADOWS CUT FROM
 SHADE modern
IN THE QUARTER OF THE NEGROES jazz
SUDDENLY CATCHING FIRE burning
FROM THE WING TIP OF A MATCH TIP the
ON THE BREATH OF ORNETTE COLE- air
 MAN eerie

IN NEON TOMBS THE MUSIC like
FROM JUKEBOX JOINTS IS LAID a neon

*From Ask Your Mama: 12 Moods for Jazz by Langston Hughes.
Copyright © 1959, 1961 by Langston Hughes. Reprinted by permission of Alfred A. Knopf, Inc.

139

AND FREE-DELIVERY TV SETS
ON GRAVESTONES DATES ARE
PLAYED.
EXTRA-LARGE THE KINGS AND
QUEENS
AT EITHER SIDE ARRAYED
HAVE DOORS THAT OPEN OUTWARD
TO THE QUARTER OF THE NEGROES
WHERE THE PRESSURE OF THE BLOOD
IS SLIGHTLY HIGHER—
DUE TO SMOLDERING SHADOWS
THAT SOMETIMES TURN TO FIRE.

HELP ME, YARDBIRD!
HELP ME!

swamp-

fire

cooled
by
dry
ice
until
suddenly
there is
a single
ear-
piercing
flute
call. . . .

And slink away—
Later you hear
Sound of gravel
Fallin' in a tin bucket
With a melodic beat:
It's the King
Callin' the Gates
To a victory feast
Of red beans and rice.

Visit if you like
With other tribes
The new cool people
Of the jazz jungle
Then bring it on back
Back to the court
Of the Zulu King
Where you see twenty six
Of the craziest chicks
Shakin' that thing!

LOUIS ARMSTRONG*

Frank Marshall Davis

Any day at court
Before the Zulu King
You'll find twenty six
Of the wildest chicks
Shakin' that thing.

King of the Zulus
Wears a swingin' crown
Made from a silver trumpet
Set with firy blue diamonds.

He was a young'un
When he blew himself
Smack dab on the throne
An ain't nobody yet
Been able to blast him off;
They've tried many times
These challengers
Their lips tough as elephant hide
Lungs like blacksmith bellows
The King grabs an earful
Then reaches for his horn
Any old horn
Dips it in
His barrel of blues
Loosens his chops
Mugs lightly
Slightly
And politely
And blows—
Notes swing out
Shining like sunstroked gold
Lithe as contortionists
Or maybe
He stomps it off
And the music darts
Like stunting jets
Burns like boiling lava
Then the ambitious Cats
Shake their heads

CHARLIE PARKER*

Frank Marshall Davis

Who named him Yard Bird?
He was a homing pigeon
With no home to fly to

Sky unlimited
Route uncharted
Eagle strong
He scorched his wings
Haunting the heavens
Buzzing the sun
And the feebler fowl
Looked up in awe
But played it safe

In the rambling sky
He lived!
Here he rendezvoused
With freedom
Flashing feathers
Of burning blue
Dipping, darting
In strange and wild
Ecstatic arcs
Dazzling with his daring
Flying
As none before had ever flown

Even an eagle tires
And returns to his airy craig
A homing pigeon
Cannot soar forever

But this majestic bird
Had no home
To go to;
Helpless
On the ground
He wandered aimlessly
Pecking in garbage
Like a common sparrow
With a weary wing
And he was trapped
And hooked
And cooked—
That's the simple story
Of the heaven haunting pigeon
Who flew his way to glory.

BROTHER JOHN*

Michael S. Harper

Black man:
I'm a black man;
I'm a black; I am—
A black man; black—
I'm a black man;
I'm a black man;
I'm a man; black—
I am—

Bird, buttermilk bird—
smack, booze and bitches
I am Bird
baddest nightdreamer
on sax in the ornithology-world
I can fly—higher, high, higher—
I'm a black man;
I am; I'm a black man—

Miles, blue haze,
Miles high, another bird,
more Miles, mute,
Mute Miles, clean,
bug-eyed, unspeakable,
Miles, sweet Mute,
sweat Miles, black Miles;
I'm a black man;
I'm black; I am;
I'm a black man—

Trane, Coltrane; John Coltrane;
it's tranetime; chase the Trane;
it's a slow dance;
it's the Trane
in Alabama; acknowledgement,
a love supreme,
it's black Trane; black;
I'm a black man; I'm black;
I am; I'm a black man—

Brother John, Brother John
plays no instrument;
he's a black man; black;
he's a black man; he is
Brother John; Brother John—

I'm a black man; I am;
black; I am; I'm a black
man; I am; I am;
I'm a black man;
I'm a black man;
I am; I'm a black man;
I am:

for John O. Stewart

Adam David Miller says that "The Africa Thing" is his poem that is closest to music. It is reminiscent of Countee Cullen's poem, "Heritage," which was that poet's attempt, during the Harlem Renaissance—that period of heightened racial consciousness—to understand his relationship to the African past. Miller improvises on the same theme, but uses a rhythmical beat, even adding musical notation in the text (Henderson's point number 6). He also shows various facets of black life in America to be a part of the African continuum, in addition to playing satirically on some cherished Western children's tales: e.g., instead of smelling the blood of an Englishman, it's "smelling the sweat of an english scum." Africa is the symbol of all black experience, and "The Africa Thing" is a song of love.

THE AFRICA THING**

Adam David Miller

What is Africa to thee?

Let's shuffle

Paint that horn
on backwards—
Knock me some skin Blow! O

They say home
is a place
in the mind
where you
can rest
when you're tired
not where

*"Brother John" by Michael Harper from *Dear John, Dear Coltrane.* University of Pittsburgh Press, 1970. Reprinted by permission of the author.

**From *Dices or Black Bones,* edited by Adam David Miller. Copyright © 1970. Reprinted by permission of Houghton Mifflin Company.

your great great
great grandfather
had his farm

Africa?

Africa	beble be
is that old man	ba
in the pickin field	bo
making that strange high sound	bibob
and all the people following	blaaba
Africa is a sound	ba ba
Africa	buddi di oooooo
is the touch	rock a diooooo
of that old woman	
your mother could not stand	do oo do o
but did respect	
who caught you as you fell	
and held you	
and rocked you	

Fat black bucks in a wine barrel	boom
boom	
What is Africa to thee	bam
thou thoo thum	boom
I smell the sweat of an english scum	boom boom

—Mamma, Mamma, but he *does*
It's *not* just his breath
He stink
Hushsssh, chile
Somebody'll hear you
Say *smell.*

Africa
is the look
of Tweebie Mae
Snapping her
head around
before she took off
 Caint ketch me
in the soft dark
You caught her

Africa
is all them roots
and conjurs
and spells
wails and chants
(say blues and hollers)
and all them stories
about Stackalee
and John Henry
and Bodidly
and the camp meetings
where the wrestling
and head and head
the foot races
the jumping
the throwing

We brought all that down
to dance at birth
when you're sick
take a wife
lose your luck
when you die

and singing in the woods
 in the fields
 when you walk
and singing on the levies
 on the chain gang
 in the jail
singing and dancing when you pray
and dancing by the light of the moon
until you drop.

Africa is the singing
of these lines
of me
of you
of love
singing.

Jazz has affected more art forms than poetry. The film *Shadows,* made by a group of acting students in New York City in 1959, was directed by John Cassavetes and scored by Charlie Mingus. It was described by critic Georges Sadoul as a "series of improvisations that gradually reveal the mood of the city and the life and relationships of the three characters."[19] The three characters are two brothers and a sister, all of varying shades of color. The audience learns about their lives in much the same way as the listener of a jazz composition begins to unravel the sounds the jazz musician spins out and improvises on. Each brother and the sister move out into life, have experiences which are both profound and petty and then return to the family group. Then they move out again.

Shadows was shot without a script; the only unity imposed upon it is the artistic unity of a jazz composition. It has a gritty sense of reality, a beat that is emphasized by Mingus's music, played by himself and Shafi Hadi on the sax solos. *Shadows,* in form, could be described as a jazz film.[20]

There are some, of course, who feel that they have "risen above" jazz. Michael Harper addresses the following poem to one of them:

19. Georges Sadoul, *Dictionary of Film*, translated, edited, updated by Peter Morris, Berkeley, 1972, p. 336.

20. *Shadows* is readily available for classroom use.

ALONE*

Michael S. Harper

A friend told me
He'd risen above jazz.
I leave him there.

for Miles Davis

The following paintings and sculpture are all abstract, a concept in art that is in a sense related to improvisation in jazz. Richard Mayhew's "Iroquois Spring" (fig. 5.1) has the colors of "cool" jazz: blues, pale golds, subtle pinks which blend together yet still retain their integrity as distinct colors.

Howardena Pindell's "Untitled 1972," (fig. 5.2), similar to her work discussed in Chapter 6, is a series of color dots or points which repeat themselves (like "riffing") in a pattern created by the artist's imagination. Mel Edward's "Double Circles" (fig. 5.3) move out and back upon themselves like sound substitution. There is an end and a beginning but the emphasis is on continuity. The eye follows the movement of circularity in space as the ear does the sound of one chord as it is replaced by another with the same meaning.

*"Alone" by Michael Harper from *Dear John, Dear Coltrane.* University of Pittsburgh Press, 1970. Reprinted by permission of the author.

Figure 5.1. Richard Mayhew, "Iroquois Spring." Oil, 5′ × 7′. Courtesy of Midtown Galleries. 11 E. 57th Street, New York, N.Y. 10022.

Figure 5.2. Howardena Pindell, "Untitled," 1972. Acrylic on canvas, 90″ × 104″. Collection of the artist, New York.

Figure 5.3. Mel Edwards, "Double Circles." Photo: Lawrence J. Sykes.

REBELLION IN THE ARTS

Much of the literature, music, and art of this chapter probably will appear radically different from that to which most readers, listeners, and viewers are accustomed. The reason that the selections will appear different is they are in fact different—that is, they are anti-mainstream American. What Julian Mayfield said about the mainstream of American Literature in 1960 remains virtually unchanged and may be extended to include music and art. Mayfield claims that the American writer has turned his back on great challenging issues: "He deals with the foibles of suburban living, the junior executive, dope addiction, homosexuality, incest and divorce. . . . Writers of the mainstream . . . seem determined not to become involved in any of the genuine fury, turmoil, and passion of life; and it is only such involvement that makes life worth living. Where for instance, is the humor that once characterized our national literature, and what has happened to the American's ability, indeed his proclivity, to laugh at himself? A stultifying respectability hangs over the land, and that is always a sign of decline, for it inhibits the flowering of new ideas that lead to progress and cultural regeneration."[1] Being outside the mainstream, the black artist has, Mayfield continues, certain advantages which may well prevent future literary, music, and art historians from terming the last few decades of American letters and arts as being almost completely sterile or utterly barren. "The advantage of the Negro writer, the factor that may keep his work above the vacuity of the American mainstream, is that for him the facade of the American way of life is always transparent. He sings the national anthem *sotto voce* and has trouble reconciling the 'dream' to the reality he knows. . . . He walks the streets of his nation an alien, and yet he feels no bond to the continent of his ancestors. He is indeed the man without a country. And yet this very detachment may give him the insight of the stranger in the house, placing him in a better position to illuminate contemporary American life as few writers of the mainstream can."[2]

Many critics denigrate poetry similar to that of this chapter on the grounds that it is didactic, too topical, too pessimistic or devoid of hope, that it does not have universal appeal. Many critics feel that it is too simplistic, too direct, not challenging to those who wish to do exercises in mental gymnastics. Generally speaking, black artists feel that there is too much intellectual gyration going on in mainstream American poetry (and the other arts too), that it does not concern itself with the "genuine fury, turmoil, and passion of life." To be sure, the tone of much of the poetry is bitter, but life has indeed been bitter for the majority of Afro-Americans. Much of the poetry is functional and direct, for its creators do not subscribe to the notion of art for art's sake. They subscribe to the notion of art for people's sake— particularly art for black people—and feel no obligation to write by standards superimposed by white or black Anglo-Saxon critics. Moreover, there are often double standards. Critics who stress "unity of design" often forget about it when attempting to make a case for a work by a white writer but apply it very rigidly when assessing the work of a black writer. To the charge that it does not have universal appeal, one can only ask what has more universal appeal than the depiction of mass human suffering and man's inhumanity to man.

The first sequence of poems outlines the credo of many black writers for the past fifty years—from Claude McKay, who wrote during the Harlem Renaissance, to Etheridge Knight and Lance Jeffers, poets who do not pray "to God for Light!" but who have experienced a common racial pain, looked the "hurricane in the eye" and lived.

THE NEGRO'S TRAGEDY*

Claude McKay

It is the Negro's tragedy I feel
Which binds me like a heavy iron chain,
It is the Negro's wounds I want to heal
Because I know the keenness of his pain.
Only a thorn-crowned Negro and no white

*From *Selected Poems of Claude McKay.* Reprinted with the permission of Twayne Publishers, a Division of G. K. Hall & Co., Boston.

1. "Into the Mainstream and Oblivion" from *The American Negro Writer and His Roots,* reprinted in Houston A. Baker, Jr.'s *Black Literature in America,* New York, 1971, p. 418.

2. Mayfield, p. 418.

Can penetrate into the Negro's ken,
Or feel the thickness of the shroud of night
Which hides and buries him from other men.

So what I write is urged out of my blood.
There is no white man who could write my book,
Though many think their story should be told
Of what the Negro people ought to brook.
Our statesmen roam the world to set things right.
This Negro laughs and prays to God for Light!

ON UNIVERSALISM*

Etheridge Knight

I see no single thread
That binds me one to all;
Why even common dead
Men took the single fall.

No universal laws
Of human misery
Create a common cause
Or common history
That ease black people's pains
Nor break black people's chains.

WHEN I AM DYING AT NINETY**

Lance Jeffers

When I am dying at ninety, my poetry
will live, unshorn
by the criminal world I fisted through;
when I am dying at ninety, my poetry
will see the secret of the traitor-negro torn
from his heart, his longitude plundered from its earth,
his latitude axed, cemented, unborne:
when, ninety, I've tramped through
the hollows of every dried and bestial corn
and kept my visceral rivers hot, I'll see Death
 kiss the drunken morn,
 pick up his tenor horn,
 and blow the blues to old women worn
strong by the struggle, and old men sworn
to write poetry till they look the swollen hurricane
 in the eye,
curse once brutally, and die!

Because black people have been programmed to believe that they are ugly and evil because of their color, black poets have sought to negate these self-effacing notions by extolling the beauty of blackness and emphasizing the evil of whiteness—a rebellious notion indeed in Western and American thought. Anyone familiar with Western color symbology and iconography knows how much emphasis has been placed on the color of white representing good, purity, and innocence while black has traditionally represented evil and depravity.

The following poems, beginning with those by Naomi Long Madgett and Michael Harper, have as their animating force the notion that "black is beautiful." Black poets feel the urge to establish this minimum salutary need, and it is interesting to observe how they express their ideas. Some assert that black is beautiful in a negative way, by focusing on the depravity of whiteness; others affirm the positive essence of blackness.

NOCTURNE†

Naomi Long Madgett

See how dark the night settles on my face,
How deep the rivers of my soul
Flow imperturbable and strong.

Rhythms of unremembered jungles
Pulse through the untamed shadows of my song,
And my cry is the dusky accent of secret midnight birds.

Above the sable valleys of my sorrow
My swarthy hands have fashioned
Pyramids of virgin joy.

See how tenderly God pulls His blanket of blackness
 over
 the earth.
You think I am not beautiful?
You lie!

BLACK CRYPTOGRAM††

Michael S. Harper

When God
created
the black child
He was
showing off.

for Sterling A. Brown

MY BLACKNESS IS THE BEAUTY
OF THIS LAND‡

Lance Jeffers

My blackness is the beauty of this land,
my blackness,

*From *Poems from Prison*. Copyright © 1968 by Etheridge Knight. Reprinted by permission of Broadside Press.
**"When I Am Dying At Ninety" by Lance Jeffers. Reprinted by permission of the author.
†From *Star by Star* by Naomi Long Madgett. (Detroit: Harlo, 1965, 1970). By permission of the author.
††"Black Cryptogram" by Michael Harper from *Nightmare Begins Responsibility*. University of Illinois Press, 1975. Reprinted by permission of the author.
‡"My Blackness Is the Beauty" by Lance Jeffers. Reprinted by permission of the author.

tender and strong, wounded and wise,
my blackness:
I, drawling black grandmother, smile muscular and
 sweet,
unstraightened white hair soon to grow in earth,
work thickened hand thoughtful and gentle on grand-
 son's head
my heart is bloody-razored by a million memories'
 thrall:
 remembering the crook-necked cracker who spat
 on my naked body,
remembering the splintering of my son's spirit
 because he remembered to be proud
 remembering the tragic eyes in my daughter's
 dark face when she learned her color's
 meaning,
and my own dark rage a rusty knife with teeth to gnaw
 my bowels,
my agony ripped loose by anguished shouts in Sunday's
 humble church,
my agony rainbowed to ecstasy when my feet over-
 soared
 Montgomery's slime,
ah, this hurt, this hate, this ecstasy before I die,
and all my love a strong cathedral!
My blackness is the beauty of this land!
Lay this against my whiteness, this land!
Lay me, young Brutus stamping hard on the cat's tail,
gutting the Indian, gouging the nigger,
booting Little Rock's Minniejean Brown in the buttocks
 and
 boast,
 my sharp white teeth derision-bared as I the con-
 queror
 crush!
Skyscraper-1, white hands burying God's human clouds
 beneath
 the dust!
Skyscraper-1, slim blond young Empire
 thrusting up my loveless bayonet to rape the sky,
then shrink all my long body with filth and in the gutter
 lie
as lie I will to perfume this armpit garbage.

While I here standing black beside
wrench tears from which the lies would suck the salt
to make me more American than America. . .
But yet my love and yet my hate shall civilize this land,
this land's salvation.

GLIMPSES
OF AN IMAGE*

Sarah Webster Fabio

Glimpses
of an image
of ourselves, now,
from glints
of our past;

to wear like
a mask of our
black nature
for all to know
us by:

a garment,
pose,
smile;
a grimace,
stance,
style
tatoos on
oaken souls,
carvings on
mahogany
hearts.

Thinly
veiled,
see the
she-child
clasping hands,
nimbly leap
into ritual dance,
ushering in the
Green Spring—
so young,
fresh,
firmly planted
those patterning
feet on the drumming
earth.

enrobed,
see Hannibal,
Othello,
and shades
like ivy along
the walls of
Timbuktu;
regally sunning
in embellished
courtyards of
Cairo and
Addis Ababa
and behind them
the splendor
of the Pyramids
Enjewelled,
splendidly,
and perfumed
see Aida,
Cleopatra
and Sheba.

See in moonlit
glimmer those

*Sarah Webster Fabio, "Glimpses of an Image" from *Boss Soul*,
Phase II Publishers, 1973. Reprinted by the kind permission of the
author.

147

middle passages,
bruised with
pain on slave
ships, in dungeons;
smouldering in
torrid tombs of
Western
industrial
nightmares,
buried in the cotton
coffins
of the
South.

Glimpses of
a memorable
past; fragments—
of the dimmed
soul of a people
of destiny

to fix as an image to
mirror us
in our Negritude—
our collective
Afro based
consciousness.

Nobly,
irrevocably
we emerge
to become
who we are
and we are
black,
beautiful,
precious,
proud.

The next sequence of poems calls for an end to passivity on the part of Blacks. McKay's eloquent plea, "If We Must Die" (first published in 1919) which follows, is written in the form of a Shakespearean sonnet; Countee Cullen's "From the Dark Tower" (which was originally published in *Copper Sun;* see *On These I Stand,* 1947) is written in the form of an Italian sonnet. Don L. Lee's "A Message All Black People Can Dig" (published in his book, *Don't Cry, Scream,* 1969) calls for revolution in free verse form. Thus rebellion is taking place not only in substance but also in form and thought. Perhaps it needs to be stated here that "rebellion" does not necessarily mean "a call for armed revolution," though it does mean that too. Quite frequently it calls for a change in mind set as in Sarah Fabio's "Evil Is No Black Thing" and in Askia Touré's "Birth of a Nation." "Birth of a Nation" is directed against the demeaning images of black people that have been created by Hollywood.

IF WE MUST DIE*

Claude McKay

If we must die, let it not be like hogs
Hunted and penned in an inglorious spot,
While round us bark the mad and hungry dogs,
Making their mock at our accursed lot.
If we must die, O let us nobly die,
So that our precious blood may not be shed
In vain; then even the monsters we defy
Shall be constrained to honor us though dead!
O kinsmen! we must meet the common foe!
Though far outnumbered let us show us brave,
And for their thousand blows deal one deathblow!
What though before us lies the open grave?
Like men we'll face the murderous, cowardly pack,
Pressed to the wall, dying, but fighting back!

EVIL IS NO BLACK THING**

Sarah Webster Fabio

1.
Ahab's gaily clad fisherfriends,
questing under the blue skies after
the albino prize find the green sea
cold and dark at its deep center.
but calm—unperturbed by the fates
of men and whales.

Rowing shoreward, with wet and empty
hands, their sun-rich smiles fuzz
with bafflement as the frothing
surf buckles underneath and their
sea-scarred craft is dashed to pieces
near the shore: glancing backward,
the spiralling waves are white-capped.

2.
Evil is no black thing: black
the rain clouds attending a storm
but the fury of it neither begins
nor ends there. Weeping tear-clear
rain, trying to contain the hoarse
blue-throated thunder and the fierce
quick-silver tongue of lightning, bands
of clouds wring their hands.

Once I saw dark clouds in Texas
stand by idly while a Northeaster
screamed its icy puffs, ringtailing
raindrops, rolling them into baseballs
of hail, then descending upon the
tin-roofed houses, unrelentingly
battering them down.

*From *Selected Poems of Claude McKay.* Reprinted with the permission of Twayne Publishers, a Division of G. K. Hall & Co., Boston.
**Sarah Webster Fabio, "Evil Is No Black Thing" from *A Mirror: A Soul,* Success Publishing Co., 1969. Reprinted by the kind permission of the author.

3.

And the night is blackest where
gay throated cuckoos sing among the
dense firs of the Black Forest, where
terrible flurries of snow are blinding
bright: somewhere, concealed here deeply,
lies a high-walled town, whitewashed.

Seen at sunset, only the gaping ditch
and overhanging, crooked tree are painted
pitch to match the night: but I've seen a dying beam of
a dying beam of light reach through
the barred windows of a shower chamber,
illuminating its blood-scratched walls.

4.

Evil is no black thing: black
may be the undertaker's hearse
and so many of the civil trappings
of death, but not its essence:
the riderless horse, the armbands
and veils of mourning, the grave shine
darkly; but these are the rituals
of the living.

One day I found its meaning as I
rushed breathless through a wind-parched
field, stumbling unaware: suddenly there
it was, laying at my feet, hidden
beneath towering golden rods,
a criss-crossed pile of
sun-bleached bones.

THE BIRTH OF A NATION*
(FOR BEVERLY AND
THE NEW BLACK FILM STARS)

Askia Touré

Ambush the Silver Screen. Rob it of its victims—
frightened coons and screeching Aunt Jemimas.
Kidnap Birmingham/Stepin Fetchit/Beulah/Butterfly.
Nature them to life with the love-cry echoes
of your soul.
A new image like a diamond sparkling in an
ebony palm. A Congo-song for the multitudes.
BEVERLY TODD!
A rhapsody-in-motion. Undulating rhythm
in panther-form; cradle us in the satin
of your skin.
BEVERLY TODD: your name and another's.
For what is your *real* name, African princess?
Sky, I call you. Wind. Mountain. Rain.
Dawn's aurora blossoming across the tropical Dark.
Passion flower growing in the maw of the hurricane.
My voice chanting paeans of Apocalypse.
Every human eye mouth breath skin-song bosom tear.
Cry of a people molding the vision of their destiny.
Lovers reflected against a rain-streaked windowpane.
High-breasted, long-legged queens gliding down
dusky avenues, cornrows transcending Frankenstein
 wigs.

PRESENTING THE REEEAL THANG: MISS
BLACKNESS/BEVERLY TODD!
Call her Sky Wind Mountain Rain Niger Goddess/
 Sista-woman
Hope. Be, Bev, the Song of us,
the loving soaring sunburst dazzle of our Image reborn.
Congo smile scorching nordic vamp/ires—Jean
 Harlow,
Virginia Mayo, Jane Fonda—back to the slime of
the sewer-caves, where "Blondes have more fun"—
 with syphillitic dogs!
Love we call you, darling, and plenty of it!

Having been made to feel "Invisible" in this coun-
try, many Blacks have often resorted to superficial
means of becoming visible. A posture growing out of
the need to be visible is that of being "cool" in a
climate which, politically and socially, has allowed
Blacks to be anything except "cool." Black poets
have sought and are seeking to correct this demean-
ing posture. The next poem by Don L. Lee ridicules
the concept of being cool because it is nothing more
than a form of escapism.

BUT HE WAS COOL
or:
HE EVEN STOPPED
FOR GREEN LIGHTS**

Don L. Lee

super-cool
ultrablack
a tan/purple
had a beautiful shade.

he had a double-natural
that wd put the sisters to shame.
his dashikis were tailor made
& his beads were imported sea shells
 (from some blk/country i never heard of)
he was triple-hip

his tikis were hand carved
out of ivory
& came express from the motherland.
he would greet u in swahili
& say good-by in yoruba.

woooooooooooo—jim he bes so cool & ill tel li gent

 cool-cool is so cool he was un-cooled by
 other niggers' cool
 cool-cool ultracool was bop-cool/ice box
 cool so cool cold cool
 his wine didn't have to be cooled, him was
 air conditioned cool

*"The Birth of a Nation" by Askia Touré. Reprinted by permis-
sion of the author.
**From *Don't Cry, Scream.* Copyright © 1969 by Don L. Lee.
Reprinted by permission of Broadside Press.

cool-cool/real cool made me cool-now
 ain't that cool
cool-cool so cool him nick-named refregerator.

cool-cool so cool
he didn't know,
after detroit, newark, chicago &c.,
we had to hip

 cool-cool/super-cool/real cool

 that
to be black
is
to be
very-hot.

Another form of escapism which is perhaps more devastating than thinning gin and jazzing June is the reliance upon drugs. The following poem by Maya Angelou details what it means to be a junkie.

LETTER TO AN ASPIRING JUNKIE*

Maya Angelou

Let me hip you to the streets,
Jim,
Ain't nothing happening.
Maybe some tomorrows gone up in smoke,
raggedy preachers, telling a joke
to lonely, son-less old ladies' maids.

Nothing happing,
Nothing shakin', Jim.
A slough of young cats riding that
cold, white horse,
a grey old monkey on their back, of course
does rodeo tricks.

No haps, man.
No haps.
A worn-out pimp, with a space-age conk,
setting up some fool for a game of tonk,
or poker or
get 'em dead and alive.

The streets?
Climb into the streets man, like you climb
into the ass end of a lion.
Then it's fine.
It's a bug-a-loo and a shing-a-ling.
African dreams on a buck-and-a-wing and a prayer.
That's the streets man,
Nothing happening.

Many Blacks have worked incredibly long hours at very laborious tasks to eke out a meager existence, and for this they have been accused of being lazy.

Black poets have reacted to this charge in various ways. Fenton Johnson, in his poem "Tired" (see *The Negro Caravan,* edited by Sterling Brown, Arthur P. Davis and Ulysses Lee, originally published, 1941) expresses (in free verse) the sheer fatigue of the black man: "I am tired of work; I am tired of building up somebody else's civilization/. . . I am tired of civilization." Arna Bontemps, in his poem "A Black Man Talks of Reaping" (also in *The Negro Caravan*) uses traditional meter and rhyme to suggest the years of labor, heartache and pain so often experienced by the sharecropper who "has planted deep," yet what he sowed was only "what the hand can hold." Countee Cullen, in the brief, satirical poem that follows, uses traditional rhyme but varies the meter. He carries the stereotypical idea of whites that black people were "born to work" (for whites) to its most absurd.

FOR A LADY I KNOW**

Countee Cullen

She even thinks that up in heaven
Her class lies late and snores,
While poor black cherubs rise at seven
to do celestial chores.

The black man's ability to survive in this country has, in a large part, been dependent upon his ability to create and appreciate humor. "The Calling of Names" is a humorous yet poignant portrayal of the black man's attempt to come to grips with his identity through what he has been called and what he wishes to be called.

THE CALLING OF NAMES†

Maya Angelou

He went to being called a Colored man
after answering to "hey nigger,"
Now that's a big jump,
anyway you figger,
 Hey, Baby, Watch my smoke
From colored man to Negro
With the N in caps,
was like saying Japanese

*Maya Angelou, "Letter to an Aspiring Junkie" from *Just Give Me a Cool Drink 'Fore I Die,* Random House, Inc., New York, 1971. Reprinted by permission.

**From *On These I Stand* (1947) by Countee Cullen. Copyright 1925 by Harper & Row, Publishers, Inc.; renewed 1953 by Ida M. Cullen. Reprinted by permission of Harper & Row, Publishers, Inc.

†Maya Angelou, "The Calling of Names" from *Just Give Me a Cool Drink 'Fore I Die,* Random House, Inc., New York, 1971. Reprinted by permission.

instead of saying Japs.
 I mean, during the war
The next big step
Was a change for true
From Negro in caps
to being a Jew.
 Now, Sing Yiddish Mama.
Light, Yellow, Brown
and Dark brown skin,
were o.k. colors to
describe him then,
 He was a Bouquet of Roses.
He changed his seasons
like an almanac,
Now you'll get hurt
if you don't call him "Black."
 Nigguh, I ain't playin' this time.

"The Calling of Names" may seem to be a super-ficial poem, but in fact it contains many profound comments on what it means and has meant to be an Afro-American. Indeed, the very use of the term "Afro-American" sporadically throughout this text and the implied meaning of the concluding line of the preceding poem indicate that the issue is not yet set-tled. Though the poem does not use the term "Afro-American" one may logically infer that it is perhaps the most descriptive term for approximately twenty-two million Americans.

"The Calling of Names" is a brief refresher course for those cognizant of the history of Blacks in this country. "Nigger" is a term which has at least three different meanings both in the past and present. It was and still is used by non-Afro-Americans as a derisive term, though few are now bold enough to use it within striking distance of an American Black. In the past, and even now, it is used by Afro-Americans as a term of contempt for those within the fold literally but outside of it mentally; this is most often expressed in the manner "A nigger ain' s—!" Now as in the past, the term has been used *among* Afro-Americans as a term of endearment as in the con-cluding line of "The Calling of Names."

To be sure, the Afro-American has "changed his seasons/ like an almanac," but not without cause. He has done so in his quest for an identity in a nation which has not only attempted to deny him his past but has also refused to accept him as a first-class citizen. This dilemma is further compounded by the fact that he is still in fact a "Bouquet of Roses"—an admixture of other races. Since he is a hybrid, he has had to go through much pain to gain even a mini-mum healthy respect for self—"From colored man to Negro/ With the N in caps."

Moreover, as "The Calling of Names" indicates, the black man has been forced to evaluate the validity of Christianity which was and still is being perverted to justify the black man's plight. Many Blacks adopted (or were adopted by) Judaism, probably because their plight is similar to that of the *mythical* wandering Jew. Until the creation of Israel, Jews and Blacks were both caught, as it were—to use Nathan Scott's phrasing—in the "Zone of Zero," a no man's land, or, to be more precise, no place where they could be men. Thus, Christianity has lost much of its attractiveness to the black man because many pro-fessed Christians violate the non-violent principles of their religion. In the quest for survival the Mosaic code of "an eye for an eye and a tooth for a tooth" makes more sense to black people. Although it is stated neither implicitly nor explicitly in "The Call-ing of Names," it should be reiterated here that many young Blacks are turning to the Islamic faith which is not a white man's religion.

Finally, in regard to "The Calling of Names," one must observe that the poem touches upon the genera-tion gap—which one must concede as at least a na-tional problem—in that Afro-Americans, depending upon their age range, still refer to themselves as "colored," "Negro," and "Black." The discomfort which may ensue in using the terms incorrectly—which, of course, involves the relationships of the speaker to the audience and the occasion—certainly borders on, if it does not enter, the realm of absurd-ity.

The height of absurdity is that some Blacks have even been led to believe that they are totally responsi-ble for their own plight as is illustrated in Samuel Allen's "View from the Corner." The poem is nar-rated from the viewpoint of a child.

VIEW FROM THE CORNER*

Samuel Allen

Now the things the Negro has GOT to do—
 I looked from my uncle to my dad
Yes, Nimrod, but the trouble with the NEGRO is
 I looked from my dad to my uncle
I know, Joseph, but the FIRST thing the Negro's got to
 do—
 It was confusing. . .

This fellow, the Negro, I thought excitedly,
 must be in a very bad fix—
We'd all have to jump in and help
 —such trouble
 —all these things to do
I'd never HEARD of anybody with so many thing to do
 —GOT to do!

*"View From the Corner" by Samuel Allen, reprinted with per-mission of the author.

I intensely disliked such things
 —go to school, wash you ears, wipe the dishes
And what the NEGRO had to do sounded worse than
 that!
He was certainly in a fix, this Negro, whoever he was.

 I was much concerned as I looked at my uncle
Now the thing the Negro has GOT to do—!

"The Boy Who Painted Christ Black," a short story by John Henrik Clarke, is not narrated by a child, but the boy Aaron Crawford is the central figure of the story. Aaron is able to express his own creative imagination, which appears to be an *extraordinary* rebellion against (white) tradition, in spite of the rigidity and racism of the Muskogee County school system. He can do it in part because he has the support of a strong black male figure. Together they assert their pride and self-esteem.

THE BOY WHO PAINTED CHRIST BLACK*

John Henrik Clarke

He was the smartest boy in the Muskogee County School—for colored children. Everybody even remotely connected with the school knew this. The teacher always pronounced his name with profound gusto as she pointed him out as the ideal student. Once I heard her say: "If he were white he might, some day, become President." Only Aaron Crawford wasn't white; quite the contrary. His skin was so solid black that it glowed, reflecting an inner virtue that was strange, and beyond my comprehension.

In many ways he looked like something that was awkwardly put together. Both his nose and his lips seemed a trifle too large for his face. To say he was ugly would be unjust and to say he was handsome would be gross exaggeration. Truthfully, I could never make up my mind about him. Sometimes he looked like something out of a book of ancient history . . . looked as if he was left over from that magnificent era before the machine age came and marred the earth's natural beauty.

His great variety of talent often startled the teachers. This caused his classmates to look upon him with a mixed feeling of awe and envy.

Before Thanksgiving, he always drew turkeys and pumpkins on the blackboard. On George Washington's birthday, he drew large American flags surrounded by little hatchets. It was these small masterpieces that made him the most talked-about colored boy in Columbus, Georgia. The Negro principal of the Muskogee County School said he would some day be a great painter, like Henry O. Tanner.[3]

For the teacher's birthday, which fell on a day about a week before commencement, Aaron Crawford painted the picture that caused an uproar, and a turning point at the Muskogee County School. The moment he entered the room that morning, all eyes fell on him. Besides his torn book holder, he was carrying a large-framed concern wrapped in old newspapers. As he went to his seat, the teacher's eyes followed his every motion, a curious wonderment mirrored in them conflicting with the half-smile that wreathed her face.

Aaron put his books down, then smiling broadly, advanced toward the teacher's desk. His alert eyes were so bright with joy that they were almost frightening. The children were leaning forward in their seats, staring greedily at him; a restless anticipation was rampant within every breast.

Already the teacher sensed that Aaron had a present for her. Still smiling, he placed it on her desk and began to help her unwrap it. As the last piece of paper fell from the large frame, the teacher jerked her hand away from it suddenly, her eyes flickering unbelievingly. Amidst the rigid tension, her heavy breathing was distinct and frightening. Temporarily, there was no other sound in the room.

Aaron stared questioningly at her and she moved her hand back to the present cautiously, as if it were a living thing with vicious characteristics. I am sure it was the one thing she least expected.

With a quick, involuntary movement I rose from my desk. A series of submerged murmurs spread through the room, rising to a distinct monotone. The teacher turned toward the children, staring reproachfully. They did not move their eyes from the present that Aaron had brought her. . . . It was a large picture of Christ—painted black!

Aaron Crawford went back to his seat, a feeling of triumph reflecting in his every movement.

The teacher faced us. Her curious half-smile had blurred into a mild bewilderment. She searched the bright faces before her and started to smile again, occasionally stealing quick glances at the large picture propped on her desk, as though doing so were forbidden amusement.

"Aaron," she spoke at last, a slight tinge of uncertainty in her tone, "this is a most welcome present. Thanks. I will treasure it." She paused, then went on speaking, a trifle more coherent than before. "Looks like you are going to be quite an artist. . . . Suppose you come forward and tell the class how you came to paint this remarkable picture."

When he rose to speak, to explain about the picture, a hush fell tightly over the room, and the children gave him all of their attention. . . something they rarely did for the teacher. He did not speak at first; he just stood there in front of the room, toying absently with his hands, observing his audience carefully, like a great concert artist.

"It was like this," he said, placing full emphasis on every word. "You see, my uncle who lives in New York

*"The Boy Who Painted Christ Black" by John Henrik Clarke from *American Negro Short Stories*, ed. by John Henrik Clarke, 1966. Reprinted by permission of the author.

3. See the art section of Chapter 1 for information about the painting of Henry O. Tanner.

teaches classes in Negro History at the Y.M.C.A. When he visited us last year he was telling me about the many great black folks who have made history. He said black folks were once the most powerful people on earth. When I asked him about Christ, he said no one ever proved whether he was black or white. Somehow a feeling came over me that he was a black man, 'cause he was so kind and forgiving, kinder than I have ever seen white people be. So, when I painted his picture I couldn't help but paint it as I thought it was.''

After this, the little artist sat down, smiling broadly, as if he had gained entrance to a great storehouse of knowledge that ordinary people could neither acquire nor comprehend.

The teacher, knowing nothing else to do under the prevailing circumstances, invited the children to rise from their seats and come forward so they could get a complete view of Aaron's unique piece of art.

When I came close to the picture, I noticed it was painted with the kind of paint you get in the five and ten cent stores. Its shape was blurred slightly, as if someone had jarred the frame before the paint had time to dry. The eyes of Christ were deep-set and sad, very much like those of Aaron's father, who was a deacon in the local Baptist Church. This picture of Christ looked much different from the one I saw hanging on the wall when I was in Sunday School. It looked more like a helpless Negro, pleading silently for mercy.

For the next few days, there was much talk about Aaron's picture.

The school term ended the following week and Aaron's picture, along with the best handwork done by the students that year, was on display in the assembly room. Naturally, Aaron's picture graced the place of honor.

There was no book work to be done on commencement day and joy was rampant among the children. The girls in their brightly colored dresses gave the school the delightful air of Spring awakening.

In the middle of the day all the children were gathered in the small assembly. On this day we were always favored with a visit from a man whom all the teachers spoke of with mixed esteem and fear. Professor Danual, they called him, and they always pronounced his name with reverence. He was supervisor of all the city schools, including those small and poorly equipped ones set aside for colored children.

The great man arrived almost at the end of our commencement exercises. On seeing him enter the hall, the children rose, bowed courteously, and sat down again, their eyes examining him as if he were a circus freak.

He was a tall white man with solid gray hair that made his lean face seem paler than it actually was. His eyes were the clearest blue I have ever seen. They were the only life-like things about him.

As he made his way to the front of the room the Negro principal, George Du Vaul, was walking ahead of him, cautiously preventing anything from getting in his way. As he passed me, I heard the teachers, frightened, sucking in their breath, felt the tension tightening.

A large chair was in the center of the rostrum. It had been daintily polished and the janitor had laboriously recushioned its bottom. The supervisor went straight to it without being guided, knowing that this pretty splendor was reserved for him.

Presently the Negro principal introduced the distinguished guest and he favored us with a short speech. It wasn't a very important speech. Almost at the end of it, I remember him saying something about he wouldn't be surprised if one of us boys grew up to be a great colored man, like Booker T. Washington.

After he sat down, the school chorus sang two spirituals and the girls in the fourth grade did an Indian folk dance. This brought the commencement program to an end.

After this the supervisor came down from the rostrum, his eyes tinged with curiosity, and began to view the array of handwork on display in front of the chapel.

Suddenly his face underwent a strange rejuvenation. His clear blue eyes flickered in astonishment. He was looking at Aaron Crawford's picture of Christ. Mechanically he moved his stooped form closer to the picture and stood gazing fixedly at it, curious and undecided, as though it were a dangerous animal that would rise any moment and spread destruction.

We waited tensely for his next movement. The silence was almost suffocating. At last he twisted himself around and began to search the grim faces before him. The fiery glitter of his eyes abated slightly as they rested on the Negro principal, protestingly.

"Who painted this sacrilegious nonsense?" he demanded sharply.

"I painted it, sir." These were Aaron's words, spoken hesitantly. He wetted his lips timidly and looked up at the supervisor, his eyes voicing a sad plea for understanding.

He spoke again, this time more coherently. "Th' principal said a colored person have jes as much right paintin' Jesus black as a white person have paintin' him white. And he says . . .'' At this point he halted abruptly, as if to search for his next words. A strong tinge of bewilderment dimmed the glow of his solid black face. He stammered out a few more words, then stopped again.

The supervisor strode a few steps toward him. At last color had swelled some of the lifelessness out of his lean face.

"Well, go on!" he said, enragedly, ". . . I'm still listening."

Aaron moved his lips pathetically but no words passed them. His eyes wandered around the room, resting finally, with an air of hope, on the face of the Negro principal. After a moment, he jerked his face in another direction, regretfully, as if something he had said had betrayed an understanding between him and the principal.

Presently the principal stepped forward to defend the school's prize student.

"I encouraged the boy in painting that picture," he said firmly. "And it was with my permission that he

brought the picture into this school. I don't think the boy is so far wrong in painting Christ black. The artists of all other races have painted whatsoever God they worship to resemble themselves. I see no reason why we should be immune from that privilege. After all, Christ was born in that part of the world that had always been predominantly populated by colored people. There is a strong possibility that he could have been a Negro."

But for the monotonous lull of heavy breathing, I would have sworn that his words had frozen everyone in the hall. I had never heard the little principal speak so boldly to anyone, black or white.

The supervisor swallowed dumbfoundedly. His face was aglow in silent rage.

"Have you been teaching these children things like that?" he asked the Negro principal, sternly.

"I have been teaching them that their race has produced great kings and queens as well as slaves and serfs," the principal said. "The time is long overdue when we should let the world know that we erected and enjoyed the benefits of a splendid civilization long before the people of Europe had a written language."

The supervisor coughed. His eyes bulged menacingly as he spoke. "You are not being paid to teach such things in this school, and I am demanding your resignation for overstepping your limit as principal."

George Du Vaul did not speak. A strong quiver swept over his sullen face. He revolved himself slowly and walked out of the room towards his office.

The supervisor's eyes followed him until he was out of focus. Then he murmured under his breath: "There'll be a lot of fuss in this world if you start people thinking that Christ was a nigger."

Some of the teachers followed the principal out of the chapel, leaving the crestfallen children restless and in a quandary about what to do next. Finally we started back to our rooms. The supervisor was behind me. I heard him murmur to himself: "Damn, if niggers ain't getting smarter."

A few days later I heard that the principal had accepted a summer job as art instructor of a small high school somewhere in south Georgia and had gotten permission from Aaron's parents to take him along so he could continue to encourage him in his painting.

I was on my way home when I saw him leaving his office. He was carrying a large briefcase and some books tucked under his arm. He had already said good-by to all the teachers. And strangely, he did not look brokenhearted. As he headed for the large front door, he readjusted his horn-rimmed glasses, but did not look back. An air of triumph gave more dignity to his soldierly stride. He had the appearance of a man who had done a great thing, something greater than any ordinary man would do.

Aaron Crawford was waiting outside for him. They walked down the street together. He put his arms around Aaron's shoulder affectionately. He was talking sincerely to Aaron about something, and Aaron was listening, deeply earnest.

I watched them until they were so far down the street that their forms had begun to blur. Even from this distance I could see they were still walking in brisk, dignified strides, like two people who had won some sort of victory.

Imamu Amiri Baraka (LeRoi Jones), poet, playwright, political activist, has written only one novel. *The System of Dante's Hell* (1965) is in some ways a parody[4] of Dante's *Inferno,* as well as a semi-autobiographical novel. Baraka used the framework of the *Inferno* as a skeleton on which to hang the recollections of his childhood and adolesence in Newark, his experiences in the Air Force in the South, and aspects of his life in New York. There is very little traditional narrative in the book. One critic, Emile Capouya, suggests that the "episodes of 'The System of Dante's Hell' tend to be representations of states of mind and states of soul. . . . Especially in the earlier portions of the novel, the author's method is less novelistic than lyrical—fragmentary, allusive, private. The general theme is developed in static set-pieces whose sign is one or another of the Dantean categories: incontinence, violence, fraud, treachery and their subdivisions. . . ."[5]

Dante's *Divine Comedy,* an allegory[6] of a human soul's journey through hell and purgatory and finally on to heaven, was written in three volumes: Hell (Inferno), Purgatory (Purgatorio), Heaven (Paradiso). In his epic poem, Dante with his guides—first Virgil (Human Reason), then Beatrice (Theology)—journeys through the circles of hell, observing the torment and punishment of the dead souls. He is instructed and purified by what he sees or what his guide(s) tell him. The poet's experience is a way of preparing for death and life after death, a great concern of people during the Middle Ages when the poem was written (ca. 1307-1321).

Baraka uses the *system,* that is, the method of the *Inferno* although his "soul" never ascends to heaven, nor does he (the poet) have a guide. It is a function of the black experience in America that the black man is forced to make the journey alone through the hell of America. Baraka's journey is a secular rather than a religious allegory, and his experiences only roughly parallel the Italian poet's (see diagram). While Dante rejects Latin, the language of the educated, and writes in the Italian vernacular,

4. Parody—imitation, sometimes humorous, of a particular form or style of writing.

5. *New York Times* Book Review, Nov. 28, 1965, p. 4.

6. Allegory—an extended symbolic narrative with a didactic (instructional) purpose.

154

Baraka rebels against the use of English, the language of the oppressor (white). His discontent and impatience with the language is implicit in his highly individualized use of symbols, punctuation and spelling.

In the following excerpt which concludes the book and clearly states the theme, some examples of his technique can be seen:

1. words and phrases shortened: wdn't for wouldn't; cdn't for couldn't; wd for would; cd for could; wheeld for wheeled; thot for thought—all appear elsewhere throughout the novel
2. symbols used to replace words or parts of words: w/love for with love; the symbol & for **and, used elsewhere throughout the book**
3. sentences often elliptical or cryptic, at times without subject or verb: "Your definitions." "The flame of social dichotomy." "Split open down the center."

Of course, Baraka is a poet, and the novel is more easily understood if read as an extended poem written in poetic prose. The whole "poem" develops three levels of hell for the audience to find its way through: Dante's hell, created for people he wanted punished; the hell which the poet has endured—black life in America; and the hell he has created for the reader, peopled with his enemies (and himself) in torment.*

What is hell? Your definitions.

I am and was and will be a social animal. Hell is definable only in those terms. I can get no place else; it wdn't exist.

Hell in this book which moves from sound and image ("association complexes") into fast narrative is what vision I had of it around 1960-61 and that fix on my life, and my interpretation of my earlier life.

Hell in the head.

The torture of being the unseen object, and, the constantly observed subject.

The flame of social dichotomy. Split open down the center, which is the early legacy of the black man unfocused on blackness. The dichotomy of what is seen and taught and desired opposed to what is felt. Finally, God, is simply a white man, a white "idea," in this society, unless we have made some other image which is stronger, and can deliver us from the salvation of our enemies.

For instance, if we can bring back on ourselves, the absolute pain our people must have felt when they came onto this shore, we are more ourselves again, and can begin to put history back in our menu, and forget the propaganda of devils that they are not devils.

* * * * *

Hell is actual, and people with hell in their heads. But the pastoral moments in a man's life will also mean a great deal as far as his emotional references. One thinks of home, or the other "homes" we have had. And we remember w/love those things bathed in soft black light. The struggles away or towards this peace is Hell's function. (Wars of consciousness. Antithetical definitions of feeling(s).

Once, as a child, I would weep for compassion and understanding. And Hell was the inferno of my frustration. But the world is clearer to me now, and many of its features, more easily definable.

The following excerpt is from Ishmael Reed's second novel, *Yellow Back Radio Broke-Down* (1969). Reed calls it a hoo-doo novel. It is a satire on almost every institution in our society from home, family, church(es) to the All-American Cowboy hero. Reed, however, reverses the images: the white-hatted (and white-skinned) cowboy, Drag Gibson, is the epitome of evil, while the black (satanic) cowboy, Loop Garoo, becomes the real hero. This section is the opening of the book where the author introduces his characters in the voice of a circus barker, calling us into the carnival world of Yellow Back Radio, a place in which we all live. Loop is described much like the "bad man" character of black folklore, and you can recognize Reed's use of the traditional, yet little known black cowboy, so long unmentioned in our history books. Ishmael Reed's rebellion is against most of the traditions that the dominant society holds dear.

THE LOOP GAROO KID
GOES AWAY MAD*

Ishmael Reed

Folks. This here is the story of the Loop Garoo Kid. A cowboy so bad he made a working posse of spells phone in sick. A bullwhacker so unfeeling he left the print of winged mice on hides of crawling women. A desperado so onery he made the Pope cry and the most powerful of cattlemen shed his head to the Executioner's swine.

A terrible cuss of a thousand shivs he was who wasted whole herds, made the fruit black and wormy, dried up the water holes and caused people's eyes to grow from tiny black dots into slapjacks wherever his feet fell.

Now, he wasn't always bad, trump over hearts diamonds and clubs. Once a wild joker he cut the fool before bemused Egyptians, dressed like Mortimer Snerd and spilled french fries on his lap at Las Vegas' top of the strip.

Booted out of his father's house after a quarrel, whores snapped at his heels and trick dogs did the fandango on his belly. Men called him brother only to cop his coin and tell malicious stories about his cleft foot.

* * * * *

Born with a caul over his face and ghost lobes on his ears, he was a mean night tripper who moved from town to town quoting Thomas Jefferson and allowing bandits to build a flophouse around his genius.

A funny blue hippo who painted himself with water flowers only to be drummed out of each tribe dressed down publicly, his medals ripped off.

* * * * *

Finally he joined a small circus and happily performed with his fellow 86-D—a Juggler a dancing Bear a fast talking Barker and Zozo Labrique, charter member of the American Hoo-Doo Church.

Their fame spread throughout the frontier and bouquets of flowers greeted them in every town until they moved into that city which seemed a section of Hell chipped off and shipped upstairs, Yellow Back Radio, where even the sun was afraid to show its botton.

* * * * *

Some of the wheels of the caravan were stuck in thick red mud formed by a heavy afternoon downpour. The oxen had to be repeatedly whipped. They had become irritable from the rain which splashed against their faces. In the valley below black dust rose in foreboding clouds from herds of wild horses hitched to Zozo Labriques covered wagon.

Those were some dangerous stunts you did in the last town, boy, bucking those killer broncos like that. A few more turns with that bull and you would have been really used up. Why you try so hard?

She sent me a letter in the last town, Zozo. She wants me to come to her. The old man spends his time grooming his fur and posing for non-academic painters. He's more wrapped up in himself than ever before and the other one, he's really gone dipso this time. Invites winos

up there who pass the bottle and make advances on her. Call her sweet stuff and honey bun—she's really in hard times. She's a constant guest in my dreams Zozo, her face appears the way she looked the night she went uptown on me.

Serves her right Loop, the way she treated you. And that trash she collected around her. They were all butch. As soon as she left, zoon they were gone. And that angel in drag like a john, he gave her the news and showed her her notices—right off it went to her head. When she humiliated you—that emboldened the others to do likewise. Mustache Sal deserted you and Mighty Dike teamed up with that jive fur trapper who's always handing you subpoenas. You know how they are, Loop, you're the original pimp, the royal stud—soon as a botton trick finds your weakness your whole stable will up and split.

I let her open my nose Zozo. I should have known that if she wasn't loyal to him with as big a reputation as he had—I couldn't expect her to revere me. What a line that guy had. A mitt man from his soul. And her kissing his feet just because those three drunken reporters were there to record it. Ever read their copy on that event Zozo? It's as if they were all witnessing something entirely different. The very next night she was in my bunk gnashing her teeth and uttering obscenities as I climbed into her skull.

She got to your breathing all right Loop. Even the love potions you asked me to mix didn't work, the follow-me-powder. Her connaissance was as strong as mine.

* * * * *

Zozo Labrique lit a corncob pipe. She wore a full skirt and bandanna on her head. Her face was black wrinkled and hard. The sun suddenly appeared, causing the gold hoops on her ears to sparkle.

Jake the Barker rode up alongside the wagon.

Well Loop, Zozo, won't be long now. Maybe thirty minutes before we pull into Yellow Back Radio. We're booked by some guy named Happy Times, who we're to meet at the Hotel.

Jake rode down the mountain's path to advise the rest of the troupe.

This was a pretty good season Loop, what are you going to do with your roll?

O I don't know Zozo, maybe I'll hire some bounty hunters to put a claim on my lost territory.

O Loop quit your joking.

What are you going to do Zozo?

* * * * *

Think the old bag will head back to New Orleans, mecca of Black America. First Doc John kicked out then me—she got her cronies in City Hall to close down my operation. We had to go underground. Things started to disappear from my humfo—even my Henry snake and mummies appeared in the curtains. She warned my clients that if they visited me she'd cross them. Everybody got shook and stayed away. Finally she laid a trick on me so strong that it almost wasted old Zozo, Loop. That Marie is a mess. Seems now though my old arch enemy is about to die. Rumor has it that the daughter is going to take over but I know nothing will come of that fast gal. Nobody but Marie has the type of connaissance to make men get down on their knees and howl like dogs and women to throw back their heads and cackle. Well . . . maybe your old lady, Loop, what's the hussy's name?

Diane, Black Diane, Zozo, you know her name.

Sometimes its hard to tell, Loop, the bitch has so many aliases.

Before their wagon rounded the mountain curve they heard a gasp go up on the other side. A dead man was hanging upside down from a tree. He had been shot.

He wore a frilled ruffled collar knee britches a fancy shirt and turned up shoes. A cone shaped hat with a carnation on its rim had fallen to the ground.

The two climbed down from the wagon and walked to where Jake the Barker and the Juggler were staring at the hanging man. The dancing Bear watched from his cage, his paws gripping the bars, his head swinging from side to side with curiosity. Handbills which had dropped from the man's pockets littered the ground about the scene.

Plug in Your Head
Look Here Citizens!!
Coming to Yellow Back Radio
Jake the Barker's lecture room
New Orleans Hoodooine Zozo Labrique
Amazing Loop Garoo lariat tricks
Dancing Bear and Juggler too
Free Beer

Above the man's head on the hoodoo rock fat nasty buzzards were arriving. Jake removed his hat and was surrounded by members of the bewildered troupe.

Nearest town Video Junction is about fifty miles away. There's not enough grub in the chuck wagon to supply us for a journey of that length. Besides the horses and oxen have to be bedded down. I wouldn't want any of you to take risks. If this means danger up ahead maybe we should disband here, split the take and put everybody on his own.

* * * * *

We've come this far Jake, and may as well go on into Yellow Back Radio, the Juggler said.

Count me in too, Loop said, we've braved alkali, coyotes, wolves, rattlesnakes, catamounts, hunters. Nothing I'm sure could be as fierce down in that town—why it even looks peaceful from here.

I'll go along with the rest, Zozo said. But I have a funny feeling that everything isn't all right down there.

After burying the advance man on a slope they rode farther down the mountain until finally, from a vantage point, they could see the rest of Yellow Back Radio.

The wooden buildings stood in the shadows, The Jail House, the Hat and Boot Store the Hardware store the Hotel and Big Lizzy's Rabid Black Cougar Saloon.

Sinister hogs with iron jaws were fenced in behind the scaffold standing in the square. They were the swine of the notorious Hangman, who was such a connoisseur of his trade he kept up with all the latest techniques of murder.

A new device stood on the platform. Imported from France, it was said to be as rational as their recent revolution. The hogs ate the remains of those unfortunate enough to climb the platform. Human heads were particularly delectable to these strange beasts.

The troupe drove through the deserted main street of the town. Suddenly they were surrounded by children dressed in the attire of Plains Indians. It appeared as if cows had been shucked and their skins passed to the children's nakedness for their shoes and clothes were made of the animals' hides.

Reach for the sky, whiskey drinkers, a little spokesman warned. One hundred flintlocks were aimed at them.

Hey it's a circus, one of the children cried, and some dropped their rifles and began to dance.

A circus? one of the boys who made the warning asked. How do we know this isn't a trap sprung by the cheating old of Yellow Back Radio?

Jake the Barker, holding up his hands, looked around to the other members of the troupe. Amused, Loop, Zozo and the Juggler complied with the little gunmen's request.

What's going on here? Jake asked. We're the circus that travels around this territory each season. We're supposed to end the tour in your town.

We're invited by Mister Happy Times. We're to meet him at the Hotel. Where are the adults? The Marshal, the Doctor, the Preacher, or someone in charge?

Some of the children snickered, but became silent when their spokesman called them into a huddle. After some haggling, he stepped towards the lead wagon upon which Jake the Barker rode.

We chased them out of town. We were tired of them ordering us around. They worked us day and night in the mines and made us herd animals, harvest the crops and for three hours a day we went to school to hear teachers praise the old. Made us learn facts by rote. Lies really bent upon making us behave. We decided to create our own fiction.

One day we found these pearl-shaped pills in a cave of a mountain. They're what people ages ago called devil's pills. We put them in the streams so that when the grown-ups went to fill their buckets they swallowed some. It confused them more than they were so we moved on them and chased them out of town. Good riddance. They listened to this old Woman on the talk show who filled their heads with rot. She was against joy and life the decrepit bag of sticks, and she put them into the same mood. They always demanded we march and fight heathens.

Where are the old people now? Jake asked.

* * * * *

They're camped out at Drag Gibson's spread. We think they're preparing to launch some kind of invasion but we're ready for them. Drag just sent his herd up the Chisolm to market yesterday but there are enough cowpokes left behind to give us a good fight. Our Indian informant out at Drag's spread tells us the townspeople haven't given in to Drag's conditions yet. He wants them to sign over all of their property in exchange for lending his men to drive us out.

Then he will not only rule his spread which is as large as Venezuela but the whole town as well. He's the richest man in the valley, with prosperous herds, abundant resources and an ego as wide as the Grand Canyon.

This nonsense would never happen in the Seven Cities of Cibola, Jake the Barker said.

The Seven Cities of Cibola? the children asked, moving in closer to Jake's wagon.

Inanimate things, computers do the work, feed the fowl, and programmed cows give cartons of milkshakes in 26 flavors.

Yippppeeeeee, the children yelled. Where is it?

* * * * *

It's as far as you can see from where you're standing now. I'm going to search for it as soon as the show is over here but since there is no sponsor to greet us we may as well disband now, Jake said, looking about at the other members of the troupe.

Why don't you entertain us? the children asked.

It's a plot. We decided that we wouldn't trust anybody greying about the temples anymore!

O don't be paranoid, silly, another child replied to the tiny skeptic. Always trying to be the leader just like those old people we ran into the hills. These aren't ordinary old people they're children like us—look at their costumes and their faces.

Let's have the circus, a cry went up.

Well I don't know—you see we have no leaders holy men or gurus either so I'd have to ask the rest of the troupe.

Loop, Zozo and the Juggler said yes by nodding their heads. The Bear jumped up and down in his chains.

* * * * *

Delighted, the children escorted the small circus group to the outskirts of Yellow Back Radio where they pitched the tents, bedded down the weary horses and oxen and made preparations for the show.

* * * * *

Three horsemen—the Banker, the Marshal and the Doctor—decided to pay a little visit to Drag Gibson's ranch. They had to wait because Drag was at his usual hobby, embracing his property.

A green mustang had been led out of its stall. It served as a symbol for his streams of fish, his herds, his fruit so large they weighed down the mountains, black gold and diamonds which lay in untapped fields, and his barnyard overflowing with robust and erotic fowl.

Holding their Stetsons in their hands the delegation looked on as Drag prepared to kiss his holdings. The ranch hands dragged the animal from his compartment towards the front of the Big Black House where Drag bent over and french kissed the animal between his teeth, licking the slaver from around the horse's gums.

This was a lonely horse. The male horses avoided him because they thought him stuck-up and the females because they thought that since green he was queer. See, he had turned green from old nightmares.

After the ceremony, the unfortunate critter was led back to his stall, a hoof covering his eye.

Drag removed a tube from his pocket and applied it to his lips. He then led the men to a table set up in front of the House. Four bottles of whiskey were placed on the table by Drag's faithful Chinese servant, who picked a stray louse from Drag's fur coat only to put it down the cattleman's back. Drag smiled and twitched a bit, slapping his back until his hand found the bullseye. Killing the pest, he and the servant exchanged grins.

Bewildered, the men glanced at each other.

What brings you here? I told you to come only if you were ready for business. Sign the town and your property over to me so that my quest for power will be satisfied. If you do that I'll have my men go in there and wipe them menaces out.

* * * * *

We decided to give in, Drag. Why, we're losing money each day the children hold the town and we have to be around our wives all the time and they call us stupid jerks, buster lamebrain and unpolite things like that. It's a bargain, Drag. What do we do now?

Now you're talking business Doc. Sign this stiffy-cate which gives me what I asked for and I'll have them scamps out of your hair in no time.

Drag brought forth an official looking document from inside his robe, to which the Banker, Marshal and Doctor affixed their signatures.

It's a good thing we got the people to see it your way, the Banker said, wiping the sweat on his forehead with a crimson handkerchief. Some reinforcements were arriving today. They were in some wagons that was painted real weird and we hanged and shot one who was dressed like a clown. We thought they might be heathens from up North, you dig?

You mulish goofies, that was the circus I ordered to divert the kids so's we could ambush them. Any damned fool knows kids like circuses.

Drag we're confused and nervous. Just today four boxes of drexol were stolen from our already dwindling supply of goods. That's why we didn't think when we killed that man. The old people are wandering around the camp building into each other they're so tightened up. All day people are saying hey stupid idiot watch where you're going. It's a mad house.

And the preacher Rev. Boyd, he's in the dumps in a strong and serious way this time. You know how hard he tried with the kids and the town's heathen, how he'd smoke hookahs with them brats and get stoned with Chief Showcase the only surviving injun and that volume of hip pastorale poetry he's putting together, Stomp Me O Lord. He thought that Protestantism would survive at least another month and he's tearing up the Red-Eye and writing more of them poems trying to keep up with the times. Drag you know how out of focus things are around here. After all Drag it's your world completely now.

How can you be so confident your men can take care of them varmits Drag? It takes a trail boss a dozen or so cowboys and a wrangler to get the herd North. You can't have many cowpokes left behind. Don't get me wrong I'm not afraid for myself cause I rode with Doc Holiday and the Dalton Boys before I went peace officer—I have handled a whole slew of punks passing through the hopper in my day . . . why if I hadn't been up the creek at the Law Enforcement Conference it wouldn't have happened anyway.

* * * * *

You always seem to be at some convention when the town needs you Marshal, Drag said, looking into a hand mirror and with a neckerchief wiping the smudges of mascara that showed above his batting lashes.

Drag, the women folk, well you know how women are, what strange creatures they be during menopause. They're against us wiping out the kids. That's one of the reasons we didn't cast lots quicker to give you the hand over of Yellow Back Radio, so that you could adjust all the knobs and turn to whatever station you wished. Anyway we tried to get Big Lizzy to talk to them but they don't recognize her as one of their own.

Pshaw, don't worry about the women Doc, Drag Gibson said, bringing his old fat and ugly frame to its feet. Start appeasing them and pretty soon they'll be trying to run the whole show like that kook back in Wichita who campaigned to cut out likker. Now quit your whining and get back to camp and see after them townsfolk. Leave the job up to me.

The dignitaries rose and tumbled down the hill. The Banker rolled over a couple of times as Drag stood jerking his shoulders and with one finger in his ear as pellet after pellet flew over the Marshal's, Banker's and Doc-

tor's heads. He relaxed, drank a glass of rotgut and give the appearance of a statesman by returning to his book *The Life of Catherine the Great.* As soon as the delegation disappeared, he slammed the book shut and called his boys.

Get in here cowpokes, we're in business.

Skinny McCullough the foreman followed by some cowhands rushed onto the lawn and surrounded their boss.

Chinaboy! Chinaboy! Bring me that there package.

The Chinese servant rushed into the scene with his arms weighed down with a bundle.

O.K. men, Drag said, this is the opportunity we've been waiting for. They signed the town over to me, the chumps, haw haw.

He opened the package and placed its contents on the table.

This a brand new revolving cylinder. It has eight chambers. A murderer's dream with a rapid firing breech-loading firearm.

* * * * *

The cowpoke's eyes lit up and foam began to form around their lips.

It was invented by a nice gent lecturer named Dr. Coult of New York London and Calcutta. Just bought it from Royal Flush Gooseman, the shrewd, cunning and wicked fur trapper, the one who sold them injuns those defected flintlocks allowing us to wipe them out.

The kids are down there with a circus I booked under a pseudonym. I been watching them through my long glass. Now get busy and before you know it Drag Gibson will be the big name in Yellow Back Radio then Video Junction then va-va-voom on to the East, Heh heh heh.

The cowpokes from Drag Gibson's Purple Bar-B drank some two-bits-a-throw from a common horn and armed with their shiny new weapons headed towards the outskirts of Yellow Back Radio on their nefarious mission.

* * * * *

The Dancing Bear, the Juggler, Loop and Zozo entertained the children far into the night. The Dancing Bear did acrobatic feats with great deftness, Loop his loco lariat tricks, and Zozo read the children's palms and told their fortunes.

Finally Jake the Barker gathered them near the fire to tell of the Seven Cities of Cibola, magnificent legendary American paradise where tranquilized and smiling machines gladly did all of the work so that man could be free to dream. A paradise whose streets were paved with opals from Idaho, sapphire from Montana, turquoise and silver from the great Southwest:

In the early half of the sixteenth century about 1528 an expedition which included the black slave Estevanico landed at Tampa Bay. He and his companions were lost trapped and enslaved by Indians. Other expeditions also vanished mysteriously. Legend has it that the city can only be found by those of innocent motives, the young without yellow fever in their eyes.

Stupid historians who are hired by the cattlemen to promote reason, law and order—toad men who adore facts—say that such an anarchotechnological paradise where robots feed information into inanimate steer and mechanical fowl where machines do everything from dig irrigation ditches to mine the food of the sea help old ladies across the street and nurture infants is as real as a green horse's nightmare. Shucks I've always been a fool, eros appeals more to me than logos. I'm just silly enough to strike out for it tomorrow as soon as the circus splits up.

A place without gurus monarchs leaders cops tax collectors jails matriarchs patriarchs and all the other galoots who in cahoots have made the earth a pile of human bones under the feet of wolves.

Why don't we all go, the children shrieked.

Wait a minute, Jake said, we don't have enough supplies for the trip. It lies somewhere far to the south.

That's no task, supplies, one of the children said.

After huddling together they all started into the town, leaving the troupe behind. Finally having had a loot-in on the Hat and Boot Store, the Feed store and the Bank they returned with enough supplies to make the long journey.

I guess I can't argue against that, Jake said turning to Loop, Zozo and the Juggler. Welcome to my expedition into the unknown.

The children reveled and danced around.

* * * * *

When they finished storing provisions into the wagons the entire party went to sleep. The next morning there would be much work to do. The troupe bedded down in their wagons and the children slept beneath warm buffalo robes.

* * * * *

Loop Garoo was dreaming of bringing down the stars with his tail when all at once he smelled smoke. He awoke to find horsemen surrounding the circle. The children began to scream and some of their clothes caught fire from torches the bandits had tossed into the area. Rapid gunfire started up and the children fell upon each other and ran about in circles as they tried to break the seizure's grip. Zozo Labrique looked out of her wagon and was shot between the eyes. She dropped to the ground next to the wagon. The pitiful moans of the children could be heard above the din of hoof-beats and gunfire as one by one they were picked off by horsemen who fired with amazing accuracy. The Juggler was firing two rifles and before catching a bullet in his throat was able to down two of the horsemen.

Loop crawled to the place where Zozo lay dying. Blood trickled from her nose and mouth.

* * * * *

Zozo let me see if I can get you inside your wagon.

Flee boy, save yourself, I'm done for, the woman murmured pressing something into his hand. It's a mad dog's tooth it'll bring you connaissance and don't forget the gris gris, the mojo, the wangols old Zozo taught you and when you need more power play poker with the dead.

But Zozo I'll try to get you a horse, Loop began—but with a start the woman slumped in his arms.

The grizzly Bear had escaped from the cage and was mangling two horsemen. This allowed an opening in the circle which two children raced through, hanging from the sides of horses. Loop did likewise but so as to divert the men from the children rode in a different direction, towards the desert.

Bullet after bullet zitted above his head. When the burning scene of children and carny freaks was almost out of his sight he looked back. His friends the Juggler, a dancing bear, the fast talking Barker and Zozo Labrique were trapped in a deadly circle. Their figurines were beginning to melt.

Despite the negative tone of much of the poetry in Chapter 6, it is not devoid of hope. "Heal Our History" by Sarah Fabio suggests the underlying theme of *Humanities through the Black Experience.*

HEAL OUR HISTORY*
for Andy and Amy
Sarah Webster Fabio

Black youth, painfully embittered,
put down our "Great Society," our
advanced civilization, dub it a
junkyard heaped high with mass
produced, self diminishing things,
skylighted by the insubstantial
dream of the brotherhood of man.

And it is our charge to relieve
their pain, to help them to believe
again that those heretofore unrealized
concepts on which we founded our land
live today and bind us to a common cause.

Their dark wails rise from the
ghetto bowels of our great robot world,
whip like lashes the sleeping American
conscience, opens up the 300 year-old
festering sore of a hate-induced violence.

We human beings are time machines
and much, much more. We need the courage
to relive and forgive a hateful past,
to balance the book of heavy deeds
and then move on.

Our untended wounds are gangrene bound.
A skilled surgeon's sharp scalpel can
cleanse away the damaged tissue to
start new growth. There is no time

in our jet-age world for quacks and
their quick-cure schemes. Now, at
all costs, we must heal our history.
Or else, our future rots in the
disease of our past.

Rebellion Against Tradition in the Arts

This section can alternately be entitled "The Blackstream versus the Mainstream in the Arts," for in the art world there is also an *establishment*—white critics, major museums and commercial art galleries—which dictates artistic standards. The first rebellion against white tradition in the arts occurred in the 1920s during a period of black awareness and cultural rejuvenation activated by the "New Negro," the Harlem Renaissance. Black writers, poets, dancers and later visual artists concentrated on themes relating to and portraying black lifestyles, black American history, and the African cultural heritage. Langston Hughes, a writer, and his contemporaries were rebels. They told the white audience (and "white is right" thinking Blacks) that if they disapproved of what Blacks were doing artistically, that was their problem![7]

The Harlem Renaissance did not last nor were all of its ideals realized. During the past several decades Blacks have not achieved the "American Dream" of total entry into the Mainstream, although there was hope during the early fifties with the Supreme Court decision to desegregate America. That decision did attempt to change the laws, but perhaps could not change men's hearts. Total integration has not been achieved nor the promise of freedom and justice fulfilled for all black people through the legal system; neither peaceful/non-violent demonstrations of protest such as the March on Washington in 1963 nor the bloody riots of the latter 1960s ushered in drastic changes. America did, however, discover through the violent demonstrations that here was a "New Negro" who was determined to take his rightful place as a first class citizen in the country he and his ancestors had helped to build. Included in his rights are the right to self-determination and the right to be proud of his blackness. He, too, wants recognition for those men and women of his race who contributed to the scientific and humanistic development of his country, and recognition of his pre-slavery African cultural heritage. In other words, Negro History Week (now called Black History Week) was not to be just a few days set aside during the year to recognize

*Sarah Webster Fabio, "Heal Our History" from *Soul Ain't: Soul Is,* Phase II Publishers, 1973. Reprinted by the kind permission of the author.

7. Langston Hughes, "The New Negro and the Racial Mountain," *Nation,* June 23, 1926.

and honor Blacks, but a way of life. Thus, there was a renewal of the Renaissance in the 1960s.

Where were black artists during this period? They, too, have taken part in the struggle and have brought attention to their own peculiar problems as black artists. In an effort to enter the Mainstream art world many of them have attempted to flow with the tide of modern aesthetic alternatives—abstract expressionism, surrealism, Pop, and Op art, minimal, Magic Realism, light art—and a precious few have been successful. Their works have been exhibited in establishment museums and commercial art galleries. But, not all artists create in an abstract, non-representational style. There are many black artists who believe that black is not merely the color of one's skin, but must also be reflected in one's creative expressions. It is this group which, more than the former, has discovered that the Mainstream art world is not color blind when it comes to an artist's skin or the racial content of his artistic expression. Black artists have had to demand space in the major public-sponsored museums; they have marched in picket lines, as Blacks did around lunch counters in drugstores in the early sixties, in order to have their works shown and to be active participants in the selection of works to be exhibited. Their efforts received brief attention. There were special exhibitions of their works in establishment museums; and whatever their comments, white critics wrote about the productions of black artists in the standard art journals. Commercial art galleries, concerned with making money, made black artists the current fad. Fads, being what they are, eventually run their course. Black artists who were suddenly visible became invisible again, with the same speed.

Followers of the Mainstream

There is a division not only between the Mainstream and the Blackstream, but between the black followers of the Mainstream and those of the Blackstream. The artists cannot be divided into equal groups, nor has any particular artist remained on either side permanently. The artist has often created social commentary in very graphic terms and moved on, sometimes to repeat a message but in more subtle, often elegant terms.

Circumstances or conditions often dictate the direction an artist or group of artists will take. Because the foundation of formally trained black American artists has been firmly rooted in the Mainstream,[8] it is natural that most will adopt the prevailing style. For example, most black artists matured or maturing during the 1950s, came under the influence of ab-

stract expressionism,[9] which was America's (New York "school") gift of a new style and an aesthetic alternative in modern art. Some Blacks were contemporaries of the artists who pioneered and propagated the new style; others studied with them as students in art schools. It was still the fifties, a time when a racially integrated America was on the horizon and the majority of black people believed in integration. The universality of the style seemed to promise non-white participation because of its essentially non-racial nature.

The survey which follows is limited to the best known black advocates of abstract and abstract expressionist styles. They represent the few black artists who have succeeded in this manner of artistic expression in Mainstream exhibitions and permanent collections.

Hale Woodruff (b. 1909) was a mature, established artist/teacher during the advent of abstract expressionism. Having studied at the John Herron Institute of Art in Indianapolis, he went to Paris in 1927; there he attended an art academy and collected the first pieces of his now extensive collection of African art while absorbing the academy's still cubism-influenced atmosphere. He returned to the United States

8. Hale Woodruff, "Preface" to *Ten Negro Artists from the United States,* 1966, exhibition catalog for the First World Festival of Negro Arts, Dakar, Senegal. The exhibition was sponsored and produced by the United States Committee for the First World Festival of Negro Arts, Inc., and the National Collection of Fine Arts' Smithsonian Institution, Washington, D.C. The artists selected for this exhibition were Barbara Chase (Riboud), Emilio Cruz, Sam Gilliam, Richard Hunt, Jacob Lawrence, William Majors, Norma Morgan, Robert Reid, Charles White, and Todd Williams. The exhibition came under attack (then and later) because most of the artists' works were abstract or non-representational/non-racial identification styles. In his remarks, Woodruff discusses the Mainstream background of the artists.

9. Abstract expressionism or "action painting" as a term applied to American painters has been in use since 1946. Action painting, as it is commonly called from a phrase coined by Harold Rosenberg, is a method of producing "relatively fortuitous and completely abstract effects in paint." The artist begins by applying paint(s) with violent action—pouring, splashing, slapping—to the canvas which is usually laid flat. The initial effects are accidental but from this point on, the artist consciously controls the composition. See Mervin Levy, ed. *The Pocket Dictionary of Art Terms* (Greenwich, Connecticut: New York Graphic Society), 1961 and later editions.

It was pioneered by American artist Jackson Pollock (1912-1956) and contributions to the method/style were made by a diverse group of individuals associated with the "New York School": Willem de Kooning (b. 1904); Jack Tworkov (b. 1900); Franz Klein (1910-1962); Robert Motherwell (b. 1915); Clyfford Still (b. 1904); Adolph Gottlieb (b. 1903); Ad Reinhardt (1913-1967); Philip Guston (b. 1913); Conrad Marca-Relli (b. 1913); Barnett Newman (1905-1970); Mark Tobey (1890-1976); and William Baziotes (1912-1963).

in 1931 and began a long teaching career at Atlanta University and later New York University from which he retired as a professor emeritus. While still a young man, he spent a summer studying fresco painting in Mexico with Diego Rivera. During 1937-38 he demonstrated his facility in this medium in the Amistad Slave Mutiny murals at Talladega College, Alabama. In 1945 he held his first one-man exhibition at the International Print Society. He has been flexible, constantly growing and absorbing various art currents, as seen in his southern landscapes in the manner of Cezanne, *genre* in the cubist/neo-primitive style, "social commentary" (on black lynchings and poverty, particularly in the thirties) in a style influenced by both the Mexican muralists and German expressionists, and finally abstract expressionism.

"Land of Many Moons" (fig. 6.1) is one of Woodruff's early paintings in the new style. A work of 1954, it is tentative; gentle, flowing, free-form patches of color float on the horizon. It seems to be landscape viewed simultaneously from above and at ground level. "Ancestral Memory," a later work of 1967, may suggest the influence of Willem de Koon-ing's "Woman" series which began in the 1950s. Woodruff creates a stylized African mask out of the broad bands of color applied vertically on the canvas. The calligraphy across the top and right side can be read as an African motif. The forms recall the symbols in relief found on Ashanti (Ghana) gold-weights. These stylized symbols recur as a proper motif in "Celestial Gate" (color slide). Whereas inspiration for Franz Klein's bold, broad slashes of black line across the canvas was oriental calligraphy, for Woodruff it is African design. He has personalized the style to express his own interests and inspirations.

Alma Thomas (b. 1896) was already a mature artist in the decade of the fifties. She, too, came under the influence of abstract expressionism as evidenced by "Tenement Scene, Harlem," of 1959 (fig. 6.2). It manifests the energetic brushwork which characterizes so much of this particular expressionist style. However, her choice of colors subdues the impact of the brush work; the patches of blue, green and orange are grayed and confined to specific areas encased in rough-edged brownish to black lines. A slash of red advances from the lower center of the pain-

Figure 6.1. Hale Woodruff, "Land of Many Moons." 1954 (destroyed), oil on canvas. From American Negro Art by Cedric Dover, 1969. New York Graphic Society. Reprinted by permission of Hale Woodruff.

Figure 6.2. Alma Thomas, "Tenement Scene, Harlem." 1959, oil on canvas. Courtesy of Mr. Adolphus Ealey, Barnett-Aden Collection, Washington, D.C. Photo: Anacostia Neighborhood Museum, Washington, D.C.

ting. Perhaps this indicates that the "ghetto" is potentially explosive.

Her more recent works are totally abstract. Vibrant colors are often applied with stacatto brush strokes suggesting a mosaic. They float vertically or horizontally against the white or whitened background creating rectangles or circles as in "Lunar Rendezvous." "New Galaxy" of 1960, shown in the controversial Whitney exhibition (Contemporary Black Artists in America, 1970), is a study in subtlety—almost monochromatic blue to blue-brown in a series of vertical block-like brush strokes.

In "Composition #3" (fig. 6.3; color slide) broad red bands dominate the composition. On the right side the red is daringly placed next to orange. To relieve the verticality of the composition, diagonal strips create acute triangles which suggest movement. A yellow strip cuts into a green one, but does not bisect it. Green, a secondary color made by mixing yellow and blue, is placed between the blue and yellow strips. Towards the bottom of the picture plane, red diminishes in value as it becomes pink, then white. The painting is visually exciting and a serious study in color relationships.

Merton D. Simpson (b. 1928) studied at the Cooper Union Art School. One of his influential painting instructors was Robert Motherwell. His development as an abstract expressionist landed him space in the "Younger American Painters" exhibition which was held at the Guggenheim Museum, New York, in 1954 when he was twenty-six years old. His abstract expressionism is evident in a mixed media work, "Poem—2", 1954 (fig. 6.4). It is visually exciting because of the active brush work and texture. In this work he employs a variety of materials—sand, newsprint, thick layers of oil paint.

Figure 6.3. Alma Thomas, "Composition #3," watercolor, 22" X 30 1/4". Courtesy of Fisk University, Nashville, Tennessee. Photo: J. Thomas Clark.

Figure 6.4. Merton D. Simpson, "Poem-2." 1954, oil, collage, 21 1/4" X 27 3/4". Courtesy of the artist.

"Oriental Fable" (fig. 6.5) of five years later more violently demonstrates the "action painting" method. Knowledge of Simpson's long association and appreciation for African art allows one the security of belief that Simpson's and his mentor's oriental references are not the same.

Figure 6.5. Merton D. Simpson, "Oriental Fable," 1959 (destroyed), oil on canvas. Courtesy of the artist.

In the late 1960s Simpson's style took an inward turn with the introduction of the figure in his compositions. The 1964 riots in Harlem inspired "Confrontation," a series of paintings which concentrates on "isolated segments of the faces of man: man angered, man confronted by time, and man slipping back into his past, echoing a 'primitive' mask. . . ."[10] "Harlem Passage No. 2" (color slide) depicts the angry black/white confrontation in that riot. Each side is at its worst; neither can hear nor see the other.

The sculptures of Barbara Chase-Riboud (b. 1936) are firmly rooted in the aesthetic of the Mainstream which has long accepted and praised her art. When she was a teenager, the artist won a *Seventeen* magazine award for a print she entered in the Museum of Modern Art, New York. The artist's works have been shown in one-person and group exhibitions since 1966. Her sculptures and drawings are included in major North American and European museums. An expatriate living in Paris, Chase-Riboud, unlike Tanner, lives abroad by choice rather than for the purpose of economic survival in the art world.

A grant-financed trip to Rome in the mid-1950s enabled the artist to travel to North Africa. Although she visited only Egypt, perhaps the experience of be-

ing on the African continent aroused an interest in tribal art farther to the south and west. Her "Last Supper," 1958, reflects this interest. In this work, several cast bronze masks and a reliquary are arranged on a flat base beneath a textured horizontal panel. The forms are stylized, but some of them can be identified by their tribal style. "Last Supper" represents an initial approach to African forms.

"Figure Volante," 1965, is in the abstract style and suggests a being in flight. It was included in the exhibition of art works by American Blacks at the First World Festival of Negro Arts in Dakar, Senegal. Hale Woodruff describes this seven-inch high sculpture as "big," as bigness refers to "the magnitude of ideas and interpretations embodied in sculpture that speaks strongly, eloquently and with conviction."[11]

Chase-Riboud matches size with ideas in her memorials to the assassinated Black Muslim leader, Malcolm X (fig. 6.6) which were created in 1969-70. Each is an abstract sculpture composed of a cast bronze form and fabric cords. Each of the sculptures

Figure 6.6. Barbara Chase-Riboud, "Monument to Malcolm X, No. II." 1969, cast bronze and wool, 72" X 40" X 10". Courtesy The Newark Museum, New Jersey. Photo: Armen Photographers.

10. David Driskell, "Foreword," to *3 Afro-Americans* (exhibition catalog). Nashville, Tennessee: The Art Galleries, Fisk University, April 20-May 15, 1969, n.p.

11. Woodruff, n.p.

is a study in contrasts: horizontal and vertical cast bronze forms, varying in degrees of relief, and funereal black silk or wool cords flowing from behind the base of the bronze form onto the floor. These are elegant pieces of sculpture which will outlive their original intent as a memorial to a particular person.

The use of contrasting materials was influenced by African masks; in their cultural context, the mask is a part of the costume of the dance the masquerade. According to Chase-Riboud, ". . . . the African dancing mask (wood) is always combined with other materials: raffia, hemp, leather, feathers, cord, metal chains or bells. My idea is to reinterpret the aesthetic function in contemporary terms, using modern materials (bronze and silk, bronze and wool, steel and synthetics, aluminum and synthetics)."[12] Going back to the roots does not mean that the artist makes copies of or merely incorporates forms of African origin, but assimilates the basic concepts to create something new and personal.

The memorials to Malcolm X developed from experiments on the theme of opposition, for example hard and soft, male and female. Post-1970 sculptures by Chase-Riboud developed with further experiments using the structural elements (form)—cast metal and fibers—from the Malcolm X memorials. This is not to say that none of the former works is finished. Each was cast by the lost wax process and therefore is unique. Once the casting has been accomplished no drastic changes can be made on or in the metal.

"Black Column," 1973 (fig. 6.7), is a vertical, polelike construction composed of blackened bronze (cast) and fiber cords. The two cast metal forms are bound by a thick mass of cords which give the illusion of rigidity and strength. They become loops at floor level suggesting separation and continuity simultaneously. The cast metal forms and fibers are redefined in "The Cape," 1973 (color slide). Bronze and copper squares create a 3-dimensional mosaic. The natural colored ropes project from a crest and appear again in long ropes extending onto the floor. It is mysterious. Like a veil of a Yoruba king's beaded crown or the headdress of the African masquerade costume, it conceals something within. Experimentation with the structural elements of earlier expressions constitutes steps which can lead the artist to new forms and visions.

Sam Gilliam (b. 1933) was a follower of the hardedge school of painting, another aspect of the Mainstream art world initiated in the early sixties.

Figure 6.7. Barbara Chase-Riboud, "Black Column." 1973, black bronze and wool, 118 1/8″ X 19 5/16″ X 19 5/16″. Courtesy of the artist. Private Collection, Nice.

12. Nora Francoise, "From Another Country," *Art News* (Mar., 1972), p. 62; see also: Nora Francoise, "Dialogue: Another Country," in *Chase-Riboud* (exhibition catalog) University Art Museum, Berkeley, January 17-February 25, 1973, n.p.

Hard-edge paintings are characterized by clean, knife-sharp edges which separate and define the limits of color in the composition. "Herald," of 1965 by Gilliam is in this tradition. In reaction to the hard-edge style, many artists returned to a more "painterly" style, but in redefined terms.

During the late 1960s and early 1970s, Gilliam became an innovator in the painterly style. His paintings were no longer to be contained within a frame. He suspended painted canvas or plastic sheets from the ceiling to create studies in color and form as in "Carousel Form, II" 1969, a painting which was included in the 69th American Exhibition at the Art Institute of Chicago. He introduced shapes other than the rectangular or square canvas to the concept of painting. His "Arc II," 1970, is such an example. Action painting methods begin these works. While the unprimed canvas is still wet, Gilliam folds it, repaints and refolds it according to his plan (which may change in the process), then lets it dry. Hanging the dry painted canvas offers yet another compositional challenge in that he has to consider the existing light and space the painting will share. Moreover, the problem of hanging and presentation is renewed each time the painting is placed in a new environment (figs. 6.8 and 6.9; color slides).

Gilliam's work was again selected for the American Exhibition at the Art Institute in 1976. "Onion Skin," 1975, is an abstract action painting on duck cloth, not on canvas. The painting is stretched over a conventional inner frame; however, it

unexpectedly juts out like a low, flattened pyramid above the external frame which surrounds it. This is another innovation, however subtle, in the presentation of a painting.

Joe Overstreet's (b. 1933) sympathies have always been with the Black Nationalist Movement, but he has never been literal in his mature visual political expressions. Earlier paintings of the 1960s were characterized by vivid motifs inspired by African sculptured forms and by the Movement. He had been innovative in his use of triangular and rectangular shaped canvases which are joined together or separated by irregular areas of space. Like Gilliam, Overstreet has experimented with unframed paintings suspended from the ceiling. At his most innovative, his paintings are like flying kites restrained by rope or steel cables attached to the ceiling and anchored to the floor.

In "Hoo Doo Mandala," 1970, colors are pure and painted in the hard-edge style. In "Revelation," 1972 (fig. 6.10; color slide), reds and blues tempered by other colors create the illusion of depth on a flat surface, the canvas. Parts of the "red side" are shaded to create the illusion of depth beneath the surface. The "blue side" advances due to the presence of lighter colors. Dividing the composition into unequal parts is a rectangle which seems to exist in space and where the two "sides" seem to merge.

Some viewers may see a figure emerging from the blue side within the rectangle. This painting is an excellent example of how evocative an abstract painting can be. Studying it is similar to watching clouds; the painting calls forth a different interpretation from each viewer.

Howardena Pindell (b. 1943) is an artist whose non-representational paintings are composed of tiny dots of color. In her own manner she has revived the concept of pointilism or divisionism which was developed in the late nineteenth century by Georges Seu-

Figure 6.8. Sam Gilliam, "Arc II." ca. 1970, acrylic on canvas, draped. Courtesy Dr. William Seeman, Cincinnati, Ohio. Photo: Rick Boltan.

Figure 6.9. Sam Gilliam. "Arc II." ca. 1970, acrylic on canvas, 90″ × 47″. Courtesy Dr. William Seeman, Cincinnati, Ohio. Photo: Rick Boltan.

rat. The classic painting in this style is "A Sunday Afternoon on the Island of Grand Jatte," 1885-86, by Seurat. Pindell's paintings are not in imitation of pointilist works of the 19th Century. She does not reproduce forms in nature, the real world. The use of dots in her works is very modern in concept.

In her earlier paintings, the dots were applied directly onto the canvas. In later works, such as "Untitled, #3" 1975 (fig. 6.11; color slide), the dots become real discs of color which project from the canvas. Depth, created by light and shadow or through perspective in conventional paintings, is here created by actual shadows cast by the dots. Lines made by threads of varying thickness cut the dots diagonally, horizontally and vertically. The composition is neither psychologically nor physically stationary.

The assassination of Reverend Martin Luther King, Jr. in 1968 provoked the only political statement ever made in visual terms by the artist. "Hommage to Martin Luther King," 1968 (fig. 6.12; color slide) is a multi-media work, collage, combining ab-

Figure 6.11. Howardena Pindell, "Untitled #3." 1975, pen and ink on paper, thread, spray adhesive, 15″ X 15″. Collection Luc and Maryvonne Rosseneau, Damme, Belgium. Photo: Bevan Davies.

straction with representation. The artist reflects on her memorial to King: "The newspaper represents the media which seems to report the news about King or Kennedy for sympathetic altruistic reasons, but is using it as a point of departure for selling newspapers, i.e., making money. The faces represent, for me, King, and Kennedy and the next victim . . . Bobby Kennedy although the drawing was done before Bobby Kennedy died. . ."[13]

The artist painted the newspaper brown to symbolize the non-white population in the world. The white lines superimposed on the brown symbolize the attempt by whites to control the non-white population. Red symbolizes blood. There is a gold bullet placed at the lower right in the composition and directed away from the targets. According to Pindell, this bullet symbolizes power through wealth, "perhaps seen two ways: the third world gaining power through wealth (oil) . . . or the attempt of those who presently have wealth to retain power through force . . . and power over the well-known 'revolutionaries,' but also power over the common people like you and me."[14]

Black artists are also involved in the more recent additions to Mainstream art, light and minimal art.

Tom Lloyd (b. 1929) sculpts with colored lights. The lights are encased in colored glass or plastic forms which are mounted in geometric molds and require electric energy to activate them. The lights are programmed to flash on and off, one at a time or in

Figure 6.10. Joe Overstreet, "Revelation." 1972, acrylic on canvas, 6′8″ X 10′8″. Courtesy of the artist.

13. Howardena Pindell, personal communication, April, 1976.
14. Pindell, personal communication, April, 1976.

Figure 6.12. Howardena Pindell. "Homage to Martin Luther King." 1968. collage of newspaper, crayon, oil stick, ball point pen on graph paper, 18″ × 22″. Collection of the artist, New York. Photo: Bevan Davies.

169

combination. Light art is, then, a marriage of art and modern technology, i.e., computer programming, which after years of experimentation has become a reality. Since light sculptures are best appreciated in action, no example is included in this text.

Minimal art works are usually geometric sculptures, constructions made of prefabricated materials, and depend upon a mood created by the object in its environment, as does all art. Mel Edwards' (b. 1936) "Double Circles," reproduced in Chapter 5, are pairs of stationary, over life-size metal rings. They can suggest to the viewer life as a never ending cycle, the vicious circle of injustice suffered by Blacks, the poor, or women. However, some works in this style are so esoteric as to escape the understanding and experiences of the general viewer.

Richard Hunt (b. 1935) is a Chicago-born sculptor who the Mainstream art world recognizes as "one of America's foremost living sculptors."[15] Testimony to this is the quantity of Hunt's sculptures in major museum permanent collections, private collections, and exhibitions in commercial art galleries across the country. To his own people, he is a black hero, an artistic giant worthy of being emulated.

Hunt began formal art training when he was thirteen years of age at the Junior School of the Art Institute of Chicago. After receiving his high school diploma in 1958, he undertook advanced courses at the Art Institute. His interest in sculpting in metal was influenced by the iron sculptures of Julio Gonzales, a Spaniard, which he saw in exhibitions. Hunt taught himself to weld and to depend upon the torch, rather than casting or hammering, to achieve the desired forms and effects. The metal for his sculptures are often discarded or broken machine-manufactured parts which he recycles into works of art.

Reflecting on his art, Hunt says, "In some of my works it is my intention to develop the kind of forms nature might create if only heat and steel were available to her."[16] He creates "hybrid" forms, nature stylized according to his artistic inventiveness. "The Chase," 1965 (color slide) is suggestive of two insects, perhaps preying mantises, in motion. "Natural Form No. 7," (fig. 6.13) suggests a horned animal arrested in motion. The sculptures excite the viewer's imagination.

Later sculptures created in the 1970s are more abstract conceptions of natural forms. "Hybrid," 1973 (fig. 6.14) denies a natural origin. It is a variation on the themes of triangles and curves in space. This piece calls to mind a statement made by Richard Hunt: "Now sculpture can be its own subject, and its object can be to express itself, by allusion to its traditions, involvement with new means and interaction with its environment."[17]

The above mentioned followers of the Mainstream trends are controversial. Since the abstract/abstract expressionist styles and the derivative forms are in opposition to any approach which stresses representation of the objective world, black abstractionists are accused of denying their racial identity, of being eclectic in order to enter the Mainstream art world. Certainly the universal message, the accepted alternative of the prevailing aesthetic allows a black artist an opportunity to enter into the Mainstream art world—its commercial art galleries and the permanent collections of major museums, the residences of modern art collections. It affords him a liberal, usually sophisticated viewing audience which will appreciate the artist's intellectual and technical facility as an artist as well as the content of his compositions. All artists want to have their works appreciated and to make a living. Still, it is unfair to underestimate the intellectual capacity of the "ghetto masses" who like other viewers bring their own experiences to a work of art and leave with their own interpretation of what they saw. Nor is it fair to limit any artist to a particular style or statement. Always, of utmost importance is how the artist treats the elements of art structure: line, shape, value, texture and color. For in the final analysis, it is on these terms that the work of art must be judged. So says the Mainstream.

The Blackstream

Since the mid-1960s there has been a movement to develop a Blackstream/Black Art which will meet black critical and aesthetic standards. Just what it is and in what manner it should be presented (style) are still points of controversy. Hughie Lee-Smith, a painter who is best described as a surrealist who paints social commentary, gave a tentative definition: "Blackstream/Black Art is that art which derives its inspiration and sustenance from the struggle of black people, for economic, social, and cultural power; an art which reflects, celebrates, and interprets that struggle in a stylistic manner which is meaningful to the Afro-American community and members of other oppressed minorities."[18] Lee-Smith is not the only artist who has defined black art, but his definition reflects a synthesis of most opinions.

15. William S. Lieberman, "Introduction," *The Sculpture of Richard Hunt*, p. 4, (exhibition catalog) New York: The Museum of Modern Art, 1971.

16. Richard Hunt, "Statements by Richard Hunt," *The Sculpture of Richard Hunt*, p. 14 (exhibition catalog) New York: The Museum of Modern Art, 1971.

17. Hunt, p. 14.

18. Hughie Lee-Smith quoted in "Black Art: What Is It?" in *The Art Gallery*, Second Afro-American Issue (April, 1970), p. 34.

Figure 6.14. Richard Hunt, "Hybrid." 1975. cast steel. 19" × 8" × 8 1/2". Courtesy of Ronald Mayne, Roslyn Heights, New York. Photo: Leni Studio.

Figure 6.13. Richard Hunt, "Natural Form No. 7." 1968, welded steel, 53" × 11" × 25". Courtesy of Ronald Mayne, Roslyn Heights, New York. Photo: Leni Studio.

What is the "stylistic manner" which is meaningful to the mass of black people? Here again, opinions differ. Many black artists who advocate Black Art see the figurative/objective style as the solution. The message presented must be clear and readily grasped by an audience which supposedly "lacks sophistication" to appreciate the art styles of the Mainstream. White critics have labelled such art as "social realism," or "protest art," a throwback to the 1930s and therefore *passé*. Black artists agree. But, they point out, the same problems that existed *then* are still in existence *now*! The idea of art for art's sake, like white society's values in general, are irrelevant to black people. Black art must be functional: it must educate politically and reinforce pride in being black, an African-American.

The following survey of artists and works demonstrates the variety of approaches to the concept of Blackstream/Black Art. Whether or not the black artist is a "militant" or only pays monetary dues to the cause, he is still a rebel if he believes in the cause of black people—in their beauty, dignity, unity, and self-direction—and insists on expressing this in his or her art.

Dana Chandler (b. 1941) is one of the most outspoken and visible (wearing apparel in the liberation colors of red, black and green) advocates of the Blackstream and pan-Africanism. Born and educated in Massachusetts, Chandler teaches art courses in a university. He refers to his style as "black expressionism" and paints in pure colors and psychedelic day glo. He says, "I ain't subtle and I don't intend to be so long as America remains the great white destroyer."[19]

The slain Black Panther chief, Fred Hampton, is memorialized in the painting, "Fred Hampton's Door," in which there is the door complete with real bullet holes. He also painted a memorial to another slain black leader, Reverend Martin Luther King, Jr. He expresses oppression of Blacks in "Land of the Free," 1967 (fig. 6.15; color slide) in which the symbols are readily understood. Against the background of Old Glory, Uncle Sam is depicted with his foot on the head of a black man whose body has been steamroller flattened by the System. "Land of the Free No. 2" depicts a black man behind a horizontal Old Glory, but also behind bars. Chandler reminds the viewer that American democracy does not apply to him.

Cliff Joseph (b. 1922) portrays black-controlled education in "Blackboard," (color slide). The female teacher wears her hair in an "Afro" and the boy whom she instructs wears a dashiki. The alphabet this pupil is learning is relevant to blacks: "A" is not "A" as in apple, but "A" as in Ashanti, a West-

African kingdom which is part of his pre-American history. The artist has been in the Black Emergency Cultural Coalition[20] and has been involved in developing socially and culturally relevant programs for Blacks in prisons and inner-city communities.

Ernest Crichlow (b. 1914) portrays in "White Fence," (color slide) the reality of growing up in the inner city in contrast to growing up in a white suburb. Behind the security of the white picket fence, the white child learns from infancy that white equals clean, beautiful and right. The ghetto/inner city child knows white fences, too. They are spike-tipped and there to keep him on the other side. The fences he knows better are the neglected unpainted boards found in his ghetto.

Everybody knows Aunt Jemima on the pancake box. She is symbolic of one aspect of black womanhood in the eyes of white society—the dependable, benign, usually fat, grinning great black mammy in white kitchens and nurseries. Murray DePillars portrays the real Aunt Jemima (fig. 6.16). She is a very angry woman who may still be in the white lady's kitchen, but on very different terms—shorter, more reasonable working hours, familiarity if allowed, and social security.

An energetic artist/college art instructor, Benny Andrews (b. 1930), is a political activist and social critic both verbally and artistically. He once said, "I want to be an artist my way,"[21] and he has stubbornly adhered to doing just that. During his student days at the Art Institute of Chicago (1954-58), Andrews resisted the attraction of abstract expressionism in spite of the adverse criticism from his student colleagues and instructors. He painted the "uglies" of Chicago's skid row in a representational style. Since

19. Dana Chandler quoted in Samella Lewis and Ruth G. Waddy, *Black Artists on Art*, Vol. I, Contemporary Craft Publishers, Los Angeles, 1969, pp. 39-40.

20. The Black Emergency Cultural Coalition (BECC) is co-chaired by Benny Andrews and Cliff Joseph. It was established in the Autumn of 1968 and organized to picket the Whitney Museum of American Art, New York, for more black participation in its exhibitions of American painting and sculpture of the 1930s, and again the "Harlem on my Mind," exhibition at the Metropolitan Museum of Art. It was instrumental in persuading the Whitney Museum to mount a black art exhibition in 1971. However, BECC criticized the exhibition for not being representative of black artists whose expressions are "protest art." In 1975-76 the organization was active again in another protest involving the Whitney Museum which denied black representation in its American bicentennial exhibition. Blacks in the fine arts have been recorded since the 1700s. Further reading on the BECC: Grace Glueck, "Into the Mainstream, Everybody," *The New York Times*, (Sunday, June 15, 1969), p. 24; "In a Black Bind," *Time* magazine (April 12, 1971), p. 46; and Acts of Art Gallery, *Rebuttal to the Whitney Museum Exhibition*, (exhibition catalog), April 6-May 10, 1971.

21. Benny Andrews quoted in Raphael Soyer, "I want to be an artist my way. . ." *Benny Andrews* (exhibition catalog) ACA Galleries, April 25-May 13, 1972.

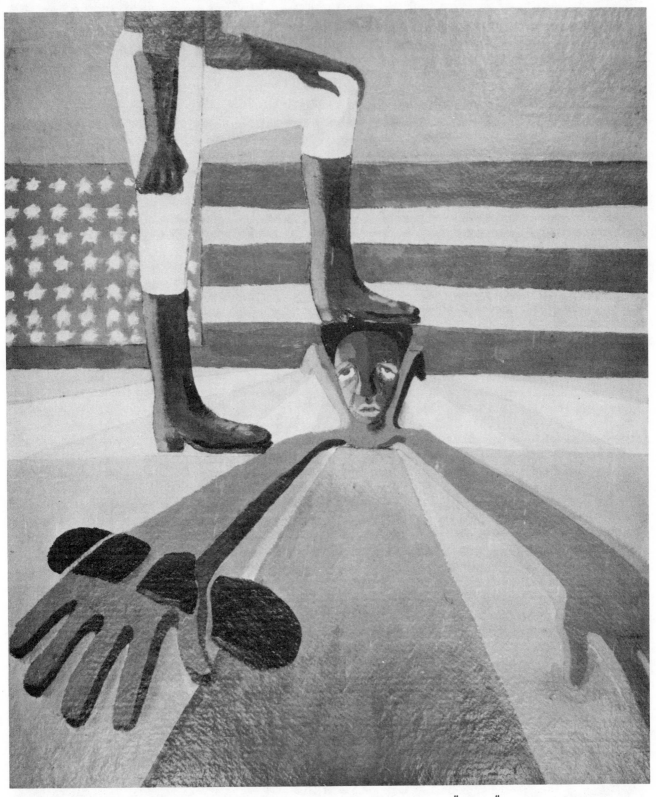

Figure 6.15. Dana Chandler, "Land of the Free." 1967, acrylic on canvas, 28″ × 38″. Courtesy of the artist.

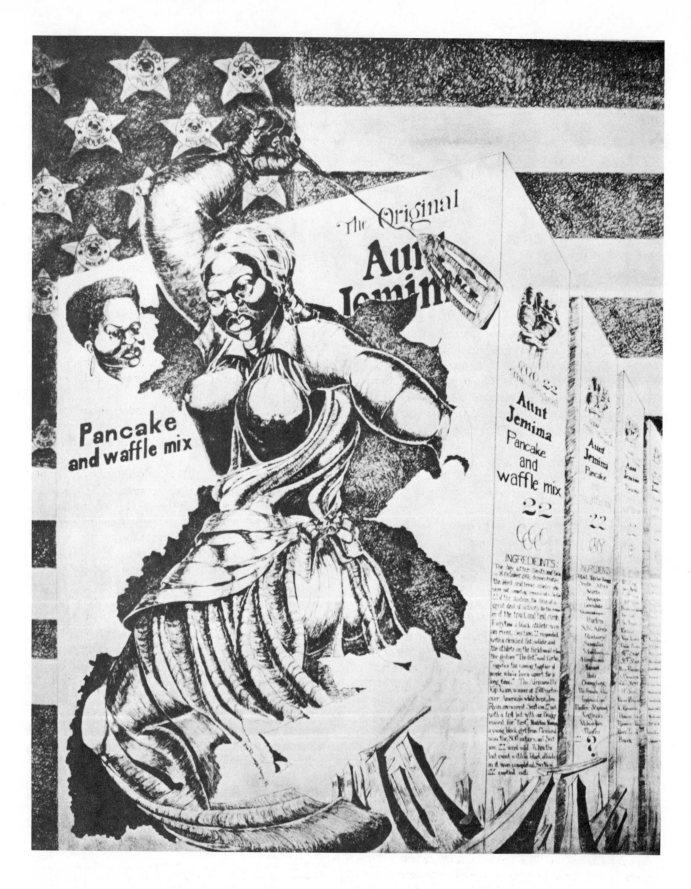

Figure 6.16. Murray N. DePillars, "Aunt Jemima." Pen and ink drawing, 22 1/2″ × 18″. Courtesy of the artist. Photo: Lawrence F. Sykes.

then, he has continued to execute visual commentaries on social injustice in a representational, but often highly symbolic style. Proof of his success is where his art has been and where it is: in exhibitions (several one-man shows since 1960) and permanent collections in America's most prestigious galleries and museums.

"Trash" (fig. 6.18) was the main attraction of Andrews' one-man exhibition held at the ACA Galleries (New York), in 1972. This multi-panel painting measures 10' × 28' and is a follow up to "Symbols," (fig. 6.17) in which the artist "got across a lot of what I'm about as a person, and where I'm coming from in this raunchy society."[22] It focuses on his southern (Georgia) background experiences in survival while indicting that region on the charges of rape, exploitation and abuse. He is more explicit in "Trash" in his indictment of institutions and ideas of racism, sexism and militarism manifested in organizations like the Ku Klux Klan and the military.

In "Trash," socio-religious bodies (symbolized by the star of David, the cross, and the star and crescent) which give sanction to those anti-human institutions and ideas are not exempt from the charge. Edmund B. Gaither, in his "Comments on 'Trash'" sees the work as an equation—"false religion plus sexism plus militarism plus false democracy equals deception equals trash or waste."[23]

The opening of that exhibition ("Trash") as well as the others that have followed, was attended by numerous affluent, mostly white patrons who came, looked and purchased. Hopefully, Benny Andrews' "visual statement of profound and artistic consequences . . . is not a seed sown on stones."[24]

Willis Bing Davis' (b. 1937) "Attica Entombment No. 1" (fig. 6.19; color slide) was inspired by the Attica prison riots. It is a carefully composed assemblage of contrasting materials and a profound statement on the penal system. Adhered to a blackened rectangular piece of wood are two faces modeled in clay. The nail-pierced wood evokes the image of the martyred St. Sebastian or an African "nail fetish" depending upon the viewer's experience. The third face is a reflection of the viewer who peers into the recessed oval which contains a mirror. The numbers below symbolize the system of depersonalization of which prison inmates and citizens alike are victims. The two faces are identical death masks; the numbers under their faces are larger symbols of a dehumanizing system. The artist comments on numbers: "Think about all the ways we are catalogued, the assignment of the number as a substitution for the person . . . what should be for the advancement of mankind is in reality reducing him. I see the situation today as very much the same, outside and in. The problems in the schools, industry, prisons and communities are the same, the prison problem is just more obvious and recognizable."[24] Further contrast in textures occurs in the unraveled ropes which hang from the base of the blackened slab. By becoming involved in the work, that is by looking into the mirror, the viewer is reminded that the unfortunate tragedy at Attica Prison is not confined to its inmates, but includes himself as well.

Edward E. Parker (b. 1941) models figures in clay. The subjects of his sculptures are Blacks—African and American—and his style is representational. He celebrates the common black laborer in a *terra cotta* (fired clay) sculpture entitled, "In From the Fields," (fig. 6.20). In it he achieves his goals of fidelity to nature and emotional appeal. The proportions, textures, physical characteristics and gestures are lifelike. The subject's head is thrown back in anticipation of satisfying a tremendous thirst from an outdoor tap (a hardware construction). The viewer identifies with the subject represented in the sculpture; he, too, anticipates the drink.

Three of the older and best known black artists who have always portrayed the black experience are Jacob Lawrence, Charles White, and Romare Bearden.

Jacob Lawrence (b. 1917) has painted a variety of subjects related to the black experience, singularly and in series. Among the series are the "Migration of the Negro," (1940-41) which depicts the movement of Blacks from the south to what they hoped would be a better life in the northern states; "The Harlem Series;" and the series depicting the history of the Haitian Revolution which was led by Toussaint l'Ouverture. We reproduce here the "Ordeal of Alice," (fig. 6.21; color slide). Pierced by arrows like the martyred St. Sebastian, "Alice" symbolizes black children who desegregated American schools and were subjected to violent displays of hatred on the part of whites. The painting has a flat quality and may remind one of the "naif" artist's style. However, in Lawrence's paintings, the use of flat planes is conscious and deliberate.

Charles White (b. 1918) celebrates the black man in a mural at Hampton Institute (in 1943). The mural

22. Benny Andrews, "Notes on Doing 'Trash,'" in *Benny Andrews* (exhibition catalog) ACA Galleries, New York, April 25-May 13, 1972, n.p.

23. Edmund B. Gaither, "Edmund B. Gaither Comments on 'Trash,'" in *Benny Andrews*, n.p.

24. Willis Bing Davis, quoted in *"Bing" Davis Paintings and Ceramics* (exhibition catalog), Wabash College Humanities Center, January 14-February 4, 1973.

Figure 6.17. Benny Andrews, "Symbols." 1971, 8′ × 36′. Courtesy of the artist.

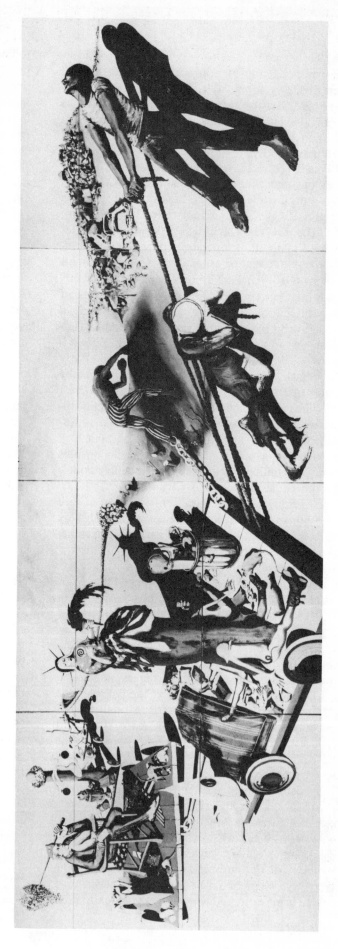

Figure 6.18. Benny Andrews, "Trash." 1971, oil and collage, 12 panels, 10′ × 28′. Courtesy of the artist. Photo: Bolotsky.

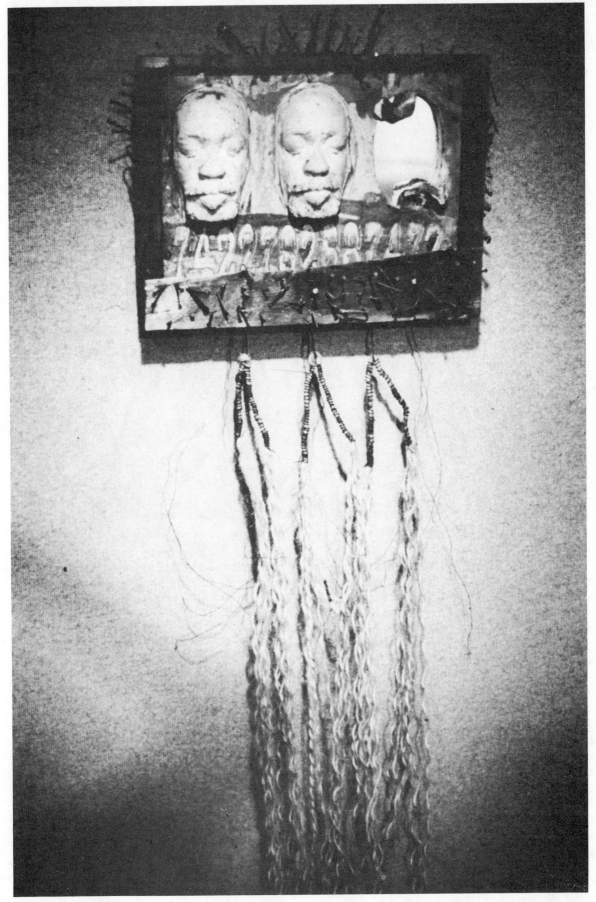

Figure 6.19. Willis Bing Davis, "Attica Entombment #1." Clay, wood, wire, rope, nails. Permanent Art Collection of Indiana State University, Terre Haute. Indiana Purchase Award from 1973 Wabash Valley Exhibition held at the Swope Gallery, Terre Haute. Courtesy of the artist.

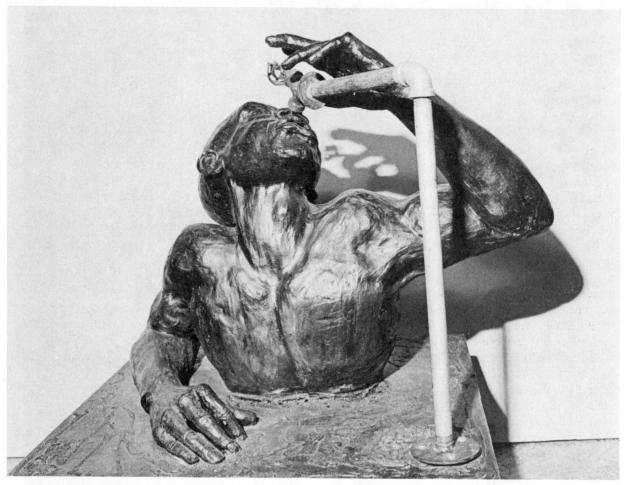

Figure 6.20. Edward E. Parker, "In From The Fields." Clay and metal, 24″ sq. at base. Courtesy of the artist.

is entitled "The Contribution of the Negro to American Democracy." The mural is peopled with soldiers, scientists, musicians, statesmen and laborers. He later commemorated the bombing of a black church in Birmingham, Alabama in "Birmingham Totem," 1965 (fig. 6.22), in which there is a black man holding a plumbline atop a pile of debris: What is the depth, where is the end to atrocities committed against black people? The "Wanted Poster Series," is a strong powerful statement on the theme of black oppression. The artist reminds us that black people are still running—escaping—toward freedom, and with a price on their heads, not unlike the slavery period.

Romare Bearden (b. 1914), like Lawrence and White, has been committed to portraying the black experience. He has always been concerned about what black artists should do with their "artistic calling" and expressed his sentiments as far back as 1934 in an article, "The Negro Artist and Modern Art," which was printed in *Opportunity, the Journal of Negro Life*. The whole article is quotable, for its con-

tent is timeless—black artists of today are still dealing with the same problems he addresses:

On factors that hinder the development of Negro artists:

First, we have no valid standard of criticism; secondly, foundations and societies which supposedly encourage Negro artists really hinder them; thirdly, the Negro artist has no definite ideology or social philosophy.

Bearden continues,

I am sure the Negro artist will have to revise his conception of art. No one can doubt that the Negro is possessed of remarkable gifts of imagination and intuition. When he has learned to harness his great gift of rythm [sic] and pours into art—his chance of creating something individual will be heightened. At present it seems that by a slow study of rules and formulas the Negro artist is attempting to do something with his intellect which he has not felt emotionally. In consequence, he has given us poor echoes of the work of white artists—and nothing of himself.

And finally,

> I don't mean . . . that the Negro artist should confine himself only to such scenes as lynchings, or policemen clubbing workers . . . if it is the race question, the social struggle or whatever else needs expression, it is to that the artist must surrender himself. An intense, eager devotion to present day life, to study it, to help relieve it, this is the calling of the Negro artist.[25]

None of his statements is mere rhetoric; Romare Bearden has practiced and continues to practice what he preached more than forty years ago. Working in collage and polymer, he has expressed the black experience, particularly in black *genre*, the everyday life. Those Harlemites who saw the 1971 exhibition of his paintings and photomontage works in the Museum of Modern Art recognized "their" Harlem in a multi-panel painting depicting the sights and sounds of 125th Street and environs. One could see and hear squad car sirens, folk singing in the storefront churches, laughter, sighs, crying, screams from numerous barrooms. "Mysteries," 1964 (fig. 6.23) from the "Projection Series," is no mystery to the black viewer—Jesus, watermelon, "Alaga Syrup," (only the word "syrup" is visible, but readers of *Ebony* magazine will recognize the lettering from the advertisements)—are but stereotypes at

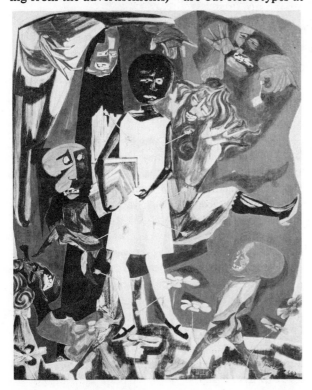

Figure 6.21. Jacob Lawrence, "Ordeal of Alice." 1963, tempera on paper, 23 7/8″ X 19 7/8″. Courtesy of Gabrille and Herbert J. Kayden, New York. Photo: Dintenfass Gallery, New York.

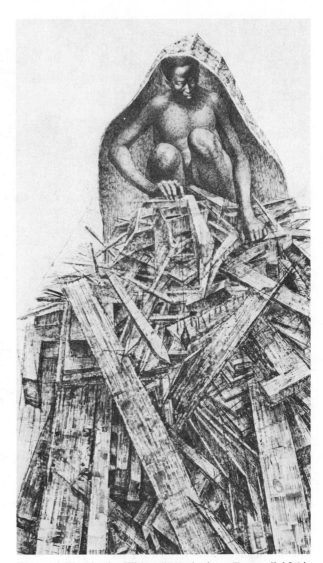

Figure 6.22. Charles White, "Birmingham Totem." 1964, ink and charcoal 73 X 43″. Private Collection. Photo courtesy of Forum Gallery, N.Y.

best of the black world to the white viewer, but completely real to the black viewer.

Anti-mainstream may also mean anti-museums. Ghetto Blacks do not tend to be museum-goers. And, with good reason, from their point of view. In the past and even currently, there are few if any works of art by black artists from any period in the history of American art on display, except when there is a "special black exhibition." This is not because museums have not collected works of art by black painters, sculptors, print makers, etc. in the past; they seem always to be in storage. Art, then, must be brought to the ghetto and it is, in community museums such as the DuSable Museum of Afro-

25. Romare Bearden, "The Negro Artist and Modern Art," in *Opportunity, the Journal of Negro Life,* Vol. XII, No. 12 (December, 1934), pp. 39-40.

Figure 6.23. Romare Bearden, "Mysteries." 1964, collage, 11 1/4″ X 14 1/2″. Courtesy Museum of Fine Arts, Boston.

American History in Chicago, art centers, and on the walls of buildings in the community. The themes of the wall murals are black history, pride, love of family, peace, black power, celebration of black humanists and scientists. "The Wall of Respect and Truth,"[26] originally located at the corner of 43rd and Langley Streets in Chicago, Illinois, was one of the first walls to be painted in a black community. The artists involved in the project are William Walker, Eugene Eda, and the OBAC. A lynching Ku Klux Klan-style, black sportsmen, musicians, statesmen and other black heroes are depicted. Other murals in Chicago include, "Nation Time," by Mitchell Caton, "Wall of Love," and "Peace and Salvation Wall of Understanding," by William Walker, (fig. 6.24; color slide). Walker's "Understanding" wall was painted on a five-story high building at the corner of Locust and Orleans Streets. Its message is the futility of racial disharmony. There are other wall murals in American cities; for example, "The Wall

of Dignity," in Detroit's inner city, and a mural by Dana Chandler and Gary Rickson in Boston, Massachusetts.

As was the condition of the Harlem Renaissance in the 1920s, the Second Renaissance of the late 1960s and early 1970s was short-lived. In each instance national attention was focused on the social, civil, and economic problems of black people; there was interest in their contributions, as a race, to the development of their country, and in their music, literature and art. This period of renewed visibility resulted in greater strides towards entry into the Mainstream for larger numbers of Blacks, while at the same time fostered racial consciousness through hard-won Black Studies programs in educational institutions at all levels of learning.

26. The remainder of the "Wall of Respect. . ." is located at Malcolm X College, Chicago, Illinois. A list of Chicago, Illinois, wall murals can be obtained from the Community Mural Project, Community Arts Foundation, 2261 North Lincoln Avenue, Chicago, Illinois, 69614.

This period of black awareness must continue in the minds of all people, for other issues have already co-opted national attention from black issues. It is for this reason that black artists who feel a responsibility towards the black community take whatever gains they have achieved in stride and tend to ignore any cautionary advice such as that offered by Werner:

> Pitfalls (the danger of being out of the Mainstream) can be avoided only if black artists are determined to create works that go beyond their racial identification . . . and if they bear in mind that black and white artists share the same reality: birth, life, sickness, pain, joy and death.[27]

Human beings all. Americans all. But, at the same time, Americans of various ethnic ancestries with traditions and life-styles which determine the perspectives from which they can live and create in America. As witnessed by the "lost" black artists of the 1950s—lost in the memories of authors of art history books of that period—there is danger in being non-racial in artistic expressions: the black artist becomes invisible, and particularly to the black community.

In the last analysis, for his own personal artistic integrity, the black artist must express that which is most important to him. If the black experience, and so-called social realism, is the style in which he must express himself, he should not be penalized, for this is his right. Otherwise, artistic freedom is a meaningless term.

Slides

Hale Woodruff, "Celestial Gate," 1968, oil on canvas, 46″ × 60″, Spelman College, Atlanta Georgia.

Figure 6.3. Alma Thomas, "Composition number 3, watercolor, 22″ × 30 1/4″. Courtesy, Fisk University, Nashville, Tennessee. Photo: Thomas J. Clark.

Merton D. Simpson, "Harlem Passage, No. 2," Confrontation Series 1964, 40″ × 30″ oil on canvas. Courtesy Merton D. Simpson Gallery, New York.

Figure 6.8. Sam Gilliam, "Arc II," 1970, acrylic on canvas, draped. Courtesy William Seeman Collection, Cincinnati, Ohio. Photo: Rick Bolton.

Figure 6.9. Sam Gilliam, "Arc II," 1970, acrylic on canvas, 90″ × 47″. Courtesy, William Seeman, Cincinnati, Ohio. Photo: Rick Bolton.

27. Alfred Werner, "Black is not a Colour," in *Art and Artists,* Vol. 4 (May, 1969), p. 17.

Figure 6.24. William Walker and Eugene Eda, "Peace and Salvation Wall of Understanding." Paint on brick wall foundation. Courtesy of Dr. Margaret T. G. Burroughs, Director, DuSable Museum of Afro-American History, Chicago, Illinois, and Humanities Department, Kennedy-King College.

Figure 6.10. Joe Overstreet, "Revelation," 1972, acrylic on canvas, 6'8" × 10'8". Courtesy of the artist.

Figure 6.11. Howardena Pindell, "Untitled number 3," 1975, pen and ink on paper, thread, spray adhesive, 15" × 15". Collection Luc and Maryvonne Rosseneau, Damme, Belgium. Photo: Davies.

Figure 6.12. Howardena Pindell, "Homage to Martin Luther King," 1968, collage and newspaper, crayon, oil stick, ball pen on graph paper, 18" × 22". Courtesy of the artist.

Figure 6.15. Dana Chandler, "Land of Free," 1967, acrylic on canvas, 28" × 38". Courtesy the artist.

Cliff Joseph, "Blackboard," oil on canvas, 28" × 36". Courtesy the artist.

Ernest Crichlow, "White Fence."

Figure 6.19. Willis Bing Davis, "Attica Entombment, No. 1,"clay, wire, wood, nails, rope. Courtesy the artist.

Barbara Chase-Riboud, "The Cape," 1973, 300 cm × 49 cm × 49 cm. Courtesy of the artist.

Figure 6.21. Jacob Lawrence, "Ordeal of Alice," 1963, tempera on paper, 23 7/8" × 19 7/8". Courtesy Dr. and Mrs. Herbert J. Kayden, New York. Photo: Dintenfass Gallery, New York.

Figure 6.23. Romare Bearden, "Mysteries," 1964, collage, 11 1/4" × 14 1/2". Boston Museum of Fine Arts, Ellen Kelleran Gardner Fund.

Figure 6.24. William Walker, "Peace and Salvation Wall of Understanding." Courtesy Margaret Burroughs, DuSable Museum of Afro-American History, Chicago, Illinois.

CONCERTO FOR FLUTE AND JAZZ BAND[28]

David N. Baker

Too many people are of the opinion that jazz and symphonic music are antithetical. Nothing could be further from the truth. This is an artificial concept that I attempted to transcend.

Jazz knows no boundaries. Its musical limitations are attitudinal. As an idiom, jazz is truly creative and can utilize any symphonic instrument for appropriate effects. The flute, for example, may not be considered a formal jazz instrument, but the symphonic flutist can perform jazz as well as non-jazz—the only limitation might be a lack of experience or training in the performance style.

From a composer's viewpoint, the rebellion in "Concerto for Flute and Jazz Band" manifests itself in an expansion and exploration of the potential sounds of all instruments. It is the combining of these elements, new sounds and old instruments, that provides us with a new genre which emanates from rebellion against artificial restrictions.

II Movement—*Chaconne*

The second movement is in the form of a *chaconne*[29] and adds a string quartet to solo alto flute. The chaconne is a lyrical sixteen bar theme which is developed through five *variations* and a theme restatement.

Theme

Trombones and tuba introduce the theme; alto flute and muted strings provide a *paraphrase* of the melody.

Variations

I. The first variation consists of a series of *rubato* exchanges between flute and string quartet.

II. The second variation is a *modal* improvisation built over a rhythm and blues bass *ostinato*. In the background, sustained chords intrude and recede sporadically.

III. The third variation reverts again to alto flute and *muted* strings. The accompaniment is based loosely on an elaborate system of *chord substitution* evolved by John Coltrane. The general mood of this movement is *impressionistic*.

IV. The fourth variation is marked "*slow groove*" and is a bluesy variation starting with alto flute and bass and progressing to jazz band and trumpet solo.

V. The final variation pits the solo flute against the *tutti* jazz band and string quartet. The sections and various musical elements are added in *pyramid* fashion, culminating in a thundering climax. The opening theme returns with alto flute voiced over the lower brass with muted string quartet providing color and counter melody.

Glossary

Chaconne—a graceful, slow theme usually in 3/4 time which is built on a bass melody.

Chord Substitution—replacing one set of harmonies with another set having essentially the same musical meaning.

Impressionism—a music that hints or creates rather than states a feeling, in which successions of colors take the place of dynamic development. Prominent in this music are unresolved dissonances, the use of chords in parallel motion, the whole tone scale, modality, and irregular and fragmentary construction of phrases.

Modal—pertaining to a mode or scale (i.e., dorian, lydian, etc.).

Mute—a device for softening or muffling the tone of a musical instrument.

Ostinato—a clearly defined phrase that is repeated persistently, usually in immediate succession, throughout a composition or section.

Paraphrase—a free rendition or elaboration.

28. This unit should be used with the audio cassette. Musical example is played by James Pellerite, Professor of Music, and the Indiana University Jazz Ensemble.

29. Words in italics are listed in the glossary which follows.

Pyramids—ascending arpeggio, or chords in which the instruments enter in staggered fashion one after the other.

Rubato—an elastic, flexible tempo involving slight accelerandos and ritardandos that alternate according to the requirements of musical expression.

Slow groove—steady, slow swing tempo.

Tutti—indication for the whole ensemble to play, as distinct from the soloist.

Variations—the repetition of a theme or idea in a new or varied form, such as expanding it or contracting it or even changing the key.

References

Suggested Additional Works of Afro-American Literature

It was not possible to include all of these works in the text; many did not fit within the chapter categories. This *selected* (not exhaustive) bibliography should give an indication of the plethora and variety of Afro-American Literature available.

I. *Anthologies*—General

Baker, Houston A., ed. *Black Literature in America.* New York: McGraw-Hill, 1971.

Davis, Arthur P. and Saunders Redding, eds. *Cavalcade: Negro American Writing from 1760 to the Present.* Boston: Houghton Mifflin Co., 1971.

Emanuel, James A. and Theodore L. Gross, eds. *Dark Symphony: Negro Literature in America.* New York: Free Press, 1968.

Huggins, Nathan Irvin, ed. *Voices from the Harlem Renaissance.* New York: Oxford University Press, 1976.

Jones, LeRoi (Imamu Baraka) and Larry Neal, eds. *Black Fire.* New York: William Morrow, 1968.

Long, Richard and Eugenia Collier. *Afro-American Writing: An Anthology of Prose and Poetry.* New York: New York University Press, 1972.

Turner, Darwin T., ed. *Black American Literature: Essays, Poetry, Fiction, Drama.* Columbus, Ohio: Chas. E. Merrill, 1970.

II. *Autobiographies*

Angelou, Maya. *Gather Together in My Name.* New York: Random House, 1974.

———. *I Know Why the Caged Bird Sings.* New York: Random House, 1970.

Baldwin, James. *The Fire Next Time* (Autobiographical Essays). New York: Dial Press, 1963.

———. *Nobody Knows My Name.* New York: Dial Press, 1961.

———. *Notes of a Native Son.* New York: Dial Press, 1955.

Brooks, Gwendolyn. *Report from Part One.* Detroit: Broadside Press, 1970.

Brown, Claude. *Manchild in the Promised Land.* New York: Macmillan, 1965.

Cayton, Horace R. *Long Old Road.* New York: Simon and Schuster, 1963.

Cleaver, Eldridge. *Soul on Ice.* New York: McGraw-Hill, 1968.

Davis, Angela. *Angela Davis: An Autobiography.* New York: Random House, 1974.

DuBois, W. E. B. *Autobiography: A Soliloquy.* New York: International Publishers, 1968.

———. *The Souls of Black Folk* (Personal Essays). Chicago: A. C. McClurg & Co., 1903. Reprinted 1968, New York: Johnson Reprint Corp.

Giovanni, Nikki. *Gemini: An Extended Autobiographical Statement on My First Twenty-Five Years of Being a Black Poet.* New York: Viking Press, 1973.

Himes, Chester. *The Quality of Hurt: The Autobiography of Chester Himes,* Vol. 1. New York: Doubleday, 1972.

Hughes, Langston. *The Big Sea.* New York: Alfred A. Knopf, 1940.

———. *I Wonder as I Wander: An Autobiographical Journey.* New York: Rinehart, 1956.

Jackson, George. *Soledad Brother: The Prison Letters of George Jackson.* New York: Coward, 1970.

Jones, LeRoi (Imamu Baraka). *Home: Social Essays.* New York: Morrow, 1972.

Malcolm X and Alex Haley. *The Autobiography of Malcolm X.* New York: Grove Press, 1965.

Mingus, Charles. *Beneath the Underdog* (Semi-autobiographical). New York: Alfred A. Knopf, 1971.

Moody, Anne. *Coming of Age in Mississippi.* New York: Dell, 1969.

Robeson, Paul. *Here I Stand.* Boston: Beacon Press, 1958.

Schuyler, George S. *Black and Conservative: The Autobiography of George S. Schuyler.* New Rochelle, N. Y.: Arlington House, 1966.

White, Walter. *A Man Called White.* New York: Viking Press, 1948.

III. *Novels*

Attaway, William. *Blood on the Forge.* New York: Doubleday, Doran, 1941.

Beaumont, Charles. *The Intruder.* New York: Putnam, 1959.

Bontemps, Arna. *Black Thunder.* New York: Macmillan, 1936.

Brooks, Gwendolyn. *Maud Martha.* New York: Harper, 1953.

Brown, Frank L. *Trumbull Park.* Chicago: Regnery, 1959.

Brown, William Wells. *Clotel; Or the President's Daughter.* London: Patridge and Oakey, 1853.

Chesnutt, Charles Waddell. *The House Behind the Cedars.* Boston: Houghton Mifflin, 1900.

Childress, Alice. *Like One of the Family.* Brooklyn, N.Y.: Independence, 1956.

Cullen, Countee. *One Way to Heaven.* New York: Harper, 1932.

Demby, William. *Beetlecreek.* New York: Rinehart, 1950.

Dodson, Owen. *When Trees Were Green.* New York: Popular Library, 1967. (First released as *Boy in the Window.* New York: Farrar, Straus, and Young, 1951.)

Ellison, Ralph. *The Invisible Man.* New York: Random House, 1952.

Fair, Ronald L. *Hog Butcher.* New York: Harcourt, Brace & World, 1966.

———. *Many Thousand Gone.* New York: Harcourt, Brace & World, 1965.

Fisher, Rudolph. *The Conjure Man Dies.* New York: Convici-Firede, 1932.

————. *The Walls of Jericho.* New York and London: Alfred A. Knopf, 1928.

Gaines, Ernest J. *The Autobiography of Miss Jane Pittman.* New York: Dial Press, 1971.

Guy, Bosa B. *Bird at My Window.* Philadelphia: Lippincott, 1966.

Himes, Chester. *Blind Man With A Pistol.* New York: Morrow, 1969.

————. *Cotton Comes to Harlem.* New York: Putnam, 1965.

————. *If He Hollers Let Him Go.* New York: Doubleday, Doran, 1945.

Hunter, Kristin. *God Bless the Child.* New York: Scribner, 1964.

Hurston, Zora Neale. *Their Eyes Were Watching God.* Philadelphia: Lippincott, 1937.

Kelley, William Melvin. *A Different Drummer.* New York: Doubleday, 1962.

————. *Dem.* New York: Doubleday, 1967.

Killens, John O. *The Cotillion; or One Good Bull is Half the Herd.* New York: Trident, 1971.

Larsen, Nella. *Quicksand.* New York: Alfred A. Knopf, 1928.

McKay, Claude. *Banana Bottom.* New York: Harper, 1933.

Marshall, Paule. *Brown Girl, Brownstones.* New York: Random House, 1959.

Mayfield, Julian. *The Long Night.* New York: Vanguard, 1958.

Morrison, Toni. *The Bluest Eye.* New York: Holt, Rinehart & Winston, 1970.

Motley, Willard. *Knock on Any Door.* New York: Appleton-Century, 1947.

Parks, Gordon. *The Learning Tree.* New York: Harper & Row, 1963.

Petry, Ann. *The Street.* Boston: Houghton Mifflin, 1946.

Schuyler, George S. *Black No More.* New York: Macaulay, 1931.

Thurman, Wallace. *The Blacker the Berry.* New York: Macaulay, 1929.

————. *Infants of the Spring.* New York: Macaulay, 1932.

Toomer, Jean. *Cane.* New York: Boni & Liverwright, 1923.

Van Dyke, Henry. *The Blood of Strawberries.* New York: Farrar, Straus and Giroux, 1968.

Walker, Margaret. *Jubilee.* Boston: Houghton Mifflin, 1966.

White, Walter. *The Fire in the Flint.* New York: Alfred A. Knopf, 1924.

Williams, John A. *Captain Blackman.* Garden City, N.Y.: Doubleday & Co., 1972.

————. *The Man Who Cried I Am.* Boston: Little, Brown, 1967.

————. *Sissie.* New York: Farrar, Straus, 1963.

————. *Sons of Darkness, Sons of Light.* Boston: Little, Brown, 1969.

Yerby, Frank. *The Foxes of Harrow.* New York: Dial Press, 1946.

————. *The Golden Hawk.* New York: Dial Press, 1948.

————. *Judas, My Brother.* New York: Dial Press, 1968.

IV. *Collected Plays*

Alhamisi, Ahmed and Harun K. Wangara, eds. *Black Arts: Anthology of Black Creations.* Detroit: Broadside Press, 1970.

Brasmer, William and Dominick Consolo, eds. *Black Drama: An Anthology.* Columbus, Ohio: Merrill, 1970.

Bullins, Ed. *Five Plays.* New York: Bantam, 1966.

————, ed. *New Plays from the Black Theatre.* New York: Bantam, 1969.

Couch, William, ed. *Black Playwrights; an Anthology.* Baton Rouge, La.: Louisiana State Univ. Press, 1968.

Hatch, James V., ed., Ted Shine, consultant. *Black Theater USA.* New York: Free Press, 1974.

Jones, LeRoi (Baraka). *Dutchman and the Slave.* New York: Morrow, 1964.

————. *Four Black Revolutionary Plays.* Indianapolis: Bobbs-Merrill, 1969.

King, Woodie & Ron Milner, eds. *Black Drama Anthology.* New York: New American Library, 1971.

Oliver, Clinton and Stephanie Sills. *Contemporary Black Drama.* New York: Scribner's, 1971.

V. *Poetry*

Bontemps, Arna. *American Negro Poetry.* New York: Hill & Wang, 1963.

Brooks, Gwendolyn. *A Street in Bronzeville.* New York: Harper, 1945.

————. *The World of Gwendolyn Brooks.* New York: Harper & Row, 1971.

Clifton, Lucille. *Good Times.* New York: Random House, 1969.

Cullen, Countee. *Color.* New York: Harper, 1925.

————. *On These I Stand.* New York: Harper, 1947.

Dodson, Owen. *Powerful Long Ladder.* New York: Farrar, Straus, 1946.

Evans, Mari. *I Am a Black Woman.* New York: Morrow, 1970.

Hayden, Robert E. *Selected Poems.* New York: October House, 1966.

Henderson, David. *Felix of the Silent Forest.* New York: Poet's Press, 1967.

Hughes, Langston. *Montage of a Dream Deferred.* New York: Henry Holt, 1951.

Johnson, James Weldon. *Fifty Years and Other Poems.* Boston: Cornhill, 1917.

————. *God's Trombones.* New York: Viking Press, 1927.

Jones, LeRoi (Imamu Baraka). *It's Nation Time.* Chicago: Third World, 1970.

————. *Preface to a Twenty Volume Suicide Note.* New York: Corinth, 1961.

Lee, Don. *Don't Cry! Scream.* Detroit: Broadside, 1969.

McKay, Claude. *Selected Poems.* New York: Bookman Associates, 1953.

Reed, Ishmael. *Catechism of D Neoamerican Hoodoo Church.* London: Breman, 1970.

Sanchez, Sonia. *We a Baddddd People.* Detroit: Broadside, 1970.

Spellman, A. B. *The Beautiful Days*. New York: Poet's Press, 1965.

Tolson, Melvin B. *Libretto for the Republic of Liberia*. New York: Twayne, 1953.

Walker, Margaret. *For My People*. New Haven: Yale University Press, 1942.

VI. *Short Fiction*

James, Charles L., ed. *From the Roots: Short Stories by Black Americans*. New York: Dodd, Mead, 1970.

Kelley, William M. *Dancers on the Shore*. New York: Doubleday, 1964.

King, Woodie, ed. *Black Short Story Anthology*. New York: New American Library, 1972.

McPherson, James Alan. *Hue and Cry*. Boston: Little, Brown, 1969.

Petry, Ann. *Miss Muriel and Other Stories*. Boston: Houghton Mifflin, 1971.

Wright, Richard. *Uncle Tom's Children*. New York: Harper, 1938.

The most recent work to consult for identification of black writers and information about their work is:

Rush, Theresa Gunnels. *Black American Writers Past and Present: A Biographical and Bibliographical Dictionary*. Metuchen, N.J.: Scarecrow Press, 1975, 2 vols.